Women Artists

MARGARET BARLOW

UNIVERSE

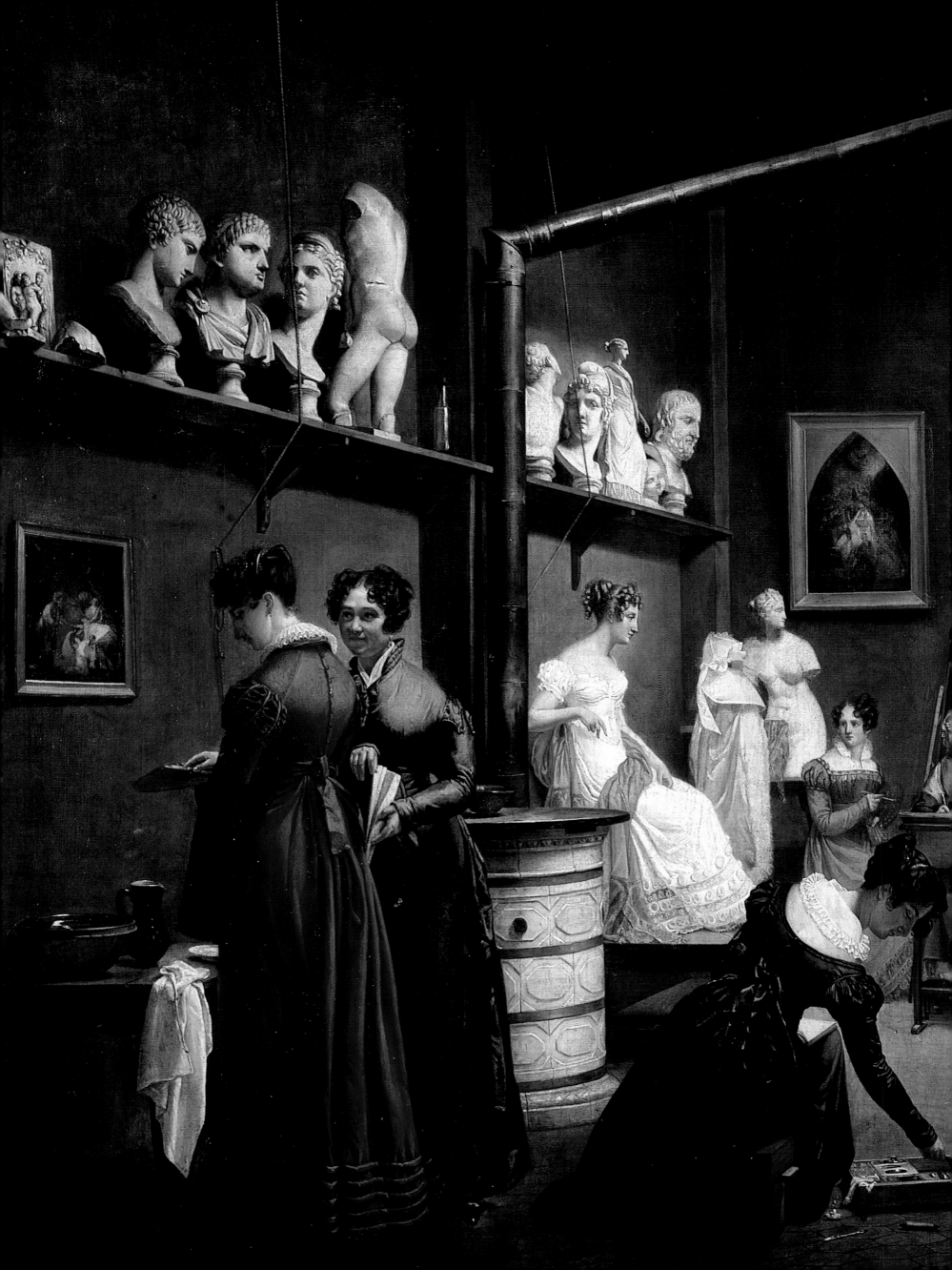

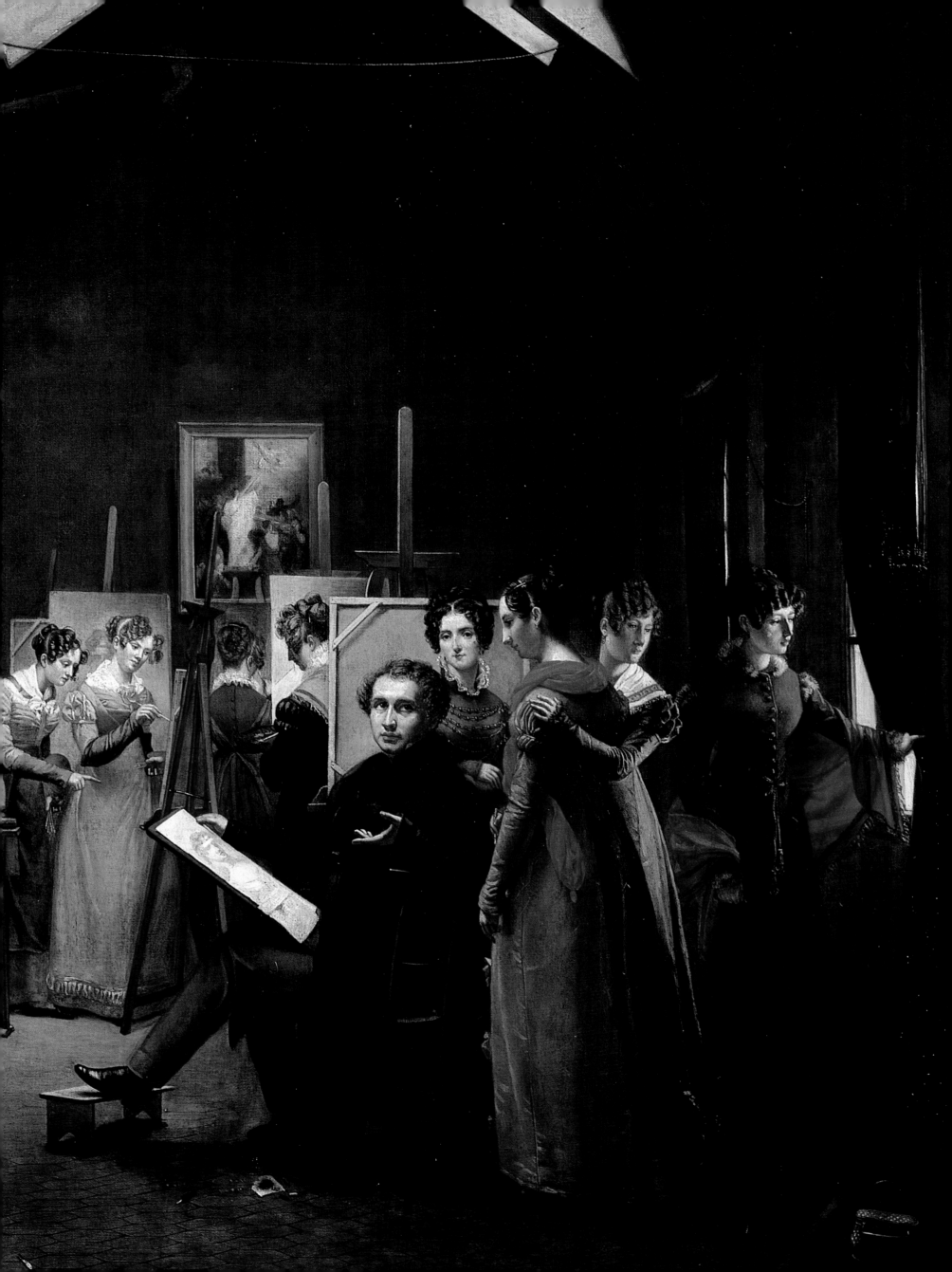

Published by Universe Publishing
A Division of Rizzoli International Publications, Inc.
300 Park Avenue South
New York, NY 10010
www.rizzoliusa.com

Design by Charles J. Ziga, Ziga Design

2008 2009 2010 2011 / 10 9 8 7 6 5 4 3 2 1

Printed in China

ISBN-13: 978-0-7893-9982-3
Library of Congress Catalog Control Number: 2008922675

Text by Cecilia Beaux reprinted courtesy of the Estate of Henry S. Drinker.

Text by Rosa Bonheur excerpted from Rosa Bonheur, *Fragments of My Autobiography*, translated by Lucie Ponsart, *The Magazine of Art 26* (1902).

Text and works by Leonora Carrington © 1999 Leonora Carrington/Artists Rights Society (ARS), New York.

Letter by Mary Cassatt to Bertha Palmer reprinted courtesy of The Art Institute of Chicago.

Work by Paraskeva Clark © Clive and Benedict Clark.

Works by Sonia Delaunay © L&M Services B.V., Amsterdam 990709.

Works by Leonor Fini, Natalia Goncharova, Niki de Saint Phalle, Dorothea Tanning, Maria-Elena Vieira da Silva © 1999 Artists Rights Society (ARS), New York/ADAGP, Paris.

Work by Katharina Fritsch, Hannah Höch, Gabriele Münter, Sophie Taüber-Arp © 1999 Artists Rights Society (ARS), New York/VG Bild-Kunst, Bonn.

Work by Barbara Hepworth © Alan Bowness, Hepworth Estate.

Letter by Eva Hesse © The Estate of Eva Hesse.

Text by Malvina Hoffman excerpted from Malvina Hoffman, *Sculpture: Inside and Out*, © 1939 Malvina Hoffman.

Works by Frida Kahlo reproduced with the permission of El Instituto Nacional de Bellas Artes y Literatura and Banco de Mexico, Mexico City.

Work by Lee Krasner © 1999 Pollock-Krasner Foundation/Artists Rights Society (ARS), New York.

Work by Tamara de Lempicka © 1999 Estate of Tamara de Lempicka/Artists Rights Society (ARS), New York.

Text by Paula Modersohn-Becker excerpted from *Paula Modersohn-Becker: The Letters and Journals*, edited by Günter Busch and Liselotte von Reinken and edited and translated by Arthur S. Wensinger and Carole Clew Hoey. Reprinted courtesy of Northwestern University Press, Evanston, Illinois.

Work by Louise Nevelson © 1999 Estate of Louise Nevelson/Artists Rights Society (ARS), New York.

Text and works by Georgia O'Keeffe © 1999 The Georgia O'Keeffe Foundation/Artists Rights Society (ARS), New York.

Work by Susan Rothenberg © 1999 Susan Rothenberg/Artists Rights Society (ARS), New York.

Text by Ellen Wallace Sharples excerpted from Katharine McCook Knox, *The Sharples: Their Portraits of George Washington and His Contemporaries*. Yale University Press, New Haven, CT. © 1930 Yale University Press; © 1957 Katharine McCook Knox.

Text by Elisabeth-Louise Vigée-LeBrun excerpted from *Souvenirs of Madame Vigée-LeBrun*, New York: R. Worthington, 1879.

p. 2-3:
Adrienne-Marie-Louise Grandpierre-Deverzy. *Studio of Abel Pujol, 1822.* 1822. Oil on canvas. 37 ⅞ x 50 ¾ in. (96 x 129 cm). Musée Marmottan-Claude Monet, Paris. Photograph: Lauros-Giraudon.

p. 8:
Berthe Morisot. *Psyche.* 1876. Oil on canvas. 25 ⁹⁄₁₆ x 21 ¼ in. (65 x 54 cm). Thyssen-Bornemisza Collection, Lugano, Switzerland. Photograph: Nimatallah/Art Resource, N.Y.

Acknowledgments

Many thanks are in order to those who traveled this two-year-plus journey with me: to my parents and sister, Jeanne, Irvin, and Elizabeth Guttmann, my daughter, Johanna Barlow, and my partner Daniel Rodgers, for their unflagging encouragement and support; to my son John Barlow for drafting a sculpture chapter, and to British art expert Thomas A. Deans, for two chapters; to Segundo and Catherine Fernandez, Salomon Grimberg, and Charlotte Streifer Rubinstein, for generously giving their expertise and assistance; and to my friends, the ubiquitous "wine and whining society," for providing laughter and equanimity. I am deeply grateful to Alexandra Bonfante-Warren for her interest in the project and her insightful editing, and to Hugh Lauter Levin Associates, and especially my editor, Jeanne-Marie Perry Hudson, whose patience, optimism, guidance, and consummate skill and book-making artistry are reflected throughout. Above all, I thank Elsa Honig Fine, whose advice, knowledge, generosity, and friendship are woven into every page.

As I began each chapter of this book, I was surrounded by dozens of books culled from the libraries of the Florida State University and the *Woman's Art Journal*. A survey like this depends on secondary sources, and I am grateful to the now hundreds of scholars for their pioneering work in uncovering the lives and art of so many remarkable women. Dictionaries and surveys abound, and women are now the subjects of countless articles and monographs. To begin to name the many would occupy a lengthy bibliography and be certain to inadvertently slight a few.

This book offers an extraordinary glimpse of the breadth and depth of women's artistic production. Whether pioneer, scholar, or new to the field, I hope that the visual richness of the material presented here is a pleasure to behold.

FOR ENID FENTON HOFSTED
WHO BROUGHT ME TO ART,
AND WHOSE ART GAVE HER WINGS

Contents

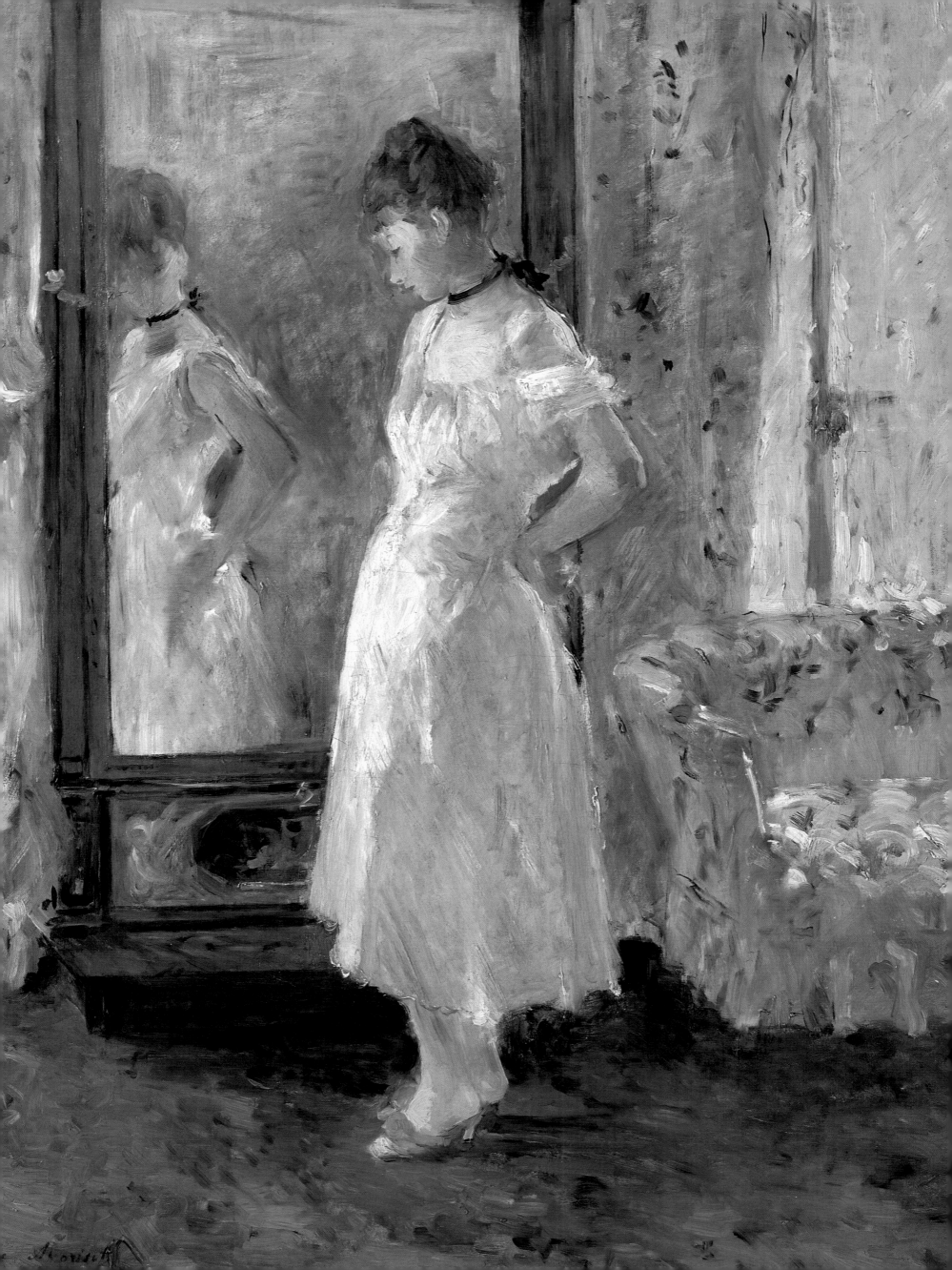

Introduction

This book celebrates the arrival of female artists into the art history mainstream. Just twenty-five years ago, research on women artists counted for a microscopic percentage of academic inquiries. During the 1960s, my female compatriots and I wrote our theses and dissertations on Leonardo da Vinci, J. M. W. Turner, Pierre Bonnard, Pablo Picasso, and Chaim Soutine. Of course, we knew about Mary Cassatt, Georgia O'Keeffe, and Käthe Kollwitz, not to mention Barbara Hepworth, whose memorial to Dag Hammarskjöld made news in 1963 when it was installed at United Nations headquarters in New York. We had never heard of Artemisia Gentileschi, Harriet Hosmer, or Emily Carr, however, and though we knew of Rosa Bonheur we had no idea that it was she who painted the mammoth *Horse Fair* that dominates the nineteenth-century gallery at New York's Metropolitan Museum of Art and graces countless schoolroom walls. A favorite among my mother's shelf ornaments turned out to be a miniature of Élisabeth-Louise Vigée-Lebrun's self-portrait with her daughter. The images were familiar, but we knew nothing of their makers.

Inspired by the feminist movement, a handful of scholars took to heart Linda Nochlin's provocative and resonant question, posed in *Art News* in 1971: "Why are there no great women artists?" In response, these scholars initiated an ever-expanding search that has turned up literally thousands of accomplished artists. They appear in every nation's own rich history of art, often among the finest practitioners. These artists overcame, in varying degrees, the obstacles women faced in every century in every part of the world. Foremost among these were lack of access to first-rate training, competing family obligations, and myopic societal and critical expectations. Thus, what has come forth are revelatory stories of and works by women who, prior to the twentieth century and even well into it, bucked the odds, family wishes, and traditional female roles to take up the brush or the chisel. Their emergence continues to reshape not only the history of art, but the history of humanity itself.

My own awakening to the subject began in the mid-1970s, thanks in large part to my long friendship with Elsa Honig Fine, who had begun researching the subject for a book. Her *Women and Art* (1978) was published on the heels of the landmark 1976 *Women Artists: 1550–1950* exhibit in Los Angeles, curated by Ann Sutherland Harris and Linda Nochlin, with its important companion catalogue. The following year, I signed on with Fine to edit the *Woman's Art Journal*, in whose pages, since 1980, salient issues have taken shape and hundreds of forgotten or neglected artists have come to light.

It has been exciting to witness the virtual explosion of monographs, exhibition catalogues, surveys, and dictionaries devoted to women artists. Together they have gone a long way toward clarifying both the extent of women's presence in the history of art since the Renaissance and the degree to which those obstacles makes that presence all the more laudable. Even more heartening has been the democratization of general art history surveys which today weaves art, including art by women, into a denser, more variegated fabric.

So true is this that one might ask whether another survey of (mostly) Western women's art is still necessary as the twenty-first century unfolds. This book, a brief chronological overview of almost three hundred painters and sculptors working since the Renaissance, is intended to be a visual index, and, as such, a wide-ranging introduction for the new and expanding audiences who are discovering women's remarkable art production for the first time. Besides those artists who were deeply drawn to, influenced by, or participated in the many "isms" of the past centuries, here are others, inspired by a place, an idea, a response to modern life, the particular circumstances of their own life, or some personal, fundamental need to make art.

It was often remarked when the subject of, say, Mary Cassatt, Rosa Bonheur, or Vigée-Lebrun came up, that the women who practiced art were, at best, expert followers but not innovators. This notion is belied in the countless works exemplifying new interpretations of mythology, history, and universal themes. The annals of modernism contain the names of a number of innovators—Frida Kahlo, Sonia Delaunay, Lee Krasner, Helen Frankenthaler, Alice Neel, Marisol, and Barbara Hepworth, to name just a few. Indeed, the position of many women as art outsiders often obliged them to forge unique expressions, while others, capable practitioners of contemporary styles, added new dimensions to the work they produced.

Artemisia Gentileschi and Judith Leyster reinterpreted biblical or everyday scenes from a woman's point of view while Rosalba Carriera's pastel portraiture and Clara Peeters's banquet pieces rang changes on the media and genre of their day. Behind almost every woman was a male artist, often her father, and sometimes her brothers, uncles, and husband. Needless to say, marriage and children, more often than not, disrupted, if it did not end, a career. So did caring for sick or aging family members, a task that traditionally fell to single women. Even marriage to another artist frequently meant subordinating the role of artist to that of artist's wife, and promoting and supporting his art first, a practice that continued well into the twentieth century.

From the earliest centuries, female artists, like their male counterparts, frequently emerged from family workshops. Unlike their brothers, however, they were unwelcome as apprentices, and so had little access to training except at home, where they learned to assist their fathers and brothers, or in the cloistered environs of church institutions. Some enlightened parents educated their daughters, even encouraged them to seek opportunities beyond marriage and family, yet these accomplished women would find their beauty, piety, and virtue often prized above their achievements in art. Despite many worthy candidates, the art establishments in every country made few allowances for women. More than 150 years elapsed between 1768, when Angelica Kauffmann and Mary Moser, its first two female members, entered the British Royal Academy, and 1932 when Dame Laura Knight, its third, did so. In that century and a half, from a society that mandated drawing as part of an upper-class girl's education, an active roster of women artists arose. Some distinguished themselves in the more acceptable areas of portrait and flower painting; hardier souls ventured out of doors to join the craze for landscape painting; and women of all classes were drawn to the romantic idealism of the Pre-Raphaelites. The male artists of the French Academy, founded in 1648, limited female membership as well. Even after they were admitted to the new, more democratic, Royal Academy in 1783, Adélaïde Labille-Guiard and Vigée-Lebrun, were subjected to unreflecting criticisms of their command of the brush, as well as to unkind rumors about their private lives. As women, they were particularly vulnerable to the effects of gossip on their livelihood.

If there is a "typical" story, perhaps it is that of Ulrica Frederica Pasch (1735–1796). She and her brother were instructed at home, in Stockholm, by their father, a painter, but her brother was sent to Copenhagen, then Paris, for further training, while Ulrica remained at home to assist in the studio and keep house for her widowed father. In 1773, at its founding, she was the only female to be elected to the Swedish Royal Academy of Painters and Sculptors; although her artistic accomplishments were many, her election commendation also stressed her role as a model daughter. On the other hand, Pasch's contemporary, Swiss-born Angelica Kauffmann (1741–1807), traveled with her father and thus had greater opportunities before electrifying London's artistic circles. As celebrated for her beauty, intelligence, wit, and voice as for her painting, she found her high profile a mixed blessing, making her fodder for gossip intended to damage her reputation. A century later American-born Harriet Hosmer (1830–1908), who shattered stereotypes about women's physical ability to make monumental works in stone, did not allow concerns about her reputation to keep her from wild horseback rides through the streets of Rome.

At least until late in the nineteenth century, though they could pose for them, women could not attend "life" classes, where artists drew from nude models and thereby learned anatomy—key to portraying figures accurately. This all but limited their ability to study the posed figures needed to produce the large history and mythological subjects that won the highest academic prizes. Instead, female artists honed their skills using available "models" and learned to excel in portraits, saints and madonnas, genre scenes of daily life and especially children, still life arrangements, flowers, even animals. In this respect, the multiplicity of modern art tended to level the playing field by emphasizing personal interpretation and abstraction over subject matter. What earlier revolutions had not accomplished for women in terms of equality, the passage of time, equal availability of training, world wars, and social upheavals throughout the twentieth century would.

From the North American continent came women like Lilly Martin Spencer of the United States, who in the mid-nineteenth century took advantage of contemporary tastes to deliver European-style pictures with a

sentimental, home-grown flavor to culture-seeking Midwesterners. To the north, like other artists who were pioneers of an art that reflected the unique character of their country, the adventurous Emily Carr documented both the grandeur and intrusions of twentieth-century modernization into the Canadian West. At the same time, in the colonial outposts of the Southern hemisphere, too, creative clashes occurred, as artists assimilated indigenous traditions, or came up against local tastes, as did the Australians Frances Hodgkins and Grace Cossington Smith and the South African Irma Stern when they imported radical ideas of European Modernism.

In the decades before and after the last century's turn thousands of aspiring artists, both male and female, left their homes to study in Paris. Attracted by the excitement of the new art expressions and the opportunity to enjoy a freer life, they came from around the globe, from Cuba and Brazil, Norway and Denmark, Russia and Germany, Ireland and the United States, Spain and Switzerland. Mostly middle class, the women enrolled in segregated art schools and lived in rooming houses designed to protect them and their reputation—and alleviate the fears of parents back home. Some came with their mothers or other chaperones. The dozens documented here formed new friendships and took their studies seriously—learning from academic teachers in the classroom, from copying at the Louvre, and the more adventurous from the experimental art filling the side-street galleries. The Americans Cecilia Beaux and Elizabeth Nourse emulated their teachers' conservative styles, joining the women who submitted their work in record numbers to the annual Paris Salons, returning home with prizes and prestige. Anna Ancher and Kitty Kielland, drawn to the Impressionists, took their lessons back to Scandinavia to capture the northern light. A few years later, Swiss painter Alice Bailly explored the expressive possibilities of Fauvist color and Cubism's faceted forms. Sculptors like Meta Vaux Warrick Fuller from Philadelphia, Anna Semyonovna Golubkina from Russia, and French-born Camille Claudel worked and learned in the studio of Auguste Rodin. Back home, many distinguished themselves and influenced others, while some, once more in the family fold, found that their most creative years were behind them.

The artists were also "New Women," modern and independent. As more women challenged restrictions on their activities and movements, many joined their male colleagues in the ever-changing avant-garde. The Macdonald sisters, Frances and Margaret, created a stir in Scotland in the 1890s with their eerie Art Nouveau interpretations. Before the Revolution, Russian women Alexandra Exter, Natalia Goncharova, Olga Rosanova, and Liubov Popova were in the forefront of national and international expressions. Afterward, Exter and Goncharova gained fame for their bold theatrical designs while Rosanova and Popova created posters, books and clothing to convey the revolutionary message to the people. Vera Mukhina's monumental sculpture of workers, first shown at the 1937 Paris Exposition, became a universally known Soviet symbol.

The overwhelming output of women artists since World War II makes it impossible to give a proper reckoning—the absence of so many artists of note from these pages signals not their neglect, but limitations of space. Their work can be seen in other books, art magazines, or monographs, or on the dozens of Internet websites devoted to art and artists.

Discoveries of women artists and art by women will continue to generate excitement among historians, students, and lovers of art. Perhaps more satisfying, however, is the seamless inclusion of these artists and art works into contemporary and forthcoming studies and books on world art. Having this opportunity to survey the lives, read the stories, and present the richness and variety of work by these remarkable women has been an honor, and I hope this book will inspire others to learn more.

MARGARET BARLOW
1999

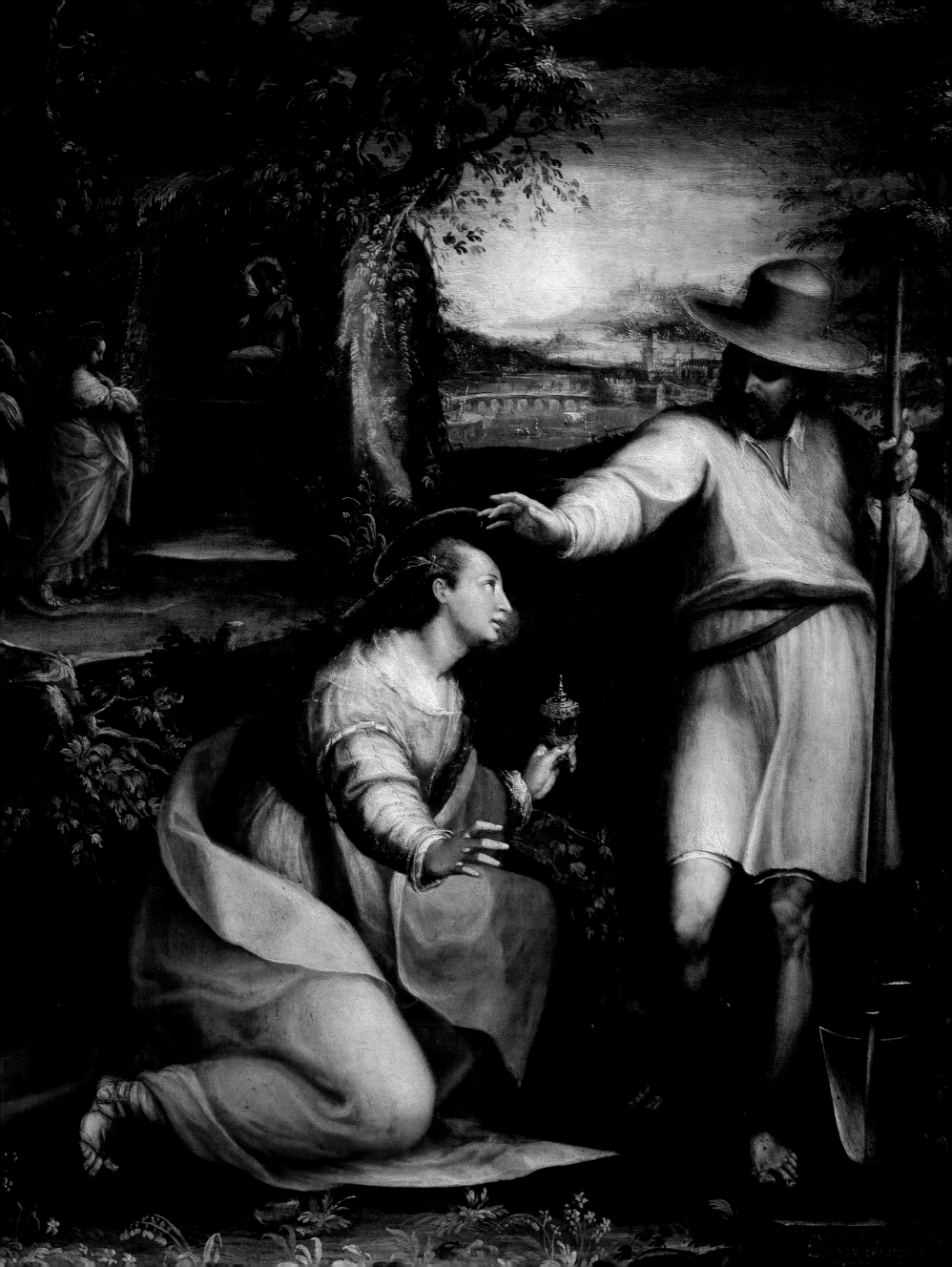

I
From Cloister to Court
Renaissance to Rococo Italy

European tradition held that a woman's place was in the home; her legal status was that of a child, regardless of her age, and she was under the tutelage, first, of her father, then of her husband. She was instructed to be pious, modest, chaste, and above all, out of the public eye. This is one reason why authenticated works by women are scarce. Depending upon her social station, a young girl was taught her duties as a wife and mother, and how to run a household. Until the Industrial Revolution of the eighteenth century created a need for clerks, and thus a need for literacy, few people of either sex could read or write more than their names. Even fewer women were literate, although this would change in the upper classes of Renaissance Italy and among the Protestants of northern Europe, who had to be able to read the Bible. Mathematics and geometry, which would become crucial disciplines for Renaissance artists, were considered inappropriate for women. The only acceptable alternative to early marriage and solitary widowhood—some girls and women chose it, others had it chosen for them—was life in a convent. In preparation for taking their vows to serve the Church, the novices learned to read, and some continued their education so that they might teach others.

Some women found more freedom in the cloister than they would have in the world, and this included the freedom to make art. During the Middle Ages and into the Renaissance, anonymous female hands illuminated manuscripts for the greater glory of God, and painted reverent works for chapel and refectory, but they also embroidered priests' vestments and altarcloths, as well as clothing for the aristocracy. Caterina dei Vigri (1413–1463) is a fascinating exception to the rule of anonymous cloistered artists: devoted followers credited her with scores of unsigned—and dissimilar—works. Most, including large "signed" paintings that were obviously created by different hands, have since been attributed to others. This daughter of aristocrats, raised and educated at the enlightened Este court in Ferrara, entered the Franciscan order of the Poor Clares by choice in 1427. Although her writings, including a book of religious instruction and accounts of her visions, are better documented than her paintings, her images of the Christ Child were said to have curative powers. In Bologna, where she founded a reformed chapter and served as abbess, her visions and miracles brought her fame and, in 1712, sainthood.

The Renaissance brought with it a renewed cult of the individual. Giorgio Vasari, taking a classical leaf out of Plutarch's *Lives of Famous Men*, wrote *Lives of the Most Excellent Italian Architects, Painters, and Sculptors* (1550), which is still today a source of much of what we know of the artists and attitudes of this period. Vasari praised Sofonisba Anguissola's (1527–1625) "rare and beautiful paintings"—but was careful also to note her personal beauty and modesty.

The first woman artist to gain international celebrity, Sofonisba Anguissola was born in Cremona to a noble family. She was the eldest of six daughters, whose father, Amilcare, saw to their excellent education, including painting. Proud of his daughter's ability, Amilcare sent an early example of Sofonisba's work to Michelangelo, and later showed off her self-portraits to acquire commissions. Early portraits done by Sofonisba and her sisters reflect their conservative, refined northern Italian style: Sofonisba's *Three Sisters Playing Chess* (1555), is an early conversation piece. Her many self-portraits are unique in sixteenth-century Italy, but her renown was such that patrons demanded images *of* as well as *by* this phenomenon.

Her reputation as a lady of great refinement as well as a painter caused her to be invited to Spain's royal court and in 1559, Anguissola arrived there to serve as a court artist and lady in waiting to Philip II's doomed young queen, Mary. The influence of Spanish artists is evident in her numerous portraits of the royal family.

Married late in life, she spent her last years in Genoa, working and inspiring young artists such as Anthony van Dyck, who painted her in her old age. Although most of her Spanish paintings were destroyed in a seventeenth-century palace fire, she is still the first woman artist to have left at least fifty known pictures— a well-defined body of work.

Contractual apprenticeships were traditionally not available to women, but successful male artists often trained their daughters to become part of the family business. Bologna, whose university had begun admitting women in the thirteenth century, was at the height of its prominence as an art center when Lavinia Fontana (1552–1612) studied painting in the workshop of her father, Prospero, who had undertaken commissions in the art centers of Rome and Florence. Fontana very soon found her portraits in demand, appreciated by fashionable patrons who considered her flattering images of them both "truthful" and "pleasing." In her *Portrait of a Lady with a Lapdog* even the massive, intricately detailed costume and exquisite Bolognese laces fail to swallow up the sitter, who comes to life as she plays with her little pet.

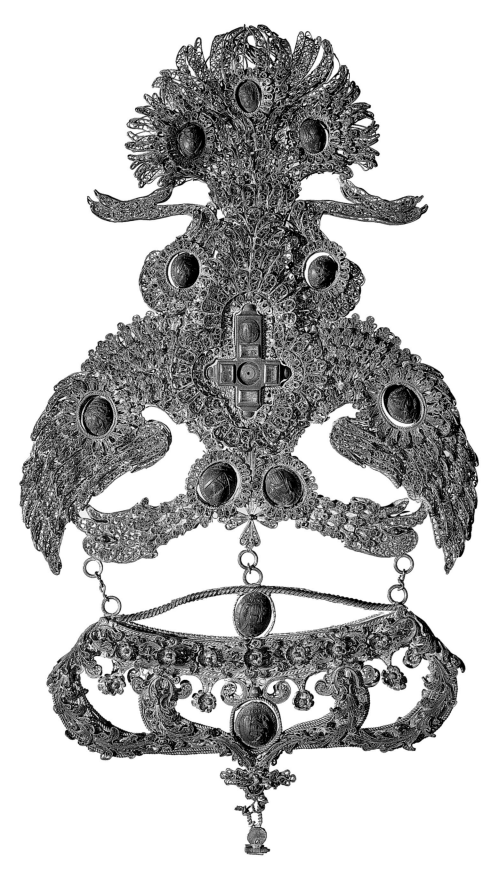

p. 12:
Lavinia Fontana. *Noli me Tangere.* 1581. Oil on canvas. 32 x 25 ½ in. (81 x 65 cm). Galleria degli Uffizi, Florence. Photograph: Scala/Art Resource, N.Y.

Left:
Properzia de' Rossi. *Carved peach stones with twelve apostles.* Museo Civico, Bologna. Photograph: Foto Studio Professionale C.N.B. & C.

Opposite:
Lavinia Fontana. *Queen Luisa of France Presenting Her Son Francis I to S. Francesco di Paola.* 1590. Oil on canvas. 83 ½ x 55 ⅛ in. (212 x 140 cm). Pinacoteca, Bologna.

After her marriage in 1577 to one of her father's less talented pupils, Gian Paolo Zappi, and despite the subsequent birth of eleven children, Fontana continued painting prolifically—Zappi assisted in the studio and with household duties. Her lovely religious panel *Noli me Tangere* (1581) shows the Magdalene against a monochromatic background, bathed in the glowing light of the Resurrection. Fontana's command of a wide range of human emotions is evident here, as it is in *Queen Luisa of France Presenting Her Son Francis I to S. Francesco di Paola* (1590). This large painting showcases the popular style that kept her work in demand and took her to Rome to carry out papal commissions. More than thirty-five known works survive, and a hundred or so more are documented from Fontana's long and successful career.

While Lavinia Fontana's success exceeded her artist-father's, her contemporaries Barbara Longhi and Marietta Robusti met with more typical fates, although Vasari took notice of the Ravenna-born Longhi (1552-1638), daughter of Luca. Several known paintings of the Madonna and Child indicate that she was a competent, if provincial, painter of simple, devotional works, featuring sweet-faced Infants and a young Virgin whose tender glance contributes to their conventionally symbolic triangular compositions.

Marietta Robusti (1560–1590) was more talented than Longhi, but equally restricted by a father's wishes. The daughter of Tintoretto, and herself known as La Tintoretta, Robusti painted in the style of her father and his students, but seldom signed her works, so that it is all but impossible to attribute them definitively. *Old Man and Boy* (ca. 1585) is one of several works by either Marietta or her brother, Domenico, that were originally attributed to their father. Certain features in this somber portrait, in fact, are in the trademark Tintoretto style: luminous faces and hands set against darker clothing, and the standing youth and seated old man—one looking intensely outward, the other inward. Robusti received invitations to the courts of Austria and Spain, but her doting father forbade her to accept, instead finding her a marriage offer that would keep her at home and in his workshop. Sadly, she died young, probably in childbirth.

Artemisia Gentileschi (1593–1652), today among the most respected late Renaissance artists, had the benefit of her father's encouragement as well as his superior instruction. Orazio Gentileschi was a gifted follower of Caravaggio, and Artemisia embraced the groundbreaking Caravaggesque style, which heightens emotional and pictorial realism by means of theatrical lighting effects. The Gentileschis seemed to attract controversy, and in 1611 Orazio accused Agostino Tassi, whom he had hired to teach his daughter drawing and perspective, of raping her and stealing his pictures. Tassi went to trial and was convicted, but it was Artemisia who was publicly humiliated, after being subjected to torture as part of the cross-examination. She married another man and left Naples for Florence, but never fully recovered her reputation. Several of her strongest works are so because of the shock of the unfamiliar and true: Gentileschi chose traditional Old Testament episodes and portrayed them from an unambiguously female point of view. In *Susannah and the Elders* (1610), an early work, instead of the conventional representation of Susannah as the personification of modesty abashed, the artist displays complex emotions, from surprise and horror to rage and humiliation at her powerlessness. The Elders are not benevolent, sexless wise men, but tyrants deriving a vicious, *unholy* pleasure at Susannah's discomfiture and helplessness. Similarly, several paintings of Judith and Holofernes, a subject her father also painted, are deeply disturbing in the cool matter-of-factness of Judith and her hand maiden. In *Judith Beheading Holofernes* (1620–21), Judith and her servant-accomplice are large, dynamic figures, as physically strong as Holofernes, concentrating on the grisly task at hand. Blood is spurting realistically, and the ferocity of the act accentuates its moral message. The action is thrust to the forefront and Gentileschi's use of foreshortening is brilliant: while Holofernes in his agony confronts the viewer with brutal immediacy, Judith's hands are as large and meaty as a butcher's.

Fede Galizia (1578–1630) and Giovanna Garzoni (1600–1670), both child prodigies, are known for their exquisite still lifes. Galizia's father, Nunzio, a miniaturist, may have used the example of Sophonisba Anguissola's success to encourage his daughter's talent. Among the early works that established her reputation and are known today are several portraits, altarpieces, and religious themes. Like her formal portrait of an elegantly dressed gentleman shown with a skull, symbolizing mortality, each contains a significant still-life, which possibly signals her later shift. Why she later turned to works without figures is not known, as there were few precedents in Italy. On the basis of one signed still life, a group of works is now attributed to Galizia, each of them filling the canvas and taking up a painterly challenge: to depict the contrasting textures of a basket or bowl and the sensuous globes of fruit it contains.

Little is known about Giovanna Garzoni's early life, although records indicate that she had a thriving career as a portrait miniaturist before she turned to still lifes—a fashionable genre imported from Protestant

Elisabetta Sirani. *Madonna of the Turtledove*. n.d. Oil on canvas. 39 ¾ x 36 ¼ in. (101 x 92 cm). Pinacoteca, Bologna.

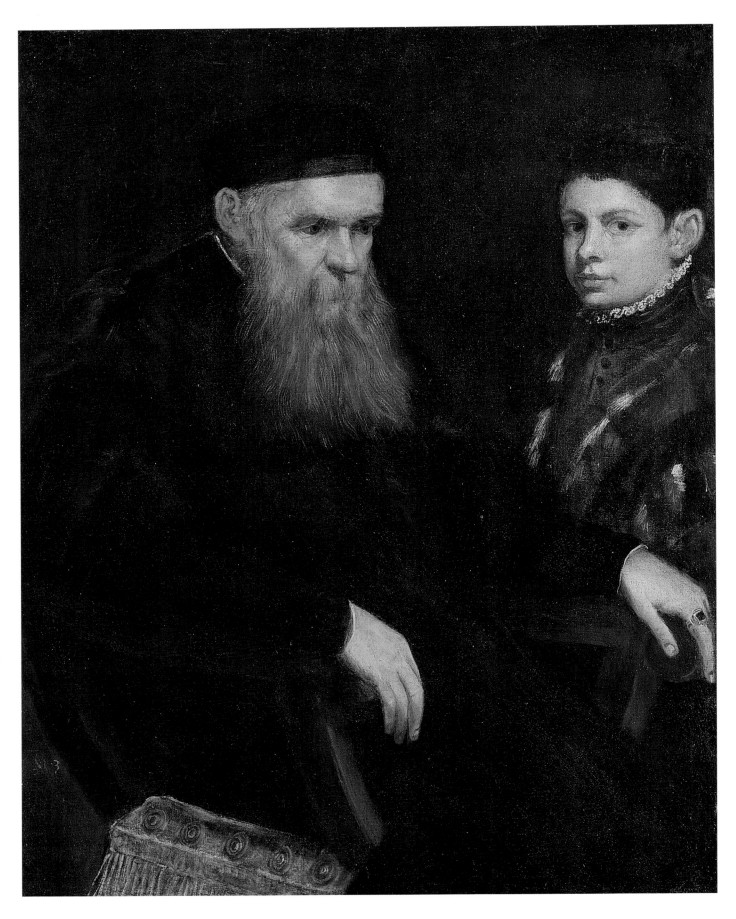

Above:
Marietta Robusti. *Old Man and Boy*. c. 1585. Oil on canvas. 40 ½ x 32 ⅞ in. (103 x 83.5 cm). Kunsthistorisches Museum, Gemäldegalerie, Vienna. Photograph: Erich Lessing/ Art Resource, N.Y.

Overleaf:
Sofonisba Anguissola. *Three Sisters Playing Chess*. 1555. Oil on canvas. 27 ³⁄₁₆ x 35 ⅞ in. (172 x 91.1 cm). Museum Narodwe, Poznan, Poland. Photograph: Erich Lessing/Art Resource, N.Y.

northern Europe. Unmarried, she traveled and fulfilled commissions in Florence, Venice, and Naples before settling in Rome. Part of her success was due to Garzoni's being very much of her time. The Renaissance, with its humanistic emphasis on direct observation, had given rise to a host of taxonomies, especially of plants, and her carefully composed still lifes have the quality of scientific studies rather than decorative pieces. Done in watercolor on vellum, they are accurate and often lively depictions of birds, insects, fruits, and flowers. Following the conventional symbolism of the time, arrangements of sometimes imperfect edibles harbor the occasional insect.

Elisabetta Sirani (1638–1665) achieved public success in spite of her artist-father's tyranny. Family friends persuaded Gian Andrea Sirani to develop his young daughter's talent. Elisabetta had before her as well the examples of de' Rossi and Fontana, who were, like Sirani, from Bologna. Later, when he became too ill to work, she supported the family by taking on numerous commissions and female students. Sirani worked swiftly, and during her short lifetime, she recorded more than 190 paintings, mostly elegant portraits, somewhat sentimentalized saints, and sweet madonnas. A few subjects featuring virtuous heroines, including a Judith shown looking away while holding the head of Holofernes, are more quietly contemplative, more refined, than those by Artemisia Gentileschi. In an unusual depiction of an incident from Plutarch's *Life of Brutus*, Porcia has just stabbed herself to prove herself worthy of her husband Brutus' trust. While the "real" story is going on in the back room, where the men are plotting Caesar's assassination, Sirani focuses on Porcia's valiant moment. By the time of her death at age twenty-seven, Sirani had mastered a complex style, exhibited great confidence in her use of color and brushwork, and become a famous daughter of Bologna: upon her death she was honored by being buried beside Guido Reni, one of the city's—and Italy's—most influential artists.

Properzia de' Rossi (ca. 1490–1530) was that rarity: a female sculptor in Renaissance Italy. The educated daughter of a notary, she translated early drawing lessons into delicate carvings onto what was available to her—peach and apricot stones. The Museo Civico in Bologna has on display an arrangement of eleven of her carved peach stones, set in filigreed silver and suspended so that both sides can be viewed. On one side are the twelve apostles, on the other the virgin saints. Vasari called her work "miraculous," while not failing to praise her musical abilities and excellence in household matters as well. For a time, de' Rossi battled jealous male competitors for commissions for larger works, but eventually she gave up and died penniless. Among the sculptures she completed for the church of San Petronio, which was to have been the showplace of Bologna, is *Joseph and Potiphar's Wife* (ca. 1570), widely interpreted as reflecting a mildly scandalous love affair with a nobleman who spurned her for a more highborn woman. More important, this work in marble is a sophisticated, vigorous portrayal exhibiting her understanding of the early Bolognese style, characterized by elegance, vitality, and classicism.

Artists most often used pastel chalks, introduced early in the seventeenth century, for copying favorite pictures because they were faster than oils. Among the earliest artists to exploit this medium for portraiture was Teresa del Pó (1649–1713). Daughter of Pietro del Pó, a well-known engraver, in 1675 she became one of the few women to gain admission to the Accademia di San Luca in her home city of Rome. Her few known works include mostly sweetly sentimental saints and Madonnas. More interesting, however, are several portraits in pastel completed after the family's move to Naples and dating from around 1700. In works such as *Ritratto di Don Pietro Moncada* (1700), del Pó used this luminous medium to great advantage in portraying her wealthy patrons, elegantly dressed and coiffed, in the stylized three-quarter view she preferred.

In the eighteenth century, Rosalba Carriera (1675–1757) popularized the medium, employing pastels to produce flattering portraits of the prominent and the wealthy. The eldest of three daughters of a minor Venetian government official, Rosalba's first artistic endeavors were creating patterns for her mother, a lacemaker, and then painting miniature scenes onto ivory snuffbox lids. By the century's end she was making pastel portraits of the dignitaries who visited Venice, refining her technique so that by 1705 she had begun receiving official honors and countless commissions. Her fame spread during a sojourn in Paris in 1720, where she painted notables including the young King Louis XV and the artist Antoine Watteau. Her deft handling of the chalks contributed to a new model of portraiture that reflected the elaborately superficial character of the rococo age, with its pompous powdered wigs, poufs of delicate laces, and pale, idealized features. Although Carriera was never extolled for her own beauty—perhaps because commentators no longer felt so obliged to qualify a woman's skill with a reference to her sex—she enhanced every sitter's image, suggesting his or her personality while softening unattractive features with forgiving strokes. Her extremely popular style was copied extensively, especially in France.

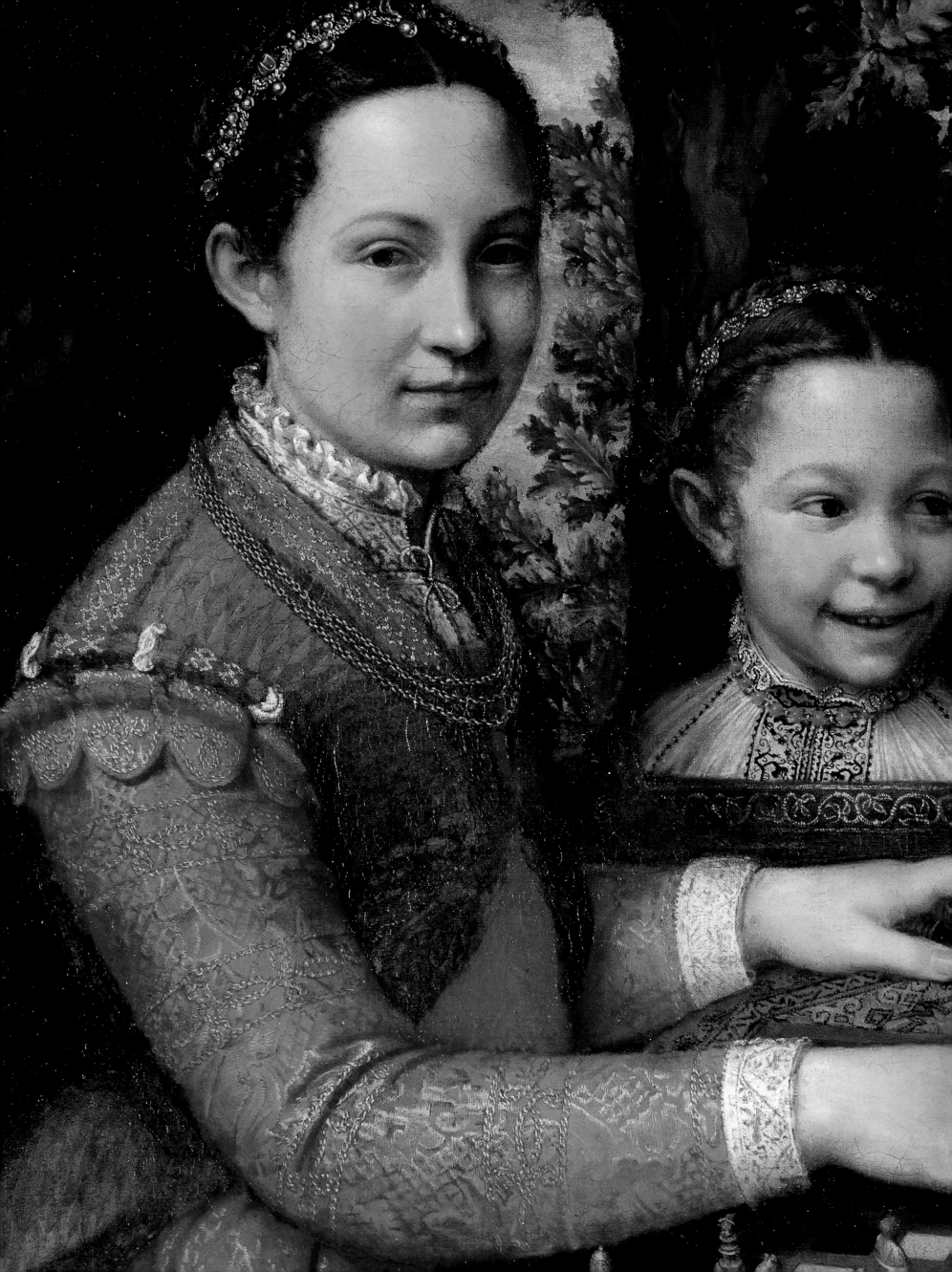

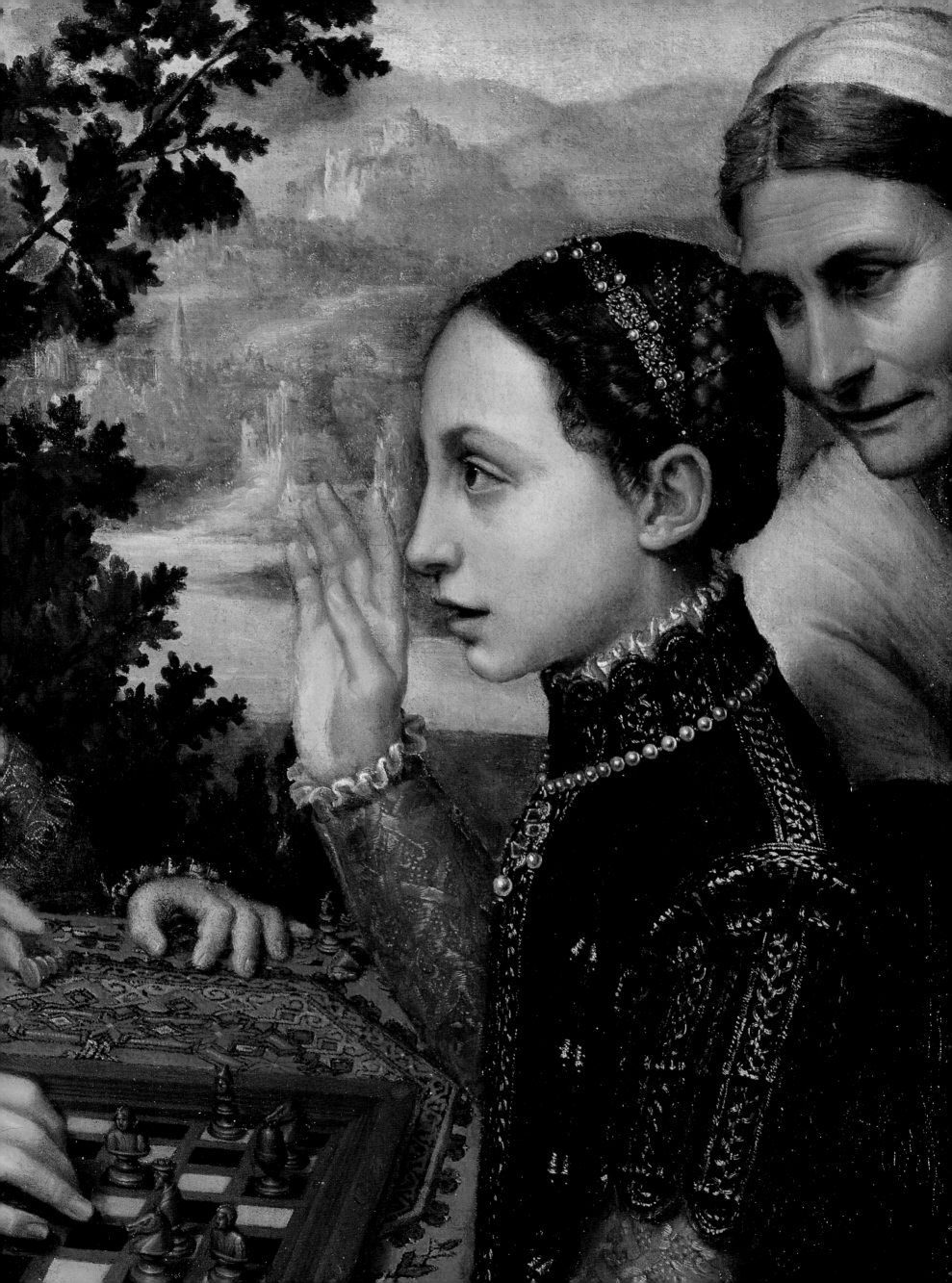

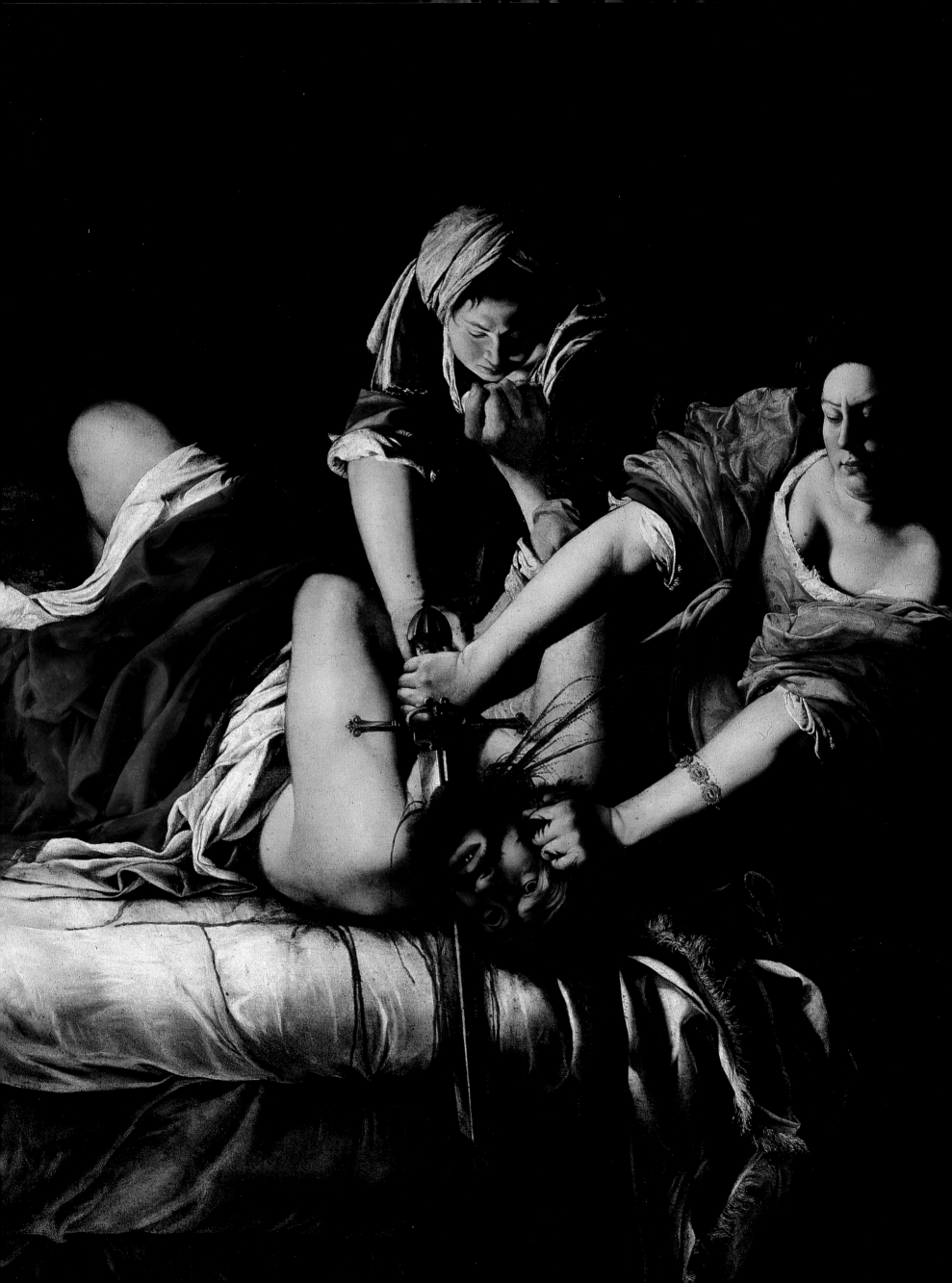

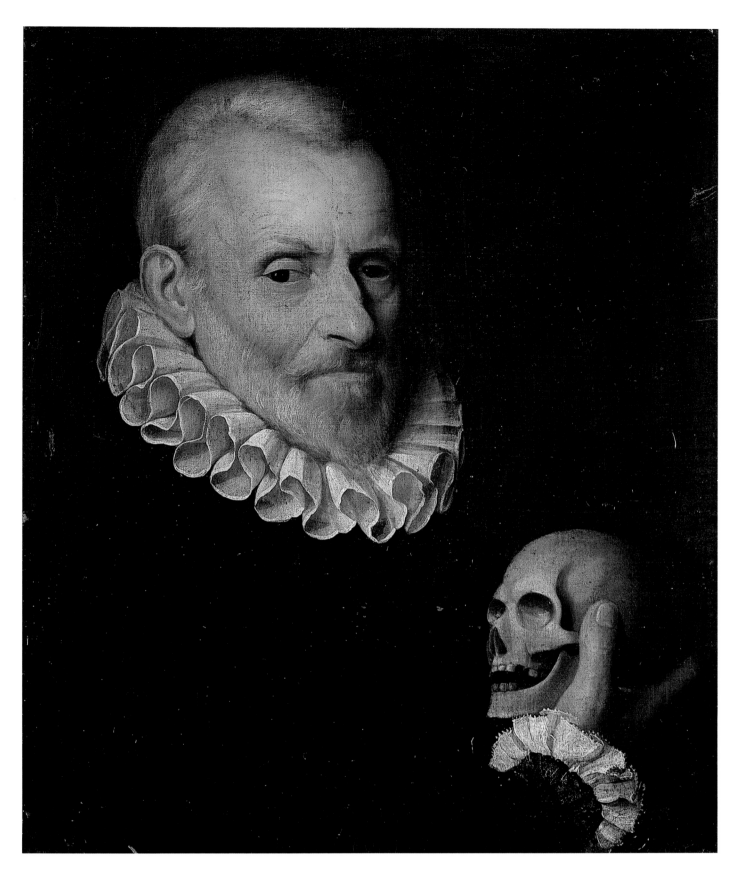

Opposite:
Artemisia Gentileschi. *Judith Beheading Holofernes.* c. 1620. Oil on canvas. 78 x 63 in. (198.1 x 160 cm). Galleria degli Uffizi, Florence. Photograph: Alinari/Art Resource, N.Y.

Above:
Fede Galizia. *Portrait of a Man.* Oil on canvas. n.d. Private collection. Photograph: Scala/ Art Resource, N.Y.

Overleaf:
Giovanna Garzoni. *Dish of Grapes with Pears and a Snail.* Tempera on parchment. 9 ¾ x 13 ½ in. (24.8 x 34.3 cm). Palazzo Pitti, Florence. Photograph: Scala/ Art Resource, N.Y.

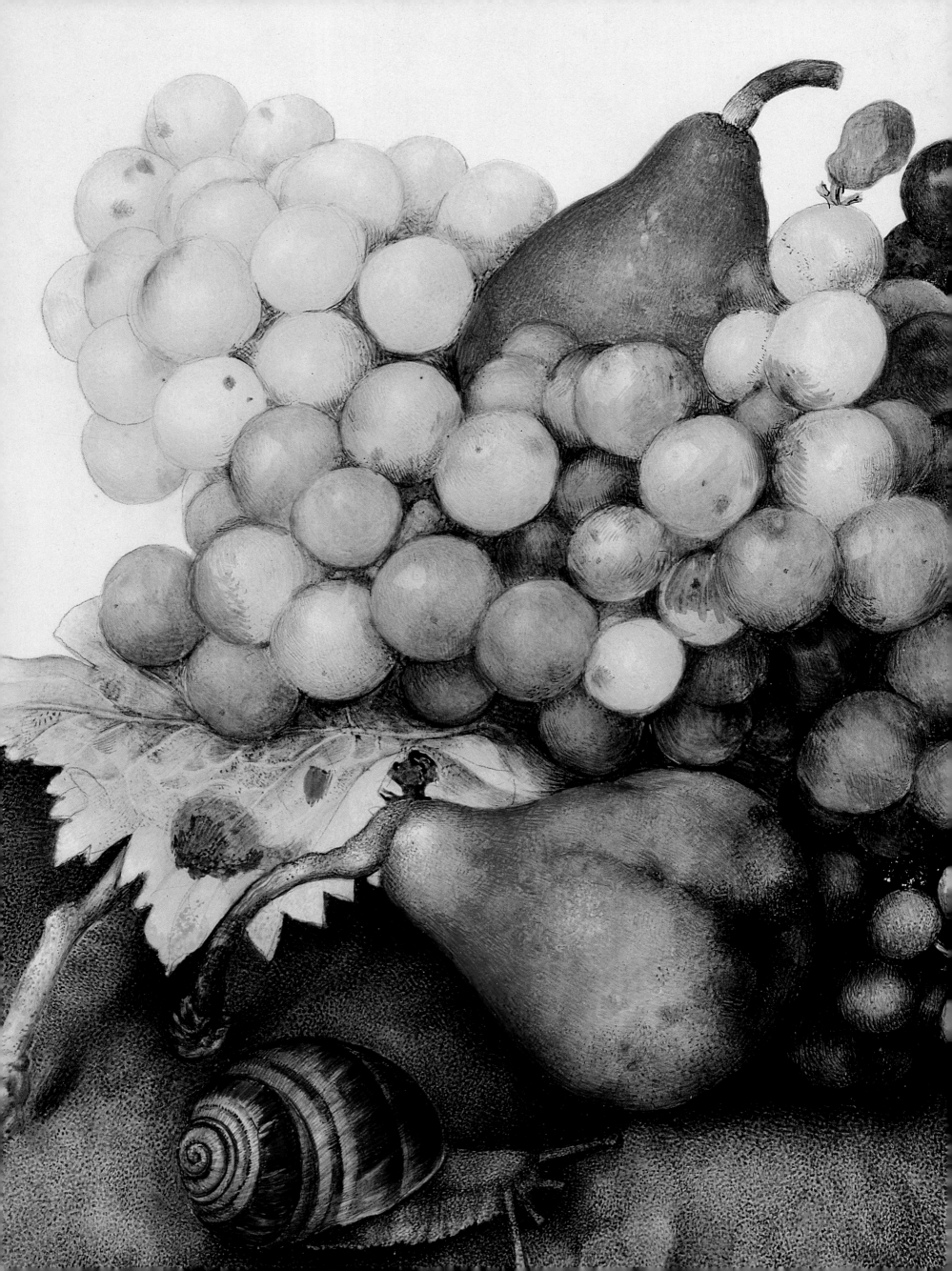

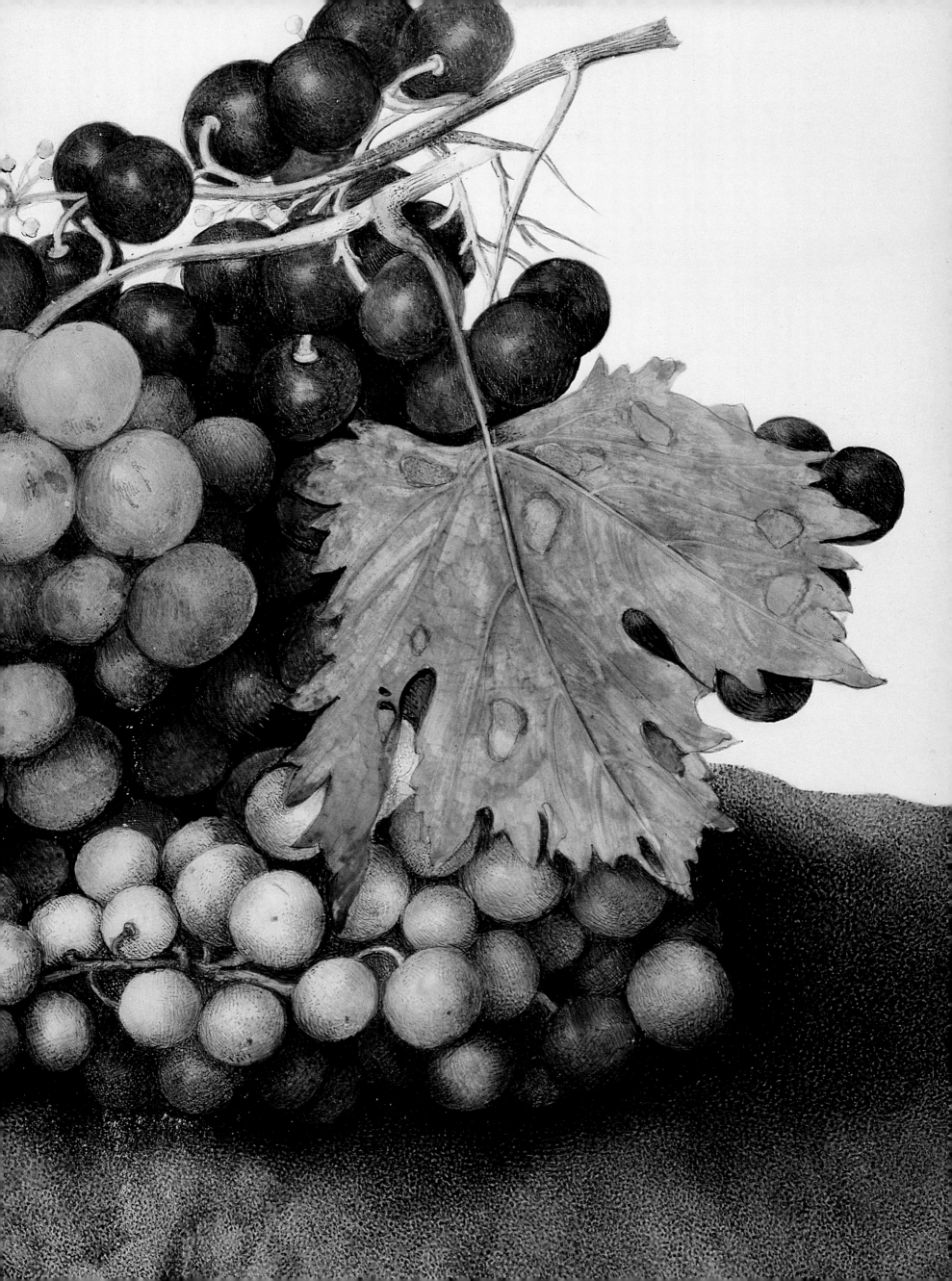

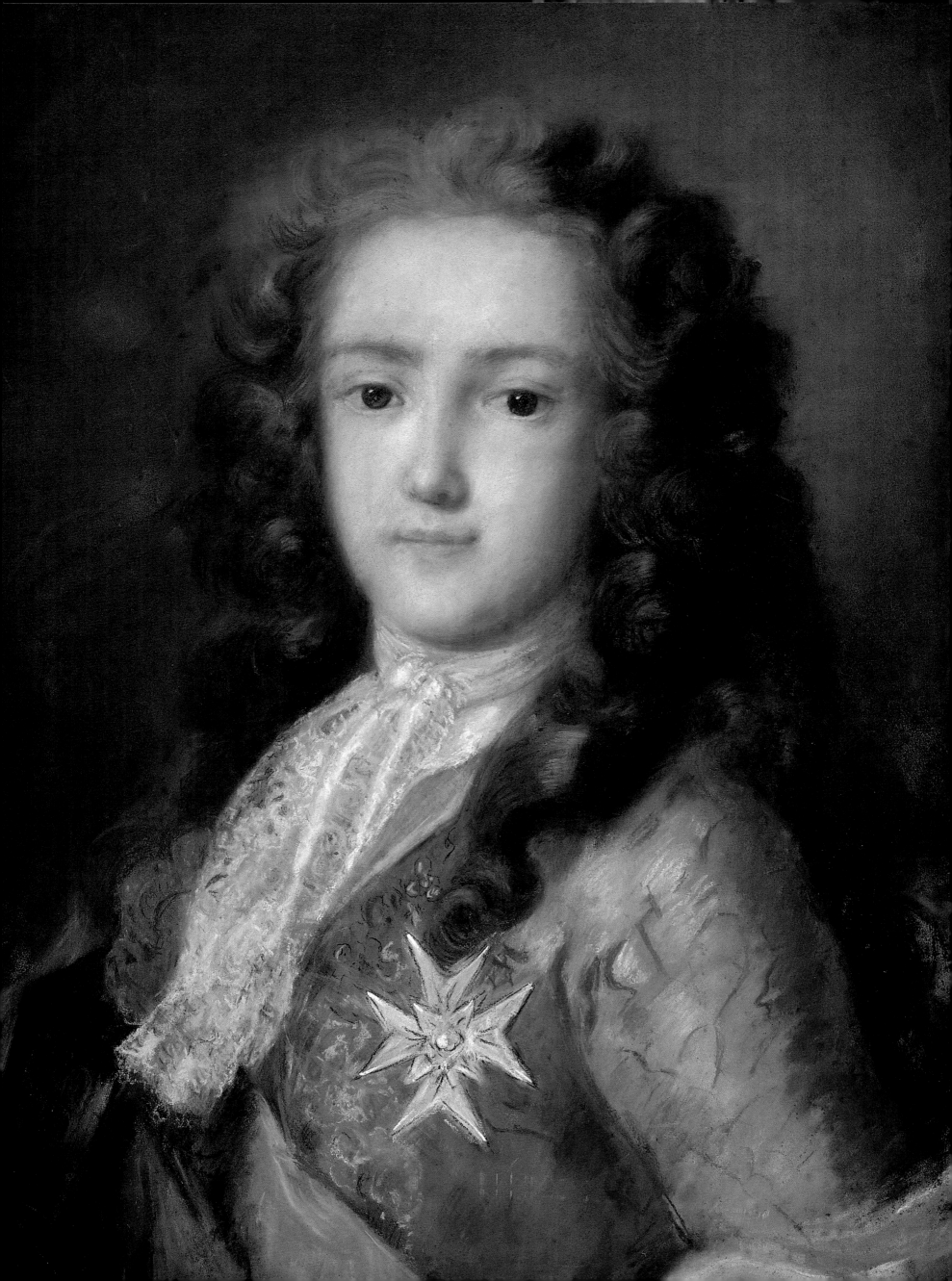

Opposite:
Rosalba Carriera. *Portrait of Louis XV as a Young Man.* 1720–21. Pastel on paper. 18 ½ x 14 in. (47 x 35.6 cm). Museum of Fine Arts, Boston. The Forsyth Wickes Collection.

Above:
Teresa del Pó. *Ritratto di Don Pietro Moncada.* 1700. Pastel and gouache on paper. 25 ³⁄₁₆ x 20 ¼ in. (64 x 51.5 cm). Museo Nazionale, Palermo. Photograph: Index/ Publifoto.

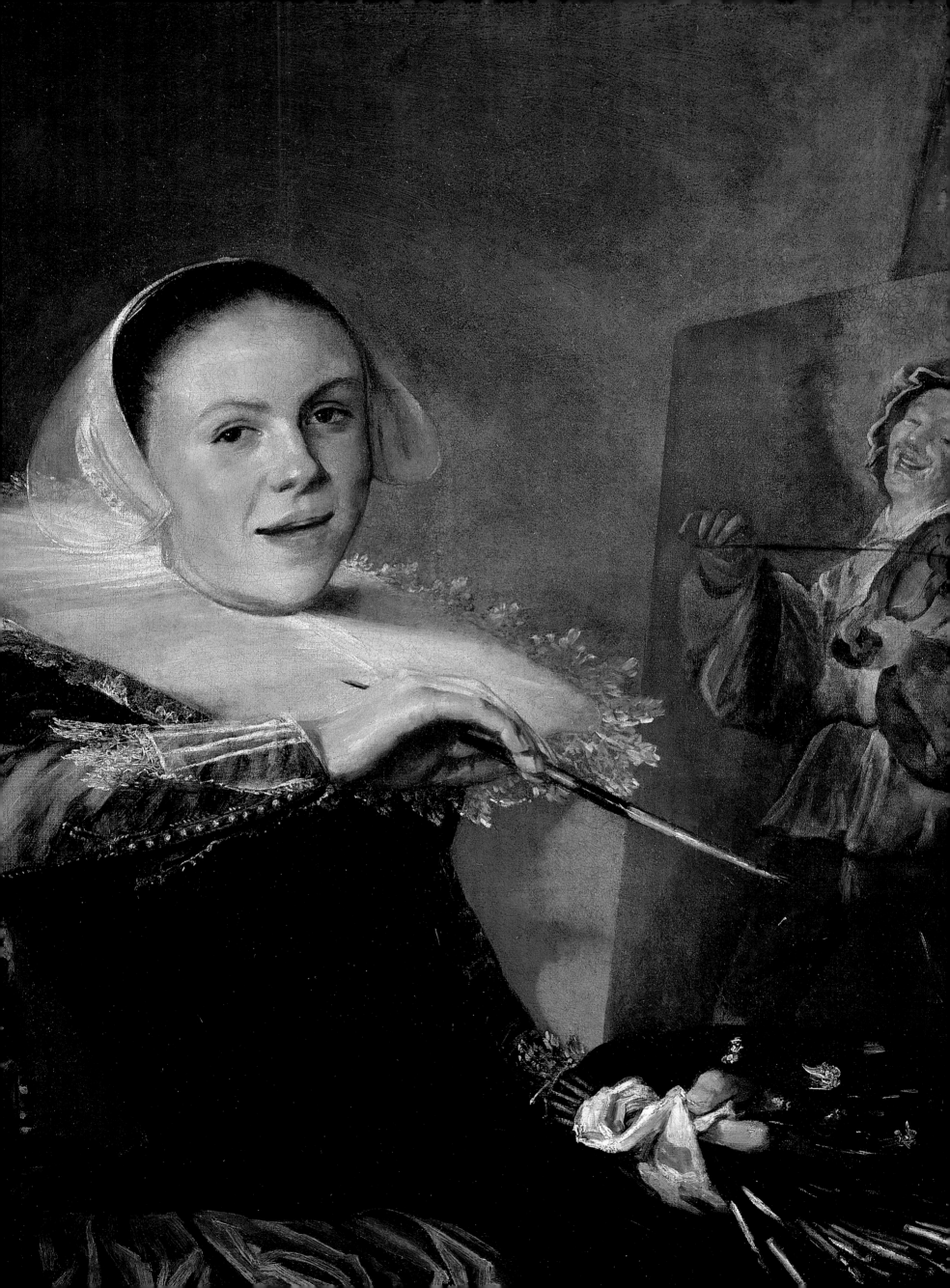

2

Domestic Preoccupations
Dutch and Flemish Painting in the Sixteenth and Seventeenth Centuries

Many southern European travelers to Flanders and the Netherlands during the seventeenth century expressed surprise at the degree of independence that women enjoyed in the Low Countries, where women owned property, entered into contracts, and participated in the commercial life of the cities. Nevertheless, a woman's primary place was still considered to be at home, virtuously fulfilling the roles of wife, mother, teacher, and household manager.

In the previous century, Martin Luther and the Protestant reformers had advocated education for all, ordering that girls attend schools to learn to read the Bible for themselves and their children. Protestantism stressed morality over spirituality, and focused on personal—unmediated—salvation. The influence of the clergy was greatly diminished generally, as was the ecclesiastical patronage of art: the reformed churches were modest, even severe, houses of community worship rather than symbols of heavenly splendor and the power of the church. Gone, too, was the cloister as a refuge for single women and a place of opportunity for female artists.

By the time of the Protestant Reformation in the early-sixteenth century, the Dutch had freed themselves from Spain, established a stable government, and become a nation of prosperous international merchants. Many families amassed enormous fortunes through shipping, manufacturing, and trade, but even the wealthiest burghers rejected the flamboyance and opulence associated with the aristocracy. As patrons of the arts, they chose for their plain but substantial homes paintings of quiet interiors, biblical stories, landscapes, flowers, and still lifes, which were often laced with symbolism and moral overtones.

Religious subjects remained popular, but on a smaller scale, intended as book illustrations or for family sitting rooms. Still lifes and genre subjects—scenes of everyday life—were often quiet and refined, harking back to the northern painting traditions established earlier by Jan Van Eyck and others. Familiar objects were often imbued with symbolism, so that the inclusion of a book or candle could transform the image of a woman at work into an allegory of faith. These interiors frequently feature women at carefully observed household tasks, but also experiencing interior lives of their own. It may be that these popular images of women tending the home epitomized the idea and appeal of home and hearth as the family's—and the nation's—spiritual center. They may also represent attractive attempts to flatter the women now living more public lives into staying or returning home, much as publicity images of women in the United States after World War II were intended to bring Rosie the Riveter back home. It may be, too, that women with money of their own chose to spend it on pictures of women acting, thinking, and feeling.

As in Italy, art production was often a family affair, and a number of women received their first instruction in their father's workshop. But painting had become a lucrative occupation, and in a society that valued education and commerce, middle-class parents might well encourage their daughters to develop their talents.

Prior to the Reformation, guilds in the region recorded a few women painters of book illuminations as members. Among the very few identifiable works by a woman guild member is a remarkably preserved linen banner, discovered in 1814 and datable to 1481–82, when it was commissioned by the city of Ghent from Agnes van den Bossche (act. from 1468). Little is known of this artist, except that her father and brother were

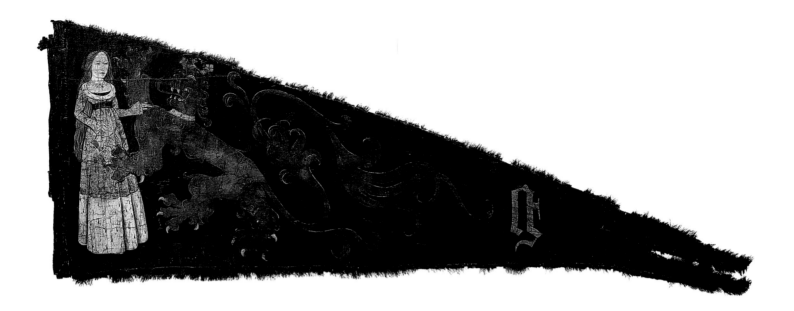

painters who also received such commissions, so it is likely that she was in the family business. Painted on both sides of the banner in a refined, late-Gothic style, along with decorative flourishes and a letter "G" for Ghent, are the Maid of Ghent and the lion from the city's coat of arms.

Public art commissions were few compared to the demand for portraits. The rich and powerful still liked to have their pictures painted: Levina Teerlinc (1515/20–1576), who, like her father and grandfather, specialized in miniature portraits, was invited to the English court of Henry VIII, where she received a salary greater than that of her male contemporary Hans Holbein the Younger. She remained the English court miniaturist under Edward VI, Mary I, and Elizabeth I. Catharina Van Hemessen, known for her dignified portraits and meticulously detailed religious paintings, was invited to the Spanish court; she and her husband, the organist of Antwerp's cathedral, would find their services much in demand in that country.

Teerlinc, born in Bruges, probably perfected her art in her father's workshop, illuminating devotional books, and creating page-size decorative scenes from the Bible and the lives of the saints. Although the English court records indicate numerous payments for pictures over a thirty-year period beginning in 1546, Teerlinc's habit of not signing her work has led to great confusion in attribution. Nevertheless, she is thought to have done several miniature portraits of Elizabeth I as a princess, showing her as a solemn young woman, her royal robes exquisitely detailed with touches of gold.

Catharina Van Hemessen (1527–1566/67) collaborated on a number of large, elaborate religious works with her father, Jan Sanders van Hemessen, a prominent Antwerp painter. The few known works from her hand alone, such as her straightforward painting of her sister playing the virginals, are most notable for their skillful use of light. In this painting, the figure emerges from a dark background, the light on the subject's delicate features subtly contrasting with the dark, rich fabric of her subdued but luxurious clothing.

Although still lifes, fruit, and flowers often were featured within portraits, genre, and religious paintings, by the early seventeenth century they began to stand alone. Clara Peeters (1594–1657) was one of the first Flemish painters to make a living from "banquet pieces," that is, arrangements of food and drink. The northern painters were famous for their skill in capturing reflected light, and Peeters's elaborate early works contain dazzling metal and glassware, which sometimes reflects minute self-portraits. Little is known of Peeters's youth, but judging from a signed and dated group of four accomplished compositions completed when she was about seventeen, she was a talented innovator who received excellent training. Peeters's early canvases are filled with arrays of beautifully presented edibles accented with rhythmic bouquets and floral sprays. The later works are simpler, representing a taste for everyday repasts—favorite cheeses, breads, and more modest, but still gleaming, glassware and crockery.

Influenced by the Dutch followers of Caravaggio, Judith Leyster (1609–1660) painted portraits, genre scenes, still lifes, and, later, detailed illustrations of tulips, a popular and vertiginously expensive recent import that soon came to stand for ruinous greed. A student of Frans Hals, her name came to light a century ago when her signature was discovered on a work thought to be his. Like Hals, her subjects were fun-loving drinkers, couples, musicians, and children. In a self-portrait done when she was in her early twenties, the confident, fashionably dressed artist looks up from her painting of a musician, a figure in her *Merry Company* (c. 1629–30). Both the artist and her fiddler smile brightly as they wield the tools of their

respective trades. Even where her palette is made up of somber browns and greens, her loose, rapid brushwork and golden highlights give an expressive, spontaneous quality to figures and faces. Leyster's quiet, intimate scenes like *The Rejected Proposition* (1631) inspired Jan Vermeer and other artists to attempt more insightful representations of young women or couples than the usual seductive looks and conspicuous glances ripe with implication. A typical fate of many women artists, past and present, Leyster's marriage in 1636 (to another Hals student, Jan Molenaer) and three children all but ended her productive career. She and her husband shared a studio, but she painted less and less, even though some critics maintained Leyster was the stronger painter of the two.

Geertruyd Roghman (1625–1653) executed a superb series of engravings of women engaged in domestic tasks that shows an uncommon aspect of this popular genre. No mere embodiments of moral messages or suggestive allusions, her women sew, spin, bake, and clean, all of them absorbed in their work. In all but one of these realistic images, the objects in view are related specifically to the task at hand. These are unsentimental portrayals in which the artist paid more attention to the values of light and shade than to instructing women in their proper roles. Only one of the series contains *vanitas* objects, symbolizing the temporal nature of the physical world. In an image that perhaps warns against frivolous activity, a woman appears to be examining a piece of fabric, representing material goods. The clock above and the skull below signify that life on earth is fleeting, the books on the table that worldly knowledge is finite.

Maria van Oosterwijk's (1630–1693) exquisitely finished flower pieces were prized by the kings of France, England, and Poland. In the spirit of scientific inquiry of the age in which she lived, she painstakingly rendered species of butterflies and insects that appear among her myriad varieties of blooms, leaves, and exotic grasses. An early biographer reported that she was so devoted to her work that she declined marriage to an ardent and persistent suitor.

Van Oosterwijk's ambitious *Vanitas*, dated 1668, contains a profusion of symbolic still-life objects as well as flowers and exemplifies this distinctive category of painting. Intended to convey both intellectual and symbolic meanings, vanitas works conveyed religious and moral messages by symbolizing the transience of various aspects of life on earth; mortality and the inevitable passage of time; and principles of Christian faith. Here the artist has included obvious symbols such as the skull, hourglass, flute and music, inkpot and pen, books, and a stalk of grain being nibbled by a mouse. The butterfly symbolizes the resurrection of Christ, with other insects representing sin and evil. As Peeters and others did, van Oosterwijk painted a small self-portrait "reflected" in the flask labeled *Aqua Vitae*, "water of life".

The daughter of an engraver who died when she was quite young, Maria Sibylla Merian (1647–1717) learned the art of flower painting in the studio of her stepfather, and eventually married a fellow student. German-born, she spent the last half of her life in Amsterdam, where she created and published several volumes of European plant and insect studies, including a large original work on the transformation of caterpillars, in which she also portrayed the plants that sustain them. In 1699, divorced and with support from the city of Amsterdam, she undertook a voyage to the Dutch colony of Surinam, where, assisted by her two daughters, she observed and gathered specimens. The result was a superbly produced volume of sixty hand-colored plates featuring the evolutionary stages of various native insects shown on exotic plants such as the banana.

With their shared interest in painting plant and insect life, it is possible that Merian and Rachel Ruysch (1664–1750) met while both were living in Amsterdam. Ruysch's scientific interests were encouraged by her father, a professor and amateur artist, and her paintings feature an impressive repertoire of plant, animal, and other natural species. As were many of the artists discussed so far, she was precocious, producing mature works while still in her teens. Ruysch was also prolific in every sense: she bore ten children and produced as many as two hundred paintings. Strong, asymmetric compositions, often featuring a gentle S-curve or a diagonal thrust, these works also contain the conventional symbolism associated with her subjects.

By the mid-eighteenth century, in the Low Countries as in Italy, women had established themselves as skilled competitors in the art market and were no longer looked upon as curiosities. With an expanding commercial middle class providing the art patrons, Dutch and Flemish painting might have been rendered mundane, but painting prevailed, even without the large church commissions and sumptuous portraits of the aristocracy that were still the rule in Italy and in France. As painters, these women were not rebels: they applied developing techniques and sophisticated artistic traditions to ennobling the home as the spiritual center of life, honoring its virtues by finding beauty and quiet morality in its details.

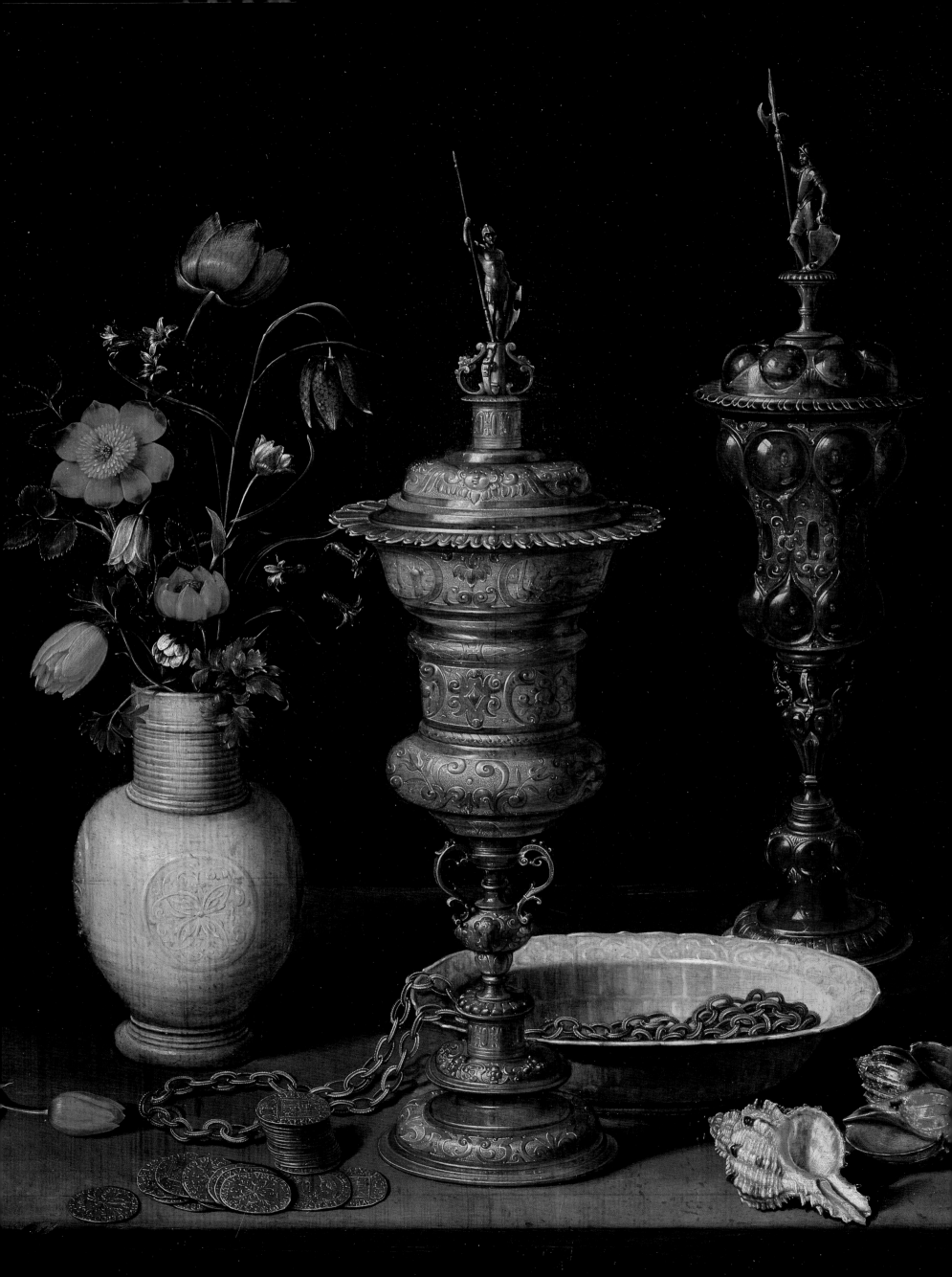

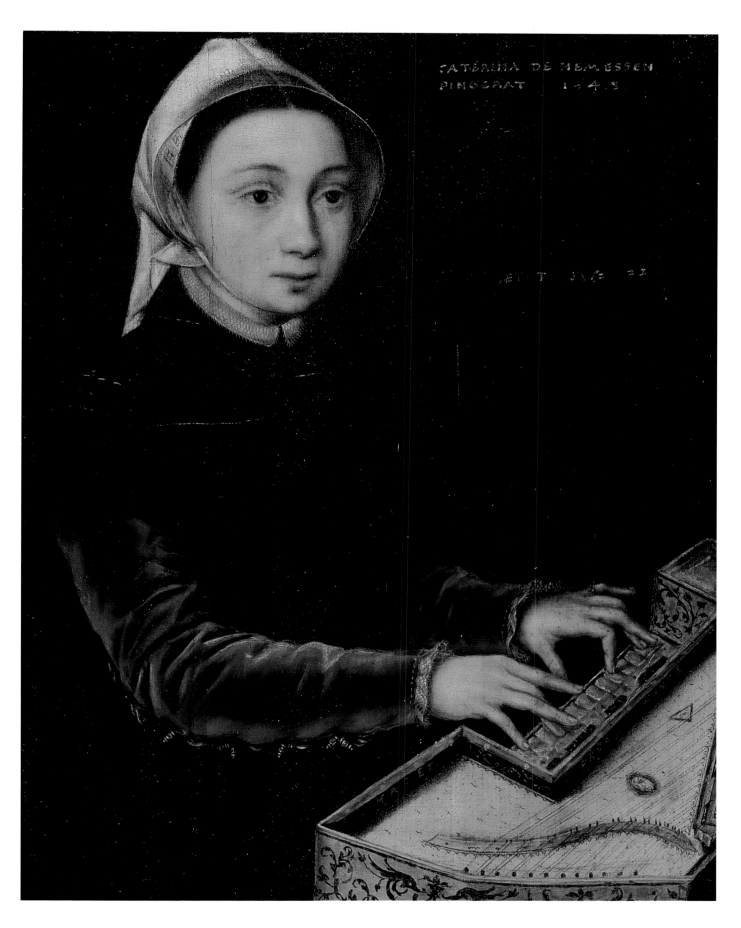

p. 28:
Judith Leyster. *Self-Portrait*. c. 1630.
Oil on canvas. 29 ⅜ x 25 ⅝ in.
(74.6 x 65.1 cm). Gift of Mr. and
Mrs. Robert Woods Bliss. © 1999
Board of Trustees, National
Gallery of Art, Washington, D.C.

p. 30:
Agnes van den Bossche. *Maid of
Ghent banner*. 1480–81. Oil on
canvas. Musée de la Byloke,
Ghent, Belgium.

Above:
Caterina van Hemessen. *Girl at the
Spinet*. 1548. Oil on canvas. 12 ¹¹⁄₁₆ x
10 ⅛ in. (32.2 x 25.7 cm). Wallraf-
Richartz Museum, Cologne.

Opposite:
Clara Peeters. *Still life with Vase of
Flowers, Goblets, and Shells*. 1612. Oil
on panel. 23 ⁷⁄₁₆ x 19 ⁵⁄₁₆ in. (59.5 x
49 cm). Staatliche Kunsthalle,
Karlsruhe. Photograph: Erich
Lessing/Art Resource, N.Y.

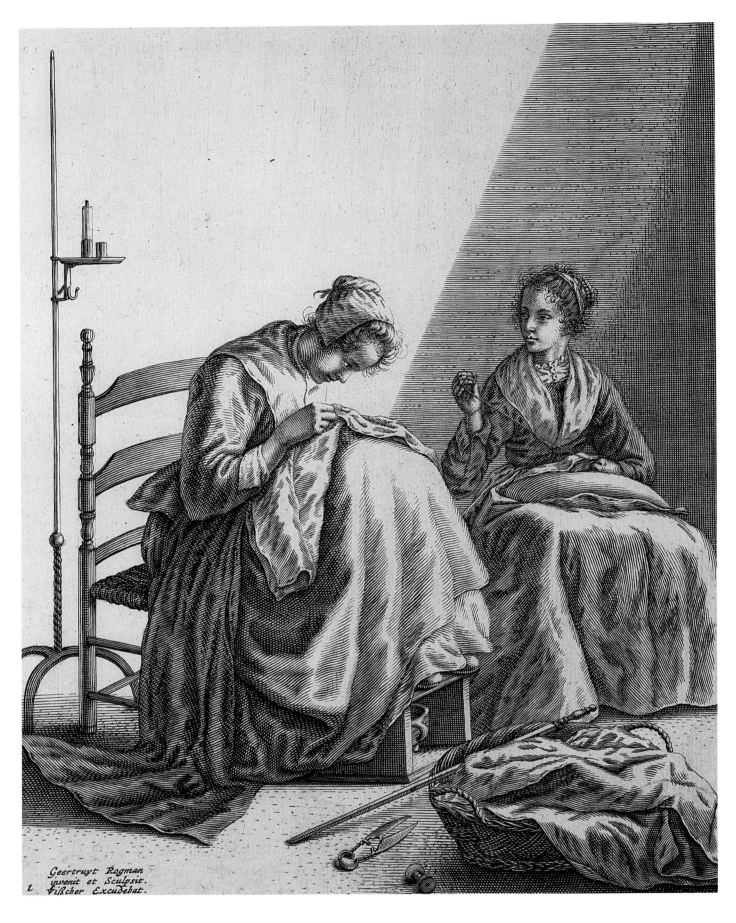

Above:

Geertruyd Roghman. *Two Women Sewing.* 1650. Engraving. 7 ⅞ x 6 ⅜ in. (20 x 16.3 cm). Rijksmuseum Foundation, Amsterdam.

Opposite:

Judith Leyster. *The Rejected Proposition.* 1631. Oil on panel. 11 ⅞ x 9 ½ in. (30.9 x 24.2 cm). Mauritshuis, The Hague, The Netherlands. Photograph: Scala/Art Resource, N.Y.

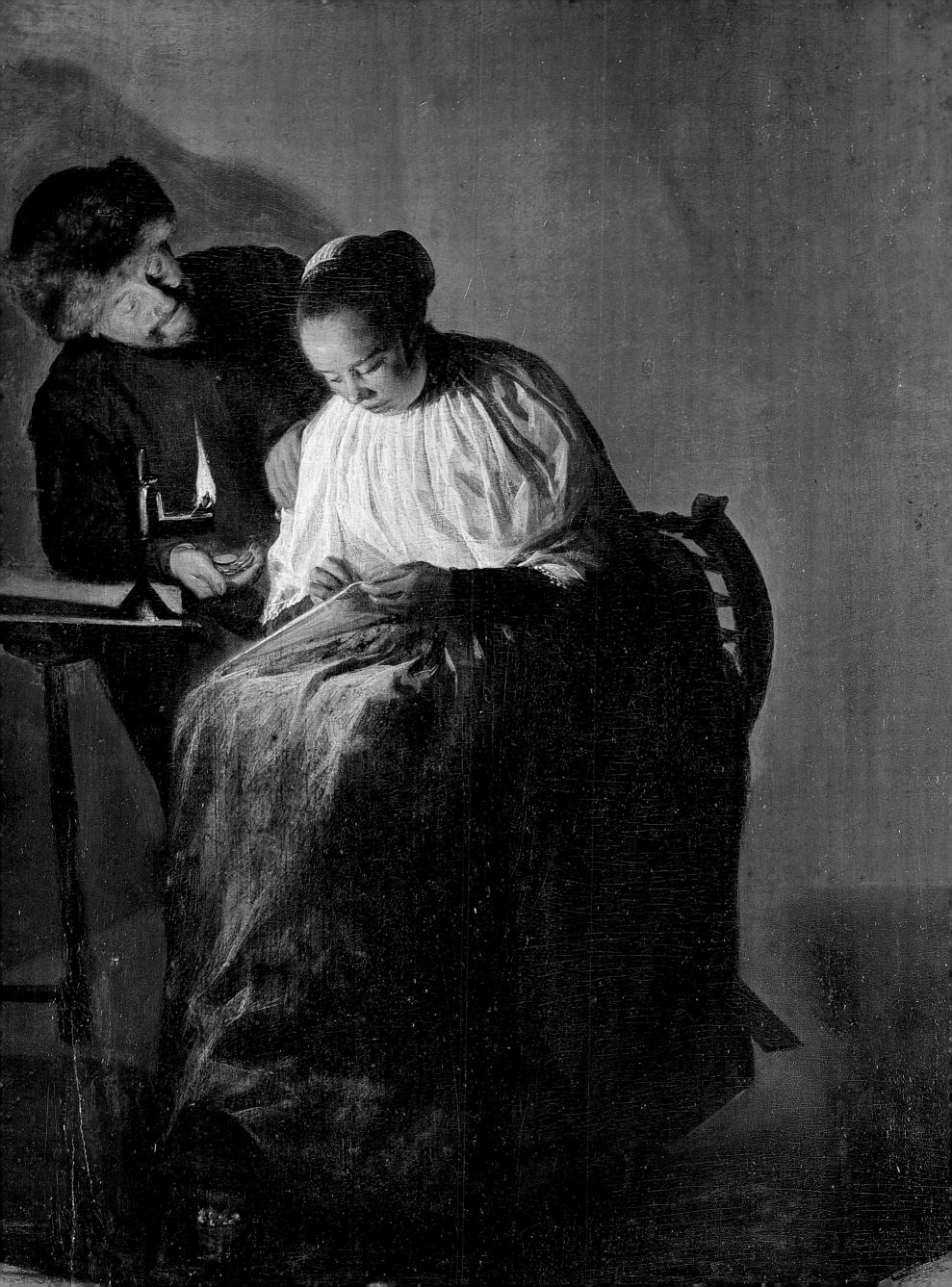

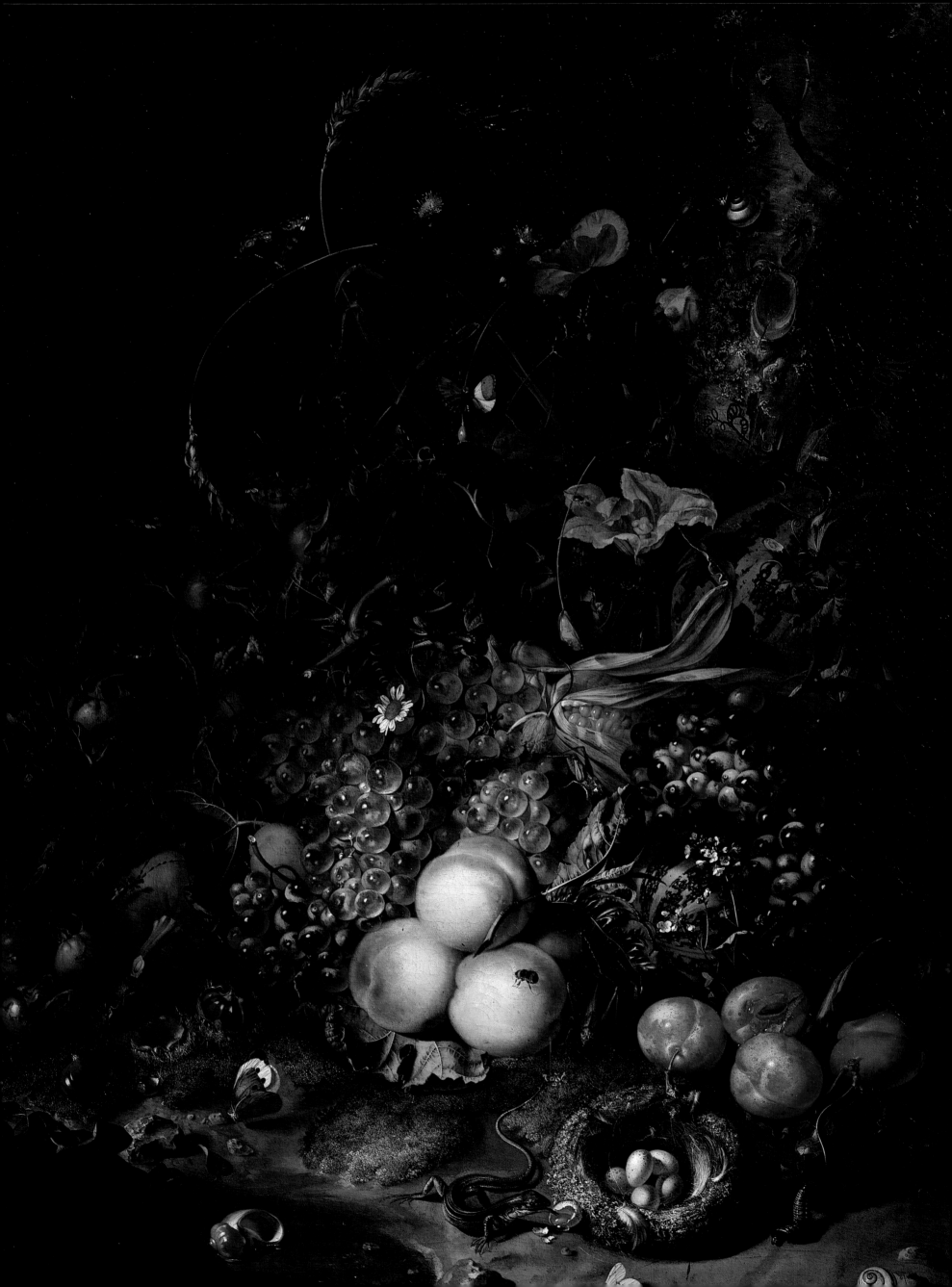

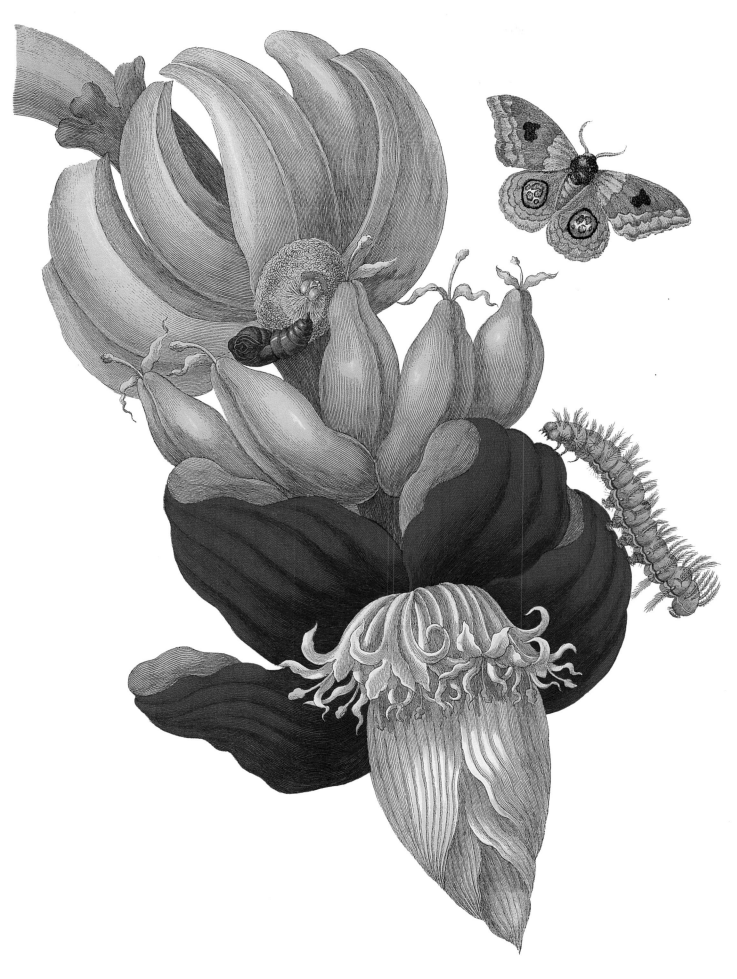

Opposite:
Rachel Ruysch. *Fruit, Flowers, Reptiles, and Insects.* c. 1745. Oil on canvas. 29 ¾ x 23 ⅞ in. (75.5 x 60.6 cm). Palazzo Pitti, Florence. Photograph: Nimatallah/Art Resource, N.Y.

Above:
Maria Sibylla Merian. *Banana Plant* from *Metamorphosis Insectorum Surinamensium.* c. 1705. Watercolor. 12 ¾ x 9 in. (32.3 x 22.9 cm). Courtesy of Special Collections, R.M. Strozier Library, Florida State University, Tallahassee.

3
Virtue and Virtuosity
Academic Traditions in French Art of the Seventeenth, Eighteenth, and Nineteenth Centuries

The eighteenth century came to be known as the Age of Enlightenment, and France was the site of its greatest intellectual ferment. The age's progressive humanist thinking inspired the American and French revolutions, but, as in the Renaissance, the new philosophies did not apply to women—in fact, differences between the sexes began to be legislated in Europe to an unprecedented degree. The well-read feminists who argued for educational and civic equality for women were largely derided as "bluestockings," or prudes, and their goals ridiculed as unnatural and absurd. Nevertheless, as in all times, public creeds and private customs diverged somewhat, and a number of women, primarily from the leisured upper class, studied history and literature, the arts and sciences, and the law. Intellectually, and sometimes politically, ambitious women hosted "salons" in their homes, inviting the most interesting and entertaining luminaries of the day—artists, musicians, writers, scientists, and politicians, mostly men, to share ideas.

France's official art institution, the Académie Royale de Peinture et de Sculpture (Royal Academy of Painting and Sculpture) had been founded in 1648, during the reign of Louis XIV. The Academy was open to women and men alike, but its teaching arm, the École des Beaux-Arts, was closed to female students, who were barred from the life classes where artists-in-training studied the nude figure. Women could submit their art to the Academy's official Salons, where juries of member Academicians selected the works that would be shown in the annual exhibitions. Although a number of women were successful working within the formal constraints of the conservative Academy style, few were granted the status of Academician. Only nine women were elected members of the Academy during its first hundred years; in 1770, to prevent the Academy from becoming overrun with women, female membership was limited to four. In 1793, France's foremost Revolutionary painter, Jacques-Louis David, called for the abolition of the Royal Academy. Under David's directorship, a new, more democratic Academy opened its doors, and the number of women exhibiting quickly increased. Still, restrictions on membership and art training for women persisted for another century.

Still lifes had never become very popular in France among the nation's predominantly aristocratic patrons. These subjects, which appealed more often to the bourgeoisie, eventually ranked lowest in the Academy's hierarchy—history was highest, followed by genre and portraiture. Louise Moillon (1610–1696), an early practitioner of the still life, was a Protestant, and thus more likely than her Catholic counterparts to be influenced by Dutch and Flemish traditions. She was also from a family of artists, and she meticulously rendered boldly colored arrangements of fruits and vegetables. Moillon painted a few genre paintings, scenes of daily life that featured still lifes, such as *At the Greengrocer* (1630).

A century later, the still lifes of Anne Vallayer-Coster (1744–1818), one of the few women elected to the Academy in 1770, were more highly prized than her portraits. Often compared with Jean-Baptiste Chardin, whose exquisite depictions of ordinary subjects had popularized genre and still-life painting in France, Vallayer-Coster's choice of subjects was quite different from his. She frequently depicted the trappings of upper-class life in works such as *Allegory of Music* (1770) and *Still Life with Military Trophies and a Bust of Minerva* (1777), and resplendent floral pictures such as *Flowers in a Blue Vase* (1782). Although she had powerful patrons and royalist sympathies, Vallayer-Coster's politically shrewd choice of this "neutral" subject matter made it possible for her to avoid ostracism or exile after the Revolution.

Among the few practitioners of the Dutch genre style in France was Françoise Duparc (1726–1778). A
sculptor's daughter, she painted her portraits and religious subjects in a naturalistic style that today is more
appealing than the elaborate manner so popular during her time. Duparc willed four paintings to the city of
Marseilles featuring working-class figures involved in some task. Her portrayal of quiet dignity in each subject,
as in *The Herb Seller,* conveys sympathy and respect for these seldom-recorded individuals; the young girl's sweet
face and the whiteness of her starched head covering contrast sharply with the well-worn, work-stained dress
and the burden she bears.

Portraiture remained female painters' bread-and-butter, although it could be perilous in a way that still
lifes were not. Throughout years of sometimes deadly political upheavals, members of the leisure classes,
obsessed with manners and appearances, wanted to see themselves depicted with dignity and aplomb. These
commissions could be very profitable, but such alliances in revolutionary times could be dangerous. Two of the
more celebrated portraitists of the day, Adélaïde Labille-Guiard (1749–1803) and Elisabeth-Louise Vigée-
Lebrun (1755–1842) were admitted to the Royal Academy on the same day in 1783. Although both had royal
patrons, their politics differed: Labille-Guiard was sympathetic to the Revolution and remained in France
during the turmoil, while Vigée-Lebrun's royalist sympathies caused her to leave France.

Labille-Guiard began her training with a miniaturist whose shop was near her father's haberdashery, but it
was her mastery of pastels that gained her early acclaim. A devoted teacher who fought quietly to increase the
presence of women in the Academy, Labille-Guiard succeeded, if only symbolically, by including two of her
female students in her commanding 1785 *Portrait of the Artist with Two Pupils, Mlle Marie-Gabrielle Capet and Mlle
Carreaux de Rosemond.* Her genteel yet perceptive royal portraits, such as *Elisabeth de France* (1788)—she had been
the official painter of the king's aunts—were quite different from Vigée-Lebrun's more flattering works.
Falling back on stereotypes of competitive women not being able to accept the fact that two talented women
artists could exist in the same time and place, the wags of the day created a rivalry between them.

Anne Vallayer-Coster. *Flowers in a Blue Vase*. 1782. Oil on canvas. Private collection, Paris. Photograph: Giraudon/Art Resource, N.Y.

Success came early to Vigée-Lebrun. Her father was a teacher and painter, one of a generation of artists to be strongly influenced by Rosalba Carriera. Elisabeth trained with him, but also taught herself by studying and copying great works by past and present masters, which she sought out at dealers and in private collections, studios, and the Salons. (In her memoir, *Souvenirs*, she mentions Peter Paul Rubens, Rembrandt, Domenichino, Raphael, and Jean-Baptiste Greuze among her "teachers.") Vigée-Lebrun was earning enough at age twenty to provide for her mother and brother when her father died. Influential and fashionable Parisians flocked to her studio to be transformed by her inventive brush. She might pose them pensively in a created landscape, add a large hat or a scarf or shawl for drapery effects, loosen and arrange their natural hair, and refine their features. As painter to the doomed Marie-Antoinette on the eve of the Revolution, Vigée-Lebrun loyally attempted to restore the controversial queen's reputation by depicting Her as a loving mother in *Marie-Antoinette and Her Children* (1787).

Vigée-Lebrun's fame was so great that she was welcomed and even flourished during a dozen years of exile in Italy, Austria, Russia, England, and Switzerland, where she continued to paint those countries' aristocracy. An unhappy marriage to Jean-Baptiste Pierre Lebrun, a picture dealer who squandered her earnings, produced her beloved daughter, Julie. Their relationship, memorialized in such works as *Madame Vigée-Lebrun and Her Daughter* (1789), became strained a decade later when Julie rushed into a destructive marriage. *Julie Lebrun as Flora* (c. 1799), the artist's last portrait of her daughter, was completed during their exile in St. Petersburg, Russia. In her career, Elisabeth Vigée-Lebrun painted almost one thousand paintings. By any measure, she was one of the most successful painters—male or female—of all time.

At the height of her success Vigée-Lebrun had closed her studio briefly in order to enlarge it, and Jacques-Louis David accepted several of her pupils. One, Marie-Guillemine Benoist (1768–1826), adopted David's Neoclassical style in paintings such as *Innocence between Virtue and Vice* (1791). Eventually abandoning such subjects in favor of those less vulnerable to political interpretation (Benoist and her husband supported the monarchy),

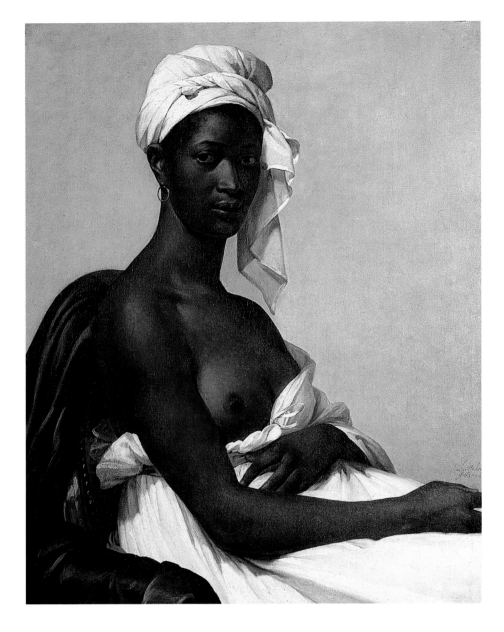

Benoist was rewarded at the 1804 Salon with a gold medal. Besides numerous sentimental scenes of family life, she was respected for her portraits, including her well-known *Portrait of a Negress* (1800) and several of Napoleon and his family after 1803.

Césarine Davin-Mirvault (1773–1844) was another student of David whose portraits and small genre scenes met with success in the Salons. Davin-Mirvault's portrait of the Italian violinist Antonio Bruni (1804) was once attributed to David, as was Constance Marie Charpentier's (1767–1849) *Mlle Charlotte du Val-d'Ognes* (n.d.). Perhaps because conventional wisdom denied women's ability to execute professional, first-rate paintings and sculptures, works by women often were attributed to their teachers: Flower-painter Margareta Haverman, elected to the Royal Academy in 1722, was accused of having submitted a picture painted by her teacher and expelled the following year.

The entrance of educated, opinionated women during the eighteenth century into traditionally male domains such as politics (where women exerted power behind the scenes) and arts and letters caused something of a backlash. Perhaps, too, the male thinkers of the Age of Reason were irritated by these living arguments against their theories of female intellectual inferiority (and virtuous superiority). In any case, by mid-century, influential writers and philosophers, such as Jean-Jacques Rousseau, were penning treatises and novels extolling the virtues of domesticity and urging women to exchange intellectual pursuits for a more "natural" course. Inspired by a romantic "cult of motherhood," women, even those of the upper classes, took over the care of their children and began to delight—at least publicly—in their upbringing and education. Motherhood became a common subject in art, both in intimate family portraits featuring tender mothers and their children, and in literature. Paintings of happy youngsters, such as Marie-Eléonore Godefroid's (1778–1849) *Sons of Marshall Ney,* (1810) reflected the new child-centered philosophy.

Marguerite Gérard (1761–1837) and Constance Mayer (1775/78–1821), however, were celebrated for their genre scenes and allegories. These often quite sentimental subjects had been made fashionable by Jean-Honoré Fragonard, Greuze, and Paul Prud'hon, among others, all active in the late eighteenth and early nineteenth centuries.

When her sister married Fragonard, Gérard became a member of their household. Working chiefly in a small format made her paintings easily portable and did not require much studio space. In a style influenced both by Dutch genre scenes and the work of her brother-in-law, Gérard created a variety of popular, slightly didactic, works such as *First Steps* (1825), or *The Piano Lesson* (1780s), which emphasizes a mother's role in her child's education. She also depicted scenes of happy families from contemporary novels, including *L'Enfance de Paul et Virginie*—from Jacques-Henri Bernerdin de Saint-Pierre's 1788 bestseller—but produced livelier portraits as well, such as *The Architect and His Family* (ca. 1787).

Mayer, who became a student and then companion of Paul Prud'hon, adopted his dramatic lighting and languid poses for paintings such as *The Dream of Happiness* (1819) and her two well-known companion works about motherhood, *The Happy Mother* and *The Unhappy Mother* (1810). Eventually, Mayer's unhappiness over her relationship with Prud'hon contributed to her suicide.

Even the most prosperous artists took students. And whether the teachers were male or female, because female students could not work from nude male models and because of the social dictates of propriety, students were segregated by sex.

Adrienne-Marie-Louise Grandpierre-Deverzy's (1798–act. to 1855) painting of the atelier of her husband, Abel Pujol, gives a view into a typical studio for female students. In crowded conditions and with few easels and limited work space, students mill about (one even looks out of the window) while a clothed female model and shelves of plaster casts offer limited subject matter.

One artist who achieved unqualified success despite her blatant nonconformity—she cut her hair, wore trousers, and lived independently—was Rosa Bonheur (1822–1899). She was taught by her father, a naturalist landscape painter and humanitarian, and, as a girl, attended a Saint-Simonian school, dedicated to feminist socialism. Fascinated by animals, she observed, sketched, and dissected them: by the time she obtained official permission to wear male attire, which was more practical for attending horse fairs, cattle markets, and other unladylike venues, she had won critical renown. Having gained international fame for monumental animal paintings such as *Plowing in the Nivernais* (1849) and *The Horse Fair* (1853), in 1865 Bonheur became the first female artist to receive the French Legion of Honor. At her home at Château de By, near the Fontainebleau forest, she kept a menagerie that included horses given to her by "Buffalo Bill" Cody, the American Wild West legend whom she painted during his troupe's French stay.

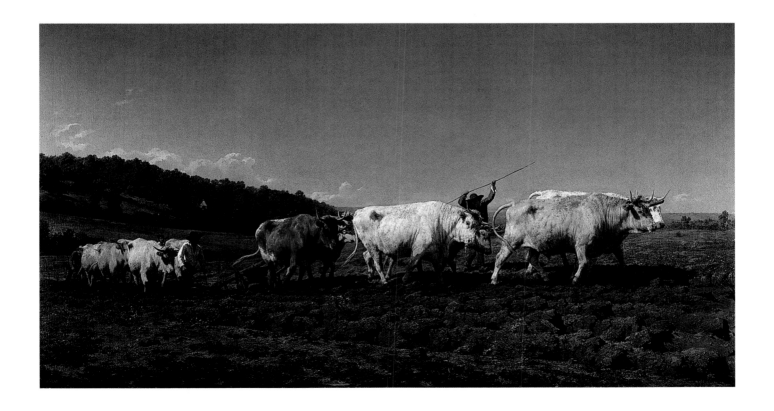

Elisabeth-Louise Vigée-Lebrun

From Elisabeth-Louise Vigée-Lebrun, *Souvenirs of Madame Vigée-Lebrun*

It was in the year 1779, my dear friend, that I painted the Queen's portrait for the first time; she was then in all the brilliance of her youth and beauty. . . .

At the first sitting, the Queen's imposing bearing intimidated me extremely, but Her Majesty spoke to me so kindly that her charm soon dissipated this impression. It was then that I painted her with a large basket, dressed in a satin robe and holding a rose in her hand. This portrait was intended for her brother, the Emperor Joseph II. The Queen ordered two copies of it, one for the Empress of Russia, the other for her apartments at Versailles or Fontainebleau. . . .

As soon as Her Majesty heard that I had a pretty voice, she rarely gave me a sitting without making me sing several of Grétry's duets with her, for she was very fond of music, although her voice was not always in tune. As for her conversation, it would be difficult to describe its affability and charm. I do not believe that Queen Marie Antoinette ever allowed an occasion to pass by without saying something pleasant to those who had the honor of approaching her, and the kindness which she always showed me is one of my most delightful memories.

One day it happened that I missed a sitting that was scheduled with her because I was well along in my second pregnancy and suddenly felt ill. The next day I hurried to Versailles to make my apologies. The Queen was not expecting me, and had called for her carriage, which was the first thing I saw when I entered the palace courtyard. All the same I went up and spoke to the gentlemen-in-waiting. One of them, M. Campan, received me very coldly and stiffly and said angrily in his stentorian voice, "It was yesterday, Madame, that Her Majesty expected you, and of course she is going for a drive and of course she will not give you a sitting." When I replied that I came merely to receive Her Majesty's orders for another day, he went to find the Queen, who immediately called me into her sitting room. She was finishing her toilette and held a book in her hand and was going over

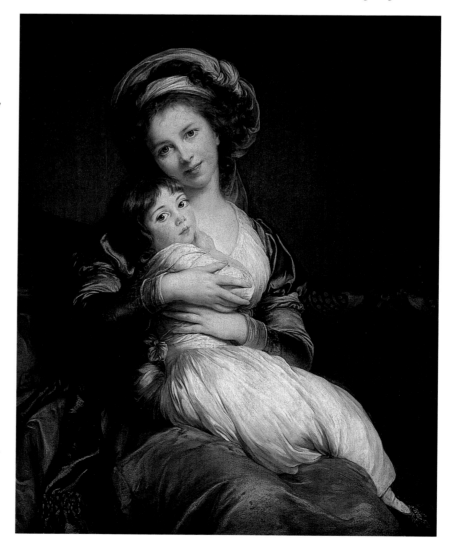

Madame Royale's lessons. My heart beat very fast, for I was as fearful as I was in the wrong. The Queen turned and said kindly, "I waited for you all yesterday morning, what happened to you?" "Alas! Madam," I replied, "I was so ill that I was unable to attend Your Majesty's commands. I have come today to receive them and will leave directly." "No! no! Do not leave," she replied. "I will not let you make your journey for nothing." She dismissed her carriage and gave me a sitting. I remember that in my eagerness to make amends for her goodness, I grabbed my box of colours so quickly that I upset them all; my brushes and paints fell to the floor, and I stooped down to collect them. "Let them alone, let them alone," said the Queen, "you are not in a condition to stoop." And not heeding what I said, she bent down and picked everything up herself. . . .

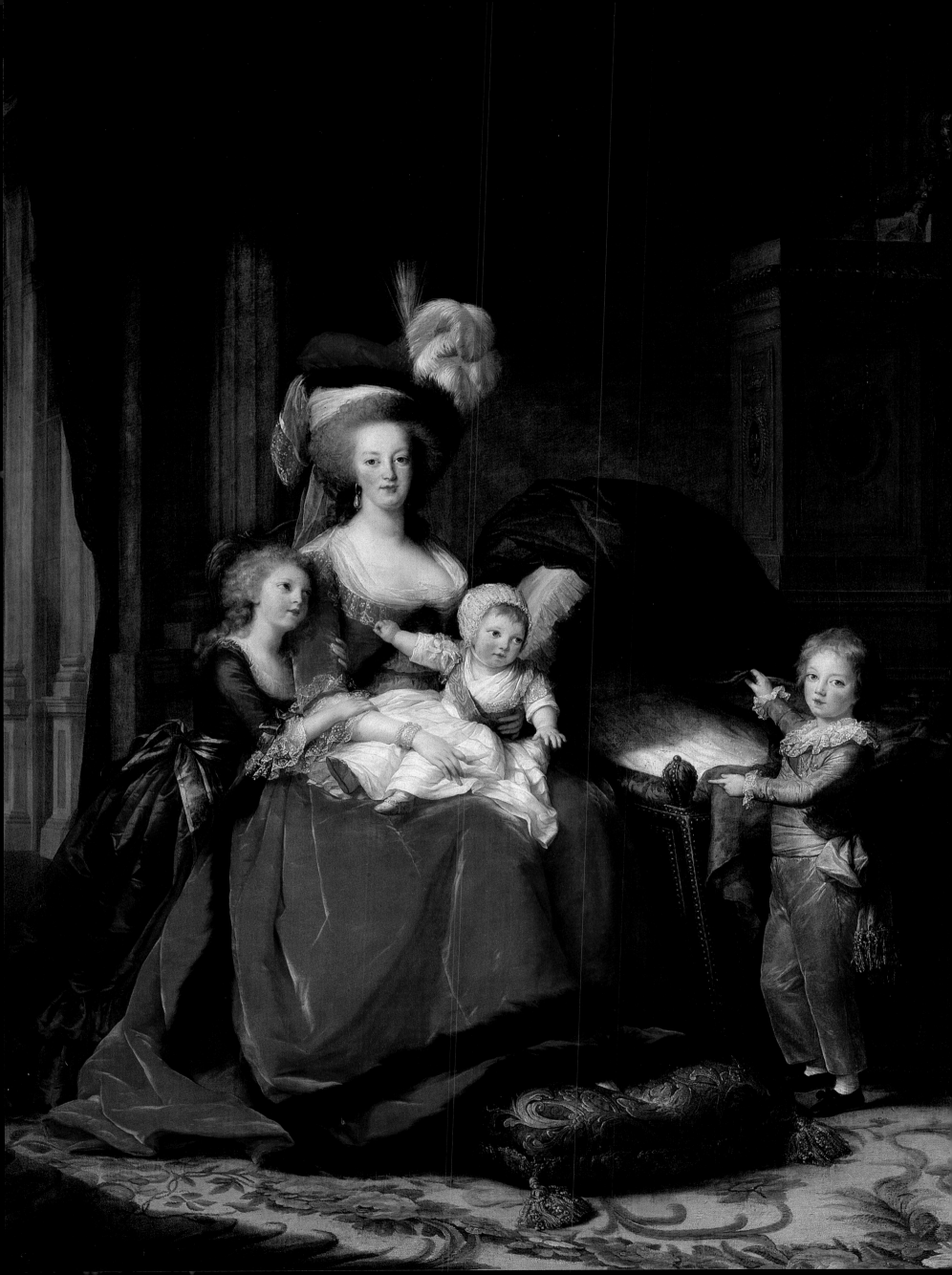

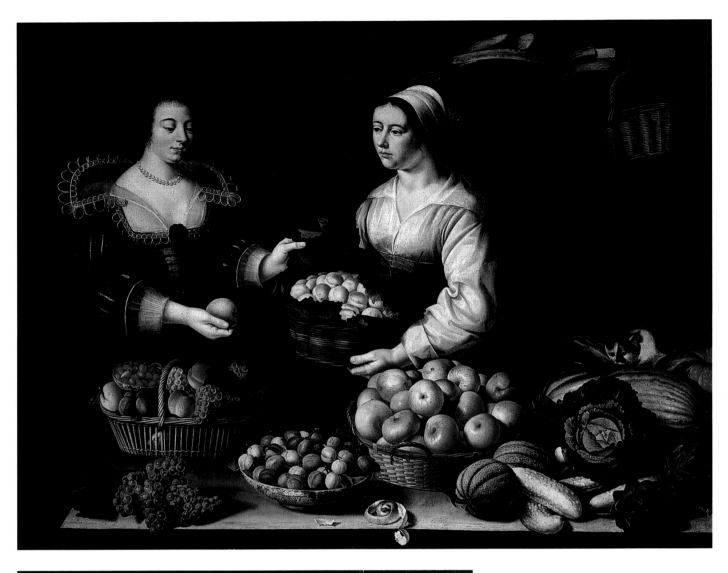

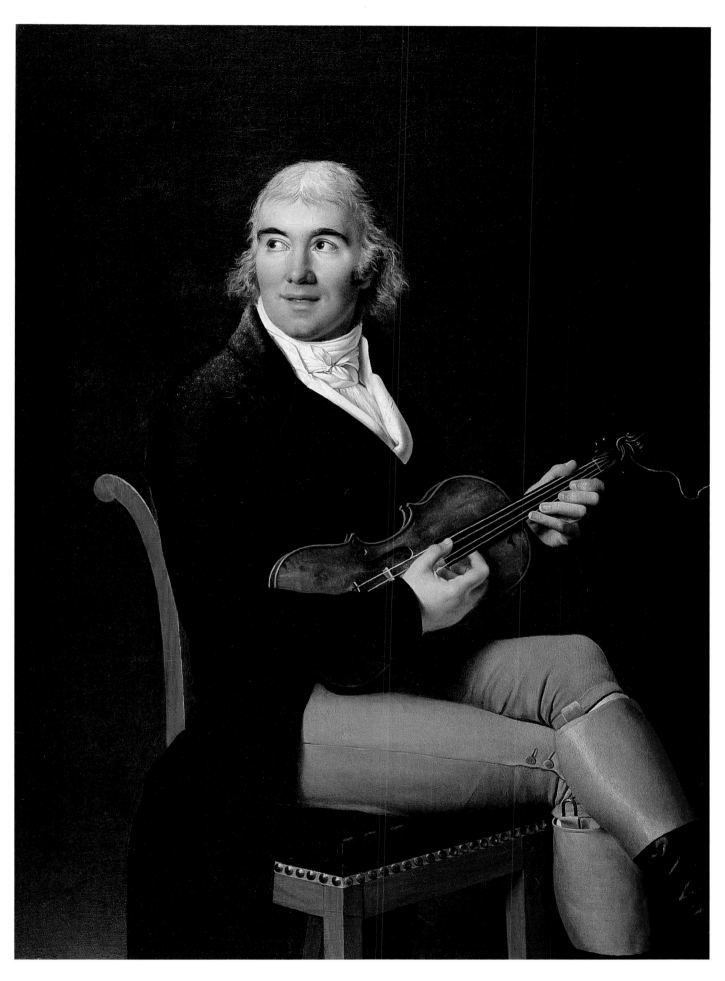

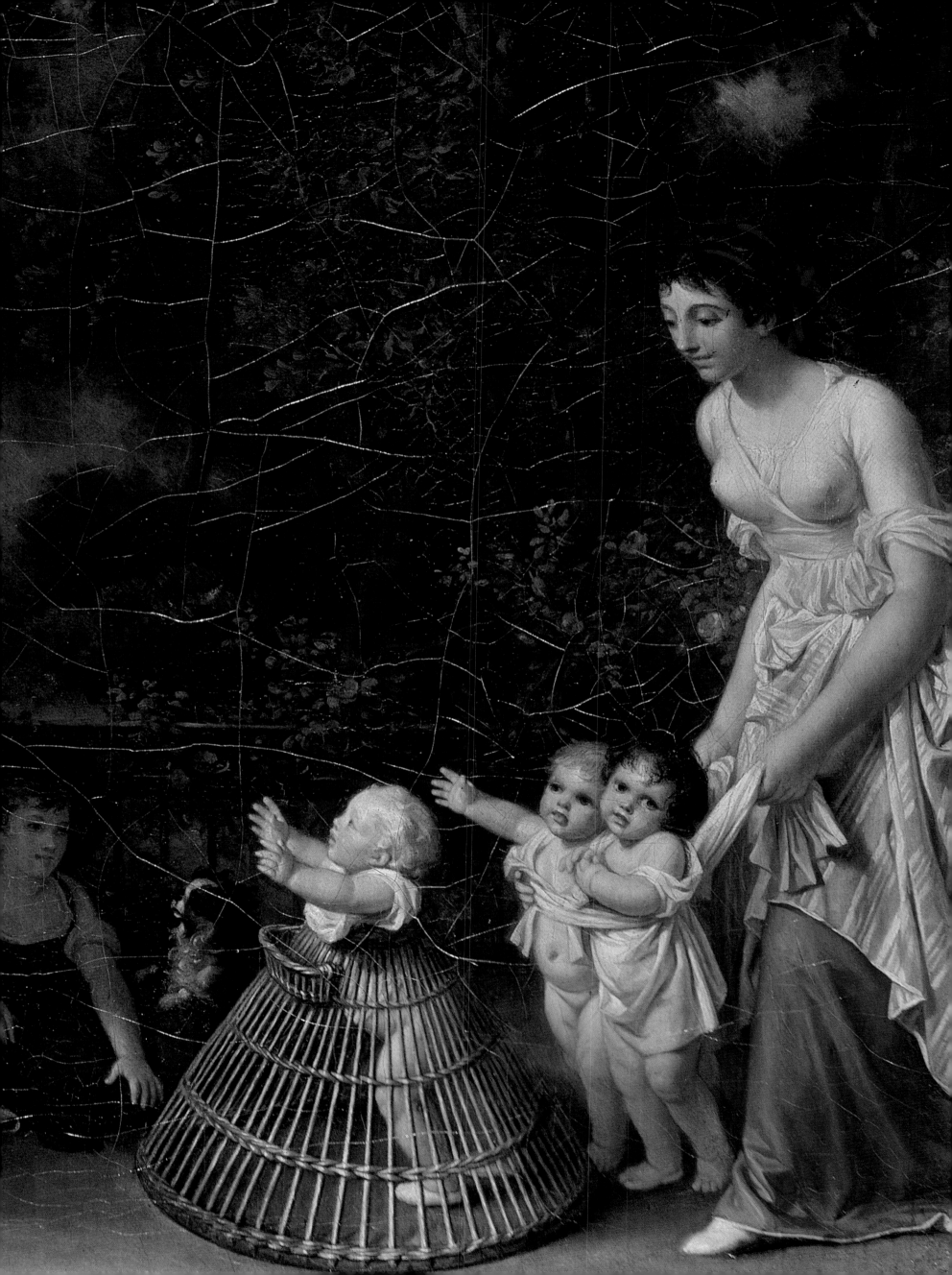

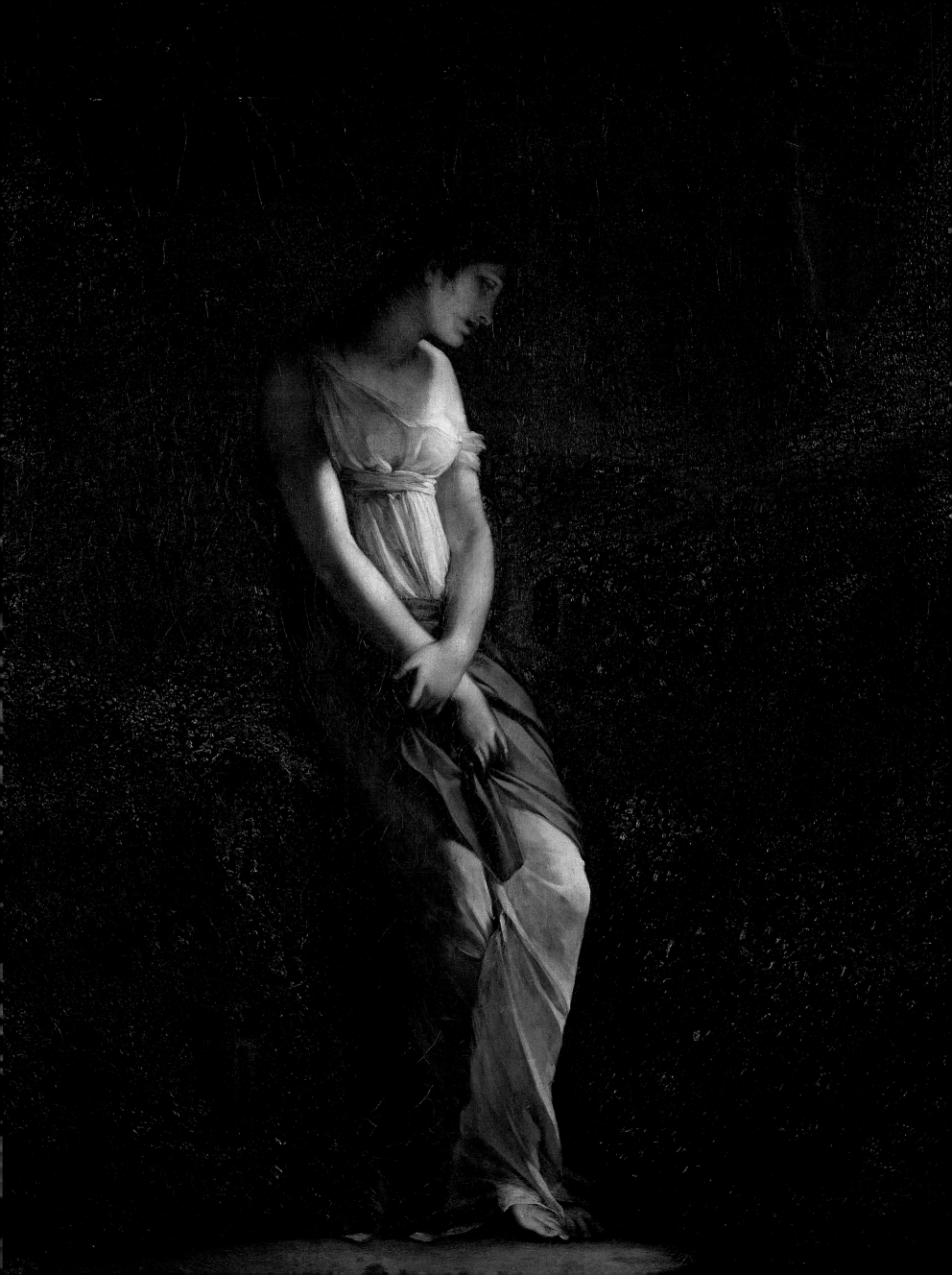

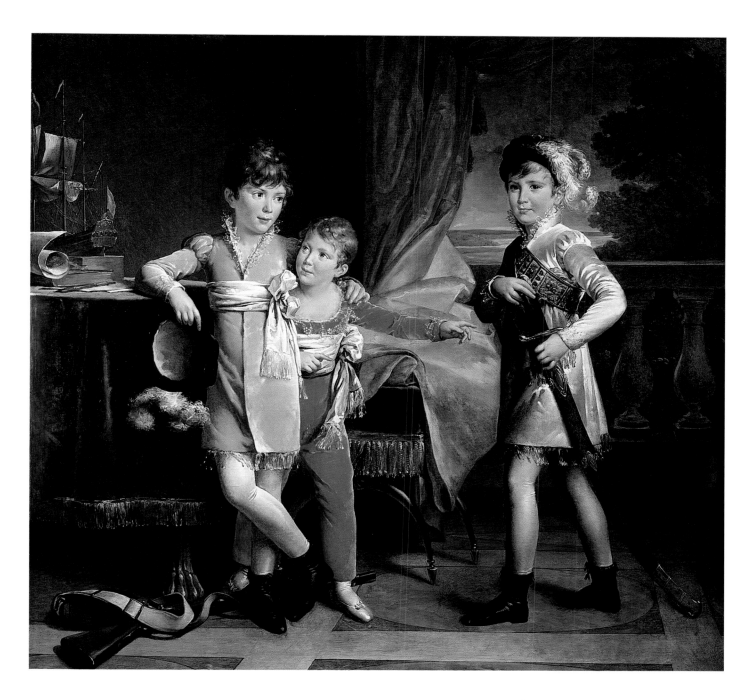

Opposite:
Constance Mayer. *The Unhappy Mother.* 1810. Oil on canvas. 75 ⅞ x 56 ½ in. (192.7 x 143.5 cm). Musée du Louvre, Paris. Photograph: Erich Lessing/Art Resource, N.Y

Above:
Marie-Eléonore Godefroid. *Sons of Marshall Ney.* 1810. Oil on canvas. 63 ¾ x 70 ⅛ in. (162 x 173 cm). Staatliche Museen Preussischer Kulturbesitz Gemäldegalerie, Berlin. © 1999 Bildarchiv Preussischer Kulturbesitz, Berlin. Photograph: Jörg P. Anders

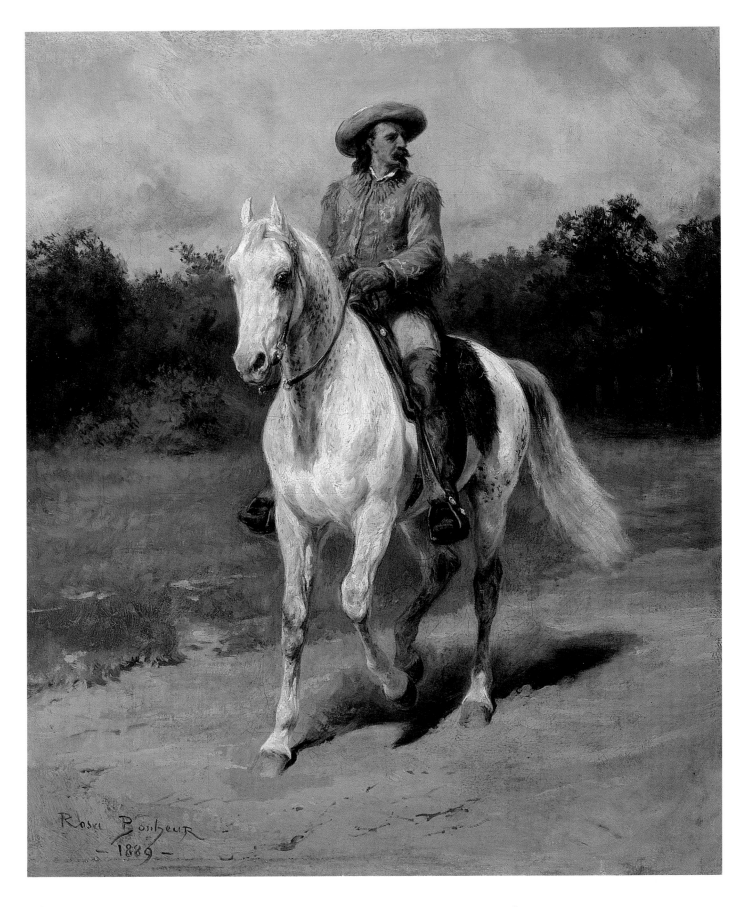

Rosa Bonheur

From Rosa Bonheur, *Fragments of My Autobiography*

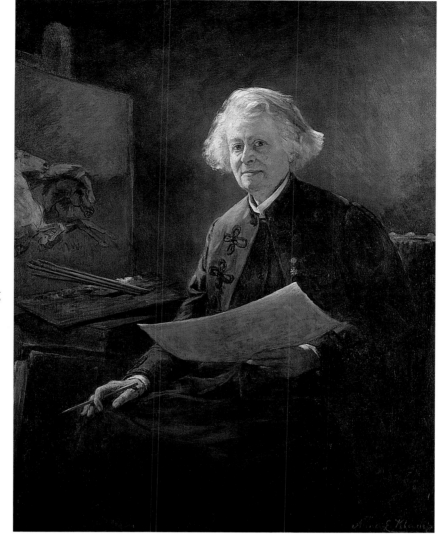

I was growing fast; my father did not want me to remain altogether ignorant, and he sent me to Madame Gilbert's school, rue de Neuilly. They found me a troublesome inmate; my romping habits had a deplorable influence on my school fellows who became turbulent like me. Once, at playtime, I suggested a game of war. Our arms were wooden swords, and I gave the order for a charge. It was such a disaster for the flower garden! Beautiful roses, the pride of M. Gilbert, were soon scattered on the ground; but this outrageous frolic was the last. M. and Mme. Gilbert refused to keep any longer such a tomboy as me, and sent me home. My parents had now removed to the rue de Tournelles. The first floor of their house had been converted into a studio. There I worked alone, as best I could, whilst my father went into every quarter of Paris to give lessons. One evening, coming home after a trying day of work, he found me putting the finishing touches to my first picture from nature, *A Bunch of Cherries.* "This is very good indeed," he exclaimed. "You must work seriously now." And I did. From that day I began to copy from casts and from engravings, without, however, neglecting to paint from nature. How much more fascinating it was to me, than to learn grammar and arithmetic! . . .

In 1845 we moved to the rue Romfort. My father had married again, and I went on working harder than ever in our new quarters, situated at the back of the beautiful Parc Monceau, near which there were at that time mostly open fields, farms, dairies. What an opportunity for me to watch the cows, sheep and goats! I had found out a delightful corner at Villiers, near the Parc de Neuilly. For a few months I boarded and lodged with a kind peasant woman. To recount all my experiences there would be telling you over again the story of all beginners.

I had to catch the rapid motion of the animals, the reflection of light and colours on their coats, then different characteristics (for every animal has its individual physiognomy). Therefore, before undertaking the study of a dog, a horse, a sheep, I tried to become familiar with the anatomy, osteology, myology of each of them. I acquired even a certain knowledge of dissection; and, by the way, I must strongly advise all animal painters to do the same. Another excellent practice is to observe the aspect of plaster models of animals, especially to copy them by lamp light, which gives more distinctness and vibration to the shadows. I can assure those who do not doubt my sincerity as an artist, that I owe all that I know to those patient and conscientious exercises.

* * *

To perfect myself in the study of nature, I spent whole days in the Roule slaughterhouse. One must be greatly devoted to art to stand the sight of such horrors, in the midst of the coarsest people. They wondered at seeing a young woman taking interest in their work, and made themselves as disagreeable to me as they possibly could. But when our aims are right we always find help. Providence sent me a protector in the good Monsieur Emile, a butcher of great physical strength. He declared that whoever failed to be polite to me would have to reckon with him. I was thus enabled to work undisturbed. . . .

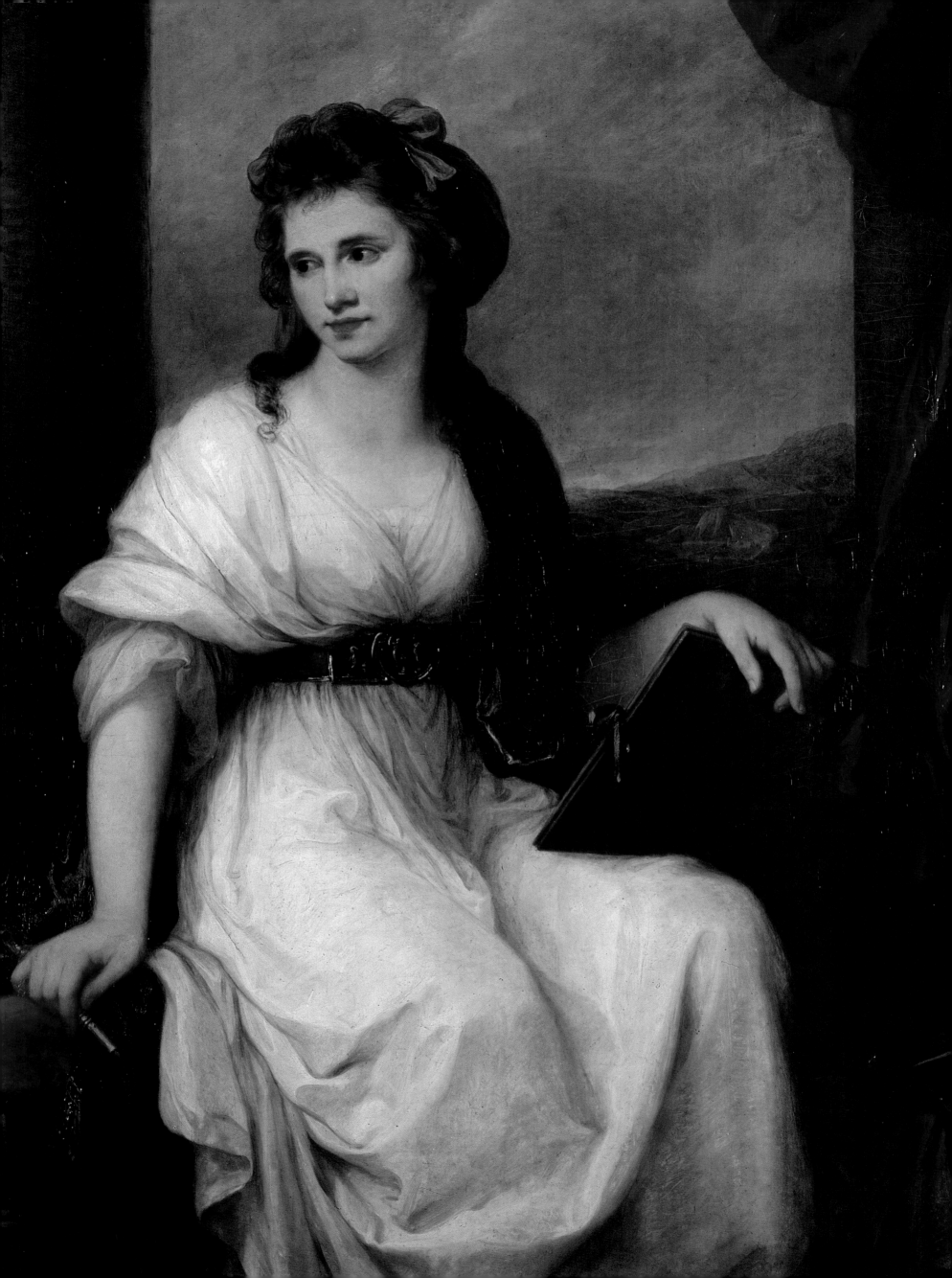

4
On the Face of It
The British Portrait Tradition

More than any other Europeans, the British were obsessed with portraiture. From its start during the Renaissance, "face painting," as it was called, reflected prestige and power, growing over time to encompass single and double portraits, from head and shoulders to full-length, and group and family portraits, including animals and property.

As elsewhere, early female artists in Britain with artist parents had the advantage of a thorough art education. More typically, however, upper-class young ladies were educated to be charming and polished wives, mothers, and hostesses. With proficiency in drawing, music, and needlework deemed at least as important as reading, the ability to take a good likeness was a much-lauded accomplishment. Without access to training beyond a hired drawing master, many talented women remained amateurs; the exceptions were those few with the determination—or the necessity—to supersede conventional limitations.

By the seventeenth century, portraiture was firmly established among the upper classes, whose members were highly receptive to seeing themselves painted in fancy dress, as mythological characters, or in Arcadian landscapes. With the Enlightenment in the eighteenth century, a more sober portraiture spread to the expanding middle strata of society, often as drawings. The great interest in England in history painting, led by the influential founders of the Royal Academy of Arts in 1768, relegated portraiture to a lower "class" of art, incapable of expressing the noblest emotions. Since women would not be permitted to draw from the nude until the end of the nineteenth century, female artists were in effect banished to the lesser categories. To bridge the gap, some women took advantage of the intellectual fashion of portraiture, representing their sitters as bards, muses, or allegorical figures.

Among the earliest known female portrait artists in Britain was Joan Carlile (c. 1606–1679). A friend of the court painter Sir Anthony Van Dyck, she was warmly admired in her own right by King Charles I, who employed her as a copyist. Her husband, a minor dramatist, also served at the pleasure of the court. By the 1650s she had gained a fair reputation with works such as her large *Stag Hunt at Lamport*, a grand group portrait of members of the nobility—stag hunting being a royal sport. Likewise she distinguished herself with paintings such as *Portrait of a Lady*: here, too, a wooded landscape forms the background for this highborn subject, thought to be Lady Anne Wentworth.

Mary Craddock Beale (1633–1697) was the daughter of a clergyman and a friend of the Dutch-born English court painter Sir Peter Lely, on whose style she at first based her own. With her marriage in 1652 to Charles Beale, her young career might well have come to an end, but instead, it was then that she began her serious apprenticeship. By the 1670s she was established as an independent portrait artist, with her husband managing her London studio, and her son Charles assisting her as a drapery painter. Her portrait of Anne Walpole is one of the hundreds of commissions that came to the artist through a wide circle of friends from the nobility and the landed gentry. Beale often included an architectural prop, but unlike many contemporary portraitists, she avoided the formulaic flattery of the period that often reduced portraiture to mere decorative iconography.

Among the Royal Academy's thirty-six founding members in 1769 were two women: Angelica Kauffmann and Mary Moser. Kauffmann (1741–1807), the daughter of a minor Swiss painter, traveled widely with her father, assisting him with commissions. They arrived in London in 1766, and Kauffmann soon electrified London's artistic and literary circles, receiving portrait commissions from the royal family and the nobility. Much-courted, she married but soon separated from a charlatan who styled himself Count Frederick de Horn.

Eventually she married the painter Antonio Zucchi, with whom she had collaborated on decorative schemes for the celebrated Scottish architect Robert Adam, and settled for the rest of her life in Italy. It was in England, however, that she reached artistic maturity and experienced lasting success. Not content with simple portrait painting, Kauffmann submitted four mythological scenes to the first Royal Academy exhibition and often cast her portraits as allegorical or classical subjects. Such is the case with *Papirius Praetextatus* (n.d.), in which the young nobleman is entreated by his mother to disclose the secrets of the deliberations of the Roman Senate. Aside from the sumptuous coloring that informs much of her work, Kauffmann had a gift for flattering her subjects. The painter Henry Fuseli, a fellow Swiss and a Royal Academician, said of her, "She pleased, and desired to please, the age in which she lived."

Mary Moser (1744–1819), like her friend Angelica Kauffmann, was of Swiss descent and the daughter of an artist who numbered King George III among his pupils. Moser principally painted flowers—a genre to which many women were directed—and contributed two flower pieces, an oil and a watercolor, to the Royal Academy's first exhibition. She exhibited her first figural piece two years later. Though she continued to exhibit figure subjects until 1800, most of her work continued to be flower painting. The portrait of the sculptor Joseph Nollekens ascribed to Moser is a rare example of her portraiture and shows the sculptor at work on the statue of Bacchus that he exhibited at the Royal Academy in 1771. After her marriage to Captain Hugh Lloyd in 1793, Moser painted only as an amateur: many of her paintings remain in private hands.

Maria Hadfield Cosway (1759–1838), the Anglo-Italian daughter of innkeepers from Leghorn, became a London society hostess and confidante of American Thomas Jefferson. Such were her gifts that she was ranked by some with Angelica Kauffmann, who helped establish the younger artist in London, where she met her future husband, the miniaturist Richard Cosway. On a trip to Paris in 1786, Cosway met Jefferson, who became a lifelong correspondent. Though she painted large history subjects, exhibiting a number of them at the Royal Academy, she was most admired for her portraits. Her *Self-Portrait Reclining on a Sofa* (n.d.) is one of a

p. 54:
Angelica Kauffmann. *Self-Portrait.*
1787. Oil on canvas. 50 ⅜ x
36 ¹³/₁₆ in. (128 x 93.5 cm).
Galleria degli Uffizi, Florence.
Photograph: Bridgeman Art
Library, London/New York.

Left:
Joan Carlile. *Portrait of a Lady.*
Oil on canvas. n.d. 49 ¼ x 39 ¾ in.
(125 x 101 cm). Photograph:
Christie's Images Ltd., 1999.

Maria Cosway. *Self-Portrait Reclining on a Sofa*. n.d. Grey and brown washes with bodycolor laid on the artist's original mount. 8 ¾ x 11 ⅛ in. (22.3 x 28.2 cm). Private collection. Photograph: Courtesy Agnews, London.

dozen drawings subsequently engraved as illustrations to "The Winter Day," a popular poem by Mary "Perdita" Robinson (1758–1800), the theme of which is the contrast between poverty and opulence. The painting's setting is probably the Cosways' London home at 20 Stratford Place.

Margaret Sarah Carpenter (1793–1864) was viewed as the artistic heir to Sir Thomas Lawrence, whose style greatly influenced her own. She moved to London from her native Salisbury at age twenty, and with talent, ambition, and wealthy patronage, she quickly established herself as a fashionable portraitist. She exhibited more than 150 paintings at the Royal Academy (though women were by now excluded from membership), more than any other woman to date. Her paintings invariably elicited praise from the critics, especially her portraits of children. Her mature work, of which the double portrait *The Sisters* is a fine example, is characterized by energetic execution and strong draftsmanship. Her subjects are skillfully lit, and the background is never allowed to detract from the central focus of the sitter's face and eyes.

Carpenter's contemporary Rolinda Sharples (1793–1838) led the less glamorous life of a provincial portrait painter. Born in Bath, as a child she lived for a time with her family in America. Both her parents, James Sharples and Ellen Wallace Sharples, were painters and, presumably, her teachers. At eighteen she moved with her mother to Clifton, near Bristol, and there spent the remainder of her life painting portraits and miniatures, though she studied for two brief periods in London. Her large paintings such as *Embarkation of the Ferry Boat* and *The Trial of Colonel Brereton after the Bristol Riots* (1832–34), represent contemporary events and include numerous recognizable portraits of participants.

Although a pleasing skill in drawing and watercolor was considered an indispensable part of a lady's education, few young women studied sculpture. Anne Seymour Damer (1748–1828) was an exception. The granddaughter of the Duke of Argyll and a cousin of the author and aesthete Horace Walpole, Damer took up sculpture on a challenge from the misogynist Scottish philosopher David Hume. Considered an eccentric by her friends, she applied herself to the unladylike disciplines of anatomy, clay and wax modeling, and marble chiseling. Married at nineteen to a dissipated spendthrift, she worked little during their nine-year marriage. Following his suicide, however, she traveled on the continent perfecting her craft. In Florence she was invited to add her self-portrait to the collection of busts in the Uffizi Gallery, and she later received several commissions from Napoleon.

The sculptor Mary Francis Thornycroft (1809–1895) was the daughter, wife, and mother of sculptors. Born in a small Norfolk village, she studied with her father, and it was in his studio that she met Thomas Thornycroft, her father's pupil and her future husband. Mary began her career with a bust of her father, exhibited at the Royal Academy in 1835; more successful than her husband, she would be her family's principal support. As a woman, however, she could not with propriety travel freely or reside in a patron's home while working on a commission. She turned instead to subjects close to home, notably infants and children, thereby setting her future course in art, and leading to a long series of royal commissions beginning in 1844. (She herself gave birth to seven children.) Among the first commissions she executed for Queen Victoria and Prince Albert were charming allegorical statues of the couple's children as the four seasons.

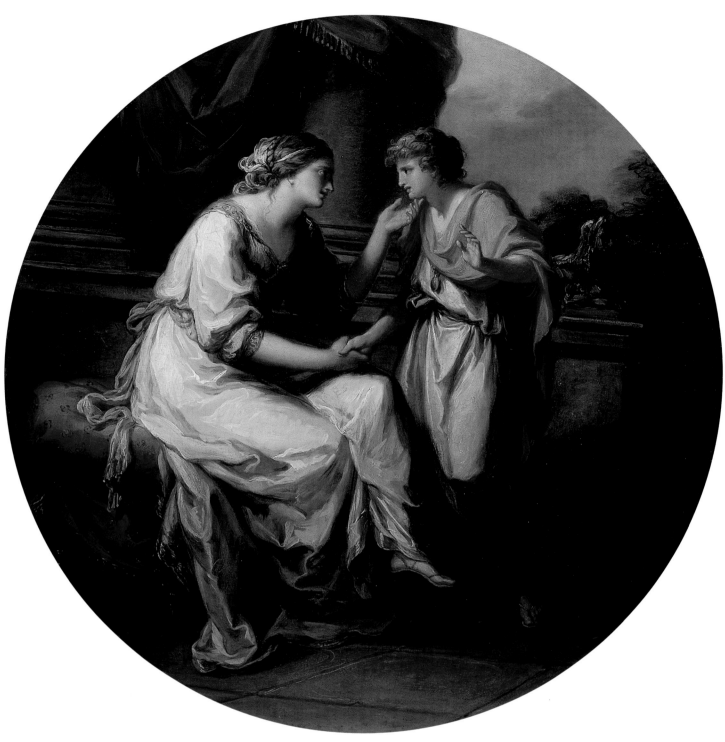

Above:
Angelica Kauffmann. *Papirus Praetextatus.* Oil on canvas. 24 ⅝ in. (62.5 cm) diameter (tondo). The Denver Art Museum, William M.B. Berger Collection.

Opposite, bottom:
Mary Beale. *Portrait of Anne Walpole.* Oil on canvas. 1670s. Private collection. Photograph: Bridgeman Art Library, London/ New York.

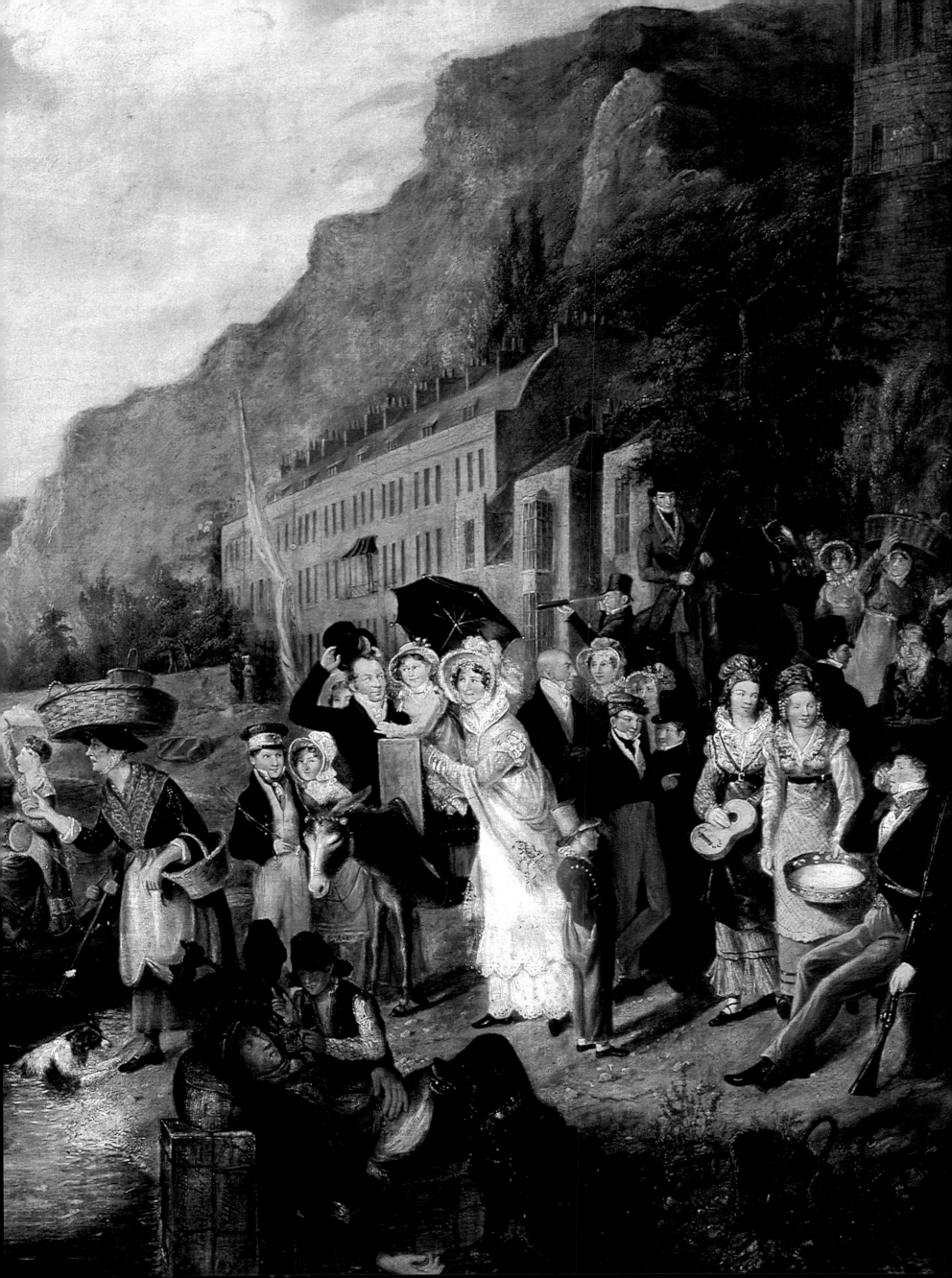

5
Slices of Life
Picturing Lives and Landscape

The last quarter of the eighteenth century and the first half of the nineteenth encompass the Golden Age of British landscape painting. Landscape in all its manifestations, from the strictly factual and topographic to the Arcadian and otherwise idealized, became a national obsession, its place in the academic hierarchy hotly debated. Though the old guard defended the primacy of history painting over all others, landscape was proving the vehicle for new ideas. A growing urban population romanticized rural life and a picturesque countryside. Landscape artists, especially women, were often hearty souls, braving inconstant weather, rough terrain, and dismay on the part of family members in their pursuit of subjects.

During the Victorian era the popularity of landscape was matched only by the interest in narrative scenes from daily life, many of which display explicitly didactic themes. These genre, or anecdotal schemes, popular for some two hundred years, focused on family and home. The Victorian age was one of science and invention; it codified eighteenth-century distinctions between the sexes. Enlightenment thinkers had "observed," for example, that Nature had made Woman morally superior to Man; she was the Angel of the Hearth, ruling by means of gentle example. Given this world view, it is not surprising that these motifs, particularly those centering on childhood, were open to female artists. Likewise, the transparent medium of watercolor with its soft hues was suitable to a lady's sensibility. The aristocratic disdain for "trade" militated against middle-class women making a living from their accomplishments, while the less explicit injunction against female visibility and passion may have discouraged talented girls from developing their gifts too prominently.

One gifted but little-known landscape artist was the Irish painter Susanna Drury (active 1733–1770), whose only surviving works are two remarkable views of The Giant's Causeway, (c. 1740), a famous basalt rock formation in County Antrim. Enlivened with charming figures exploring and taking in the view, as tourists still do, they have an appeal similar to that of the work of the London-based French painter and engraver Joseph Goupy, with whom Drury may have studied. Engravings of her views of The Giant's Causeway were published during her lifetime and again in the next century. Drury's contemporary, the formidable correspondent and amateur artist Mary Grandville Pendarves Delany despaired of ever doing anything "so exact and finished" herself.

Mrs. Delany (1700–1788) was a social arbiter, an inspired and inveterate letter writer, and, beginning at the age of eighty, the creator of astounding floral creations in cut paper, widely praised in her time and since. She studied with several masters, including the painter and engraver William Hogarth, and represents the generations of women who received enough training to produce charming, if rather naïve, landscape drawings, but remained amateurs. Nevertheless, she filled ten albums with her beautiful and botanically accurate cut-paper plant and flower illustrations, such as *Thistle* (1774–88), often based on designs she had first created in embroidery.

Matilda Lowry Heming (flourished 1804–1855) was a more skilled landscape artist. She was the daughter of engraver Wilson Lowry and the sister-in-law of the watercolorist and teacher John Varley, and her style is related to Varley's and to that of the other early members of the Society of Painters in Watercolor. She later developed a distinct style and seems to have had some professional standing, exhibiting over a forty–five-year period and receiving a gold medal from the Society of Arts in 1804. Her picturesque watercolor of a castle on the Welsh coast was formerly attributed to Varley; though it shows Heming working in his style, she was also capable of careful realism.

Louisa Stuart, Marchioness of Waterford (1818–1891), a daughter of Lord Stuart de Rothesay, was a great society beauty who pursued her art throughout her life. Married to the Marquess of Waterford, she was largely

self-taught, corresponding with the critic and teacher John Ruskin and seeking advice on color from the Pre-Raphaelites. Though she made charming landscape sketches on her continental sojourns, her real interest was figure-drawing. Perhaps her most ambitious work is a series of life-size watercolor murals (using local families as models) of biblical subjects, including *Abraham and Isaac*, which she painted for the schoolhouse for children of estate workers near her home at Ford Castle, Northumberland. She exhibited at the fashionable Dudley and Grosvenor galleries in London, where her work was praised for its rich, Venetian-style coloring.

Barbara Leigh Smith Bodichon (1827–1891) departed from Victorian convention both in temperament and in her circumstances. The daughter of a radical Unitarian and Member of Parliament, she was given a thorough liberal education. A passionate advocate for women's rights, especially in marital law, she was a founder of Girton College, Cambridge, the university's first women's college. In 1857 she married Dr. Eugene Bodichon, an anthropologist and physician, with whom she traveled extensively, including a long sojourn in the United States. Bodichon studied watercolor with William Henry Hunt, received encouragement from John Ruskin, became friendly with the Pre-Raphaelites, and knew the landscape artist David Cox—considered by some the greatest English watercolorist—learning much from his work. Later she was intrigued by the open-air paintings of the Barbizon School and studied for a time in Jean-Baptiste-Camille Corot's studio and with Charles-Francois Daubigny, who was also a friend. Despite, or because of such a variety of influences, she developed a unique style and exhibited widely from 1853. Her *Study of Sunflowers* (1875) is unusual in her body of work in that it is both an oil painting (watercolor was her preferred medium) and a vertical composition. What is typical, however, is the intensity, passion for detail, and strong open-air feeling found in this and much of her best work.

Sophie Anderson (1823–1898) was one of the best of the many painters of the scenes from modern life that were so beloved by the Victorians. Born in Paris to an English mother and a French father, she moved with her family to the United States, where she married the painter Walter Anderson. Having learned to paint from her husband, Anderson became proficient in portrait painting and established a reputation in Cincinnati and Pittsburgh before returning to England in 1854. Though the couple later lived in Italy, Anderson exhibited at the Royal Academy over a thirty-year period. Her best-known work, *No Walk Today* (1856), is one of the finest genre paintings of the Victorian era.

Her contemporary Emily Mary Osborn (1834–after 1913) was the daughter of a London clergyman. Her painting *Nameless and Friendless* (1857), which shows a young artist of uncertain means offering her work to a skeptical dealer in a large city art gallery, still resonates with today's viewers. It dramatizes the marginal role of women in the male-dominated art establishment, although Osborn herself was quite successful: she won prizes, her works were engraved, and Queen Victoria was one of her patrons. Osborn's portrait of Barbara Bodichon (1884) hangs at Girton College.

Edith Hayllar (1860–1948) and her sister Jessica (1858–1940) were two of the nine children of the artist James Hayllar, who was their sole teacher. Both sisters were inspired by the lively social life centered on the

family's large Berkshire home. In *Summer Shower* (1883), Edith insightfully captured life among the middle classes: uncertain weather has interrupted a tennis party, causing the players to retire indoors for lemonade and conversation. In Jessica's *A Coming Event* (1886), the artist incorporated still life, at which she excelled, within the broader context of a handsome Victorian interior and preparations for a forthcoming wedding. Two other Hayllar sisters, Mary (exhibited 1880–1885) and Kate (active 1883–1898) were also talented painters.

Elizabeth Thompson, Lady Butler (1846–1933) favored scenes of military life and patriotic battle tableaux. The Swiss-born painter was educated by her father, and brought up mostly in Italy. At sixteen, she entered the South Kensington Art Schools in London, and later studied in Florence and Rome. She achieved fame in 1874 when Queen Victoria purchased her entry at the Royal Academy, *The Roll Call*, a stark subject from the Crimean War. Such was the painting's success that one reviewer enthusiastically suggested that female artists could now expect to be considered on an equal footing with their male counterparts. Her portrayal of the suffering of the common soldier and the sobering price of military glory was outstanding in works that frequently brought the public face to face with the shock and despair of defeat in battle. In *Remnants of an Army, Jellalabad, January 13, 1842* (1879), her portrayal of a lone British survivor of a large army forced to retreat from Kabul recalled one of the worst humiliations of the First Afghan War. Her 1877 marriage to Major William Francis Butler brought her closer to her chosen subject matter. In all of her works, the horses are splendidly realized and the details of uniform and equipment exactly described.

Far removed from the wars and travails of the British Empire are the enchanting, world-famous watercolors of Kate Greenaway (1846–1901). Greenaway was born in London, the daughter of a wood engraver, and became one of the first students at the new Slade School of Art. Though she began exhibiting in 1868, she was best known as an illustrator: her rich and charming mix of childhood nostalgia and whimsy struck just the right chord with the public. In 1879, she wrote and illustrated her own children's book—the first of many—*Under the Window*, which sold 150,000 copies and brought her enormous fame. Many books followed, including illustrated versions of Mother Goose nursery rhymes, alphabets, yearly "almanacks," and children's favorites such as *The Pied Piper of Hamelin* (1888), with text by the poet Robert Browning. Greenaway's work inspired fashions in contemporary clothing as well as illustration, and she was widely imitated. Ten years later she was elected to the Royal Institute of Painters in Watercolors.

Helen Paterson Allingham (1848–1926), too, was hugely popular with her contemporaries. Her watercolors of English cottages provided a reassuring vision of country life, in stark contrast to the relentless industrialization of late-nineteenth-century England. Like her friend Kate Greenaway, whom she influenced, Allingham began her career as an illustrator, supporting herself while attending the Royal Academy Schools, which had only recently begun to accept women. In 1874 she married the Irish poet William Allingham and the couple settled in Surrey, where her watercolors of country cottages, many slated for destruction, gained wide recognition. Typical is *Cottage at Chiddingfold* (1890), in which, as elsewhere, Allingham's work is notable for its fresh colors and loving observation. She was elected a member of the Royal Society of Painters in Watercolor in 1890, and after her husband's death supported her family through her art. Her sister, Caroline Paterson, was also a talented artist.

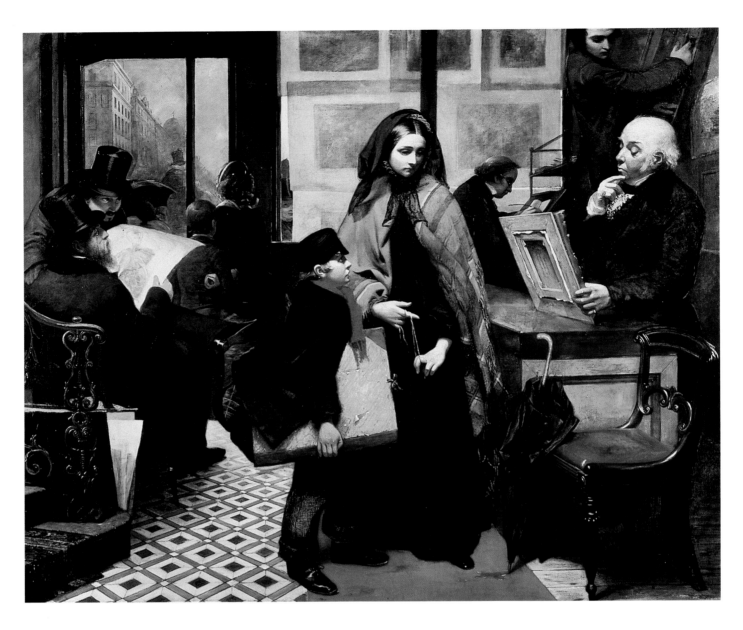

p. 62:
Sophie Anderson. *No Walk Today.*
1856. Oil on canvas. 19 ¾ x 15 ¾ in.
(50.1 x 40 cm). Private collection.
Photograph: Bridgeman Art
Library, London/New York.

p. 64:
Susanna Drury. *The East Prospect of
the Giant's Causeway.* c. 1739.
Gouache on vellum. 13 ½ x 27 in.
(34.3 x 68.6 cm). Ulster Museum,
Belfast. Photograph reproduced
with the kind permission of the
Trustees of the National
Museums & Galleries of
Northern Ireland. Photograph:
© Ulster Museum, Belfast.

p. 65:
Lady Elizabeth Butler.
*The Remnants of an Army, Jellalabad,
January 13, 1842.* 1879. Oil on
canvas. 52 x 92 in. (132.1 x
233.7 cm). Tate Gallery, London.
Photograph: Tate Gallery/Art
Resource, N.Y.

Above:
Emily Mary Osborn. *Nameless and
Friendless.* 1857. Oil on canvas.
34 x 44 in. (86.3 x 111.7 cm).
Private collection. Photograph:
Bridgeman Art Library,
London/New York.

Opposite:
Jessica Hayllar. *A Coming Event.*
1886. Oil on canvas. 22 ½ x
18 ½ in. (57.1 x 47 cm). The
Forbes Magazine Collection,
New York. © All Rights
Reserved. Photograph: Bridgeman
Art Library, London/New York.

Overleaf:
Matilda Heming. *A Welsh Castle.*
n.d. Watercolor on paper. 6 ⅛ x
9 ⅛ in. (22.3 x 28.2 cm).
Photograph: Courtesy Agnews,
London.

Carduus eriophorus
Cotton-headed Thistle.

Above:
Mary Delany. *Thistle (Carduus ercophorus, cotton-headed thistle).* 1774–88. Mixed media. 131 ½ x 89 ¾ in. (334 x 228 cm). British Museum, London. Photograph: Bridgeman Art Library, London/New York.

Opposite:
Barbara Leigh Smith Bodichon. *Study of Sunflowers.* 1875. Oil on canvas. 32 ¼ x 15 ¾ in. (82 x 40 cm). The Mistress and Fellows, Girton College, Cambridge. Photograph: Nevelle Taylor, University Photographer.

Edith Hayllar. *Summer Shower.* 1883.
Oil on canvas. 20 x 16 ¾ in. (50.8
x 42.5 cm). The Forbes Magazine
Collection, New York. © All
Rights Reserved. Photograph:
Bridgeman Art Library,
London/New York.

Above:
Kate Greenaway. *Afternoon Tea.*
1886. Watercolor. Private
collection. Photograph: Image
Select/Art Resource, N.Y.

Below:
Helen Allingham. *Cottage at
Chiddingfold.* 1890. 15 ½ x 13 in.
(39.3 x 33 cm). Watercolor on
paper. Victoria & Albert Museum,
London. Photograph: Bridgeman
Art Library, London/New York.

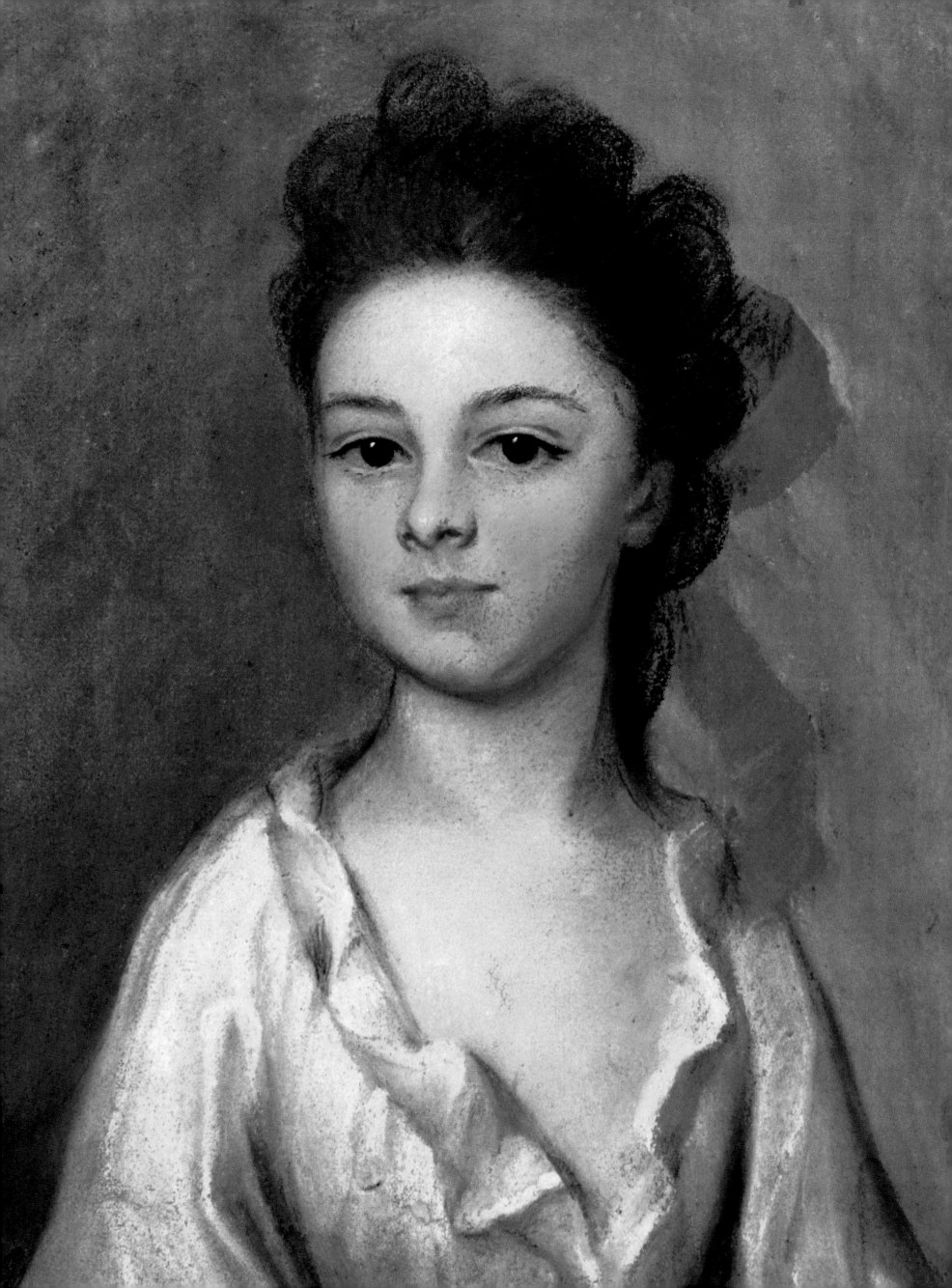

6

American Pioneers
Expressing a New Spirit

In Colonial America the demand for art was initially small, and so was the number of artists. As the colonists prospered and built homes in the style of those of their mother country, a concomitant desire for home decoration emerged—many even ordered landscapes by the yard from fashionable London decorators to place over their mantels. Because the colonists wanted to demonstrate their prosperity to family members left behind—and grandparents needed to be introduced to their American children's offspring—a demand for portraiture arose. Learning their craft from English copybooks, traveling "limners" visited homes in large and small towns and in the countryside, often staying at a client's residence for several days at a time while they captured the likenesses of the extended family. They were joined by second- and third-rate portraitists from the old country who found a lucrative market denied them at home. These recent immigrants often brought paintings with them to copy and to use in teaching students.

Few of those arriving in the New World were members of the leisure classes, and women worked side by side with the men to make a life for their families. Separated from their families overseas, widows and other single women often were obliged to be entirely self-supporting. Few women had time to practice the ladylike arts.

Henrietta de Beaulieu Dering Johnston (1674–1729), trained in England or Ireland, was one of the first professional artists in America. With her second husband, Gideon Johnston, a Church of England missionary, she sailed from Ireland to the new settlement of Charles Town (today Charleston, South Carolina) in 1708. From the moment they arrived and discovered that her husband's pulpit had been usurped, they encountered political, health, and financial problems. To make ends meet, Johnston resumed her practice of pastel portraiture, most likely as payment or thanks for goods and services for the family. She was a contemporary of the celebrated Rosalba Carriera; the two are among the very few portraitists to work in pastels.

Several portraits predating her American work have been discovered in Ireland in this century; they are richer in tone than her later work, suggesting that she adopted a softer style in the New World, probably to conserve her precious crayons. The charming portrait of eleven-year-old Henriette Charlotte de Chastaigner (1711) bears all the features of Johnston's American style: it is bust-length, and the sitter, in a slightly angled frontal pose, has large eyes, while her simple gown is open at the neck with a ruffle. American children often wore red around their necks for good health, either a scarlet ribbon, which here adds a cheerful touch, or a piece or necklace of coral. Compared with others of Johnston's Charles Town pictures, this portrait exhibits more modeling in the face and definition in the hair.

The road was easier for Ellen Wallace Sharples, when in 1794 she began the first of two extended stays in America. Her husband, James, who had been her teacher, found a ready market for his small pastel portraits: in Philadelphia and New York, George Washington, James Madison, and dozens of other important figures sat to James's brush. Ellen and several of their older children, also artists, working in a Sharples family style, fulfilled orders for numerous copies and accepted other commissions as well. In addition, Ellen translated several portraits, including one of George Washington, into silk embroidery. Ellen's journal reveals her surprise at the warm reception that greeted her work and at the number of her subsequent commissions. After James's death in 1811, Ellen returned to England with her daughter Rolinda, who had great success there as an artist.

These professionally trained artists were the exception. More often, hardships and crude dwellings notwithstanding, mothers, daughters, and wives exercised their domestic instincts to embellish the family home. Decorations might take the form of stitchery pictures or of more practical items: colorful samplers taught schoolgirls different stitches as well as the alphabet and numbers, morals and maxims. Girls and

p. 74:
Henrietta Johnston. *Henriette Charlotte de Chastaigner.* 1711. Pastel on paper. 11 ⅝ x 8 ⅞ in. (29.5 x 22.5 cm). (38.20.04) Gibbes Museum of Art/Carolina Art Association.

Left:
Harriet Powers. *Bible Quilt.* 1895–98. Pieced, appliquéd, and printed cotton embroidered with plain and metallic yarn. 69 x 105 in. (175 x 267 cm). Museum of Fine Arts, Boston. Bequest of Maxim Karolik.

housewives added personal touches to store-bought stencils and other patterns, thereby devising pictures and designs to paint. Known as "theorem paintings," these took less time than needlework and made decorative accents. Most of the creators of these engaging domestic artworks remain anonymous.

Quilts were another medium for self-expression as well as ornamentation. They were made with new silks by the wealthy and from worn-out clothing scraps by the Westward-moving pioneers and plantation slaves, while quilting "bees" provided opportunities for women to socialize. Working together in small and large groups, they produced intricately stitched quilts based on established geometric, floral, and symbolic patterns, to celebrate a birth, marriage, housewarming, or other event. Story quilts allowed for more personal subjects drawn from family histories and memorable events, or like those of former slave Harriet Powers (1837–1911), the Bible. In her *Bible Quilt* of 1895, Powers interspersed interpretations of Old and New Testament stories with narratives handed down in the oral tradition. By her own explanation, several squares of the quilt illustrate the creation of every kind of animal, two by two, others the Creation of Adam and Eve, Moses lifting up the serpent, and the crucifixion, and still others what Powers describes as "The dark day of May 19, 1790," "The falling of the stars on Nov. 13, 1833," and "The red light night of 1846." Appliquéd cut-outs eloquently render the simple, direct subjects of each story square.

A Connecticut resident, Eunice Pinney (1770–1849), based many of her paintings on engraved illustrations; her balanced compositions and strong patterning compensate for the flatness of her figures. Among her watercolors are memorials made to honor departed loved ones, paintings of daily life that show fashionably dressed friends or young families enjoying the niceties of middle-class life, and depictions of popular literary subjects. In *Lolotte and Werther* (1810), for example, Pinney portrayed the unfortunate couple in Johann Wolfgang von Goethe's bestselling Romantic tale of unrequited love.

Little is known of Massachusetts artist Susan Merritt (act. mid 1800s), but her busy *Fourth of July Picnic at Weymouth Landing, Massachusetts* (c. 1845) provides a vivid account of this midsummer celebration. For her mural-like composition, using paint and paper cut-outs, in this, her only known picture, she captured the spirit of the games, costumes, and general festivities.

Deborah Goldsmith (1808–1836) was among the few female limners. Self-taught, she traveled throughout rural New York State, painting portraits to support herself and her aging parents, until one of her clients, George Throop, proposed marriage. Shortly after their second child was born, Deborah died, at age twenty-seven. Her three-generation portrait of the Talcott family (1832) typifies the naïve style of many itinerant artists of the period. Posed like cutouts, the family members are set against the contrasting patterns of a striped floor and a delicate floral wallpaper. She signed her work "D. Goldsmith," and were it not for the research of a curious granddaughter, her name would have been lost to history.

Although there was no titled aristocracy in the young Republic, factors such as wealth, race, country of origin, and geography largely determined one's position in society. Increasingly, prosperous families in New England and in large Southeastern and Midwestern cities enrolled their daughters in schools for young ladies, many of them founded by widows and spinsters. Families in the more rural South frequently engaged tutors, and in a very few cases slaves attended their young mistresses' lessons, learning to read, write, and assist in

needlework. For the most part, education at every level was intended to prepare women for their domestic roles, although some groups, such as the Quakers and Unitarians, fostered more progressive ideas, promoting formal education for girls as part of a program of social reform. Commerce and the country expanded Westward; towns and cities grew and flourished. The emerging middle class cultivated increasingly separate realms: success in business and politics for men, and culture and refinement through domesticity for women.

The first art academies founded in the early nineteenth century in New York and Philadelphia emulated their conservative European counterparts. A number of female artists were included in academy exhibitions, but women were not permitted to attend classes until the 1840s, and live classes would not be open to women until the late 1870s.

Sarah Goodridge (1788–1853) was all but self-taught in the art of portrait miniatures when she opened a studio in Boston. Thanks to advice and critiques from Gilbert Stuart, best known today for his portraits of George Washington, she was able to strengthen her technique and her career flourished. Goodridge's likeness of Stuart, a truthful one that the artist himself approved for reproduction, opened the door to a number of important commissions. Ironically, Stuart gave his own daughter, Jane (1812–1888), little encouragement to develop as an artist in her own right. Jane Stuart preferred literary subjects, but after her father's death, she helped support the family by painting portraits and copies of his most famous works.

The Peale sisters, members of a renowned family of artists, recorded likenesses of the affluent and eminent in Philadelphia, Baltimore, and St. Louis. Anna Claypoole (1791–1878), Margaretta Angelica (1795–1882), and Sarah Miriam (1800–85) were fortunate to receive encouragement and, more important, lessons from their father, James, a miniaturist, and their more colorful uncle, Charles Willson Peale, a painter and inventor who opened his own museum. (It was Uncle Charles who, hoping that they would become artists, named his sons Titian, Raphaelle, Rembrandt, and Rubens, and his daughters Sophonisba Anguisciola, Angelica Kauffmann, Rosalba Carriera, and Sybilla Miriam.)

Anna Peale assisted her father, but her own miniatures on ivory, distinguished by their subtle modeling and intricate brushwork, were also in demand after her work was shown at the Pennsylvania Academy of the Fine Arts. These tiny, flattering likenesses of Madame Lallemand (1810) and the society matrons and visiting dignitaries who visited her studio served as photographic keepsakes. Widowed twice, each time Anna resumed her profession, developing a style in her maturity that continued her success. Margaretta Peale, who never married, was a gifted still-life painter who also exhibited at the Academy. In a Peale family style, her still lifes are rather modest displays: typically, as in *Still-Life with Watermelon and Cherries* (1828), she presented a few pieces of just-picked fruit, with the leaves still on, on a simple plate in a spare setting.

Sarah Peale devoted her life to her painting, beginning as an assistant to her father; she supported herself with her art for more than sixty years. She first exhibited at the Pennsylvania Academy in 1817, and, in 1824, she and Anna were elected to its membership—a rare honor for women. Sarah worked in Baltimore for many years, including, for a time, in studios in the family museum, with occasional excursions to Washington, D.C. She produced large-scale oil portraits and family groups as well as still lifes; among her commissions were Major General Lafayette, Daniel Webster, Thomas Hart Benton, Virginia Congressman Henry A. Wise, and other prominent personages. In the 1840s, in poor health, Sarah Peale relocated to St. Louis, where she worked steadily for thirty years before rejoining her sisters in Philadelphia.

Unlike the academies, which served primarily as exhibition and teaching institutions, the short-lived American Art-Union (1839–52) had a broader mission. The Union, based in New York City with a branch in Cincinnati, responded to empty walls across America by attempting to cultivate the taste of the newly rich and middle class for pictures based on American themes. Engravings based on popular paintings by member artists, as well as the paintings themselves, gained wide distribution. The Union sold memberships and subscriptions for copies that were suitable for framing.

Lilly Martin Spencer (1822–1902) was one of the artists whose work was featured at the first Western Art-Union exhibition in 1847 in Cincinnati. A hard-working artist all of her life, she turned down an opportunity to study abroad and continued painting despite the birth of thirteen children, seven of whom survived. In a reversal of traditional roles, Spencer's husband assisted her in the studio and shared the housework at home. Her lively scenes of domestic life, laced with humor and sentimentality, struck just the right chord with the art-buying middle class. Although Spencer's work was immensely popular and perfectly suited for the mass market, her earnings were never adequate to support her large family. Remuneration for copies was low, and the Civil War and consequent inflation depressed sales, but the principal reason for Spencer's declining

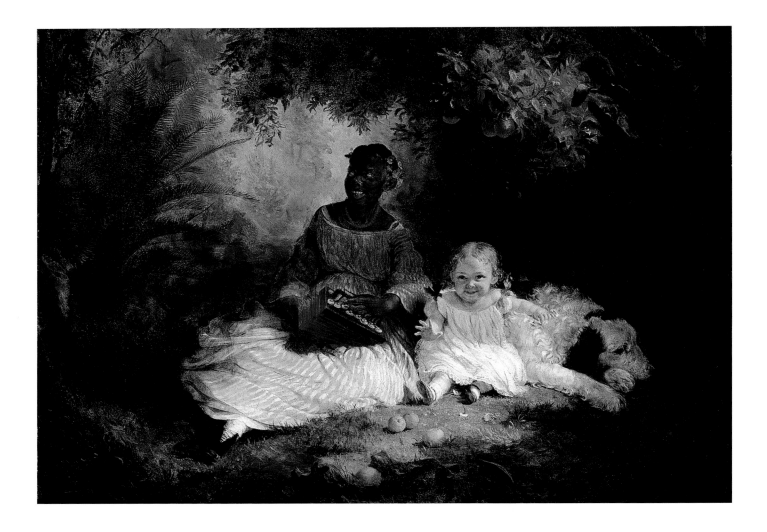

fortunes was the competition from the imported French Salon pictures then in fashion. Still, she continued painting until the day she died.

Dixie Land (1862), depicting a brightly smiling child in the care of her African-American nursemaid and devoted watchdog, is an unusual subject for Spencer, who generally did not voice explicit political views and knew little about the South. (Spencer's mother, an active feminist, chided her daughter for not supporting that cause.) The painting may hint at war issues, but Spencer's focus is clearly on the child-pet relationship, not political commentary.

The American elite, like their British counterparts, viewed travel to Europe as indispensable to their cultural formation. Aristocratic painters, such as Mary Cassatt later in the century, went to Paris to work with modern masters, while Italy, especially Rome, provided treasures for those wishing to study works of antiquity. Sculptors in particular found also a number of trained studio workers as well as the resources of the quarries of famed white Carrara marble. It was not uncommon for sculptors, having completed their models at home in Europe or America, to travel to Italy to finalize their work in marble or bronze.

In the mid-nineteenth century, Harriet Hosmer (1830–1908) was one of those who led the way for a number of "emancipated" female sculptors to journey from America to Rome. Disparaging these young women who defied conventional behavior, writer Henry James called them a "white, marmorean flock." His unsubtle reference to sexual coldness may have been a reaction to the single status many of these artists chose, agreeing with Hosmer, who wrote of the detrimental effect of marriage on women engaged in the practice of art and considered her works her "children."

Not surprisingly, women in the United States wishing to work in three dimensions found it at least as difficult as their painter sisters to obtain art instruction. For Hosmer and Edmonia Lewis, among others, a formula of willfulness, wealthy patrons, and arduous labor brought success. Although nominally in competition with one another for precious commissions, many sculptors were generous in sharing knowledge and encouraging the efforts of younger women bent on pursuing this rigorous art.

The Massachusetts-born Harriet Goodhue Hosmer became legendary—and notorious—in Rome for riding through the streets on horseback. The doctor father of a school friend arranged for Hosmer to take anatomy classes (not open to women) at the medical school in St. Louis, and provided her first commissions. Just twenty-two when she arrived in Rome as a guest of the American expatriate actress Charlotte Cushing, Hosmer flourished under the tutelage of the British sculptor John Gibson, whose connections also served her

well. Within a few years she was netting praise—and commissions—from European royalty as well as from home. From accounts of friends such as the poets Elizabeth Barrett and Robert Browning, Hosmer seems to have been as charming as she was gifted.

Working tirelessly, Hosmer supported larger works by producing "fancy" pieces, such as an elfin *Puck* (1856) that sold dozens of copies at $1,000 each. Her *Beatrice Cenci* (1856) the portrayal of a woman about to die for the murder of her cruel father, was a great success at the British Royal Academy as well as in St. Louis. Showing a gently sleeping Cenci on her hard prison bed, the prison foreshadows the tomb that soon will enclose her. This and others of Hosmer's major works, such as the captive queen *Zenobia* (1859), who wears her chains as if they were her finest jewels, represent strong female figures. In the style of classic Greek sculpture, these exquisitely draped, elegant figures in white marble astonished European and American audiences whose preconceptions made it difficult for them to believe that the maker was a woman.

A number of successful female artists supported abolition, but no other artist was as close to the cause as Edmonia Lewis (1845–after 1911), the daughter of a black freedman and a Chippewa. Lewis's older brother, educated and successful, saw to her schooling. After Oberlin College, Lewis headed to Boston, where sales of her medal of Robert Gould Shaw, the young colonel who died leading the heroic black fifty-fourth Massachusetts Regiment in the Civil War, financed Lewis's emigration to Rome. Like Harriet Hosmer, she, too, studied with Gibson in that city. Among her best-known works are *An Old Arrowmaker* (1872), scenes from *Hiawatha*, the hugely popular poem by Henry Wadsworth Longfellow, and *Forever Free* (1867), done to commemorate passage of the Thirteenth Amendment, prohibiting slavery. The recently recovered *The Death of Cleopatra* (1876) departs from the artist's usual style, adopting the Egyptian convention of front-facing figure with a head in profile.

Malvina Hoffman (1885–1966) began studying painting and sculpture in her native New York City, postponing marriage for Paris. Working in Rodin's studio heightened her sensitivity to the effects made possible through textures in the carved surface. The range of Hoffman's work is broad, from a series of small dance compositions inspired by the great Russian ballerina Anna Pavlova, to heroic war memorials, and private commissions. A group of African heads brought Hoffman the commission and recognition that made her famous. She was hired in 1929 by the Marshall Field Museum in Chicago to sculpt "the living races of man." With the goal of portraying the dignity of each racial type, she and her husband Samuel Grimson traveled the globe in search of models. Hoffman oversaw every detail of production of the more than one hundred heads that complete this series, from anthropological correctness to final castings. After the triumphant 1933 Chicago debut of the works, copies were sold and Hoffman wrote and lectured on her experiences.

The daughter of a Boston zoologist, Anna Hyatt Huntington (1876–1973) made animals her subject, and quite a popular one. Her brief periods of formal study were complemented by afternoons of modeling at the zoo; once established and working in New York, in 1907 she traveled to Paris to view the works of Antione-Louis Barye and other great animaliers. Huntington received steady commissions for her graceful and expressive animals and birds, but she had another goal: to create an equestrian statue of Joan of Arc. In the face of voiced doubts that a woman could have achieved such a feat, the armored saint—sword raised—astride a magnificent mount was praised at the 1910 Paris Salon and subsequently commissioned by the city of New York, cementing her reputation. The philanthropist and scholar Archer Huntington approached her to do a sculptural program for New York's Hispanic Society of America, which he had founded. There, along with birds and beasts, is her poignant equestrian statue *Don Quixote*, so dissimilar in spirit and intent from the bold Joan. Neither her marriage to Huntington, with its social obligations, nor a bout with tuberculosis halted her work. The couple's estate in South Carolina, Brookgreen Gardens, which they filled with sculptures, is now a state park.

Although Anna Huntington and others worked well into the twentieth century, these women—many of whom had strong ties to the Boston or New York social elite—kept alive nineteenth-century sculptural traditions. Abastenia St. Leger Eberle (1878–1942), who briefly shared a studio with Huntington, struggled in a different direction. Instead of large public works, the Iowa-born Eberle was drawn to social reform and subjects depicting everyday moments. Along with other rebellious artists, a group known as the Ashcan school, Eberle abandoned traditional grand, literary, and sentimental themes for somber slices of life. Eberle's small bronzes, whether of children dancing or women wielding bucket or broom, often display sweeping curves and a dynamic tension. Cast from clay studies, they have the immediacy of sketches from life.

The 1913 Armory Show marked the unofficial introduction of Modernism in the United States, but that radical panoply of styles would be slow to make its way into the mainstream of American art. Nevertheless, these generations of Victorian rebels left enduring monuments, a legacy of principles, vision, and valor.

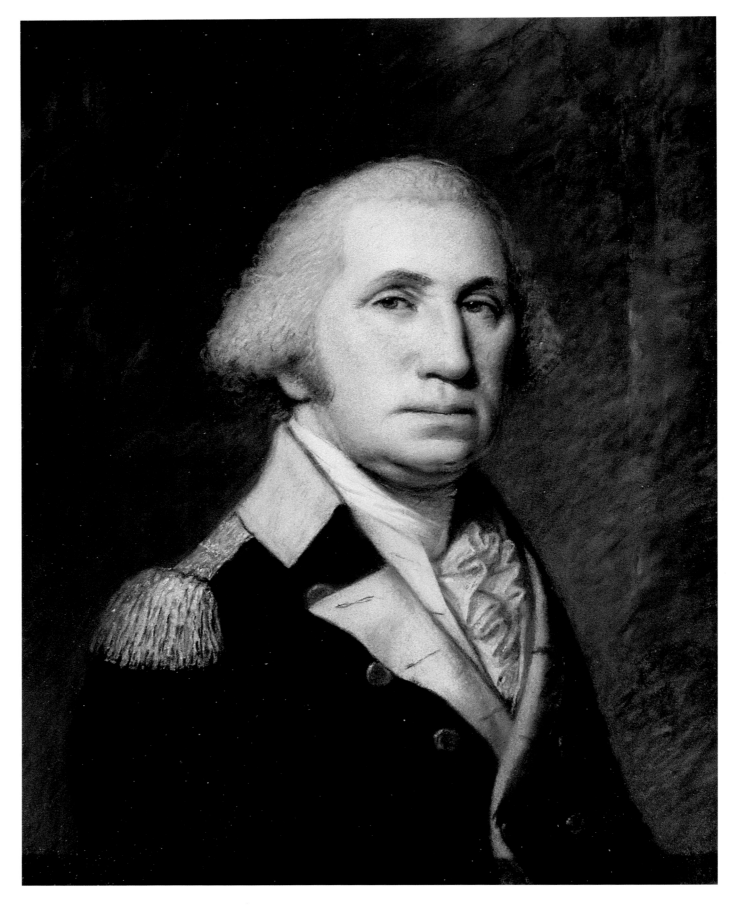

p. 78:
Lilly Martin Spencer. *Dixie Land.*
1862. Oil on canvas. 20 x 24 in.
(50.8 x 60.9 cm). Courtesy of
Robert M. Hicklin Jr., Inc.
Spartanburg, South Carolina.

Above:
Ellen Wallace Sharples. *General
Washington.* 1796. Pastel on paper.
9 x 7 in. (22.8 x 17.7 cm). City of
Bristol Museum and Art Gallery.
Photograph: Bridgeman Art
Library, London/New York.

Opposite:
Ellen Wallace Sharples. *The Artist
and Her Daughter.* Oil on panel.
14 ½ x 11 ½ in. (36.8 x 29.2 cm).
City of Bristol Museum and Art
Gallery. Photograph: Bridgeman
Art Library, London/New York.

Ellen Wallace Sharples

From Katharine McCook Knox, *The Sharples: Their Portraits of George Washington and His Contemporaries*

[Philadelphia, United States] *1796.*

I had frequently thought that every well educated female, particularly those who had only small fortunes, would at least have the power, (even if they did not exercise it) by the cultivation of some available talent, of obtaining the conveniences and some of the elegances of life and be enabled always to preserve that respectable position in society to which they had been accustomed. Many circumstances had led to the formation of this opinion, not only the French Revolution, which occasioned the entire loss of fortune to the great number of ladies and gentlemen who sought refuge in this and other countries. The reverse of fortune had been frequently observed in married and single ladies, a few the loss of their whole income, others of a part, obliging them to observe the strictest economy. In mercantile and various other concerns, men of abilities once affluent had become poor, others by thoughtlessness and extravagance. . . . The continual fluctuation of the funds and other property in which our money had been invested, the uncertainty in mechanical pursuits in which Mr. Sharples delighted—all had an influence in deciding me, soon after our arrival in Philadelphia where Congress then assembled, to make my drawing which had been learnt and practiced as an ornamental art for amusement, available to a useful purpose. Mr. Sharples was generally engaged in drawing in crayons the portraits of the most distinguished Americans, foreign ministers and other distinguished visitants from Europe. Copies were frequently required; these I undertook and was so far successful as to have as many commissions as I could execute; they were thought equal to the originals, price the same; we lived in good style associating in the first society.

June 29, 1803.
Commenced a miniature of Mr. Sharples. Should I excel in this style of drawing it will be a great satisfaction to me. I shall then consider myself independent of the smiles or frowns of fortune, so far as the fluctuating and precarious nature of property is concerned.

December 1804.
During the year 1804 copied in miniature Mr. Adams, President of the United States, Mr. Jefferson, President, General Hamilton, Commander in Chief of the Forces of the U.S., Chancellor Livingston, Mr. B. Livingston, Mr. Galletin, Dr. Priestly, 2nd of General Washington, executed in a very superior style to the one done of him last year, as are all the latest pictures. The manifest improvement as I persevere is very pleasing to me.

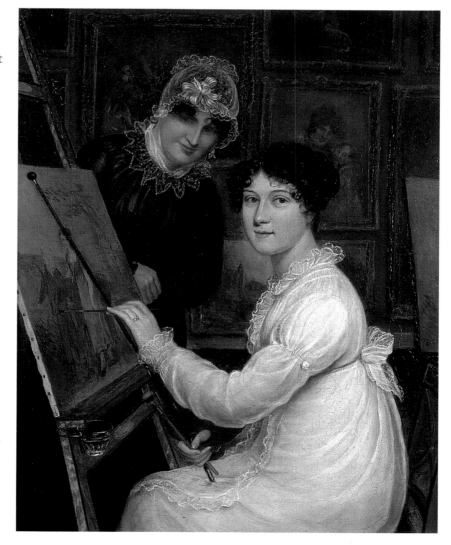

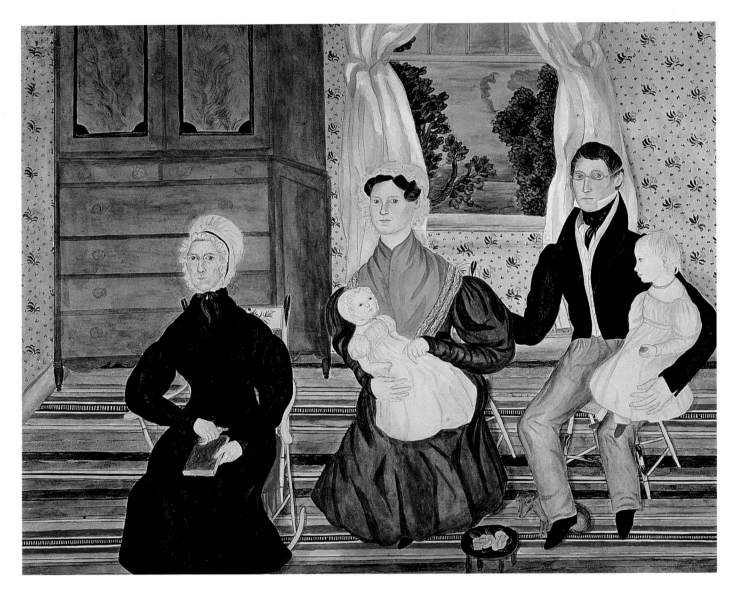

pp. 82-83:
Susan Merritt. *Fourth of July Picnic at Weymouth Landing, Massachusetts.* c. 1845. Watercolor, gouache, and collage on paper. 29 ½ x 39 ⅜ in. (74.9 x 100 cm). The Art Institute of Chicago. Gift of Elizabeth R. Vaughan. (1950.1846). Photograph © 1999 The Art Institute of Chicago. All Rights Reserved.

Above:
Deborah Goldsmith. *The Talcott Family.* 1832. Watercolor on paper. 18 x 21 ⁷⁄₁₆ in. (45.7 x 54.4 cm). The Abby Aldrich Rockefeller Folk Art Center, Williamsburg, Virginia.

Opposite:
Eunice Pinney. *Lolotte and Werther.* 1810. Watercolor on paper. 14 ⅞ x 11 ½ in. (37.7 x 29.2 cm). Gift of Edgar William and Bernice Chrysler Garbisch. © 1999 Board of Trustees, National Gallery of Art. Washington, D.C.

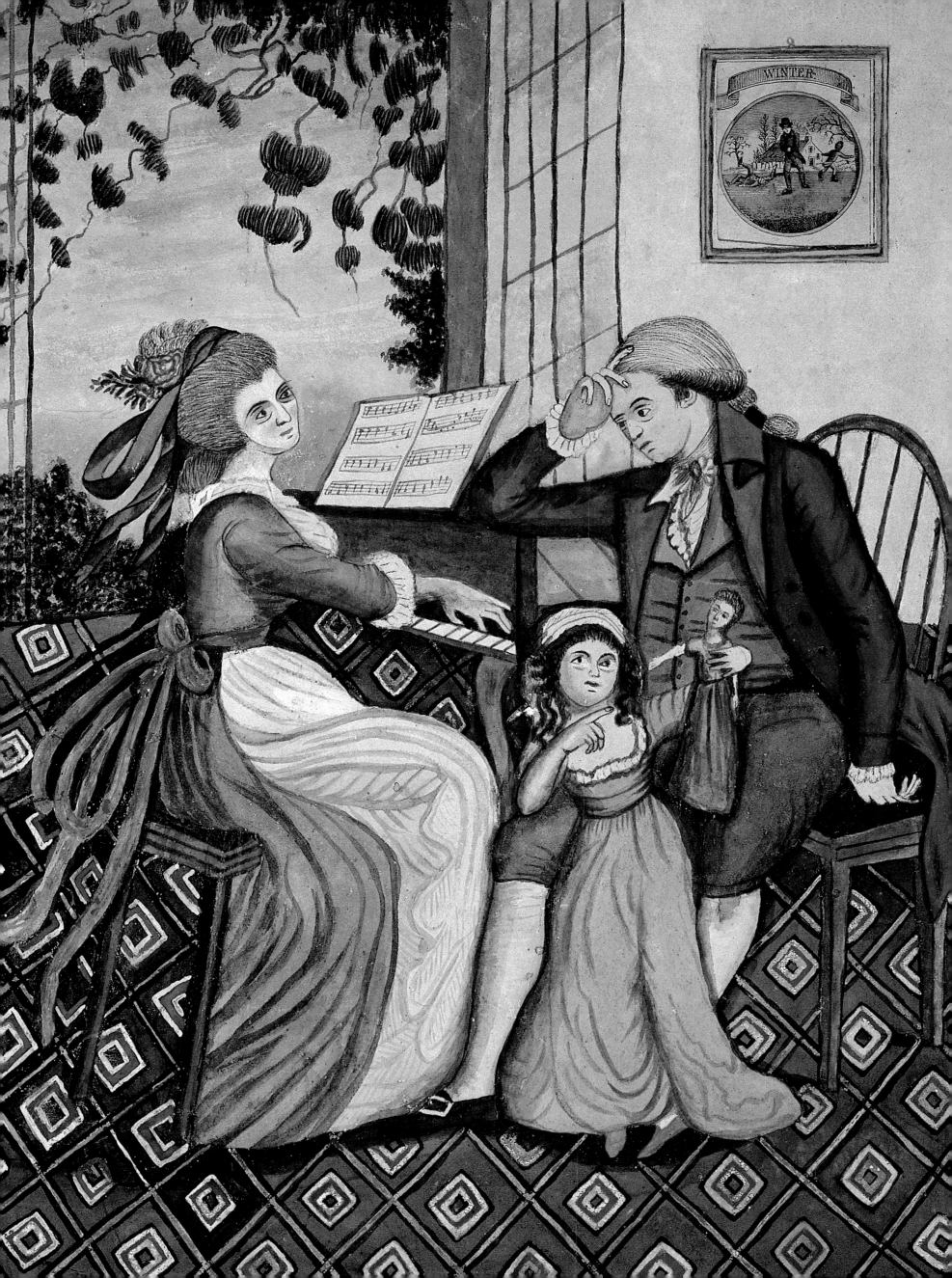

Above:
Anna Claypoole Peale. *Madame Lallemand.* c. 1810. Watercolor on ivory. 1 ⅞ x 1 ½ in. (4.7 x 3.8 cm). (1898.10) Courtesy of the Pennsylvania Academy of the Fine Arts, Philadelphia. Gift of Charles Hare Hutchinson.

Opposite:
Sarah Miriam Peale. *Thomas Hart Benton.* c. 1842. Oil on canvas. 30 x 25 in. (76.2 x 63.5 cm). Missouri Historical Society, Saint Louis.

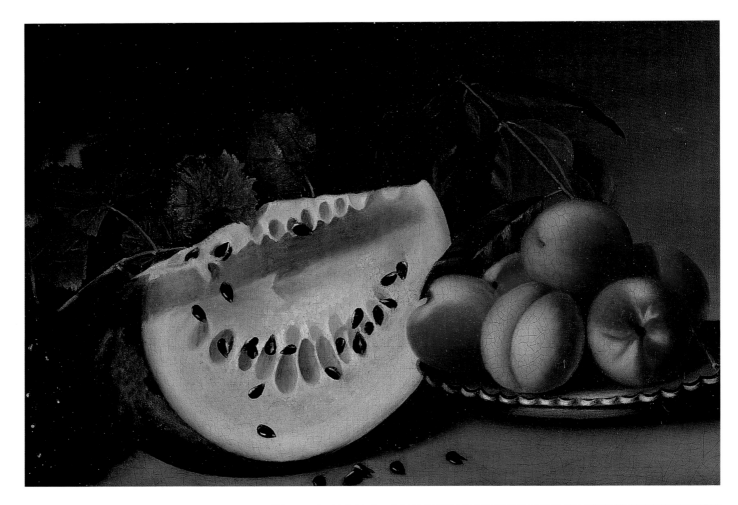

Above:
Margaretta Angelica Peale. *Still Life with Watermelon and Peaches*. 1828. Oil on canvas. 13 x 19 ⅛ in. (33 x 48.6 cm). Smith College Museum of Art, Northampton, Massachusetts. Purchased with funds given anonymously by a member of the class of 1952.

Right:
Malvina Hoffman. *Bengali Woman*. 1933. Bronze. Height: 13 ½ in. (34.3 cm). Field Museum of Natural History, Chicago. (#MH39T)

Opposite:
Malvina Hoffman with Kamalia Chatterji, the model for *Bengali Woman*. Photograph: Field Museum of Natural History, Chicago. (#A86015)

Malvina Hoffman

From *Sculpture, Inside and Out:* "Can Sculpture Be Taught?"

Sculpture cannot be taught by books or the spoken word; it must be experienced by the artist. Art is a command. The hands must be trained by practice, the mind by constant acquisition of knowledge, and the heart by its undefeated faith and desire to overcome all obstacles. For sculpture is a thorny road beset by barriers, defeats, and disappointments.

Art is, however, made of the stuff that dreams are made of, and they say the dreamer is a favorite of the gods. To him they whisper their secrets, to him the moon reveals her innermost beauty, and the night will enfold him to her heart and guard him with her strong dark wings.

The poet and the artist must be ready to harness Pegasus to pull a heavy load. Labor and fatigue are the inevitable price of accomplishment, for no great creation is easily conceived or expressed. Art has been called the Holy Land where the initiates seek to reveal the spirituality of matter.

For grownups as well as for children the intelligent study of art can be of great benefit. Psychologists and physicians agree that manual labor helps to readjust the mind to a balanced rhythm. The training of the hands to respond deftly to the mind is a distinct and joyful experience. When the skill of an artist becomes that of an expert, the creator may sense a sort of ecstasy in the actual accomplishment of a difficult task.

Even though we generally fall far short of our aim, we still are impelled by this ever-flowing stream of hope and desire to try again to surpass ourselves. Failures are many and often devastating to our morale, but one or two bull's-eye successes will carry us over months of hard labor. No composer would attempt to write a musical composition until he had studied the theory and technique of his art, harmony, counterpoint, and orchestrations. No sculptor can hope to create a work of art without the equipment of a thorough knowledge of his craft.

A real artist cannot be encouraged or discouraged. He will overcome all obstacles to gain his objective. He will be his own severest critic and come up from any beating with renewed faith and determination. He will not wait for inspiration: he will search passionately and work ceaselessly, finding his inspiration reborn in every problem that he tackles. . . .

A student often feels that after a certain period of study he will suddenly become an artist, whereas if he is really an artist both at heart and in his spirit, he knows that he will never reach his ideal and that he will remain a humble student to the end of his days. The mirage of beauty leads him forward along lonely and exhausting roads, and at the end of each journey he knows that the mirage is no nearer, only the light has broken through more vividly and his faith is stronger than ever, that the struggle is worth while, and that no passionate effort is ever wasted.

The artist records the spiritual history of his time. His work lives on to tell the future generations the inner workings of man's conscious and subconscious mind; be it realistic or abstract, nonobjective or cubistic, it is still a record of evolution or revolution, a soaring of wings or a slipping downward, and this responsibility must be accepted and revered.

Opposite:
Edmonia Lewis. *Death of Cleopatra.*
1876. Marble. 63 x 31 ¼ x 46 in.
(160 x 79.3 x 116.8 cm). National
Museum of American Art,
Washington, D.C. Photograph:
National Museum of American
Art, Washington, D.C./Art
Resource, N.Y.

Right:
Harriet Goodhue Hosmer. *Zenobia
in Chains.* 1859. Marble. Height: 49
in. (124.4 cm). Wadsworth
Atheneum, Hartford.
Gift of Mrs. Josephine M.J. Dodge.

HE WORE THE CLOAK OF GRANDEUR · IT WAS BRIGHT
WITH STOLEN PROMISES AND COLOURS THIN.
BUT NOW AND THEN THE WIND — THE WIND OF NIGHT—
RAISED IT AND SHOWED THE BROKEN THING WITHIN.

Opposite:
Abastenia St. Leger Eberle. *Girls
Dancing.* 1907. Bronze. 13 x 16 ½ in.
(33 x 41.9 cm). Collection of the
Corcoran Gallery of Art,
Washington, D.C. Bequest of
the artist. (68.28.4)

Above:
Anna Hyatt Huntington. *Boabdil.*
Limestone. 270 ½ x 301 ½ in.
(687 x 765.8 cm). Courtesy of the
Hispanic Society of America,
New York.

7
Past Perfect
The Pre-Raphaelite Aesthetic

In the mid-nineteenth century, when industrialization was transforming British society, the Pre-Raphaelite Brotherhood sought inspiration in what they perceived as the straightforward naturalness of Gothic and Early Renaissance painting and sculpture. True art, they believed, had been corrupted by facile artists who unwittingly created pictorial "formulas,"—they named the sixteenth-century painter Raphael as an early symbol of art's "corruption."

The Pre-Raphaelites drew their subjects from a wide range of traditional sources—history and mythology, poetry and literature, medieval legends, and Bible stories. Using the clear, bright colors of early Italian and Flemish art, these artists often incorporated romantic outdoor settings, heavy doses of symbolism, and female figures that were sometimes sensuous, sometimes virginal, but always beautiful.

Most of the striking faces featured in their paintings belonged to working-class women the artists "discovered" and then groomed to be models, mistresses, sometimes wives, and occasionally painters. Other models and muses were relatives and friends of the artists, some of whom also painted. These well-educated, trained artists made up a smaller, significant, but little-known Pre-Raphaelite "sisterhood." The women frequently chose as their subject matter heroic women, or else subtly commented on social issues, often sympathetically depicting "fallen" or forsaken women.

Elizabeth Siddal (1829–1862), one of the first and most important associates of the Pre-Raphaelites, was working in a millinery shop when she first modeled for two of the "brothers." She became a student, then the companion, and later the wife of the painter and poet Dante Gabriel Rossetti, and wrote poetry herself. Instead of passing along to her the lessons he had learned as a painting student at the Royal Academy School, Rossetti encouraged Siddal to develop a rather naïve style, featuring stiff figures in awkward poses, mysterious surroundings, and heavy symbolism. (Rossetti briefly appropriated these elements of Siddal's into his own painting.) The difficulties of their marital relationship were compounded by her drug addiction, which contributed to her early death.

For five years, beginning in 1852, until sales from her first public show freed her from the agreement, Siddal accepted an allowance from the influential art critic John Ruskin in exchange for her pictures. Typical of Siddal's work are several interpretations of Alfred, Lord Tennyson's *The Lady of Shalott*, and of Sir Walter Scott's *Clerk Saunders*, illustrating contemporary poems about ancient legends. In Scott's tale, the lowborn Saunders returns from the dead to appear before his highborn lover, whose brothers murdered him. She gives him a crystal wand, symbolizing her eternal love, before he leaves her—this time forever. In this somber-toned watercolor, the wood paneling of the dark interior is more palpable than the ethereal figures, one alive, one a spirit.

Another early Pre-Raphaelite "sister" was Joanna Mary Boyce (1831–1861), whose father encouraged both her and her brother, the Pre-Raphaelite landscape painter George Price Boyce, to pursue art studies. Well-educated, formally trained, and an independent spirit—although she hid from her mother the fact that she was studying from the nude model in Paris—Boyce drew from many influences. Paintings such as *Elgiva* (1854) and *Gretchen* (1861), however, owe much to Pre-Raphaelite concerns in both style and subject matter. Romantic themes—an ancient British queen and a young woman betrayed in Goethe's *Faust*—alternated with portrayals of children, especially after her marriage in 1858 to the painter Henry Wells. When she died, following the birth of her third child, three of her pictures were on exhibition at the Royal Academy, and her passing was mourned as a loss to the English school of painting.

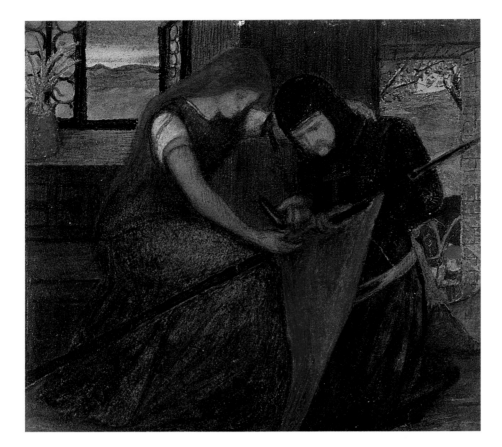

Lucy Madox Brown (1843–1894) and her half-sister Catherine Madox Brown (1850–1927) modeled for their father, the Pre-Raphaelite painter Ford Madox Brown, and assisted him. Both established themselves as independent artists by 1869, and both their subsequent marriages—Catherine's in 1872 and Lucy's in 1874—curtailed their painting activities. (Lucy's husband, William Rossetti, Dante Gabriel's brother, was a founder and the principal chronicler of the Pre-Raphaelite Brotherhood.) Lucy's *Ferdinand and Miranda* (1871) typifies what became the predominant Pre-Raphaelite style: beautiful figures in natural poses and high-minded subject matter. Here she depicts the young lovers from William Shakespeare's *Tempest* in a cave illuminated by a small window that looks onto the sea, at the moment after the tempest when they are to be reunited with their fathers.

The Madox Browns' colleague Maria Spartali (1844–1927) continued working and exhibiting through marriage, motherhood, and numerous moves. The beautiful Spartali sisters, Maria and her younger sister Christine, also modeled for Rossetti and others in the circle. Spartali drew on an excellent education as well as extensive Pre-Raphaelite influences for her romantic heroines and madonnas, usually portrayed out of doors and surrounded by plants and flowers. Italian poetry, especially in Rossetti's translations, inspired a number of Spartali's large paintings, such as *Fiammetta Singing* (1879) depicting the abandoned lover from Giovanni Boccaccio's pastoral romance *Fiammetta in Love.* Spartali's American husband, the journalist and painter William James Stillman, helped popularize the Pre-Raphaelites in the United States, paving the way for the inclusion of Spartali's paintings in the 1876 Philadelphia Centennial.

Evelyn Pickering de Morgan (1855–1919) came to the Pre-Raphaelite style through a passion for the classics and Italian painting. She had been determined since childhood to become an artist: her first drawing tutor resigned after she produced a nude study instead of the assigned still life. She demanded serious instruction—and refused social obligations such as a debut at court—and eventually overcame her aristocratic family's opposition. Numerous large, richly colored works based on themes from history and mythology declared the artist's professional intentions, and her paintings, which featured nude as well as draped figures, found buyers as well as critical recognition. Her art was influenced by her favorite uncle, J.R. Spencer-Stanhope, a painter living in Italy, and by the Pre-Raphaelite painter Edward Burne-Jones, a friend of William de Morgan, who became her husband. After their 1887 marriage, Evelyn's painting supported William's pottery enterprise for many years until it became profitable and he became a successful novelist. In their life together they shared a passion for art, travel, and books, and an interest in spiritual phenomena.

De Morgan continued painting in the Pre-Raphaelite style until she died. More than outside the mainstream, she worked in a sort of cultural time warp: the Victorian age had given way to a new century and shocking changes, from the "New Woman," who smoked cigarettes, to modern-day warfare and the once-unimaginable expressions of modern art.

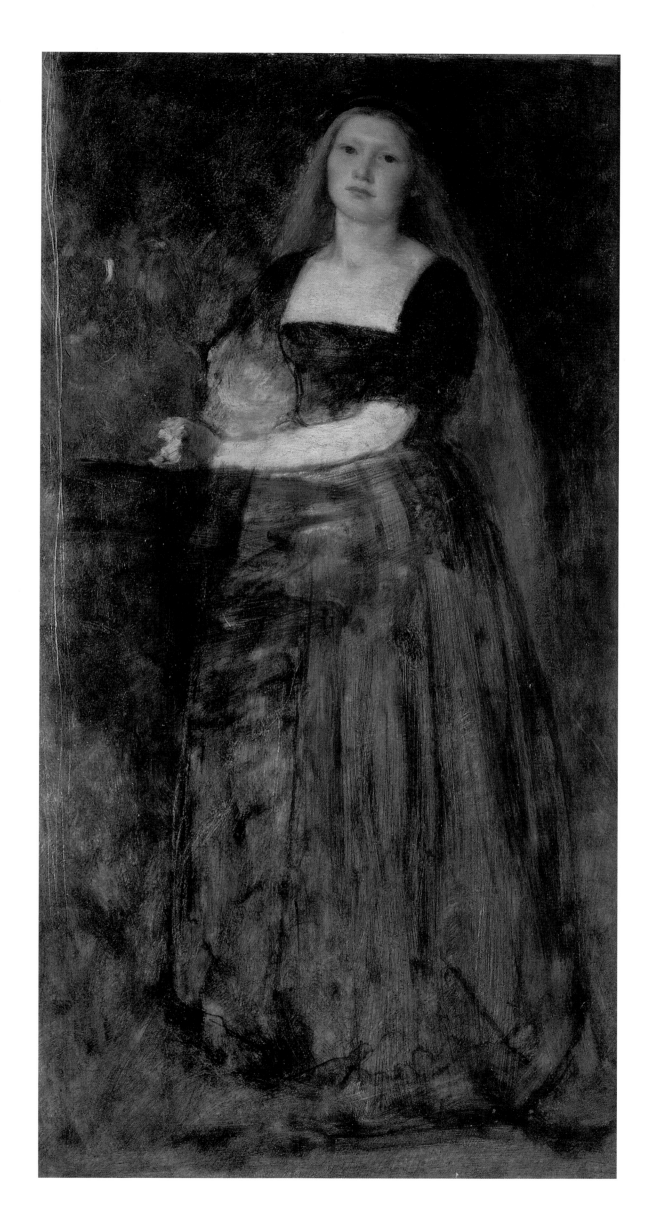

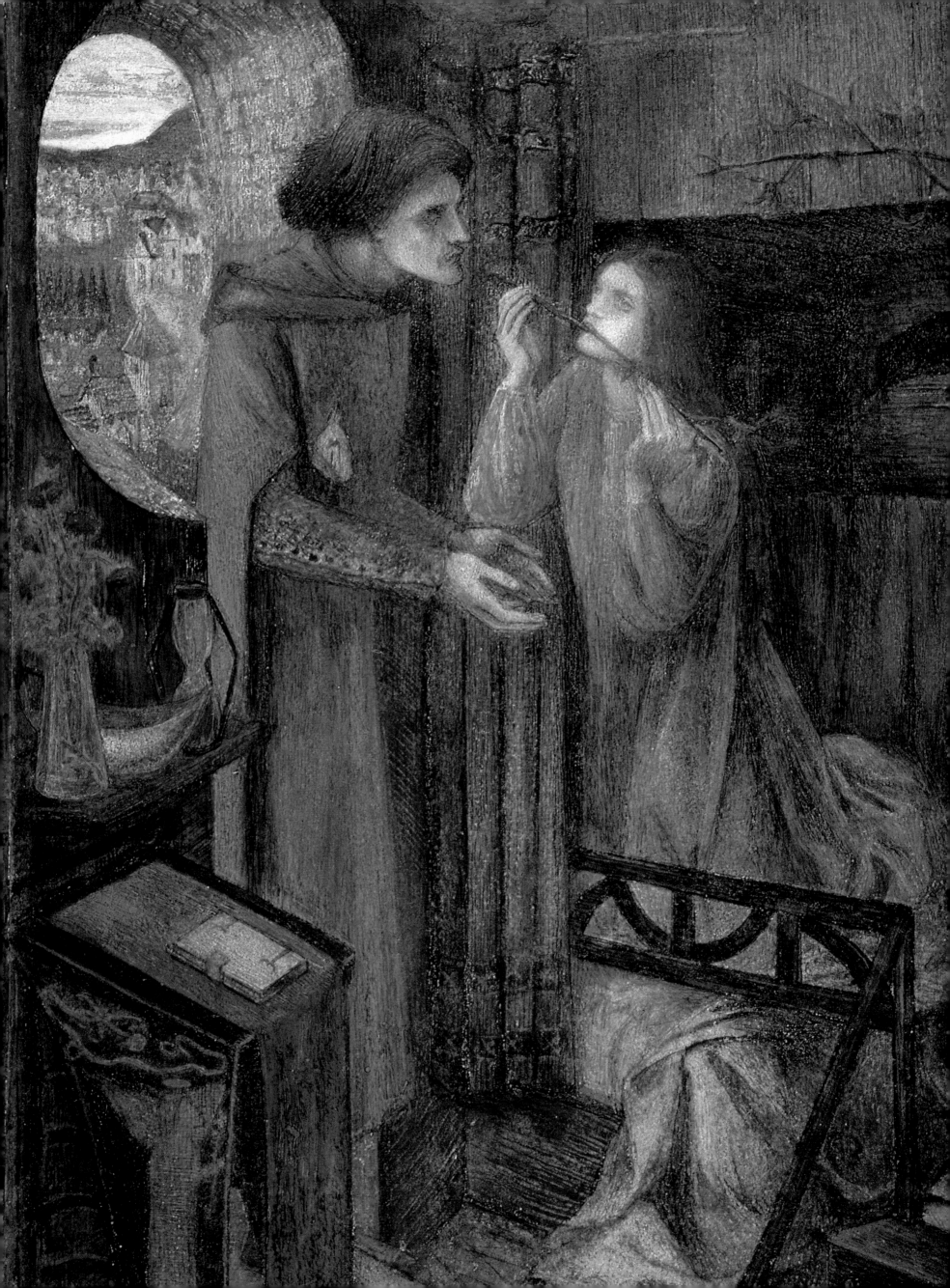

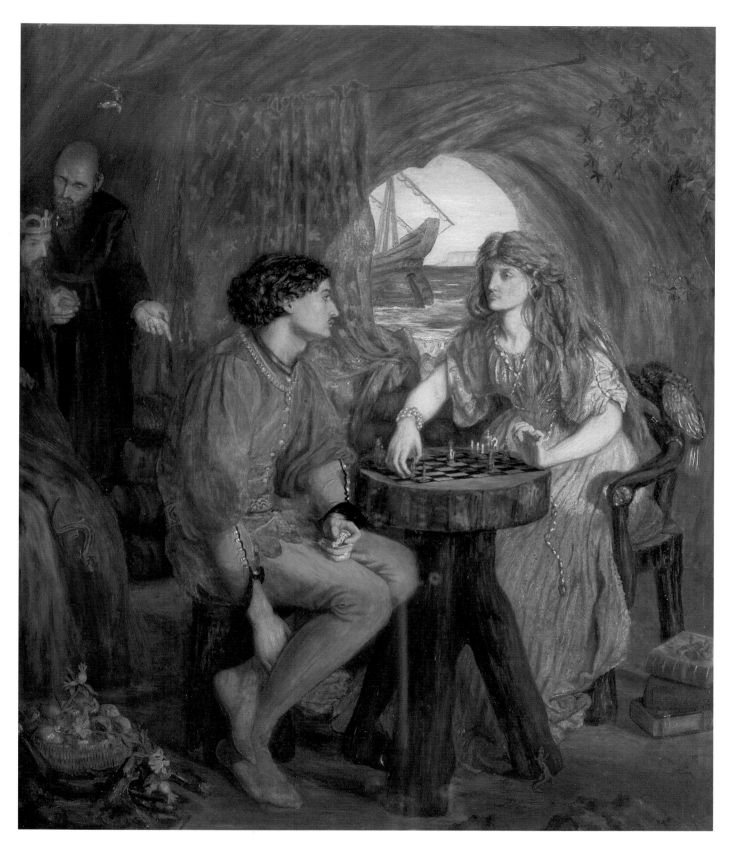

pp. 100-101:
Evelyn de Morgan. *Night and Sleep.*
1879. Oil on canvas. 42 x 62 in.
(106.7 x 157.5 cm). The De
Morgan Foundation at Old
Battersea House. Photograph:
Bridgeman Art Library,
London/New York.

Above:
Maria Spartali Stillman. *Fiametta
Singing.* 1879. Oil on canvas. 30 x
40 in. (76.2 x 101.6 cm). Julian
Hartnoll, London. Photograph:
Bridgeman Art Library,
London/New York.

Opposite:
Anna Lea Merritt. *Love Locked Out.*
1889. Oil on canvas. 45 ½ x
25 ¼ in. (115.6 x 64.1 cm). Tate
Gallery, London. Photograph:
Tate Gallery/Art Resource, N.Y.

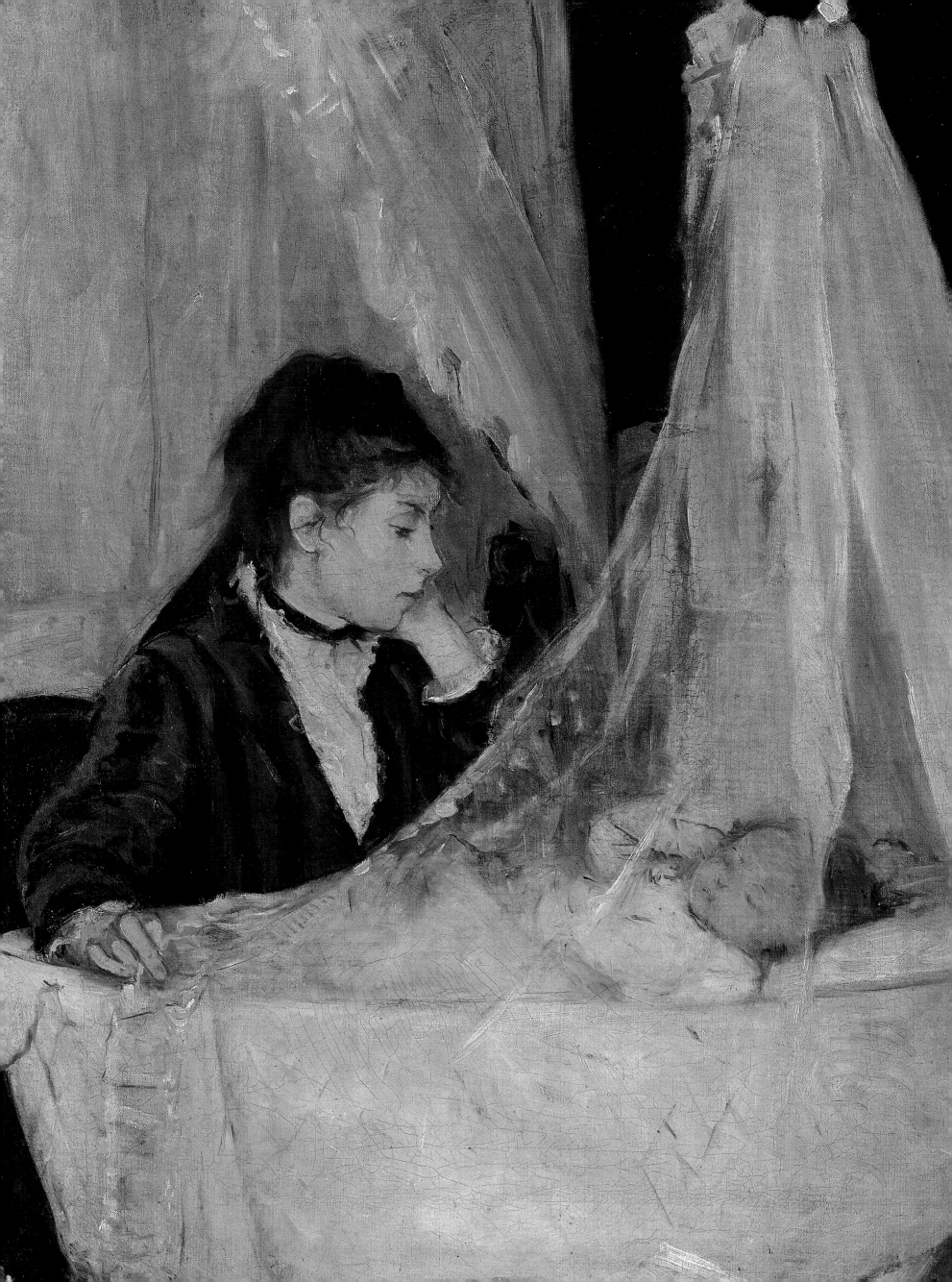

8

En Plein Air

The Impressionists and Their Circle

Today, we speak of the Impressionists as a school, but in their day, beginning in the last quarter of the nineteenth century, the artists, a more or less close group of friends, associates, and relations, had no single artistic philosophy or even technique. What they seem to have had in common was an interest in techniques of investigation into light and color, and in subjects that reflected contemporary life but without the sentimentality or moralizing elements of genre painting. But while Claude Monet, for example, tended to explore the varying effects of light, Édouard Manet, Edgar Degas, and Pierre-Auguste Renoir inclined toward portraying figures, either solitary or in groups, and often from a nontraditional vantage point. Initially—and briefly—the artists known as the Impressionists scandalized public and critical establishment alike with their radical deconstructions and reconstructions of perceived reality.

Berthe Morisot (1841–1895) was one of the first members of the Impressionist circle. Berthe and her sister Edma, granddaughters of Jean-Honoré Fragonard, had received painting lessons and great encouragement from family and friends, and by the early 1860s both were submitting work to the annual Salons. Through Corot and the Barbizon school, the sisters began working *en plein air* (outdoors), and Berthe continued to do so, although close to home. During copying sessions at the Louvre—an important stage of every artist's training—the sisters met other young artists, including Manet, Henri Fantin-Latour, and Félix Bracquemond. The Manet and Morisot families became friends, making it socially acceptable for Berthe to pose for Manet on a number of occasions. (She is, for example, the seated woman in *On the Balcony*.)

While male artists sat in cafés discussing art, all of Morisot's exchanges with her friends Degas, Renoir, and Monet took place during weekly salons or chaperoned visits. Edma abandoned painting after her marriage, but Berthe, who in 1874 married Eugène Manet, Édouard's brother, did not, nor did her husband wish her to. In the same year she married, Morisot broke with the official Salon, showing instead with the Impressionists in their first exhibition as the Groupe d'artistes indépendants.

Morisot painted her immediate environment and family for the most part, and after the birth of her daughter Julie in 1879, she gracefully combined motherhood and her work. She delighted in her sister's growing family, and in *The Cradle* (1879), she paints Edma gazing intently at her sleeping infant daughter. Edma's two young daughters follow her lead in *The Butterfly Hunt* (1874). Morisot's assured brushstrokes mark the lively play of light on the wildflowers and butterflies that dot the deep, glistening shades of meadow and trees. In each case Morisot achieves the effect of direct painting, although the strong underlying composition reveals the planning that went into the work.

Of the Impressionist circles, Mary Cassatt (1844–1926) was most associated with the theme of mothers and children, and was critically admired for a painting style that combined realism and tenderness. Unmarried herself, she painted family outings that were not sentimental narratives, but often bold compositions of simplified forms, while broad and energetic brushstrokes created sparkling and light-filled surfaces.

Cassatt was born near Pittsburgh into the American aristocracy and grew up in Philadelphia, where she attended the Pennsylvania Academy of Fine Art in the early 1860s. No stranger to Europe, where, like so many of her contemporaries, she had traveled to extensively with her family, she returned there to complete her studies. After studying Renaissance painting in Italy, she went on to Paris and remained in France, a member of the Impressionist inner circle, for the rest of her life. At the same time, she was extremely influential in extending the increasing popularity of Impressionism to the United States, advising American friends on purchasing works by

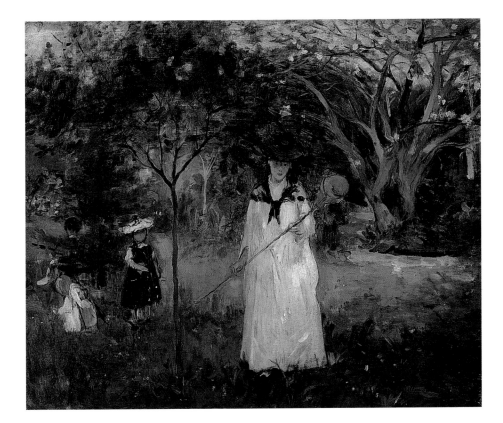

p. 104:
Berthe Morisot. *The Cradle.* 1872.
Oil on canvas. 21 ⅛ x 18 ⅛ in.
(56 x 46 cm). Musée d'Orsay,
Paris. Photograph: Erich
Lessing/Art Resource, N.Y.

Left:
Berthe Morisot. *The Butterfly Hunt.*
1874. Oil on canvas. 18 ⅛ x
21 ⅛ in. (46 x 56 cm). Musée
d'Orsay, Paris. Photograph: Erich
Lessing/Art Resource, N.Y.

her associates as well as Old Master paintings. These would later enhance museum collections in New York, Philadelphia, and elsewhere, but in the meantime Cassatt's efforts meant financial support for Manet and others.

Initially attracted to the work of Gustav Courbet and Manet, Cassatt absorbed their influence, which is visible in her early Salon entries. Degas discerned in Cassatt's work a kindred spirit, and invited her to exhibit with his colleagues. Shared interests and mutual respect led to a long friendship, but though Degas gave advice, Cassatt was neither his student nor his protégé, as critics alleged, to explain the exceptional draftsmanship that both artists displayed.

By the late 1870s, Cassatt's parents and her sister Lydia had joined her permanently in Paris. Along with her other brothers and sisters and their children, they were her favorite models, and Lydia was Mary's close companion until her death in 1882. She is the red-haired operagoer wearing a pearl necklace in *Lydia in a Loge* (1879) and the determined carriage driver in *Woman and Child Driving* (1881), an unconventional subject — though not an unusual sight — in that the groom sits behind while his mistress takes the reins. *Ellen Mary Cassatt in a White Coat* (1896) is a mature work with massive forms, prominent outlines, and distinct features that give its two-year-old subject a formidable presence.

Cassatt and Mary MacMonnies Low were the two female American artists invited to paint murals for the Woman's Building at the 1893 Columbian Exposition in Chicago. Entitled *Modern Woman,* Cassatt's decorative triptych (now lost) featured a central panel, *Young Women Plucking the Fruits of Knowledge and Science,* that inspired several related paintings and prints, including *Baby Reaching for an Apple* (1893).

A contemporary of Morisot and Cassatt, the still-life painter Victoria Dubourg (1840–1926), was a member of the same social and artistic circles as the Impressionists, although she did not follow any of their several directions. She met her future husband, Henri Fantin-Latour, in 1869, while copying pictures in the Louvre. Throughout their long life together, Dubourg's and Fantin-Latour's paintings were similar in subject matter and in their elegant style. Her distinct manner is evident in *Corner of the Table* (1901), for which Dubourg looked to seventeenth-century Dutch examples, with their gleaming silver and sparkling glass accents.

Although Marie Quiveron Bracquemond's (1841–1916) early talent had been nurtured by the great Jean-Auguste-Dominique Ingres, by the 1860s she was drawn to the informality of plein-air painting and the radical techniques of Impressionism. Her husband, Félix Bracquemond, disliked both. Still, when she was not working for him—designing plates and other items for the Haviland studio where he was director—she painted and exhibited with the Impressionists. Influenced by Renoir and by Monet, who, she said, opened her eyes and helped her to see, she captured the nuances of color produced by sunlight filtering through a leafy background and mixing with the reflected light on her sitters' costumes. In *On the Terrace at Sèvres* (1880) (the figures once were identified as the artist with Dubourg and Fantin-Latour), Bracquemond took up the masterly challenge of rendering the effects of sunlight on white.

Eva Gonzalès (1849–1883), whose strict family, like Morisot's, allowed Manet to paint their daughter, became that artist's only official student. She quickly assimilated his lessons into a more personal style, often with women as subjects, as in *Box at the Italian Opera* (c. 1874), encoding into gently anecdotal subjects the societal restrictions of her upper class background. Against a dark, flat background, Gonzalès's mysterious figures emerge, solid and stylish and painted in clear, bright tones. Separated by the blackness, it is through the colors of the flowers in the bouquet at the left—bright white and pink, their freshness a hallmark of her teacher's flower subjects—that the figures connect. With Manet, she continued to seek validation through the official Salons instead of exhibiting with Morisot, Cassatt, and the other Independants. Gonzalès was only thirty-four when she died of an embolism, less than a week after giving birth to a son, and just a day after Manet's death.

After meeting Monet in Giverny in the summer of 1889 with her friend Cecilia Beaux, Lilla Cabot Perry (1848–1933) returned home to Boston and, like Cassatt, championed Impressionism in the United States. Every summer for ten years, the Perrys returned to Giverny, where Lilla painted haystacks and hillsides and observed Monet's techniques for capturing color and light. During this period, the Perrys also lived in Japan, where the artist's husband, Thomas Sergeant Perry, a descendant of the Admiral Perry who opened Japan to trade with the West, was a professor of literature. Lilla Cabot Perry's odd practice of plein-air painting drew crowds of curious onlookers in Japan, and her passionate interest in Japanese prints—also shared with Monet, who collected them—can be seen in works such as *The Trio* (c. 1898–01), painted in Tokyo. In this scrupulously composed work, the figures (her daughters, Alice, Edith, and Margaret) are separated in the upper third of the picture by the decisive verticals of the spare Japanese setting. By contrast, their sinuous forms and those of the instruments flow into each other.

The Connecticut-born Mary MacMonnies Low (1858–1946) met her first husband, the successful American sculptor Frederick MacMonnies, when she was studying in Paris. After they married in 1888, they, too, spent summers in Giverny, where something of an American colony had begun to form. Mary MacMonnies embraced the light-drenched Impressionist style, in paintings such as *Between Friends* (1891), portraying neighbors in a garden. The Japanese influence, evident in the hanging lanterns, is more subtly at work in the strong diagonal pull of the figures, and in the lines of the seated woman's flowing gown. At the 1893 Colombian Exposition, MacMonnies's large mural, *Primitive Woman*, with its classically robed women in a wooded background, was far more popular than Cassatt's more jarring, sharp-toned *Modern Woman*.

Impressionism was not an instant success in the United States. When it did take hold it often became sentimentalized. Among the best-received American Impressionists was Lillian Westcott Hale (1881–1963). A Bostonian who never studied abroad, she developed a more tranquil interpretation, with fewer harsh angles and disturbing tonalities. For example, in *The Deluxe Edition* (1910), instead of unexpected patches of color expressing plein-air light effects, the artist's careful texturing of the pale, filmy tones gives a characteristic refinement.

Victoria Dubourg. *The Corner of the Table*. 1901. Oil on canvas. 20 ½ x 24 in. (52 x 61 cm). Musée d'Orsay, Paris. Photograph: Reunion des Musées Nationaux, Paris, Gérard Blot.

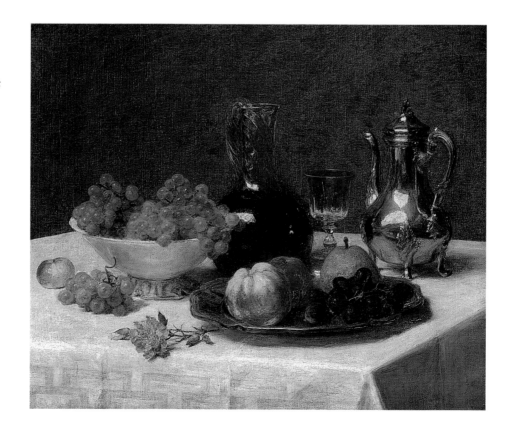

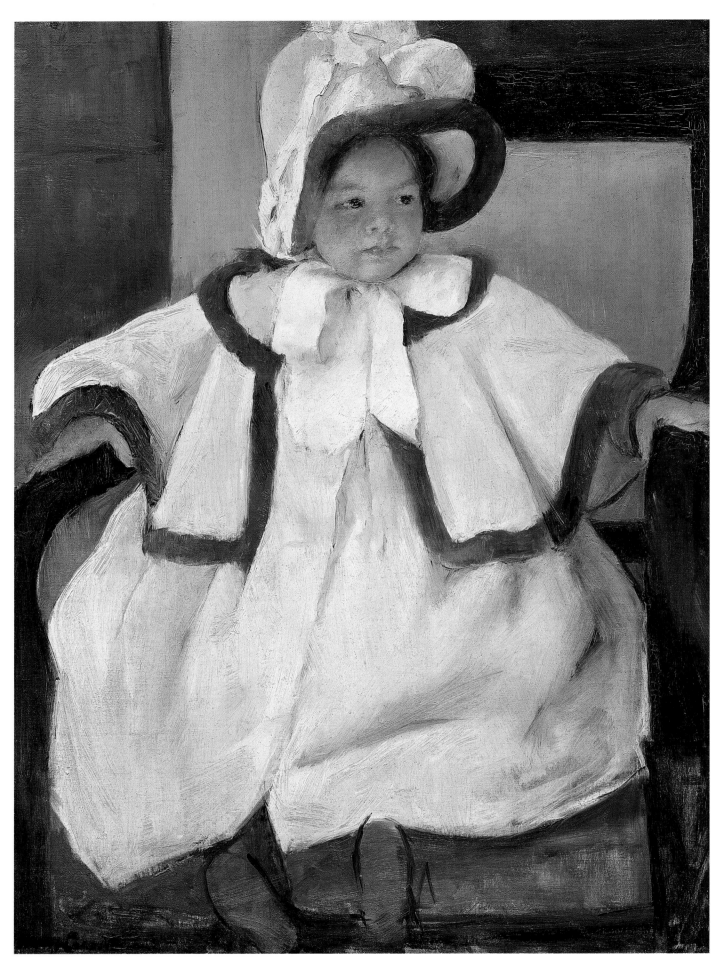

Above:
Mary Cassatt. *Ellen Mary Cassatt in a White Coat.* c. 1896. Oil on canvas. 32 x 23 ¾ in. (81.3 x 60.3 cm). Museum of Fine Arts, Boston. Anonymous fractional gift in honor of Ellen Mary Cassatt.

Opposite:
Mary Cassatt after 1900. Frederick A. Sweet Research Material on Mary Cassatt, Archives of American Art, Smithsonian Institution. Location of original unknown.

Overleaf:
Mary Cassatt. *Woman and Child Driving.* 1881. Oil on canvas. 35 ¼ x 51 ½ in. (89.5 x 130.8 cm). Philadelphia Museum of Art. The W.P. Wilstach Collection.

Mary Cassatt

Letter to Bertha Palmer

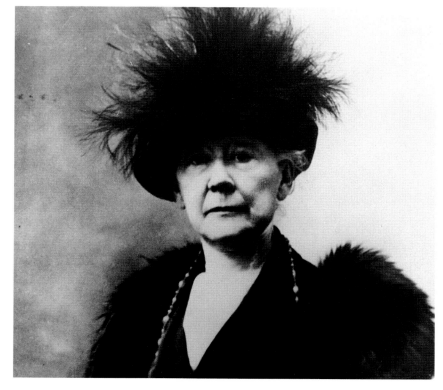

My Dear Mrs. Palmer,

Your letter of September 27th only arrived this morning, so unfortunately this will not reach you by the 18th as you desired. Notwithstanding that my letter will be too late for the ladies of the committee, I should like very much to give you some account of the manner [in which] I have tried to carry out my idea of the decoration. Mr. Avery sent me an article from one of the New York papers this summer in which the writer, referring to the order given to me, said my subject was to be "The Modern woman as glorified by Worth!" That would hardly describe my idea of course. I have tried to express the modern woman in the fashions of our day and have tried to represent those fashions as accurately and as much in detail as possible. I took for the subject of the center and largest composition Young Women plucking the fruits of Knowledge and Science. That enabled me to place my figures out of doors and allowed for brilliancy of color. I have tried to make the general effect as bright, as gay, as amusing as possible. The occasion is one of rejoicing, a great national *fête*. I reserved all the seriousness for the execution, for the drawing and painting. My ideal would have been one of those admirable old tapestries brilliant yet soft. My figures are rather under life size although they seem as large as life. I could not manage women in modern dress eight or nine feet high. An American friend asked me in a rather huffy tone the other day, "Then this is woman apart from her relations to man?" I told him it was. Men I have no doubt are painted in all their vigor on the walls of the other buildings; to us the sweetness of childhood and the charm of womanhood, if I have not conveyed some sense of that charm, in one word if I have not been absolutely feminine, then I have failed. My central canvas I hope to finish in a few days. I shall have some photographs taken and sent to you. I will still have place on the side panels for two compositions, one which I shall begin immediately is Young Girls Pursuing Fame. This seems to me very modern and besides will give me an opportunity for some figures in clinging draperies. The other panel will represent the Arts, Music (nothing of St. Cecilia), Dancing and all treated in the most modern way. The whole is surrounded by a border, wide below, narrow above, bands of color, the lower cut with circles containing naked babies tossing fruit, etc. I think, my dear Mrs. Palmer, that if you were here and I could take you out to my studio and show you what I have done that you would be pleased. Indeed, without too much vanity, I may say I am almost sure you would.

When the work reaches Chicago, when it is dragged up 48 feet and you will have to stretch your neck to get sight of it at all, whether you will like it then, is another question. Hillman in a recent article declares his belief that in the evolution of the race painting is no longer needed, the architects evidently are of that opinion. Painting was never intended to be put out of sight. This idea however has not troubled me much, for I have passed a most enjoyable summer of hard work. If painting is no longer needed, it seems a pity that some of us are born into the world with such a passion for line and color. Better painters than I am have been put out of sight. Baudry spent years on his decorations. The only time we saw them was when they were exhibited in the Beaux-Arts, then they were buried in the ceiling of the Grand Opera. After this grumbling I must get back to my work knowing that the sooner we get to Chicago the better.

You will be pleased, believe me, my dear Mrs. Palmer.

Most sincerely yours,

Mary Cassatt

Above:
Marie Bracquemond. *On the Terrace at Sèvres.* 1880. Oil on canvas. 34 ⅝ x 45 ¼ in. (88 x 115 cm). Musée du Petit Palais, Geneva. Photograph: Erich Lessing/Art Resource, N.Y.

Opposite:
Mary Macmonnies Low. *Between Friends.* 1891. Oil on canvas. 89 x 61 in. (226 x 154.9 cm). Collection of the Sheldon Swope Art Museum, Terre Haute, Indiana.

Overleaf:
Lilla Cabot Perry. *The Trio (Alice, Edith, and Margaret Perry).* c. 1898–1901. Oil on canvas. 28 ¾ x 38 ⅞ in. (73 x 98.7 cm). Courtesy of the Fogg Art Museum, Harvard University Art Museums, Friends of the Fogg Art Museum. Photograph © President and Fellows of Harvard College, Harvard University, Cambridge, Massachusetts.

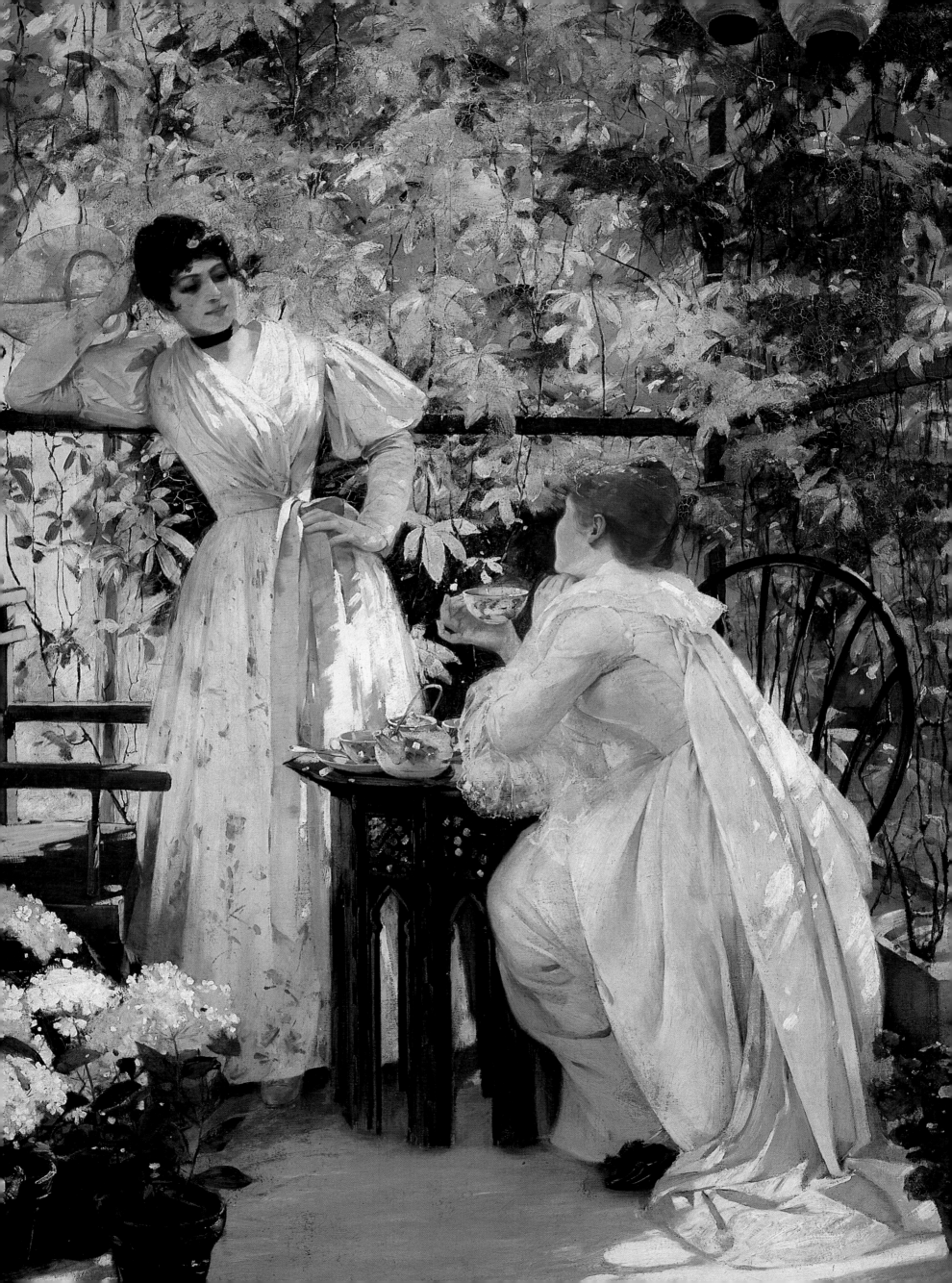

Above:
Eva Gonzalès. *Box at the Italian
Opera.* c. 1874. Oil on canvas.
38 ½ x 51 ³⁄₁₆ in. (98 x 130 cm).
Musée d'Orsay, Paris.
Photograph: Erich Lessing/
Art Resource, N.Y.

Opposite:
Lillian Westcott Hale. *The Deluxe
Edition.* 1910. Oil on canvas. 23 x
15 ⅛ in. (58.4 x 38.4 cm). Museum
of Fine Arts, Boston. Gift of
Miss Mary C. Wheelwright.

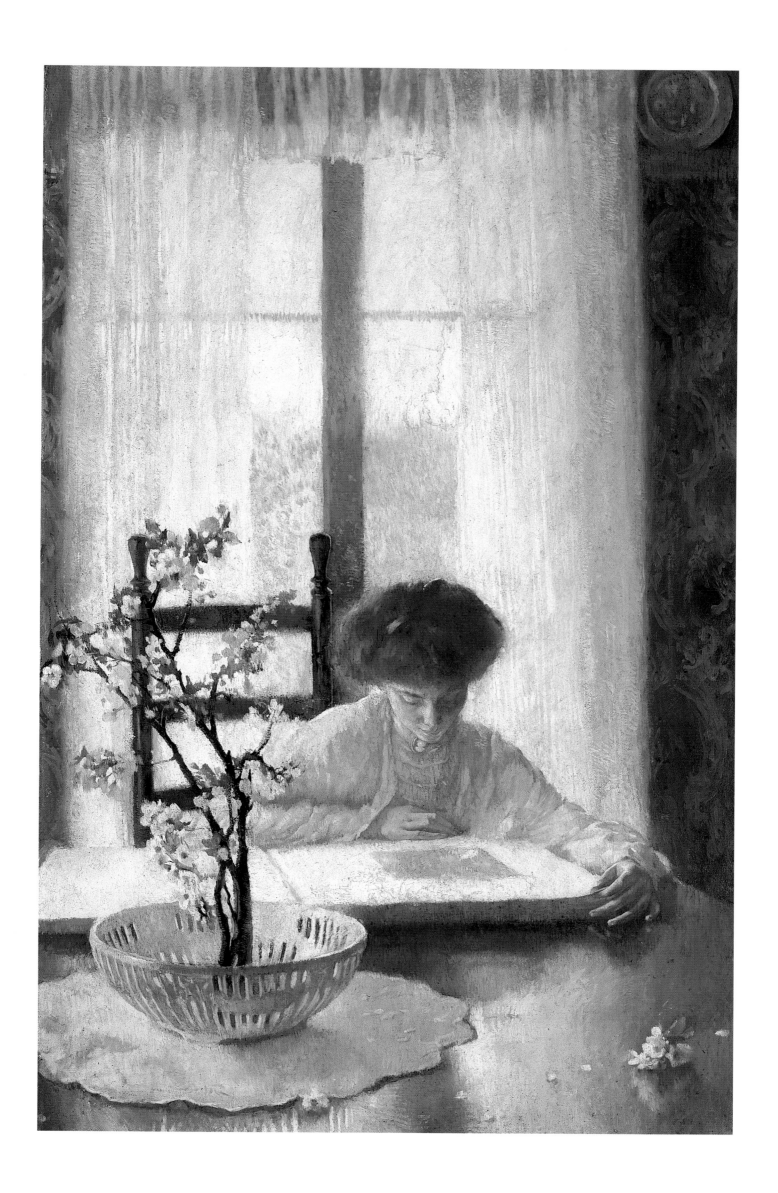

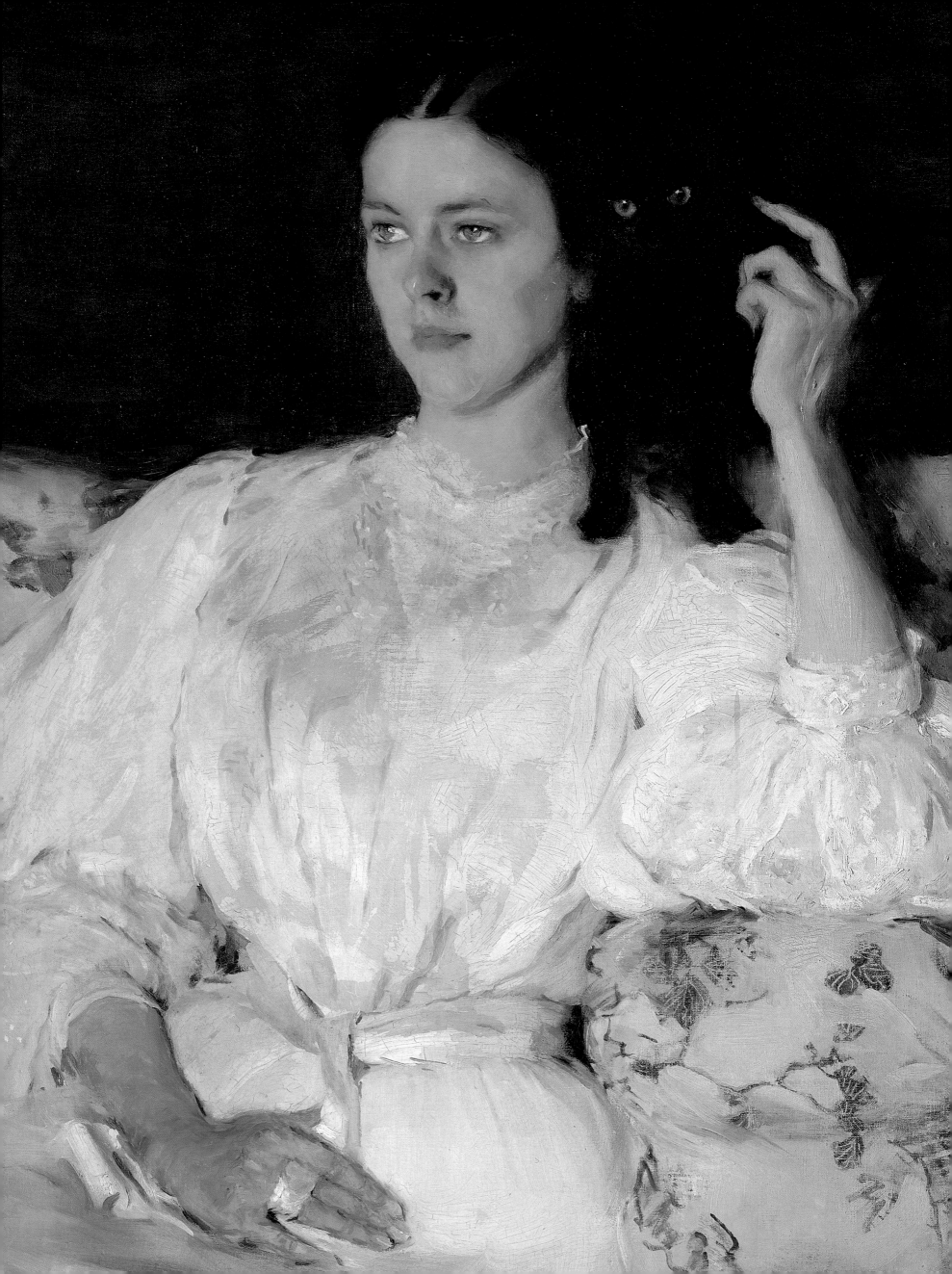

9
Paris

The Turn of the Century

In the last decades of the nineteenth century, Paris superseded Rome as the lure for aspiring artists from around the world. Many remained there, establishing themselves professionally and in turn opening their studios, or *ateliers*, to more recent arrivals, providing safe havens for the "innocents abroad." Communities of artists from each country congregated at favorite cafés, where they argued about art in their native tongue. By the century's turn, newly emancipated women, freed from family restrictions—but housed in safe, women-only accommodations—were joining these café gatherings.

Foreigners were denied entry into the prestigious École des Beaux-Arts, and this stimulated the establishment of private academies. Two that took advantage of the growing demand by women for art training—the académies Julian and Colarossi—also charged them twice the men's tuition. Inspired by Morisot, Cassatt, and others, many women soon mustered the courage to submit their work to the annual Salons of the Académie Française. Those able to meet the exacting standards had their work accepted, and some won prizes, notices of which, in their hometown newspapers, often convinced parents to extend their daughters' study trips. As the nineteenth century faded and the new century dawned, talented and ambitious young women came to Paris from every continent.

The Philadelphian Cecilia Beaux (1855–1942), one of the hundreds of American women who made their way to the City of Light, had as her mentor Catharine Drinker, a painter and teacher who was also a distant cousin. Beaux was brought up by her grandparents after her mother died, and studied privately in Philadelphia. At first, she earned money by painting china, before turning to portraiture, often using family members as subjects. Beaux first submitted work to the Paris Salon in 1883, five years before she began a self-financed two-year stay in Paris. She took classes at the Académie Julian and a summer course in Brittany, visited museums and the ateliers of prominent French and expatriate American painters, and had a successful showing at the 1889 Salon. After absorbing lessons from the Impressionists, she returned home in 1890, although she continued to win medals and other honors in France as well as in the United States. In 1892 Beaux was invited to teach at the Pennsylvania Academy of Art, a rare honor for a woman.

Portraiture was Beaux's greatest strength, and her intuitive approach, which often related sitters to their environment or to each other, quietly revealed subtle aspects of personality. Her expressive brushstrokes captured nuances of color, often in broad expanses of a single color. In her many portraits, Beaux paid tribute to the various masters, both old and new, whose work she had admired at home and abroad. One of her loveliest portraits, *Dorothea and Francesca* (1898), is not only inventive in its composition but also illustrates Beaux's skillful handling of pale colors.

While Beaux eventually returned to the Unites States, Anna Elizabeth Klumpke (1856–1942) and Elizabeth Nourse (1859–1938) remained abroad. The San Francisco-born Klumpke and her sisters were educated in Europe and the United States under the direction of their progressive mother. Inspired by the example of Rosa Bonheur—as a child she had even had a Rosa Bonheur doll—Anna studied painting at the Académie Julian, while her sisters studied science, medicine, and music. Klumpke's entries in the Salon won her acclaim on both sides of the Atlantic; they included an 1887 portrait of the American feminist Elizabeth Cady Stanton and several peasant subjects, one of which received a gold medal at the Pennsylvania Academy. Bonheur agreed to let Klumpke paint her portrait; in the process, they established a rapport that led to Klumpke becoming the famous artist's biographer and final companion. Painted the year before Bonheur's death, *Portrait of Rosa Bonheur* (1898), showing Bonheur relaxed and at her easel, her face illuminated by a soft halo of white hair, is one of Klumpke's finest works (see page 53).

Elizabeth Nourse sailed for Paris in 1887 to continue the study of art she had begun in her native Cincinnati. She would return to the United States only once, to attend the 1893 Colombian Exposition in Chicago, where her works were among those relegated to the Woman's Pavilion. Before settling permanently in Paris the following year, Nourse and her sister, Louise, visited the art centers of Europe. Nourse's academic, Salon-style scenes of street life and peasants, such as *Plein été (Midsummer)* (1898), were favorites with her American patrons. Although the composition is unusual, with its back-to-back figures, the subject of women and children is one Nourse painted often.

Jennie Brownscombe's (1850–1936) work was immensely popular in the United States, and her sentimental scenes of idyllic rural life and formal depictions of historical events were often engraved and reproduced. During the years that she studied art in New York City, from around 1870 to 1881, art education there was undergoing major changes, including the availability or life drawing classes for women. In Paris in the early 1880s, Brownscombe joined the studio of the American painter Henry Mosley, and painted scenes of French country life. She later became interested in American history, and works such as *The Peace Ball at Fredericksburg* (1897) contain accurate portraits and costume studies.

Rose Barton (1856–1929), an Irish artist who studied in Paris in the early 1880s, took an interest in the Impressionist works that were then being shown in private galleries, but she was probably influenced more by the British painter J. M. W. Turner's use of watercolor. With that medium, she created strong, atmospheric effects in her depictions of Irish peasant life and city subjects. In *Going to the Levée at Dublin Castle* (1897), architectural forms break through the evening mist that envelops arriving guests, their carriages and clothing occasions for the splashes of color that were Barton's trademark.

Marie Bashkirtseff (1859–1884), a wealthy Russian emigrée, kept a colorful journal recounting her experiences as an art student in Paris—she spent her nights at the opera, but by day she worked diligently at the Académie Julian. Bashkirtseff's forte was sentimental scenes such as *The Meeting* (1884), an encounter of tough little schoolboys, completed for the 1884 Salon, shortly before her untimely death from tuberculosis. However, her painting *L'Académie Julian* (1881) detailing the women's studio, reads like a page torn from her journal.

At the century's end and in the years preceding the devastation of World War I, a series of upheavals upset the Parisian art world. Those still seeking to perfect the traditional Salon styles were joined by others who came to see the new art: alongside Impressionism there arose various forms of Post-Impressionism and Expressionism, then Cubism, and even greater degrees of abstraction. Artists took home with them what they saw and learned, dispersing new ideas around the globe, bringing about an infusion of international ideas into national styles.

Dissatisfied with the limited art training available to women in Germany, Ida Gerhardi (1862–1927) went to Paris in 1891, enrolling in the Académie Colarossi. She frequented the cafés with German avant-garde artists and, like Henri de Toulouse-Lautrec, spent evenings at Parisian dance halls sketching the vivid movement and color of the dancers and the crowds of spectators. In Germany, her pictures of swirling dancers kicking up their heels, such as *Can Can Dancers in the Bal Bullier* (1904), were considered somewhat decadent.

Two sculptors from very different backgrounds, Anna Semyonovna Golubkina (1864–1927), a Russian, and Meta Vaux Warrick Fuller (1877–1968), an African American, both trained with Auguste Rodin. Although Fuller remained at the Académie Colarossi for several years, (from 1899–1902), Golubkina tired quickly of the sculpture classes there. Before her second trip from Russia to Paris, in 1898, Golubkina applied to Rodin, who did not have a formal school but agreed to guide her development, as he did with many talented young people, male and female. Inspired by Rodin's instruction, Golubkina worked exhaustively, producing several works for the Salon, including *Old Age* (1898). This moving study of an elderly woman is often compared with similar works by Rodin because of the power of its brutal truthfulness. Back in Russia, through years marked by revolution, poverty, even prison, Golubkina continued working, sometimes creating tiny portraits of friends and important figures on shell when commissions and materials were scarce.

Meta Vaux Warrick Fuller's early, realistic, often grim sculptures were highly expressive. Impressed, Rodin agreed to critique her work. His influence was evident in her 1905 Philadelphia exhibition, which marked her return home. Although her early works explore universal themes such as war, death, and human suffering, later subjects embody social and cultural themes. *Ethiopia Awakening* (1914), which personifies that nation's emergence from bondage, is innovative in its adaption of allegory to African forms.

In the early twentieth century, the Americans Anne Goldthwaite (1869–1944) and Jane Peterson (1876–1965) traveled to Paris to study Modernism, and interpreted the new manners very differently. Goldthwaite's Paris years (1906–13), were an extraordinary opportunity for this artist open to change—she

p. 118:
Cecilia Beaux. *Sita and Sarita (Young Woman with a Cat).* 1893–94. Oil on canvas. 37 x 25 in. (94 x 63.5 cm). Musée d'Orsay, Paris. Photograph: Erich Lessing/Art Resource, N.Y.

Right:
Rose Barton. *Going to the Levée at Dublin Castle.* 1897. Watercolor on paper. 14 x 10 ½ in. (35.6 x 26.6 cm). Courtesy of The National Gallery of Ireland, Dublin.

p. 122:
Cecilia Beaux. *Dorothea and Francesca.* 1898. Oil on canvas. 80 ⅛ x 46 in. (203 x 116.8 cm). The Art Institute of Chicago. A.A. Munger Collection. (1921.109) Photograph © 1999 The Art Institute of Chicago. All Rights Reserved.

p. 123:
Cecilia Beaux. *Self Portrait* c. 1880–85. Oil on canvas. 18 x 13 in. (45.7 x 35.5 cm). National Portrait Gallery, Washington, D.C. Photograph: National Portrait Gallery/Art Resource, N.Y.

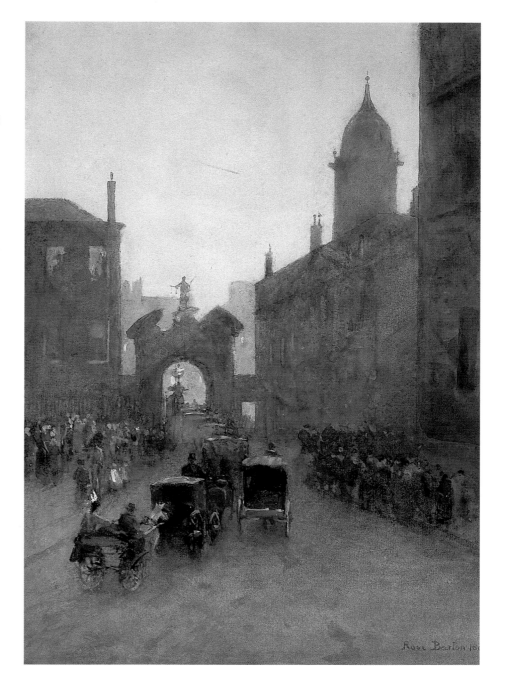

collaborated with other students in founding a new académie dedicated to modernist art. Upon her return to New York in 1913, Goldthwaite exhibited in the watershed Armory Show, which introduced Modernism to America, and shocked artists, critics, and collectors alike into heeding this sea of change. Although Goldthwaite lived and taught in New York, she spent part of each year back home in Alabama; her paintings and etchings convey the slow, easy rhythms of Southern life, as well as its debilitating heat and poverty. She primarily painted figures, and frequently African American subjects such as *The Coiffeur* (n.d.), a brisk, insightful watercolor of women engaged in an everyday activity.

Jane Peterson's *Girl in Striped Jacket* (c. 1914) shows her close attention to Paul Cézanne and Henri Matisse. In 1909, Peterson went on to Madrid, where she was profoundly inspired by the energetic sun-drenched style of the Spanish artist Joaquin Sorolla y Bastida. Before her marriage in 1925 to an art patron, Moritz Philip, she taught and traveled extensively, capturing the light and movement of life and landscapes throughout Europe and North Africa. Later, dividing her time between the couple's homes in New York and New England, she applied her vibrant palette to floral still lifes.

When Tarsila do Amaral (1886–1973) first journeyed to Paris in 1920, she attended the Académie Julian, still a mecca for foreign students. When she returned to Brazil in 1922, she and a group of artists and writers met regularly at her studio; the writer Oswald de Andrade, who would become Amaral's husband and fervent supporter, drafted in 1924 the "Pan-Brasil Poetry Manifesto," a nationalist modernist document. Back in Paris in 1923, she belonged to a circle that included the modernist painter Fernand Léger, the poet Blaise Cendrars, and others. Amaral combined influences as varied as Cubism, Surrealism, and Afro-Brazilian cultural elements into unique compositions such as *Urutu* (1928) named for a poisonous snake of southern Brazil. Surreal, dreamlike, and confident, it shows how far art had traveled from the academy.

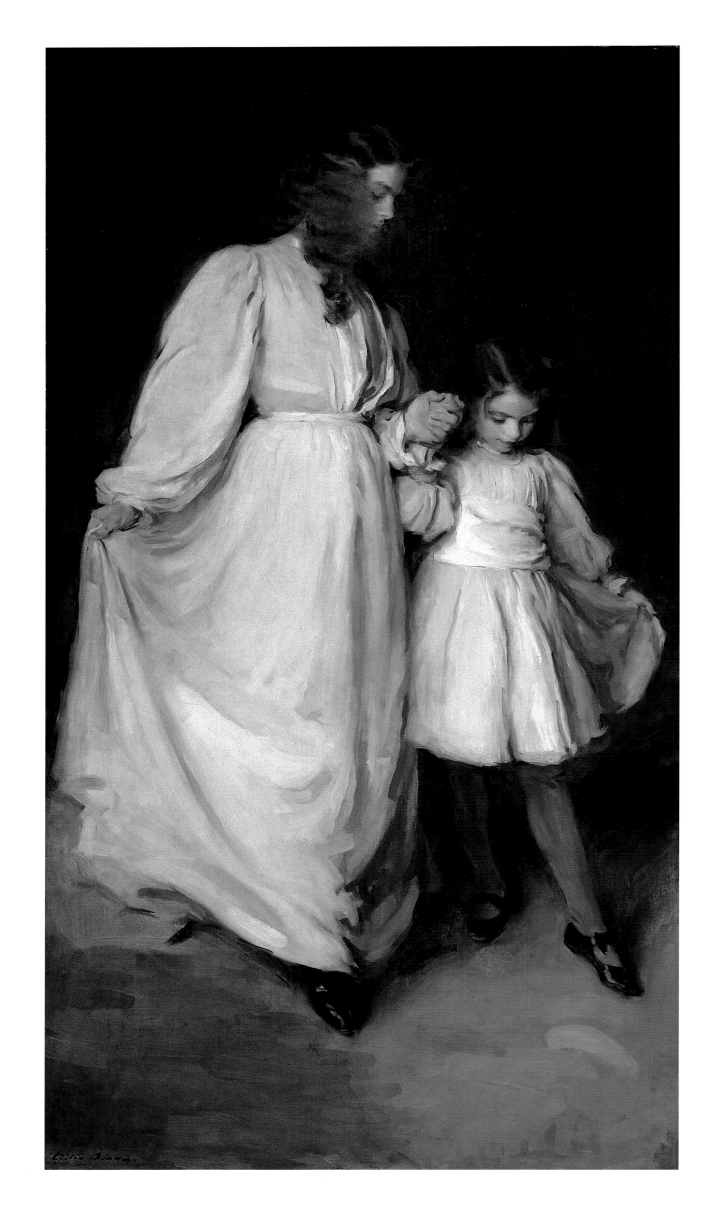

Cecilia Beaux

From Cecilia Beaux, *Background with Figures*

I did not linger long on this visit. It was midsummer, the least characteristic period of the year in Paris. But before I left, one, to me, highly memorable event had occurred. Mrs. Tom Perry (Lilla Cabot Perry) was painting at Giverney, to be near Monet, and would take me to see him. No sun and weather could have been more fortunate for a visit to the specialist in light than we were blessed with. We found him in the very centre of "a Monet," indeed: that is, in his garden at high noon, under a blazing sky, among his poppies and delphiniums. He was in every way part of the picture, or the beginning and end of it, in his striped blue overalls, buttoned at wrists and ankles, big hat casting luminous shadow over his eyes, but "finding," in full volume, the strong nose and great grey beard. Geniality, welcome, health, and power radiated from his whole person. . . . Monet pulled out his latest series, views, at differing hours and weather, of the river, announcing the full significance of summer, sun, heat, and quiet on the reedy shore. The pictures were flowing in treatment, pointillism was in abeyance, at least for these subjects. Mrs. Perry did not fear to question the change of surface, which was also a change of donné. "Oh," said the Maître, nonchalantly, "la Nature n'a pas de pointes." This at a moment when the haute nouveauté seekers of that summer had just learned "how to do it," and were covering all their canvases with small lumps of white paint touched with blue, yellow, and pink. But they had not reckoned on the non static quality of a discoverer's mind, which, in his desire for more light, would be always moving. For Monet was never satisfied. Even the science of Clemenceau, and his zeal for his friend, did not get to the bottom of the difficulty, which was purely physical. One could push the sorry pigment far, but not where Monet's dream would have it go, imagining that by sheer force of desire
and volonté, the nature of the material he thought to dominate would be overcome. For the moment, when actual light gleamed upon it, fresh from the tube, it had the desired effulgence, but it could not withstand time and exposure, and maintain the integral urge of Monet's idea.

To me it seems less important if we are seeking to understand the rock in its beauty to look at it historically ... Rather than to look at its beautiful union with nature, its hold on life around it, then its interlife and relation. This seems more essential to me than to dig it out, weigh it and measure it.

. . . For my part I would always rather look for what a subject is than for what it is not. I believe that every feeble, vulgar, spurious so-called Art production has a distinct and lasting effect wherever it is seen. . . . The artist has leaped a chasm. For he does not join soul with soul, mind with mind, but soul with body. The artist joins force of thought with the force of matter. From a few notes he must make great harmonies, out of reserve must come richness.

Fire and flood must accompany every touch of his hand.

The great works are all abstractions. The result of an alchemy so powerful that were the living subject to pass before us we should disbelieve in the evidence of our senses. The artist has turned matter into mind.

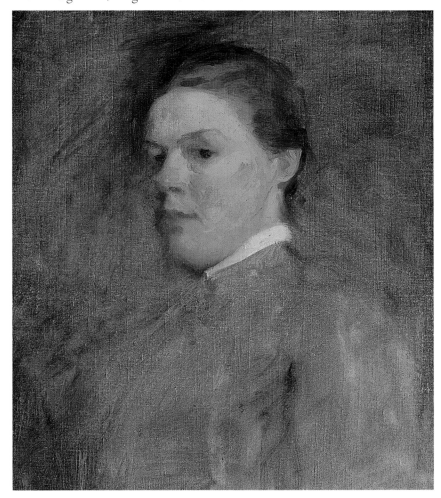

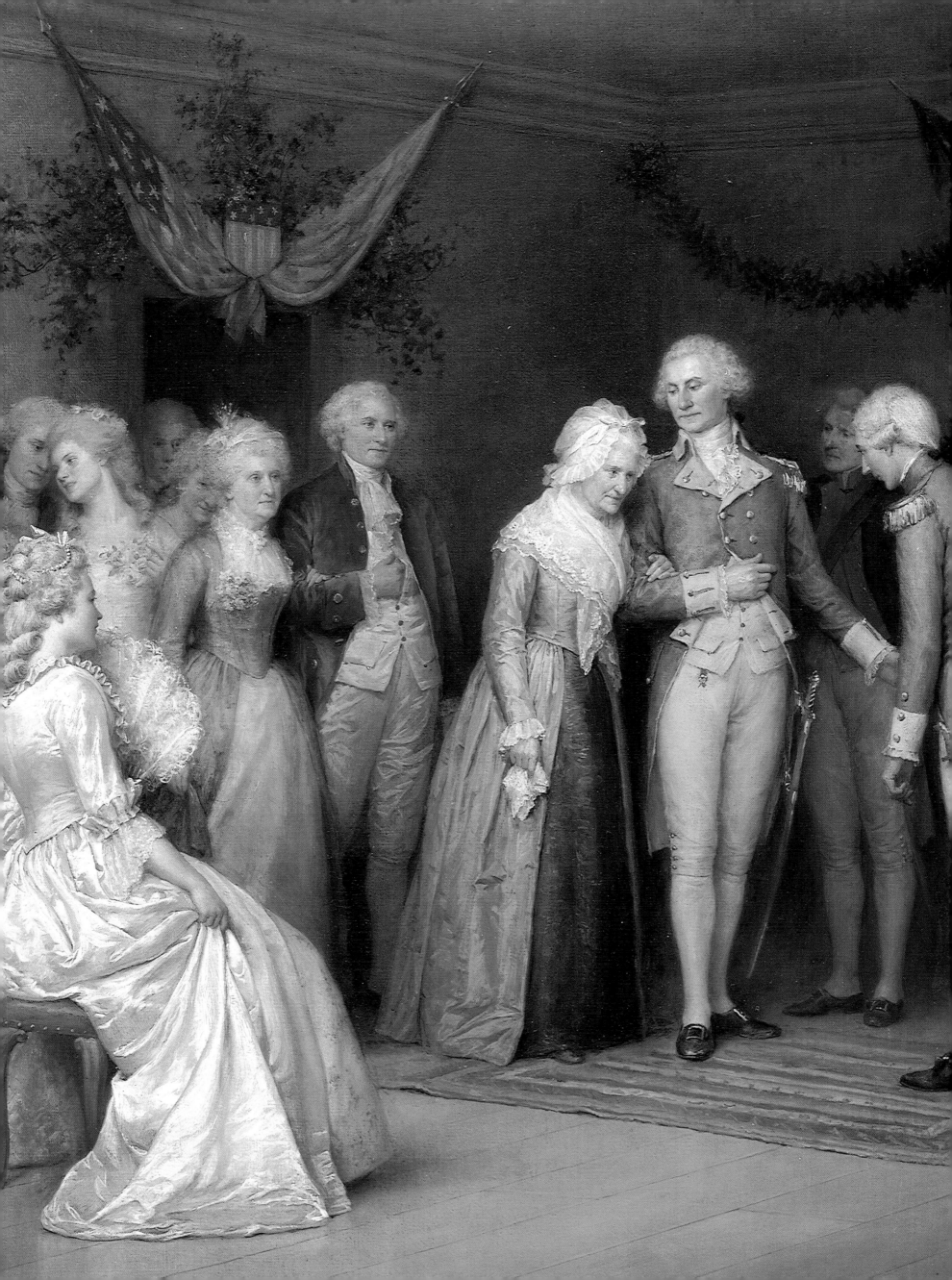

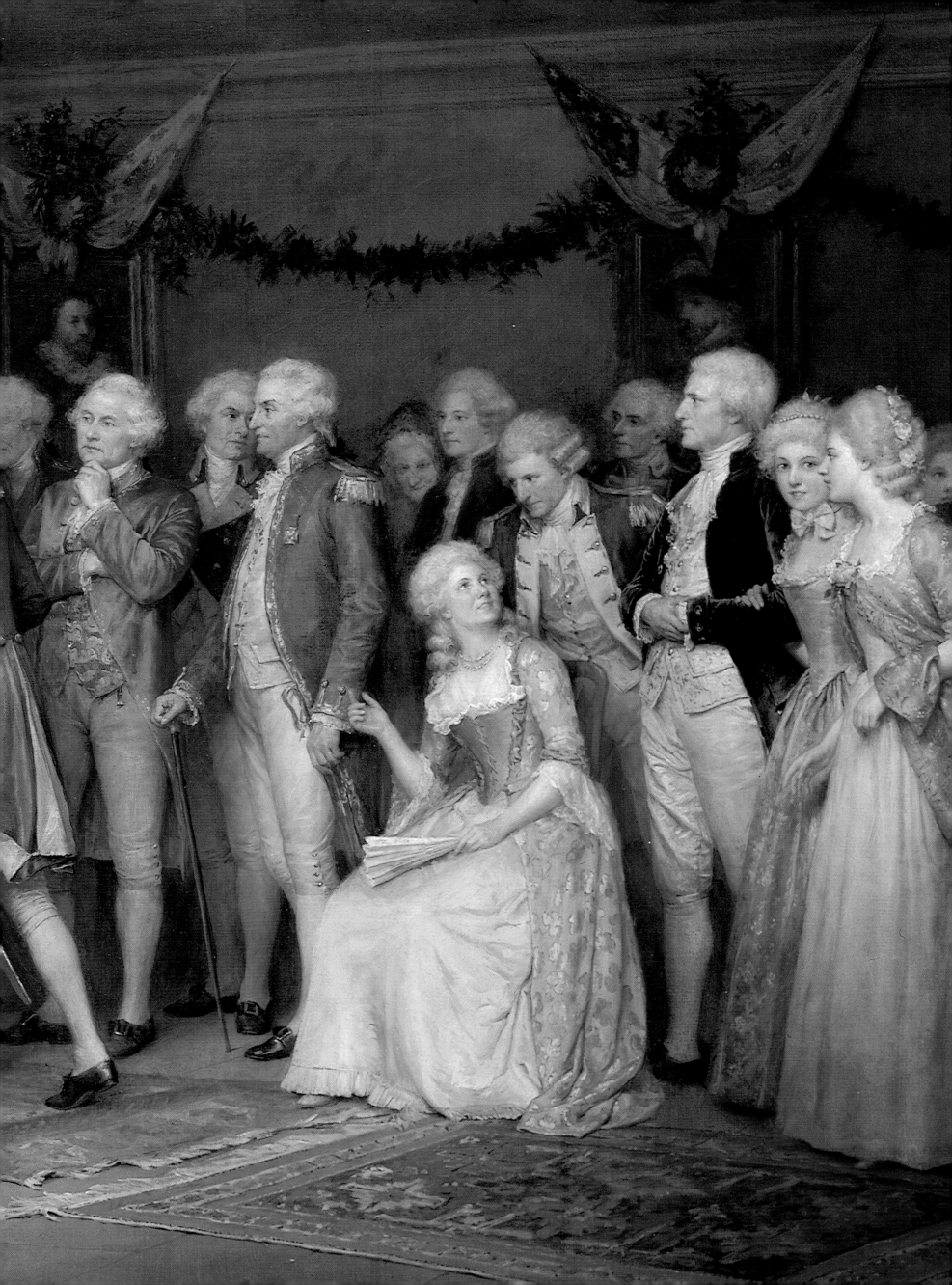

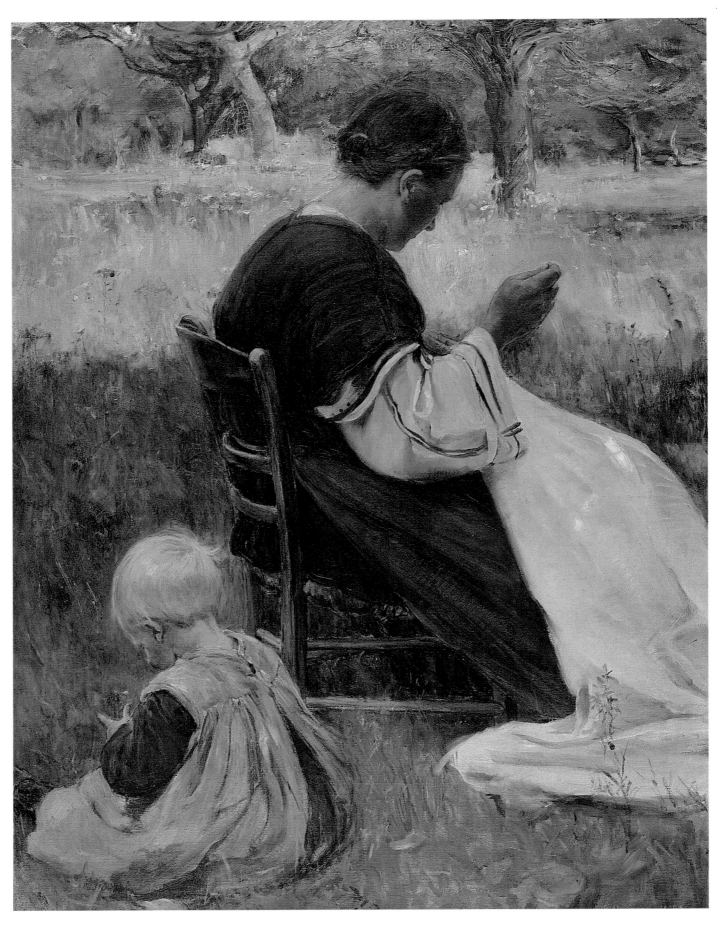

pp. 124-25
Jennie Brownscombe. *The Peace Ball at Fredericksburg*. 1897. Oil on canvas. 31 ¾ x 50 in. (80.6 x 127 cm). Collection of the Newark Museum. Gift of Dr. J. Ackerman Coles, 1926. (Inv. 26.1257) The Newark Museum, Newark, New Jersey. Photograph: The Newark Museum/Art Resource, N.Y.

Above:
Elizabeth Nourse. *Plein été (Midsummer)*. 1898. Oil on canvas. 43 ⅛ x 31 ⅞ in. (109.5 x 81 cm). Art Gallery of South Australia, Adelaide. Elder Bequest Fund, 1899.

Opposite:
Maria Bashkirsteff. *The Meeting*. 1884. Oil on canvas. 76 ¾ x 69 ¹¹⁄₁₆ in. (195 x 177 cm). Musée d'Orsay, Paris. Photograph: Erich Lessing/Art Resource, N.Y.

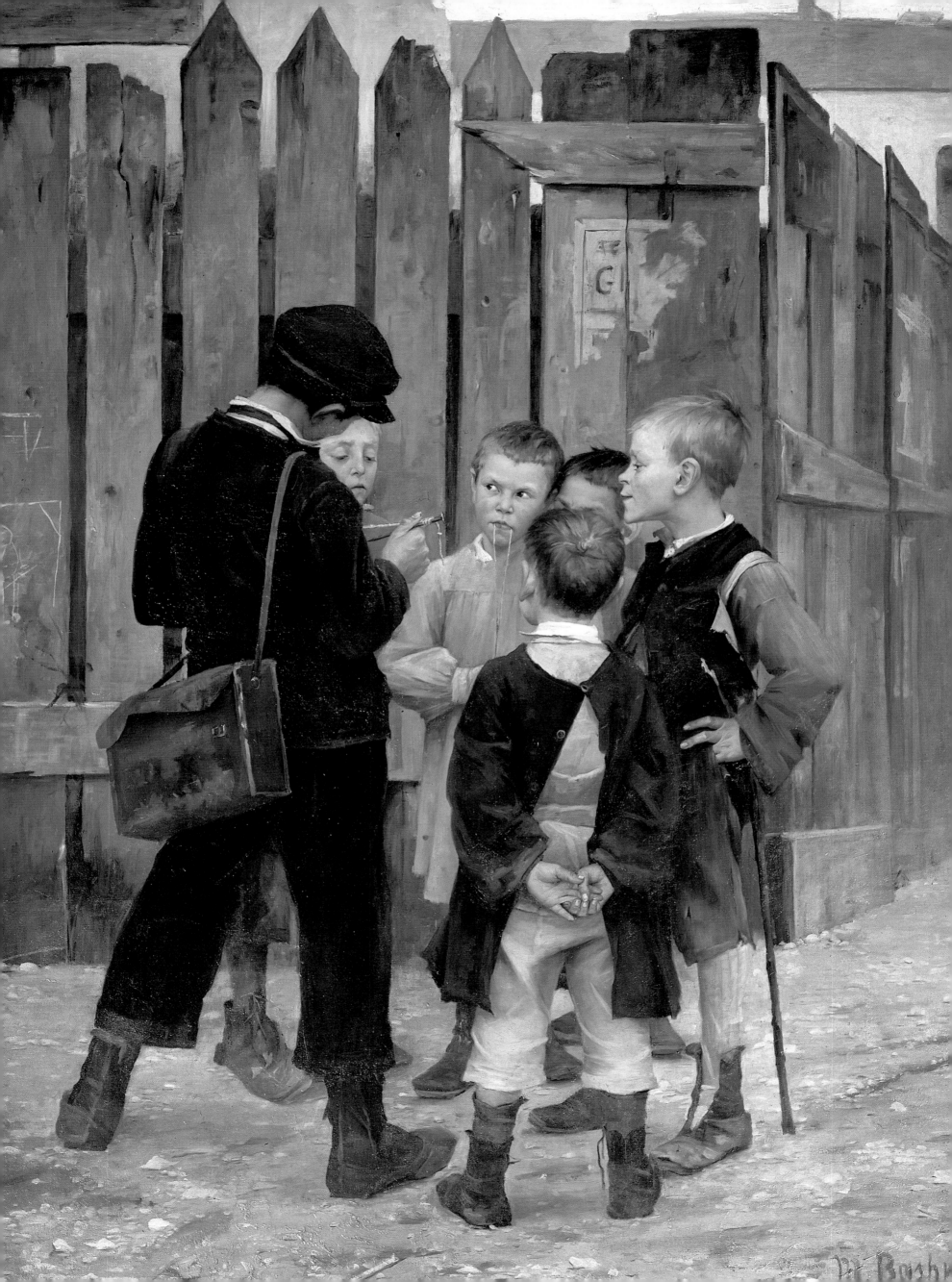

Above:
Ida Gerhardi. *Can Can Dancers in the Bal Bullier*. 1904. Oil on cardboard. 12 ³⁄₁₆ x 19 ⁵⁄₁₆ in. (31 x 49 cm). Museum der Stadt Lüdenscheid.

Right:
Anne Goldthwaite. *The Coiffeur*. n.d. Watercolor on paper. 19 ³⁄₄ x 14 in. (50.1 x 35.5 cm). Collection of the Newark Museum. (Inv. 37.113) The Newark Museum, Newark, New Jersey. Photograph: The Newark Museum/Art Resource, N.Y.

Jane Peterson. *Girl in Striped Jacket*.
c. 1914. Oil on canvas. 30 x 24 in.
(76.2 x 61 cm). The Walters Art
Gallery, Baltimore.

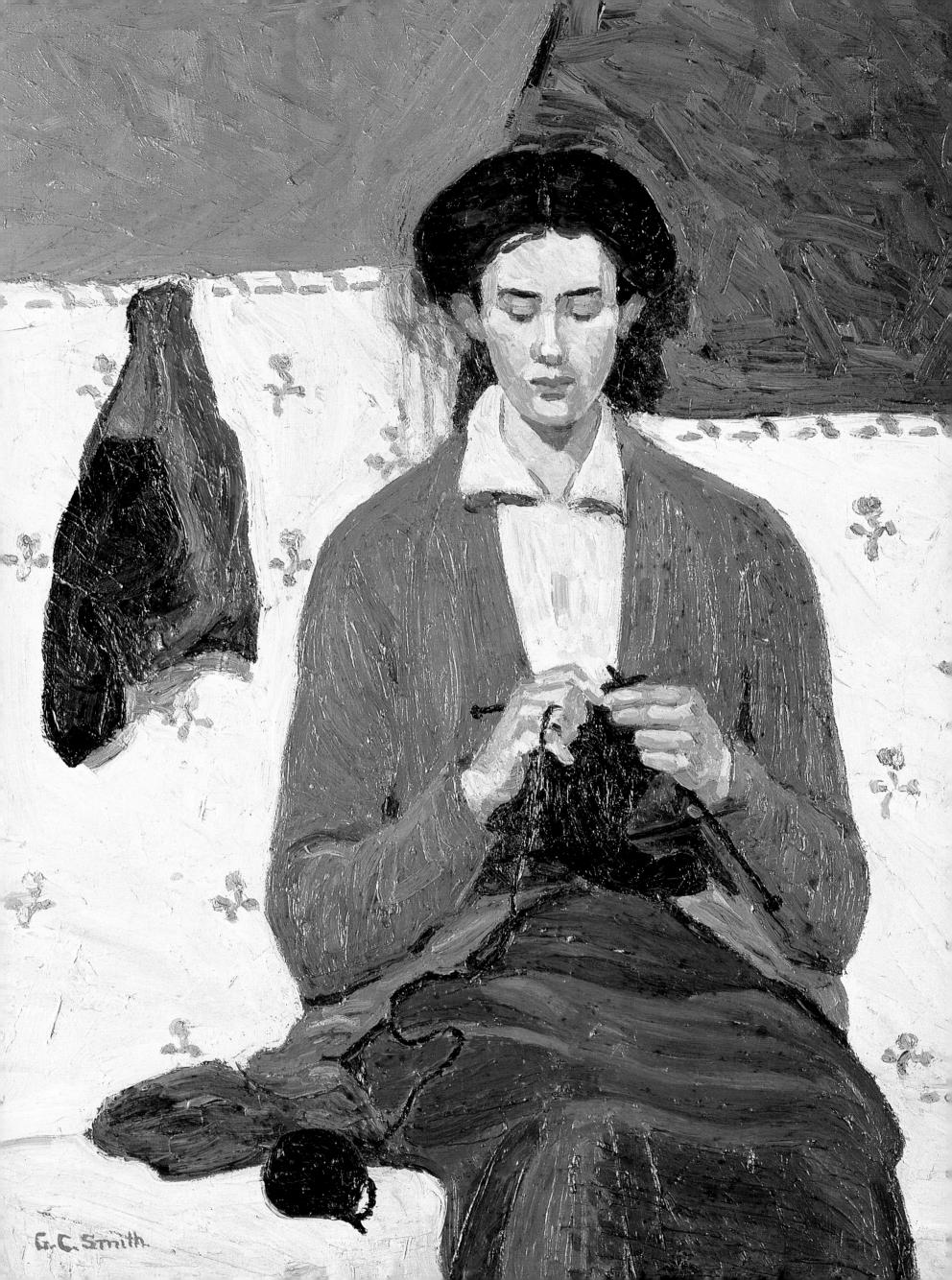

IO
Beyond Europe
The Commonwealth of Modernism

One of the principal reasons for the rapid success and dispersal of Modernism was its adaptability. It encompassed multiple—and multiplying—idioms throughout the world. In the areas of British influences, it took several directions. At the turn of the twentieth century, a number of expressions grafted new influences onto old traditions. Women began to gain entry into the more progressive art schools, including the Slade School in London and the Glasgow School of Art. Although Impressionism had little impact in the British Isles, several Post-Impressionist currents from the Continent attracted interest.

In Scotland, the Macdonald sisters, professional artists, combined Art Nouveau elements with imaginative symbolism in their painting and design work. The art of Margaret Macdonald (1864–1933) and Frances Macdonald (1873–1921) is unique for its style, subject, and collaborative nature. Shortly after enrolling at the progressive Glasgow School of Art in 1890, the sisters opened their own studio. Inspired by the sophisticated and eccentric strains of Art Nouveau, their compositions—more popular abroad than at home—featured ethereal figures, stylized plant forms, and acidic colors that earned them the epithet the "spook school." Collaborating in the mid-nineties with artist-architect Charles Rennie Mackintosh and the artist Herbert MacNair (who became their respective spouses), Margaret and Frances Macdonald were invited to exhibit their multimedia works—variously combining paint, glass, metal, wood, and stitchery—in London, Vienna, and elsewhere. Mackintosh featured Margaret's *O Ye, All Ye that Walk in Willowwood* (1903–04), a painted panel overlaid with glass beads and twine, as the decorative centerpiece of the high-concept Willow Tea Room he designed in Glasgow.

Katharine Cameron (1874–1965), more in tune with the kind of modern painting that Glasgow patrons found acceptable, was the sister of Sir David Young Cameron (1865–1945), one of the "Glasgow Boys" who had made Glasgow an art center of renown. She studied at the Glasgow School of Art and in Paris, and was an accomplished etcher as well as a painter in oils and watercolor. In the course of her long career, Cameron was elected to membership in both the Royal Scottish Watercolor Society and the Royal Society of Painter-Etchers. Among her most personal and elusively beautiful works are watercolors of flowers, such as *Still Life with Roses in a Glass* (1894), which often included butterflies or bees, rendered with the utmost delicacy and confidence.

Norah Neilson Gray (1882–1931) seized on more contemporary currents in art during her training in Glasgow under a Belgian symbolist. She built a reputation as a portrait painter and earned numerous medals in London and Paris as well as at home. Some of Gray's strongest works came out of her experiences as a volunteer nurse in the Scottish Women's Hospital in France during World War I. *The Belgian Refugee* (1916) shows the solid, deep-colored shadows that were Gray's signature.

Vanessa Stephen Bell's (1879–1961) home attracted London's forward-thinking intellectuals, the multi-faceted and fascinating "Bloomsbury group." Central to the group were her sister and brother-in-law, Virginia (Stephen) Woolf and Leonard Woolf, and Vanessa's husband, the art critic Clive Bell, all of whom were influential in bringing both literary and artistic Modernism to England. As unconventional in her life as in her art, Vanessa Bell carried on liaisons with other Bloomsbury figures, including Roger Fry, who brought pictures by Paul Cézanne, Paul Gauguin, Henri Matisse, and Pablo Picasso to England. Bell designed fabrics and furniture for Fry's avant-garde Omega Workshop, and he hung her daringly abstract paintings alongside contemporary French works. Her distillation of form and color so apparent in the 1916 portrait of her friend and Omega supporter Mary Hutchinson reveals her interest in Cézanne especially.

Gwen John's (1876–1929) introspective figures in interiors are related to works by the French Symbolist painter Édouard Vuillard, and to Picasso's Blue Period paintings. John, like her brother, the artist Augustus John, studied at the Slade School; she would continue to exhibit in London even after 1904, when she moved to Paris. Although she had an intense and stormy relationship with Rodin, there is a reclusive quality in the recurring themes she painted—simple rooms and single figures sitting or reading. Yet her subjects interested her less than the problem of constructing and balancing forms and tonal values. For many years an American patron, John Quinn, bought all that she would sell, including *Girl Reading at the Window* (1911). In this characteristic light-filled composition, probably a self-portrait, lemony walls contrast sharply with the figure's dark dress, whose curve then echoes the floating curtain.

Outside the art centers of London and Glasgow, artists in the British Isles still portrayed contemporary life in more traditional terms. This was the case of Dame Laura Knight (1877–1979), who in 1907, with her husband, the painter Harold Knight, settled at Newlyn, a fishing village in southwestern England that had become home to a number of prominent artists. A trained artist, throughout her long life Knight painted what interested her. Her canvases, which were often quite large, were peopled with children and friends, as well as with gypsies and theatrical performers. Ebullient responses to the more casual tenor of modern life, Knight's local scenes, whether rocky beaches or circus acts, are sensitive but unsentimental portrayals, filled with light and color. During World War II she painted fighter pilots and women factory workers; afterward, she was invited to record her impressions of the Nuremburg trials, which she experienced as an "extraordinary event."

Knight's 1913 *Self-Portrait with Nude*, a highly unusual twist on two traditional subjects, was a statement of her seriousness of purpose. In 1929 she became the first female artist to be made a Dame of the British Empire.

Orovida (Pissarro) (1893–1968) developed a highly personal, decorative style of animal painting that was quite different from the far better-known work of her artist father, Lucien Pissarro, and grandfather, the popular Impressionist Camille Pissarro. Orovida, as she preferred to be known, was influenced by Japanese, Indian, Persian, and other Asian art—although she admitted that her research took her no farther than the British Museum. She experimented with egg tempera and other media to achieve singular, delicate effects in paintings such as *The Archer's Return* (1931). Here, the decorative elements of authentic costumes and patterned frame are strengthened by the solidly curving composition, emphasized by the camel that appears to almost burst through the picture's surface.

The Irish artists Mary Swanzy (1882–1978), Evie Hone (1894–1955), and Mainie Jellett (1897–1944) found in the contemporary art of Paris the inspiration that was missing from their art training at home: as a student in Paris in 1906, Swanzy met Gertrude Stein and viewed her art collection. Swanzy continued exhibiting in Dublin, even though she lived there only sporadically, between the time she spent doing relief work in Eastern Europe and long excursions to Samoa, Hawaii, and elsewhere. Works such as *The Message* (c. 1945) reveal the artist's insightful synthesis of new and old influences—Cézanne and the Cubist landscape with Italian Renaissance painting.

Hone and Jellett were drawn to abstraction in the early 1920s, after studying in Paris with the Cubists Albert Gleizes and André Lhote. Jellett's *Abstract* (1922) is based on their theories, "translating" and "rotating" an object to show its various surfaces. These modern pictures met with general disapproval among Irish patrons, who preferred more familiar figurative subjects. Eventually, though, aspects of the new art, such as the simplification of objects and landscapes, were accepted, and for its 1939 World's Fair entry, the government commissioned from Jellett a Cubist-style painting of horses, a powerful—and traditional—symbol of Ireland.

Hone, who became known for her work in stained glass, adopted a more accessible expressionism, visible in later paintings such as *Landscape with a Tree* (1943). Still, her works found little general acceptance, prompting Jellett to form in 1943 the first Irish Exhibition of Living Art, to promote Modernism in that country. Jellett never lived to see her efforts come to fruition: she died of cancer before the exhibition opened.

In colonies distant in miles from Great Britain, but close to the motherland in spirit, female artists received traditional instruction at schools and academies. Those who could continued their formal studies in Europe, but they also traveled throughout the European continent, exploring great works of the past and present, and discovering firsthand exciting and controversial contemporary expressions. Over the decades, many women brought these idioms home; some artists remained within the European modernist current, while others altered the course of their national art by adapting Modernism to the complex identity of their environment, and to the tumultuous historical events they experienced. As the colonies asserted their independence, as history became global, new fusions of art and culture emerged in the sunset of the British Empire.

Emily Carr (1871–1945), one of Canada's best-known painters, was born in Victoria, B.C. She studied and lived in California, England, and France, where she absorbed the lessons of Impressionism, Post-Impressionism, and Fauvism. Preferring rural life to city life, she returned to western Canada, journeying into remote areas to preserve images of historic totem poles being lost to decay. Carr's vision of landscape painting was transformed when she attended a 1927 national exhibition of works by the so-called Group of Seven, an enclave of male artists who would later exclude Carr and other female painters. In works such as *Old Time Coast Village* (1929–30), dark, draping tree forms enclose a native village, whose intrusion on nature is minimal. Carr's deep, contrasting colors and shadowy forms expressed a spiritual presence that she believed dwelt within the forest. Elsewhere in her work, using subtle means of protest—barren stumps and scrawny pines climbing skyward—Carr occasionally hinted at the devastation caused by clearcutting in the great forests. Following a heart attack in 1937, at a moment when her paintings were gaining recognition, Carr began writing and in the following years earned literary prizes for a book about her experiences as a painter among Canada's native peoples.

Anne Savage (1896–1971) and Sarah Robertson (1891–1948) were among the Beaver Hall artists who banded together in Montréal to share studio and exhibition space. Although influenced by the Toronto-based all-male Group of Seven—with whom they shared at least one member, A. Y. Jackson—the Beaver Hall painters addressed a variety of subjects in a number of styles, and exhibitions of Canadian art tended to include works by both groups. Savage was a school teacher who devoted her summers entirely to painting, including an excursion into British Columbia to record decaying totem poles, a project similar to and exhibited

with Carr's. Influenced and encouraged by A. Y. Jackson, Savage lovingly portrayed the rambling Québec landscape: in *The Plough* (1931), the plough dominating the foreground is emblematic of human activity, while the rolling hills are carefully built up into textured and colored shapes. Sarah Robertson's approach to landscape, infusing color and rhythmic lines into expressive compositions, was more poetic and decorative. Her bright banners set a high tone for the brilliantly colored trees in *Coronation* (1937), commemorating the coronation in England of King George VI.

Margaret Preston (1875–1963) and Grace Cossington Smith (1892–1984) tried to import Modernism into Australia, in the face of a strong popular preference for traditional academic painting. At the same time, because they preferred still lifes and quiet interiors, still considered women's subjects, the innovative qualities in their paintings generally were dismissed by contemporary critics. This was the case, for example, with Cossington Smith's *Sock Knitter* (1915): this picture of a woman contributing to the war effort, a strong composition with boldly painted flat areas of color, was later considered the first modernist painting to be exhibited in Australia.

Margaret Preston spent many years in Europe studying with the New Zealander Francis Hodgkins, among others, before returning to Australia. As a young woman, Preston deliberately focused on painting still lifes, declining opportunities for the nude life-study classes that women before her had fought so hard to attend. In works such as *Thea Proctor's Tea Party* (1924) she applied the modernist principles she distilled from sources as varied as Cézanne's Cubism, Japanese prints, and Roger Fry's Omega Workshop. Until her marriage at age forty-five, Preston supported herself as a teacher so that she could paint as she wished and not be tempted to appeal to the public's taste. She also did much to promote interest in Aboriginal art and designs, not as a curiosity, but as an essential aspect of her culture. Her still lifes, too, celebrated native plants and flowers.

Frances Hodgkins (1869–1947) lived in two worlds for many years, traveling back and forth between New Zealand and Europe, studying, teaching, and sending works, mostly watercolors, home for exhibition. The first woman to teach at the Académie Colarossi in Paris, Hodgkins also opened her own school in that city. For a time she worked in the impressionist style, influenced mostly by Morisot and Cassatt, whose renowned mother-and-child pictures may have inspired Hodgkins's popular "Maori madonnas," paintings of indigenous New Zealanders. In England after World War I, she was attracted increasingly to contemporary art practices, but her work of the next decade failed to gain acceptance in New Zealand. Hodgkins ceased exhibiting in her native country and thenceforth made her home in England.

The story of Hodgkins's friend Edith Collier (1885–1964) is a sad one, and unfortunately all too representative. Having learned what her New Zealand teachers had to offer, she was reluctantly sent by her family to England to further her education. Taken first under Margaret Preston's wing, then Hodgkins's, Collier, like her mentors, used flat color and outlined forms. Paintings like *Ministry of Labour, The Recruiting Office for Women* (c. 1916–1917), an energetic composition that celebrates women's contributions to the war effort, gave way to more experimental canvases, with simplified forms and bolder color. When, after nine years, she returned home, her father destroyed many of her English paintings. In the New Zealand art world, critics were crying out for more contemporary art expression, yet they savaged Collier's British works in favor of somber, highly traditional depictions of Maoris and other conventional subjects. Disheartened, Collier abandoned painting altogether.

The South African–born Irma Stern (1894–1966) was sent to Germany for her education, which eventually included art school. She met and admired Max Pechstein, and was deeply influenced by German Expressionism generally. Stern's early journal illustrations contain distorted nudes and other figures, perhaps an adaptation of Expressionism to the looming threat of war. This tortured intensity would characterize her oeuvre, coloring her formal modernism and often infusing the personal, the political, and aspects of South African tribal cultures. She sought untouched African edens to depict in her landscapes, like *Umgababa* (1922). In this study in contrasts, a tribeswoman carries her burden on her head alongside the newly laid railroad track that careens through the picture's center.

Bertha King Everard (1873–1965) did her early art training in England, where she specialized in landscape painting. After returning home to South Africa, Everard continually explored ways to translate to canvas the sometimes harshly splendid, familiar rural landscapes. Her early modernist style was strongly intuitive: in *Lekkerdraai I* (1934–35) thick areas of luminous color were applied with a knife to form the elements of an uninhabited landscape, made clear and dreamlike in the evening light. A schoolteacher, Everard painted sporadically, taking time out to raise a family, including two daughters who became artists.

Opposite:
Emily Carr. *Old Time Coast Village.* 1929–30. Oil on canvas. 36 x 50 ¹¹⁄₁₆ in. (91.3 x 128.7 cm). Vancouver Art Gallery/ Trevor Mills.

Right:
Sarah Robertson. *Coronation.* 1937. Oil on canvas. 34 x 24 in. (86.3 x 61 cm). Art Gallery of Hamilton, Ontario. Gift of H.S. Southam, Esq., C.M.G., LL.D., 1951.

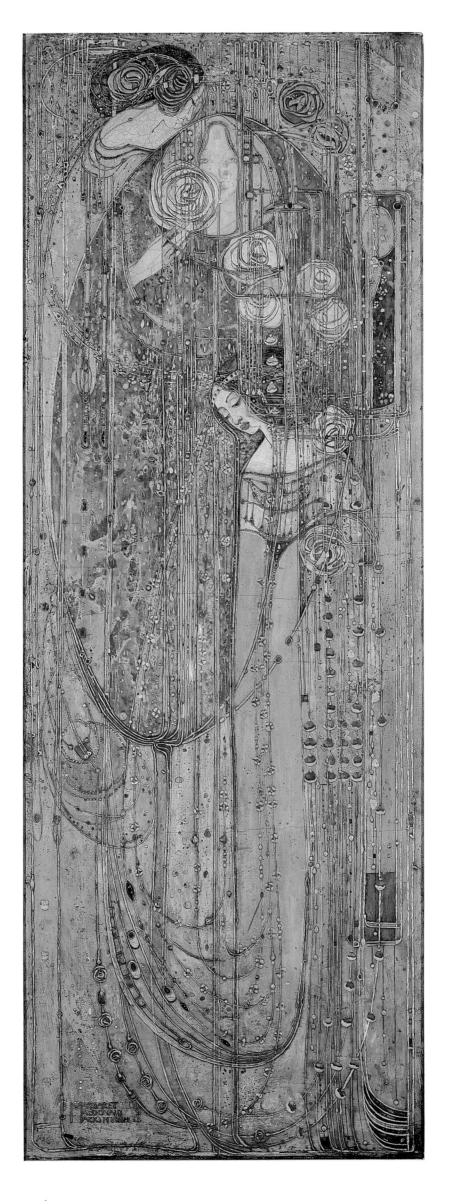

Left:
Margaret Macdonald
Mackintosh. *O Ye, All Ye that Walk in
Willowwood.* 1903–04. Painted gesso
on hessian with glass beads. 64 ¾
x 23 in. (164.5 x 58.4 cm). Glasgow
Museums: Art Gallery and
Museum, Kelvingrove.

Opposite:
Frances Macdonald Macnair.
Spring. 1897. Pencil and gouache
on vellum with beaten lead frame.
17 ¼ x 15 ⅛ in. (43.8 x 13 cm).
Glasgow Museums: Art Gallery
and Museum, Kelvingrove.

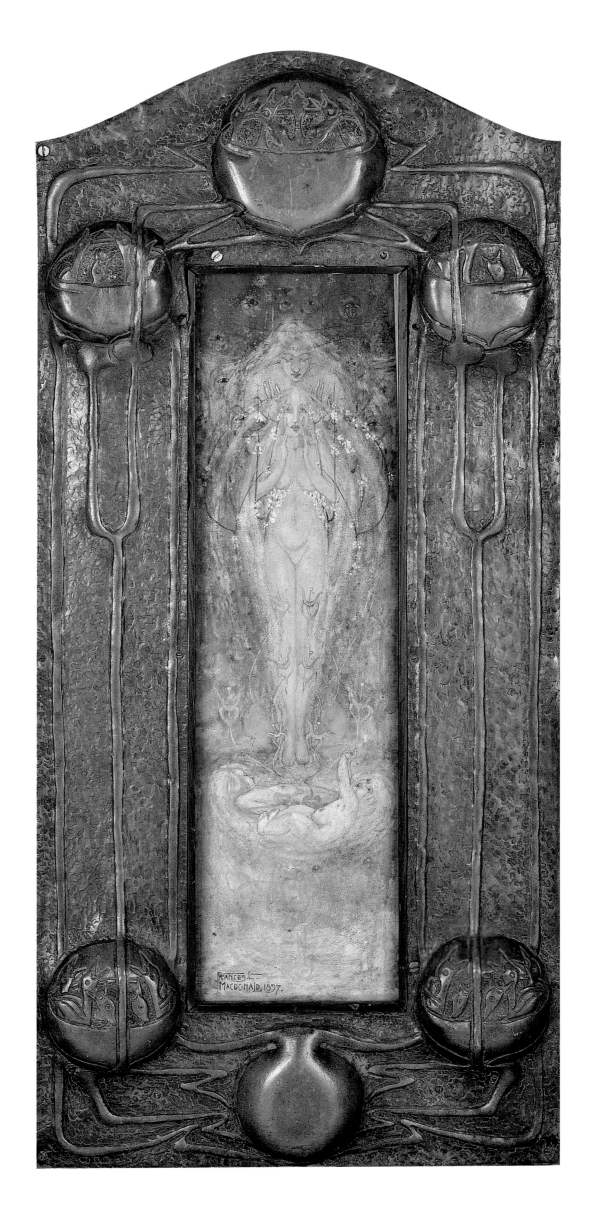

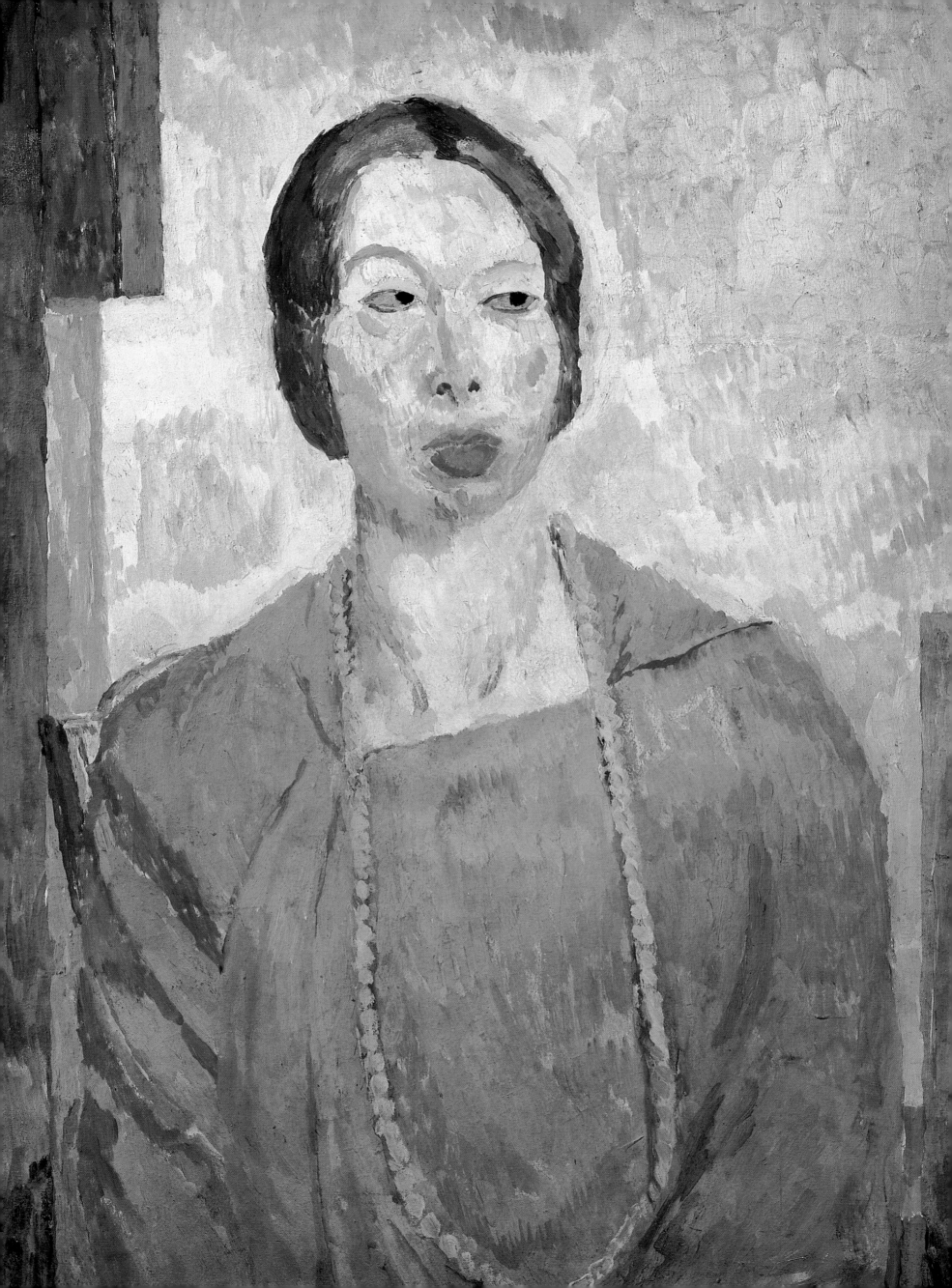

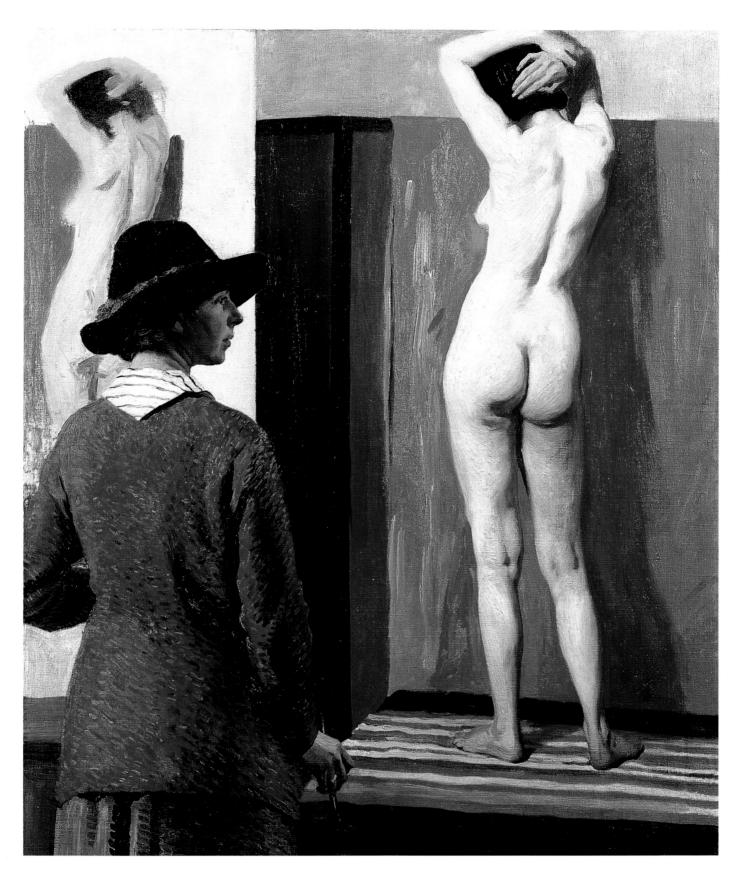

Opposite:
Vanessa Bell. *Mrs. Hutchinson.* 1915.
Oil on canvas. 29 x 22 ¾ in. (73.7
x 57.8 cm). Tate Gallery, London.
© Estate of Vanessa Bell 1961,
courtesy Henrietta Garnett.
Photograph: Tate Gallery,
London/Art Resource, N.Y.

Above:
Dame Laura Knight. *Self Portrait
with Nude.* 1913. Oil on canvas.
60 x 50 ¼ in. (152.4 x 127.6 cm).
Courtesy of The National
Portrait Gallery, London.
Reproduced with permission
of Curtis Brown Ltd. London,
on behalf of the Estate of
Dame Laura Knight. © Dame
Laura Knight.

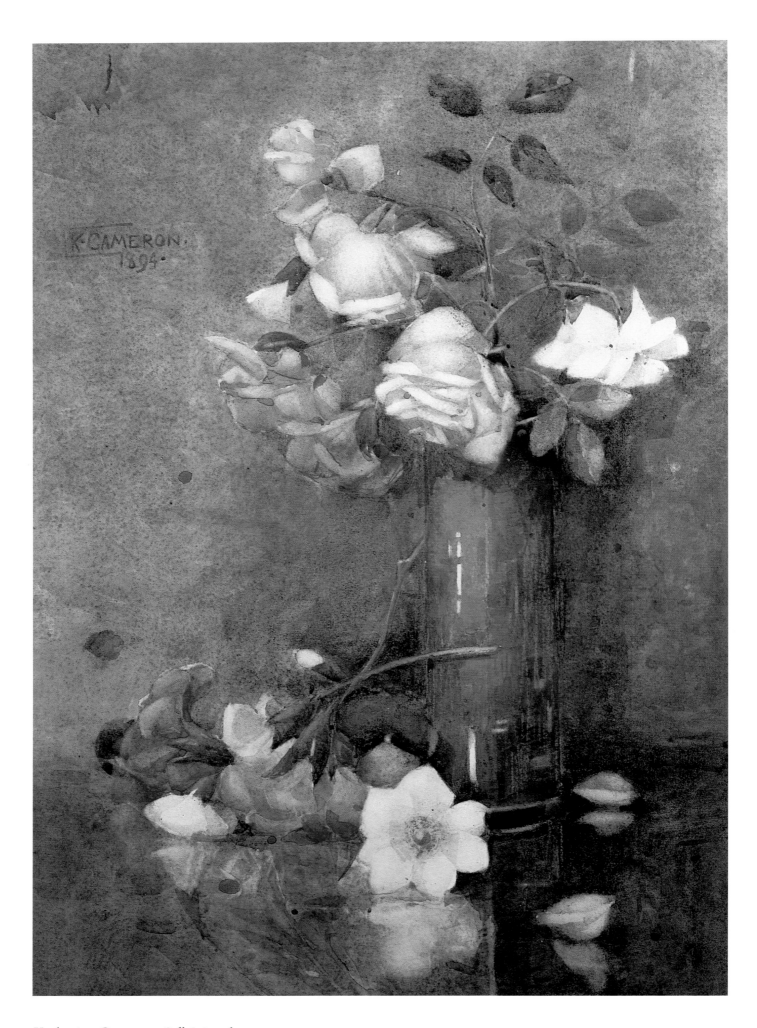

Katherine Cameron. *Still Life with Roses in a Glass.* 1894. Watercolor on paper. 21 ½ x 12 ½ in. (54.6 x 31.7 cm). Private collection. Bourne Fine Art, Edinburgh. Photograph: Bridgeman Art Library, London/New York.

Above:
Mary Swanzy. *The Message*. c. 1945.
Oil on canvas. 17 ¾ x 21 ¼ in.
(45 x 54 cm). Collection Miss. M.
Tullo. Courtesy of Hugh Lane
Municipal Art Gallery, Dublin.

pp. 142-43
Orovida Pissarro. *The Archer's
Return.* 1931. Tempera on linen.
44 x 63 in. (112 x 160 cm).
Ashmolean Museum, Oxford.

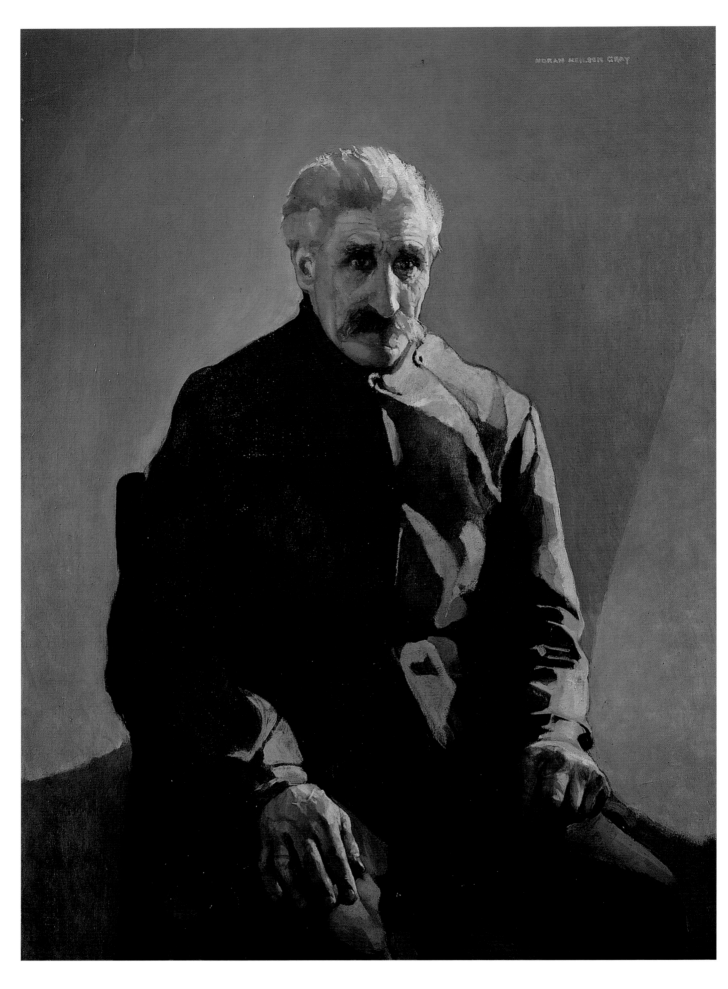

Above:
Norah Neilson Gray. *The Belgian Refugee*. 1916. Oil on canvas. 49 ½ x 34 ½ in. (125.7 x 87.6 cm). Glasgow Museums: Art Gallery and Museum, Kelvingrove.

Opposite, above:
Anne Savage. *The Plough*. c. 1930. Oil on canvas. 30 x 40 ¼ in. (76.4 x 102.3 cm). The Montreal Museum of Fine Arts. Gift of Arthur B. Gill. Photograph: The Montreal Museum of Fine Arts, Brian Merrett.

Opposite, below:
Mainie Jellett. *Achill Horses*. 1939. Oil on canvas. 24 x 36 ¼ in. (61 x 92 cm). Courtesy of The National Gallery of Ireland, Dublin.

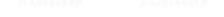

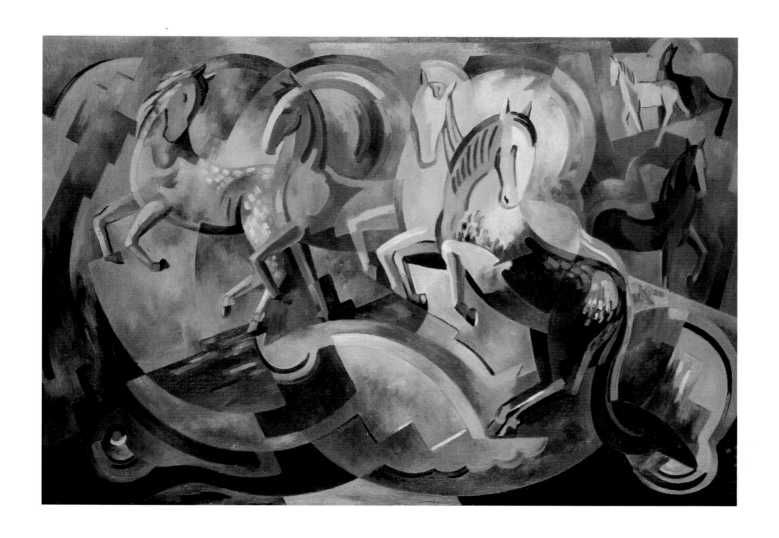

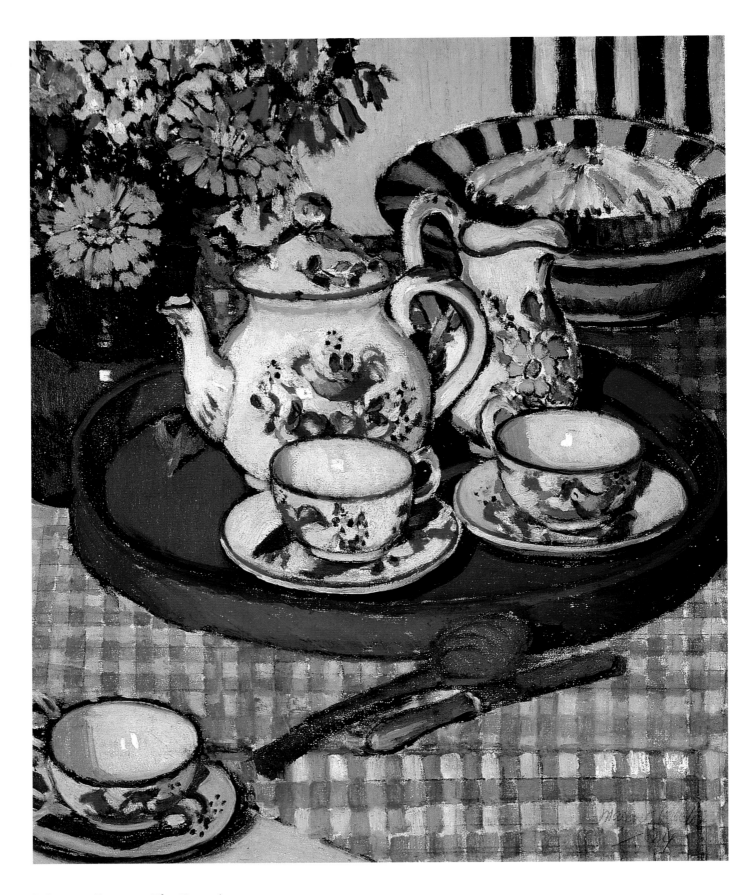

Margaret Preston. *Thea Proctor's
Tea Party.* 1924. Oil on canvas
on paperboard. 22 x 18 in. (55.9 x
45.7 cm). Art Gallery of New
South Wales, Sydney.

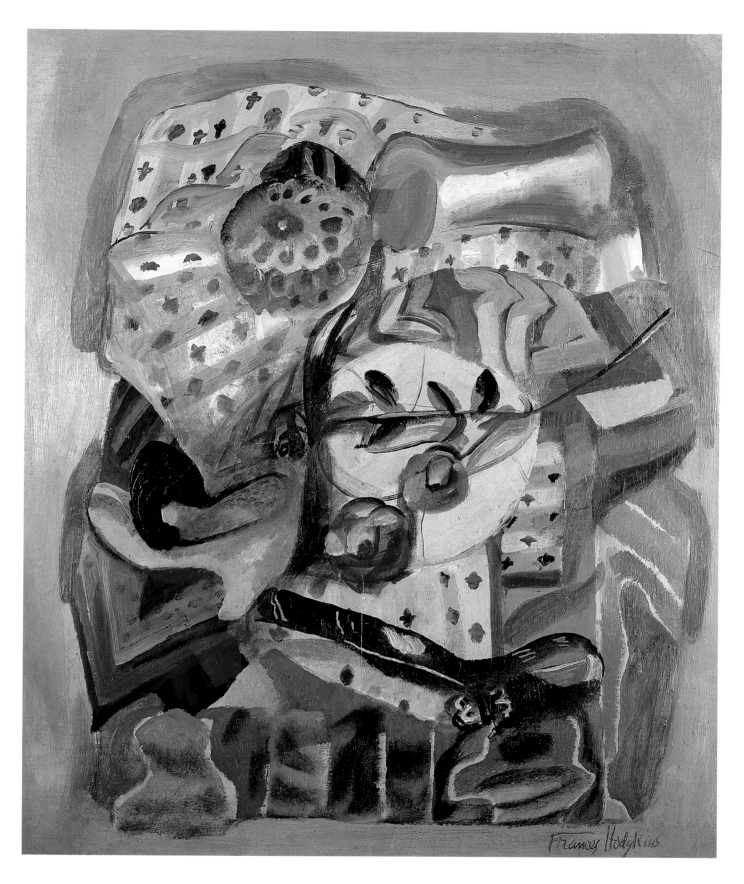

Frances Hodgkins. *Self Portrait: Still Life.* 1941. Oil on cardboard. 30 x 25 in. (76.4 x 63.5 cm). Collection of the Auckland City Art Gallery. Photograph: Toi o Tamaki.

Edith Collier. *Ministry of Labour: The Recruiting Office for Women.* 1917–18. Oil on canvas. 17 x 20 ½ in. (43.1 x 52 cm). Edith Marion Collier Loan Collection, Sargeant Gallery, Wanganui, New Zealand.

Irma Stern. *Umgababa.* 1922.
Oil on canvas. 23 ¹³⁄₁₆ x 35 ¹³⁄₁₆ in.
(60.5 x 91 cm). Courtesy of the
Irma Stern Museum, Cape Town,
South Africa.

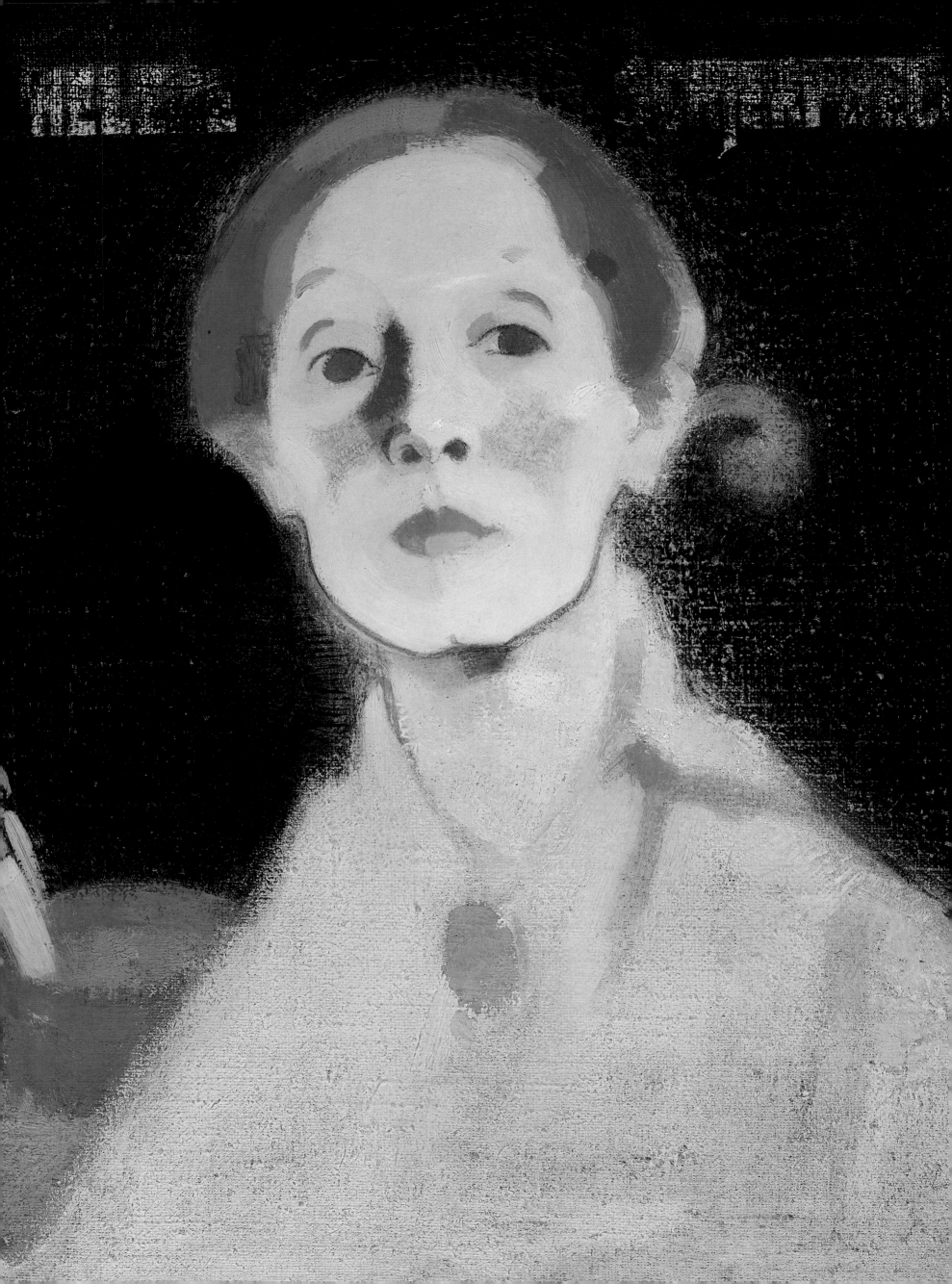

II

Northern Lights
Painters of Scandinavia

Aspiring artists from Sweden, Norway, Denmark, and Finland were studying in Munich, Düsseldorf, and Rome, in the time-honored academic tradition. After 1870 it was Paris, the center of plein-air painting and other radical researches in the effects of light and color, that attracted these artists—especially the more adventurous among them. In the close Scandinavian expatriate community that formed in Paris, unmarried artists provided friendship and support for one another, making their long stays happy and fruitful. Painters Anna Ancher and Oda Krohg, who were married to prominent artists, found themselves at the center of a lively and ever-changing group of Scandinavian artists, writers, and intellectuals, whether in Paris or at home in Christiania or Skagen.

From the Impressionism of the 1880s, many of these artists gained insights into the rendering of light that would enhance their ability to capture the nuances of the distinctive northern light and colors. Balancing the darkness that characterized works by the playwrights Henrik Ibsen and August Strindberg and the painter Edvard Munch, for example, was a longing for an appreciation of light.

More than a century earlier Ulrica Frederica Pasch (1735–1796) and her brother were instructed at home, in Stockholm, by their painter-father, Lorentz Pasch the Elder. While her brother, Lorentz the Younger, was sent to Copenhagen, then Paris, for further training, Ulrica remained at home to assist in the studio and keep house for her widowed father. In 1773, she was the only woman elected to the Swedish Royal Academy of Painters and Sculptors at its founding. Although her artistic accomplishments included portraits of leading figures of the day, the Academy also stressed her role as a model daughter, recalling Vasari's praise of Anguissola's beauty and modesty some two hundred years earlier. In Ulrica Pasch's *Self Portrait* (c. 1770), likely presented to the Academy on the occasion of her election, the artist left out brush, palette, and every sign of her profession, perhaps allowing the work itself to proclaim her proficiency. From the classic half-length pose in an imaginary landscape to the exquisitely rendered details of her costume with its lace sleeves, striped ribbon bow with a floral spray, and sheer shawl, she demonstrated her mastery of her art.

Amalia Lindegren (1814–1891) helped improve education for female artists in Sweden. Although girls were allowed to study only in the lower classes of the state art school, she was able to obtain a scholarship to study in Paris. Returning after five years of study and travel, Lindegren supported herself by painting portraits of important personages, but she was also known for her lively genre representations of idyllic country life. In fact, when the state museum purchased her *Sunday Evening in a Farmhouse in Dalarna* (1860), the event caused such a stir that it provided an impetus for opening the national art academy to women in 1863. A practical education in art, reasoned government officials, also would enable the growing number of unmarried women—like Lindegren—to earn a living.

The Norwegian Harriet Backer (1845–1932) had the financial support of a wealthy family and thus the luxury of taking years, in some cases, to depict detailed stave church interiors. Paintings such as *Barnedap i Tanum Kirke* (1892) of Norway's traditional, highly decorated country churches frequently required repeated visits to the sites to capture the perfect light. Backer had been greatly impressed by an 1883 Monet exhibition, and applied the same attention to the light and color of each painted folk art panel or post that the master Impressionist did to haystacks and poplars.

Backer's friend Kitty Kielland (1843–1914) was also dedicated to rendering the changing aspects of the landscape, particularly around the Jaeren plain, near her birthplace on Norway's southwestern coast. In early naturalistic paintings, made before her stay in Paris, Kielland recorded the wild plant stands that brighten the

rugged terrain. Like many Scandinavian artists, she took advantage of the long hours of summer twilight that draw people out of doors. In *Summer Night* (1886), Kielland communicates one of these perfect evenings. Beyond the deep green mountains, the creamy evening sky reflects back every nuance of light and shadow on the crystalline water. Influenced by her French experience of plein-air painting, Kielland let the light reveal — but not become — her forms and surface.

Asta Nørregaard (1853–1933) sits sewing in one of Harriet Backer's early interiors, done in Paris but with the same palette Backer used in her church paintings. Nørregaard took a more conservative path in her art than her friend, painting mainly portraits, probably because she had to earn her own living. In an 1883 self-portrait showing her at work in her studio on a large religious commission, Nørregaard advertised her skills in composition, landscape, still life, and genre. Her pastel *Portrait of Edvard Munch* (1885) shows the young artist, her friend, at age twenty-one, probably during his first trip to Paris. By splitting the background, Nørregaard acknowledges the two worlds of art that already beckoned to Munch, one of friends and figures, the other a spiritual realm, represented here by the landscape.

Anna Bröndum Ancher's (1859–1935) family owned the hotel in Skagen, a fishing village at the northernmost tip of Denmark that attracted a summer colony of artists and intellectuals. As a teenager, Ancher traveled to Copenhagen for women's art classes, but learned more at home by observing the guests. It was also in Skagen that she met and married the artist Michael Ancher and settled into a happy life as a wife, mother, and artist — many of her works are domestic interiors. She is sometimes compared with Berthe Morisot for the luminous quality of her pictures as well as for her grace in combining her various roles. She was, in fact, attracted to the Impressionists, whose orchestration of light and color she admired and emulated: the subject of *Sunshine in the Blue Room* (1891) is not her young daughter sewing, but the sunlight that suffuses each object and form in the room with pure, defining color.

Oda Lasson Krohg (1860–1935) was an independent spirit. By age twenty-three she had left her husband and taken up painting to support her two children. Members of a free-thinking, Bohemian group of artists, writers, and intellectuals who embraced sexual freedom, even within marriage, Oda and her second husband, Christian Krohg, an influential artist and teacher whose pupils included Munch, were perpetual subjects of scandal. Oda Krohg's early paintings were as radical as her life. A series of aggressively angled close-ups of her young son attacking a newspaper with his scissors, including *Subscriber to "Aftenposten"* (1887), are fresh and lively compositions, while an earlier work anticipated the Symbolism the artist would encounter in France. *By Christiana Fjord* (1886) is a moody pastel, depicting either Oda or her sister at the family's summer home, contemplating the merging blues of sea and sky. Instead of moonlight, a Chinese paper lantern overhead is reflected in an open window, capturing the dreaminess of a summer evening.

Helene Schjerfbeck (1862–1946) spent most of the 1880s abroad, studying and painting. As she grew more self-assured, she undertook large paintings intended for public display; one of these, *The Convalescent* (1888), is an autobiographical depiction of a sickly child. Back home in Helsinki, burdened with family responsibilities and financial difficulties, she taught art and painted what she saw around her. In 1902, Schjerfbeck moved to a remote, rural village, where for more than twenty years she cared for her mother, a gloomy woman with no interest in art; Schjerfbeck kept up with trends in art and fashion through periodicals sent by friends. Transferring her own melancholy into haunting, ostensibly simple still lifes, portraits of her mother reading, and self-portraits, she developed a spare modernist style that reduces forms to light and shadow with evocative dabs of color. Nowhere is Schjerfbeck's development as an artist more evident than in the dozens of self-portraits she executed over sixty years. Documenting changes in both the artist and art history, they begin in 1885 in Paris with a light-filled impressionist image of a clear-eyed young painter, and end in 1945 with a masklike abstraction. In spite of her isolation, a 1915 *Self Portrait with Black Background* proclaims this artist's indomitable style and spirit. Commissioned by the Finnish Art Association and unique among her self-portraits in its inclusion of paint brushes, it reveals the artist as a fully confident being, both demanding and ignoring the viewer's attention.

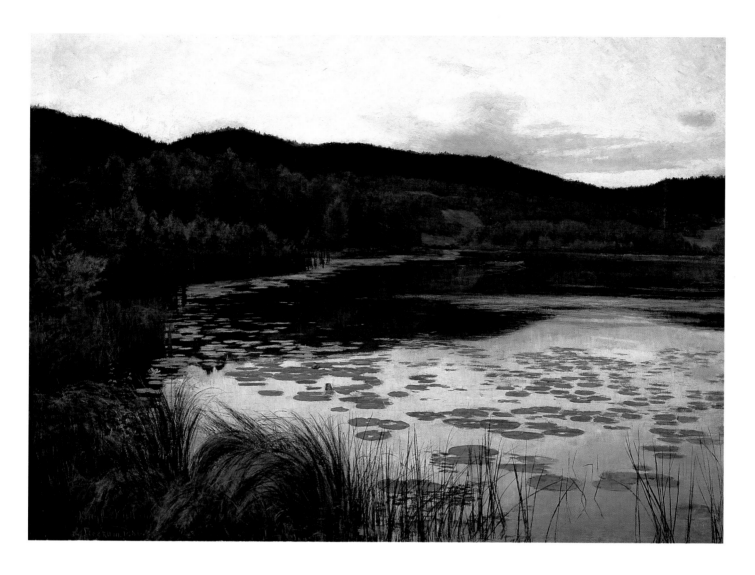

p. 150:
Helene Schjerfbeck. *Self Portrait on Black Background.* 1915. Oil on canvas. 17 ¹⁵/₁₆ x 14 ³/₁₆ in. (45.5 x 36 cm). The Finnish National Gallery Ateneum, Helsinki. Photograph: The Central Art Archives/Hannu Aaltonen.

Above:
Kitty Kielland. *Summer Night.* 1886. Oil on canvas. 39 ½ x 53 ⅜ in. (100.5 x 135.5 cm). Nasjonalgalleriet, Oslo. Photograph: © Nasjonalgalleriet 1996/J. Lathion.

Overleaf:
Amalia Lindegren. *Sunday Evening in a Farmhouse in Dalarna.* 1860. Oil on canvas. 34 ¼ x 45 ¹¹/₁₆ in. (87 x 116 cm). Nationalmuseum, Stockholm. Photograph: Nationalmuseum, Stockholm/Bodil Karlsson.

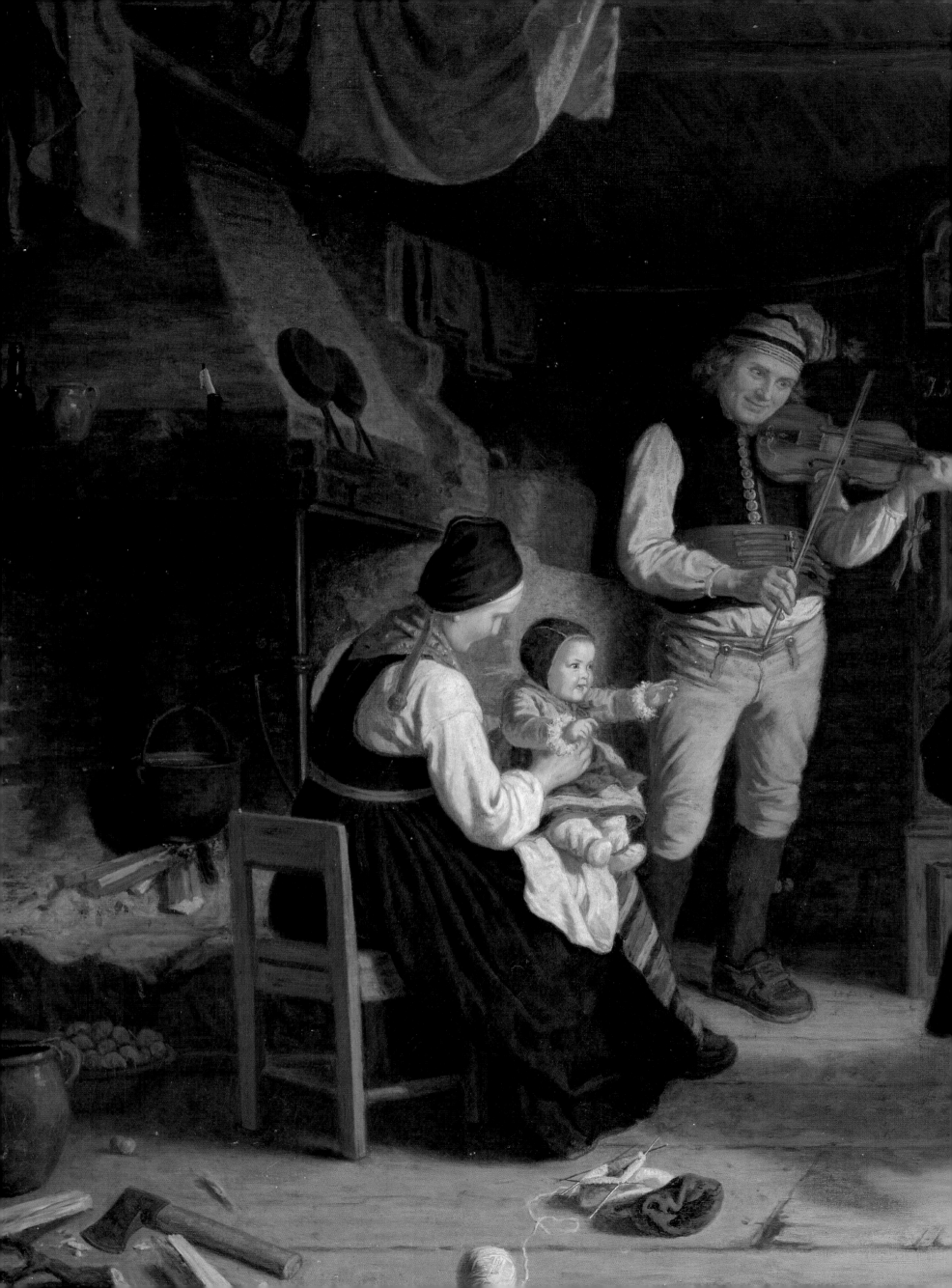

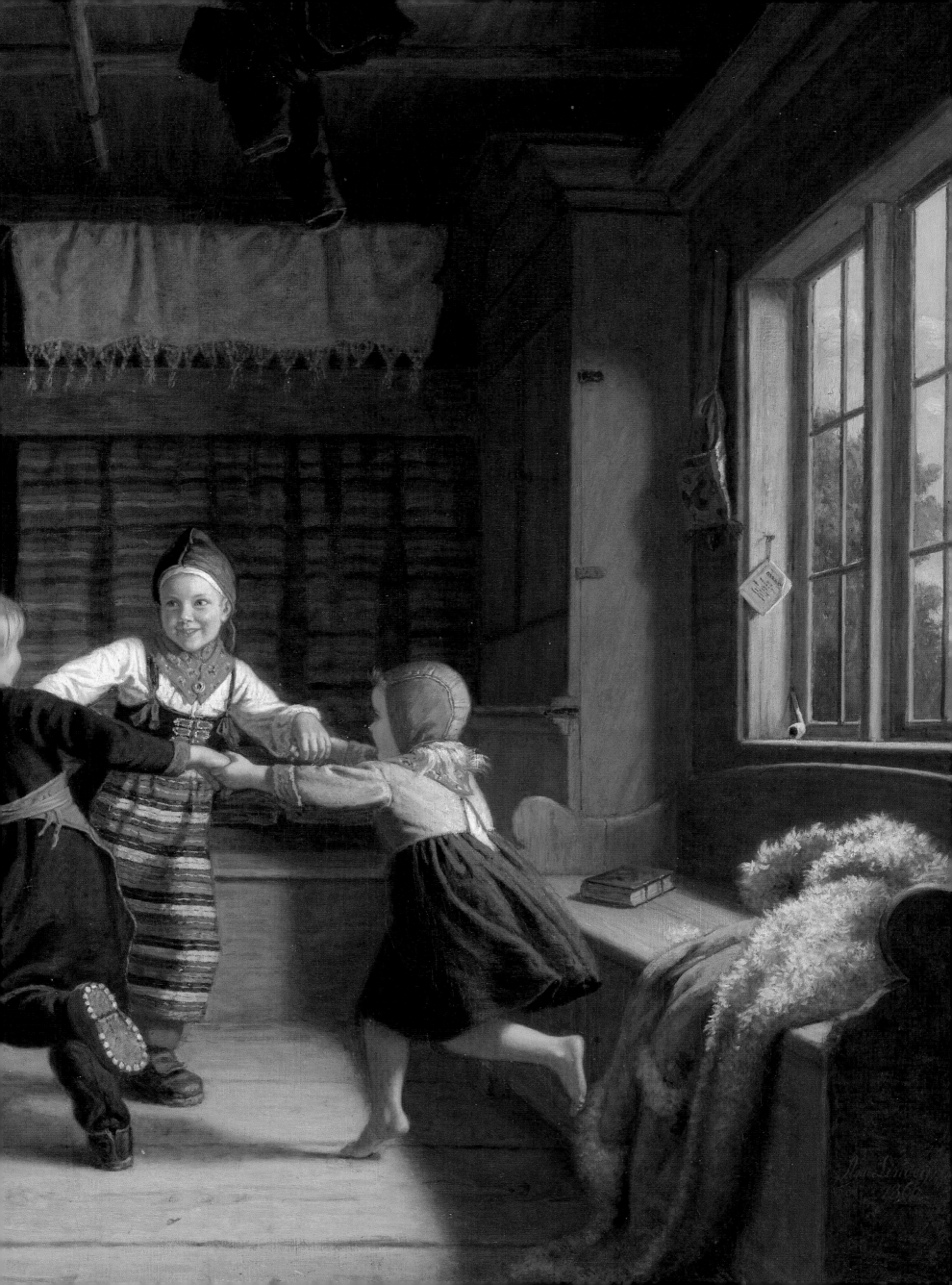

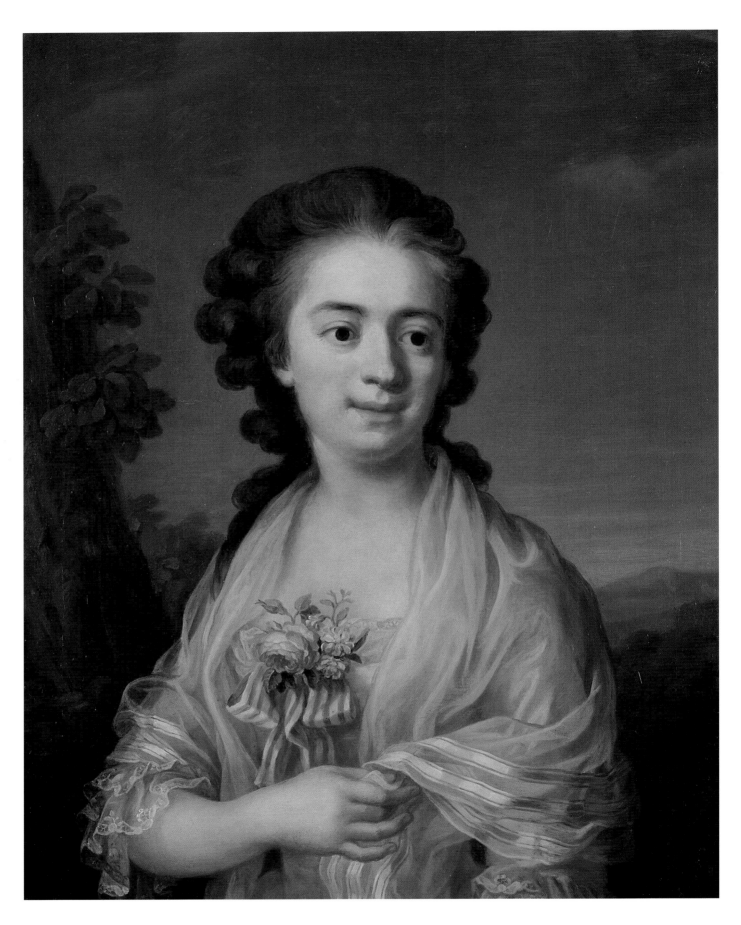

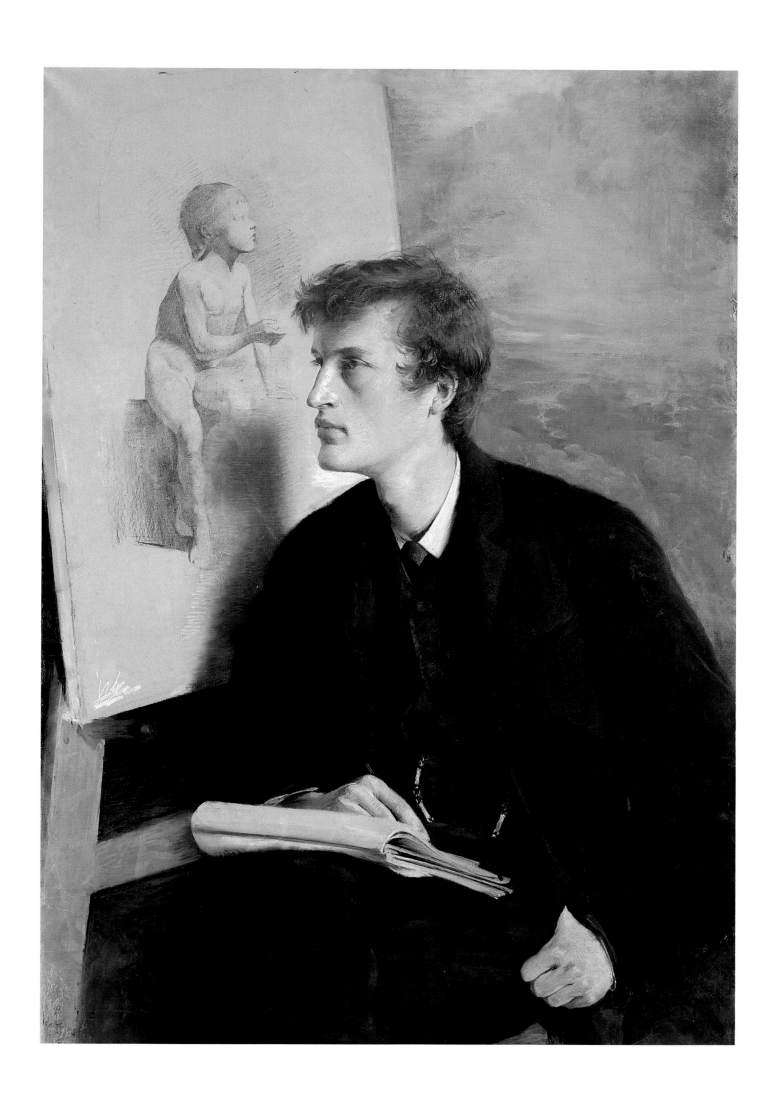

Above:
Anna Ancher. *Sunshine in the Blue Room.* 1891. Oil on canvas. 25 ⅝ x 23 ¼ in. (65 x 59 cm). The Skagens Museum, Skagens, Denmark.

Opposite:
Oda Krohg. *By Christiana Fjord (Japanese Lantern).* 1886. Pastel on paper. 39 x 26 in. (99 x 66 cm). Nasjonalgalleriet, Oslo. Photograph: © Nasjonalgalleriet 1996/J. Lathion.

12
Independent Expressions
A Dilemma of Autonomy

By the early years of the twentieth century, women were accepted by the art academies, but by then these conservative official institutions were being rejected by the period's more progressive artists. It was no longer shocking that women drew from the nude model, yet women who worked against type found it difficult to prosper. Critics would praise one painter for being thoroughly "feminine," and disparage another for portraying nudes and not flowers, or for painting "like a man." Did critics think it proper for ladies to exhibit aggressive, roughly finished canvases, in the manner of the Fauves, the "wild beasts?"

Critics reviled the male *fauves* as well, and sometimes with a similarly visceral revulsion, but female artists tended to be more financially and socially vulnerable. Likewise, history is replete with examples of older professionals mentoring younger ones; a sexual relationship with an established painter could gain a woman an opportunity for apprenticeship she might not otherwise have, as well as entrée into artistic circles. When the bond was emotional as well, the results could be harmonious, as we have seen, but it could also mean sometimes deep additional struggles.

Camille Claudel (1864–1943), educated in Paris with her brother, the poet and diplomat Paul Claudel, was twenty and already an accomplished sculptor when she entered Rodin's studio. Besides assisting him on *Gates of Hell* and other large projects, Claudel became Rodin's model and lover. With his guidance she incorporated a greater degree of movement, intensity, and drama into her own work. During the last difficult years of their relationship, Claudel maintained her own studio, separate from Rodin's; experimenting with new forms and materials, she created her finest works. She turned to themes from her own life: her feelings of abandonment because Rodin refused to make a commitment to her, the children she would never have, and her great despair over the situation. She visualizes the intensity of her desolation in *Maturity* (1907), in which the imploring young Claudel has lost hold of her powerful older lover. Rodin, in his late sixties, does not look back as he is led away in the arms of Old Age. The roughly formed drapery, contrasting textures, and powerful tension impart a sense of the artist's frenzied grief. After her final break with Rodin in 1898, Claudel's love for him turned to paranoid hatred and she became increasingly unbalanced. In 1913 her family committed her to an asylum, where she remained until her death.

Like their male counterparts, female artists more often than not were from middle-class families. Suzanne Valadon (1865–1938) was an exception. The illegitimate daughter of a seamstress, Valadon gave birth to her son, Maurice Utrillo, when she was seventeen. Although she undoubtedly refined her skills by watching the artists for whom she modeled, including Puvis de Chavannes, Renoir, and Henri de Toulouse-Lautrec, Valadon had a marked natural talent for drawing. Degas, another master draftsman, admired her boldness and honesty, taught her printmaking, introduced her to gallery owners, and became a lifelong confidant. With colors and patterns inspired by Gauguin and Matisse, *Two Bathers* (1923), a popular subject among modern artists, exhibits Valadon's preference for earthy subjects, unselfconsciously posed and forcefully drawn. Valadon's numerous affairs and friendships with influential artists gave her professional advantages available to few artists, but women were becoming increasingly visible in the art world, as in other professional fields.

The French artist Jacqueline Marval (1866–1932) was divorced and thirty when she became a student of the controversial Gustave Moreau. The works of his students Henrí Matisse, Georges Rouault, Albert Marquet, and Henri Manguin infuriated the critics, one of whom wrote that the paintings of the group looked as if they had been painted by *fauves* or *"wild beasts."* Marval's *Desire* of 1908 is in the fauve manner, a

deceptively loose style with a bold palette, but with Moreau's stylized figures and erotic edge. *Desire* differs dramatically from an earlier, strangely chaste harem scene, *Les Odalisques* (1902–03), whose success in the 1903 Salon des Indépendants led to its inclusion in the watershed 1913 New York Armory Show.

Early interiors and portraits by another French painter, Emilie Charmy (1878–1974), display a strong impressionist style. Done the same year as Marval's *Odalisques* and in shocking contrast to it, is Charmy's *La Loge* (1902–03), a brothel scene that was probably composed from a series of paintings of nudes. Degas's drawings of prostitutes in a brothel where well known in the artistic community, but a lady's public acknowledgment of this ancient institution could only be met with discomfited outrage. Charmy's subjects were consistently unorthodox and by 1906 she was using heavy outlining and bold, thickly applied colors that appeared spontaneous. Although these paintings hung near the Fauves' in exhibitions at Berthe Weill's avant-garde gallery, and in the Salon des Indépendants and Salon d'Automne, the critics' attention tended to be directed toward the male artists. Charmy's flowers, portraits, and still lifes, though neither delicate nor sweet, were considered more appropriate subjects for a woman.

Like Valadon, Marie Laurencin (1885–1956) had powerful friends to champion her art. By 1908, the poet and art critic Guillaume Apollinaire had become her lover, and she was a regular at Picasso's famous studio in the Bateau Lavoir section of Paris. Her two cubist-inspired paintings of their group, which were included in the Armory Show, immortalized both the group and the artist. Critics compared her work with that of Cassatt and Valadon—who, they said, painted too much like men—crowning Laurencin the finest woman painter. Her exemplary "feminine" style, seen in *Portrait of Madame Chanel*, features beautiful, quietly posed, doe-eyed women, and soft, pastel colors. After a period of exile in Spain during World War I—she was married briefly to a German artist—Laurencin returned to Paris and continued painting, creating theater sets and costumes as well as her confectionery portraits.

Anne Estelle Rice (1877–1959) arrived in Paris in 1905 as a fashion illustrator for a Philadelphia newspaper. She became involved with the British painter John Duncan Fergusson and with painting, adopting the daring and energetic qualities of the Fauves. (Rice was the model for Theodore Dreiser's fictional artist Ellen Adams Wrynn in his 1929 *Gallery of Women*.) To effect what she called the "natural rhythm" of her subject, in *La Toilette* (1910–11), for example, Rice used confident line, color, and decorative effects; these demonstrated her awareness of Cézanne and Matisse, but dismayed the critics. The next few years were personally and professionally difficult: she broke with Fergusson, and her paintings sold poorly in New York, in part because of the onset of the war. In 1914 Rice married a British theater critic O. Raymond Drey, and gave up the exciting life of a Paris artist. Married and the mother of a son, Rice did book illustrations, designed theater sets and costumes, and painted, but never regained the momentum she had experienced in Paris.

Economic freedom helped to compensate for the emotional scars carried by Romaine Goddard Brooks (1874–1970). Brooks's illustrated memoir, *No Pleasant Memories*, selectively recounts—and sometimes invents—events of her peripatetic and very unhappy childhood with a disturbed mother and brother. Even her escape in 1895 to art school in Rome proved problematic. When she inherited a large fortune in 1902, she felt free to leave her sham marriage to John Brooks, although she kept the name, and to paint and live as she wished. During two years in London she met the transplanted American painter and etcher James McNeill Whistler, whose influence is visible in the somber black-and-white palette that was to characterize her work. In Paris, Brooks lived openly as a lesbian with Natalie Barney, whose literary salons were frequented by numerous Parisian and expatriate artists and intellectuals, but rarely attended by the high-strung, unsociable Brooks. Less conventional than her portrait of Barney are Brooks's many paintings of the androgynous women from her world. The exotic Russian dancer Ida Rubinstein was the subject of one of Brooks's best-known paintings, *The Crossing* (1911), done in a French symbolist style. Despite the unconventional subject matter of her art, Brooks was awarded the French Legion of Honor in 1920.

Fortunately, Florine Stettheimer's (1871–1944) last wish—that her paintings be buried with her—was ignored. She was one of three eccentric sisters, members of New York's literary and artistic elite between the two world wars. Devoted to the mother who had raised and educated them in Europe, sister Ettie had a Ph.D in philosophy and wrote novels, while Carrie constructed an elaborate dollhouse with exquisite furnishings, original artworks in miniature and likenesses of their famous friends. Florine's large, candy-colored paintings of parties and events feature elaborate settings, including a garden, the grand staircase of the Metropolitan Museum of Art, and newly rising skyscrapers. Her style is personal but hardly naïve, as some critics have charged: she frequently used clusters of figures to provide a rhythmic, musical feel. Recognizable in Florine's and Carrie's gregarious works are Marcel Duchamp, Virgil Thomson, Elie Nadelman, Carl Van Vechten, Alfred Stieglitz, Georgia O'Keeffe, Marguerite and William Zorach, Gertrude Stein, Alice B. Toklas, and others. In *Family Portrait II* (1933), the Stettheimers—Florine in her customary black pantsuit, Ettie, Mother, and Carrie—remain youthful and elegant. Their home exudes a rarified, sheltered atmosphere signified by fanciful furnishings and exotic flowers, while modern life goes on and skyscrapers rise outside. Stettheimer considered her paintings private belongings and showed them only once during her life.

Frida Kahlo (1907–54) painted even more personalized images. Much admired by the Surrealists, Kahlo rejected the label, insisting that it was her reality and not dreams that filled her canvases. Crippled in her teens by a streetcar accident, Kahlo endured constant physical pain, which she rendered visible on tin and canvas. Her physical anguish, intensified by her inability to bear children, found its emotional counterpart in her two tumultuous marriages to the larger-than life Mexican muralist Diego Rivera. Of mixed Mexican and European heritage, unconventionally beautiful, and physically deformed, Kahlo essentially made art of her otherness, embracing the complex symbolism of Mexican folk and religious art, just as she adopted the typical Mexican Tehuana dress, which came to symbolize her essential being. In obsessive, challenging paintings of burning honesty and sometimes scathing wit and insight, Kahlo exposed every aspect of her life—her history, illnesses, pain, conflicts and emotions, religious beliefs, and Communist politics. *The Two Fridas* (1939), a double self-portrait of her European and Tehuana selves, exposes her broken heart over the divorce between her two marriages to her beloved Rivera. Set against a turbulent sky, the figures hold hands but are also joined by an artery that links the exposed hearts. She holds a Diego portrait doll at one end of the blood vessel, in the Tehuana Frida's lap. At the other end, the pale, Victorian Frida controls the blood loss with a pincer, choosing life.

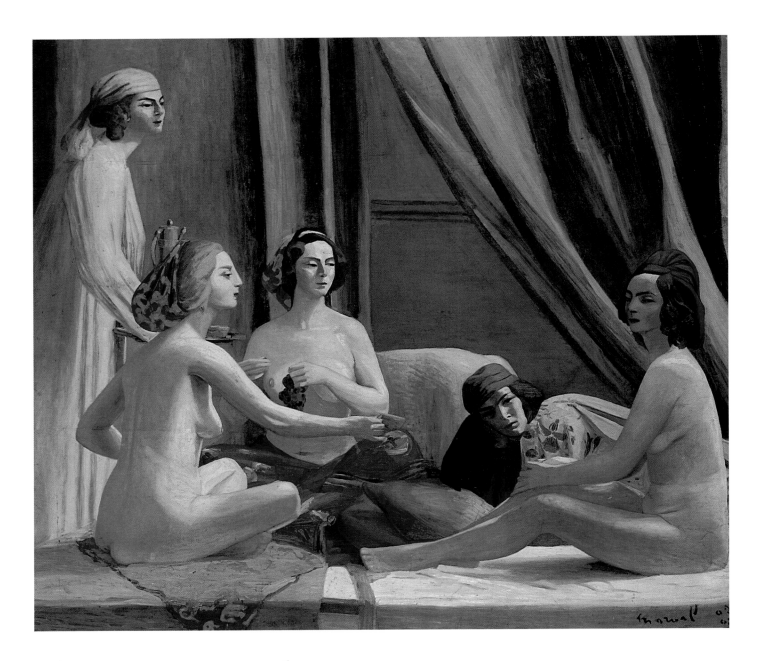

p. 162:
Frida Kahlo. *Self Portrait with Monkey*. 1940. Oil on masonite. 21 x 16 ¾ in. (53.3 x 42.5 cm). Private collection. Photograph: Art Resource, N.Y.

p. 164:
Camille Claudel. *Maturity*. 1907. Bronze. 44 ⅞ x 64 ¼ x 28 ⅜ in. (114 x 163 x 72 cm). Musée d'Orsay, Paris. Photograph: Erich Lessing/Art Resource, N.Y.

Above:
Jacqueline Marval. *Les Odalisques*. 1902–03. Oil on canvas. 77 ⅜ x 90 ¹³⁄₁₆ in. (196.5 x 230.7 cm). Musée de Grenoble.

Opposite:
Suzanne Valadon. *Two Bathers*. 1923. Oil on canvas. 46 x 35 in. (117 x 89 cm). Musée des Beaux-Arts, Nantes, France. Photograph: Giraudon/Art Resource, N.Y.

Above:
Florine Stettheimer. *Family Portrait II.* 1933. Oil on canvas. 46 x 64 ⅝ in. (117.4 x 164 cm). The Museum of Modern Art, New York. Gift of Miss Ettie Stettheimer. Photograph © 1999 The Museum of Modern Art, New York.

Opposite:
Emilie Charmy. *Still Life with Bananas.* 1912. Oil on canvas. 39 ⅜ x 29 ⅛ in. (100 x 74 cm). Musée des Beaux-Arts, Lyon, France. Photograph: Studio Basset-69300 Caluire.

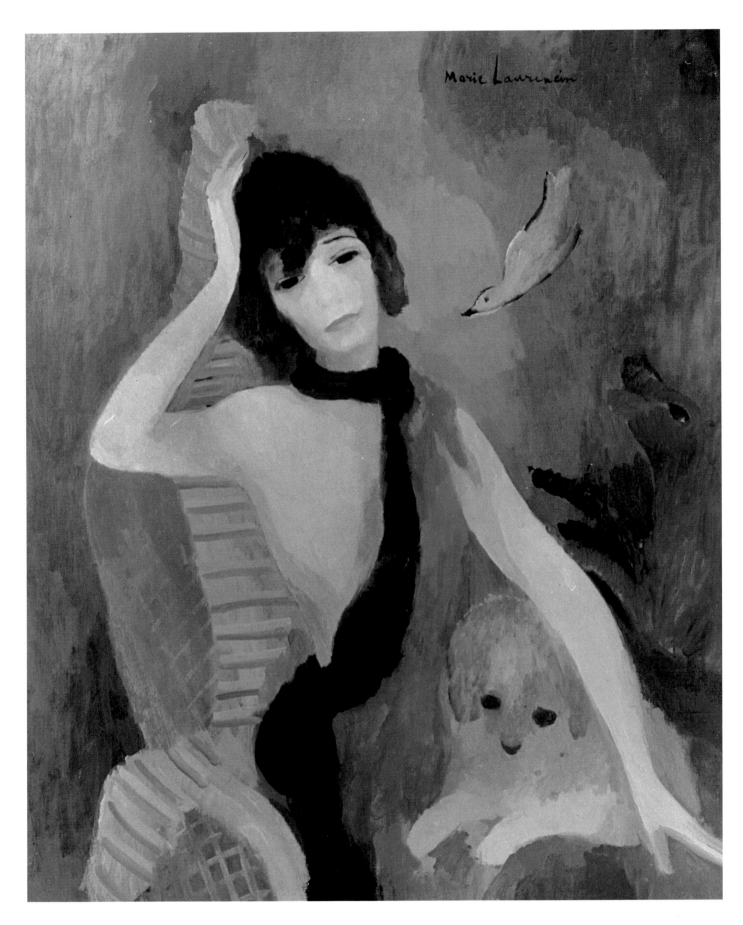

Above:
Marie Laurencin. *Portrait of Madame Chanel.* Oil on canvas. 36 ¼ x 28 ¾ in. (92 x 73 cm). Musée de l'Orangerie, Paris. Photograph: Art Resource, N.Y.

Opposite:
Anne Estelle Rice. *La Toilette.* 1910–11. Oil on artist's board. 24 x 18 in. (60.9 x 45.7 cm). Courtesy Hollis Taggart Gallery, New York.

Romaine Brooks. *Natalie Clifford
Barney* or *The Amazon*. 1920. Oil on
canvas. 33 ⅞ x 25 ⅝ in. (86 x
65 cm). Musée Carnavalet, Paris.
Photograph: Giraudon/Art
Resource, N.Y.

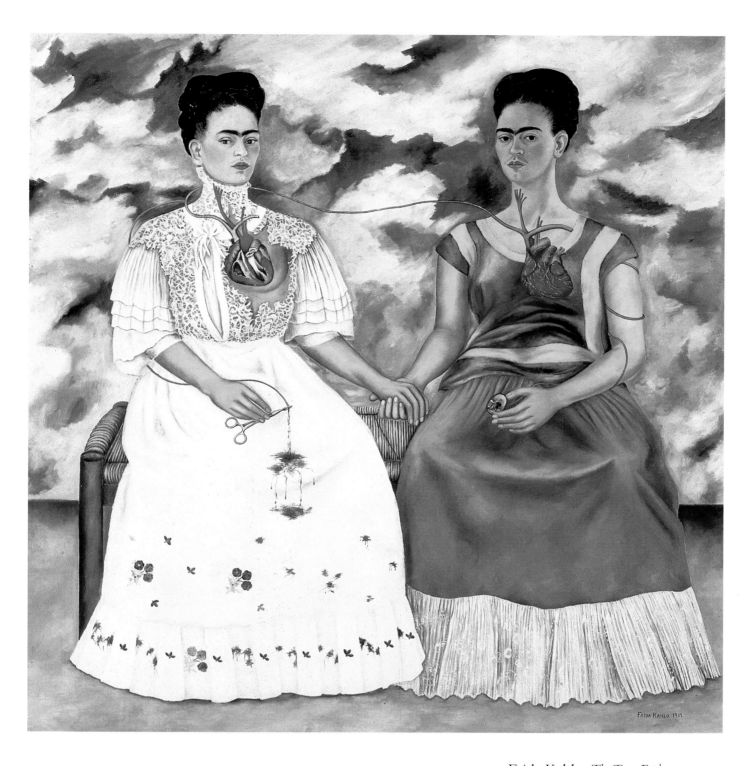

Frida Kahlo. *The Two Fridas.* 1939.
Oil on canvas. 68 x 68 in.
(173 x 173 cm). Museo de Arte
Moderno, Mexico City.
Photograph: Schalkwijk/Art
Resource, N.Y.

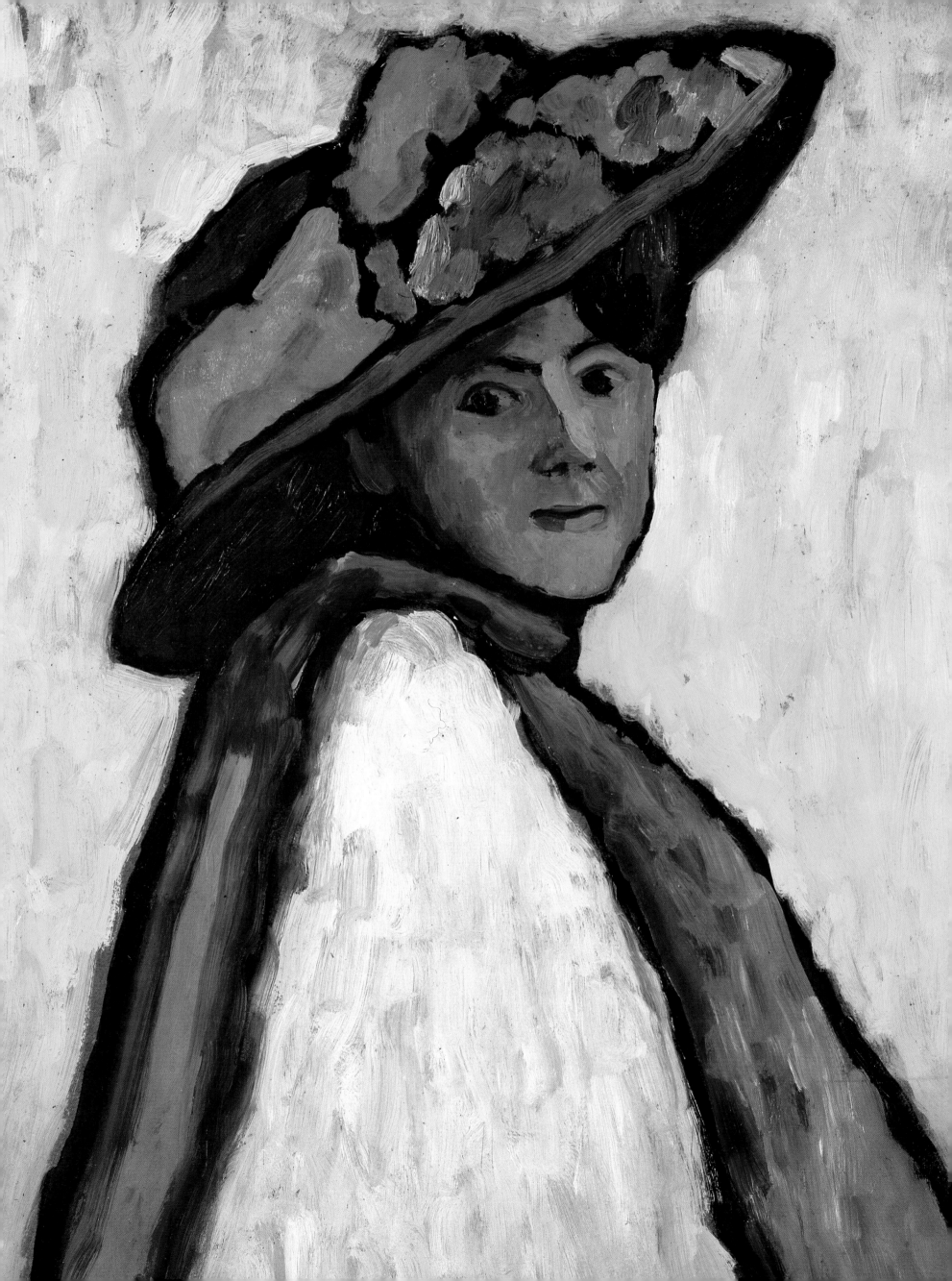

13
Collective Efforts
Art and War in Northern Europe

Naturalism, based on observation, and Realism, which sought to remove sentiment from the subject, remained important strains in northern European art, coexisting with the more avant-garde Expressionism. During the first decades of the twentieth century, German artists singly and collectively, in both artists' and women's groups, explored both traditional and new ideas.

The two world wars shook the century, and these activist artists were not exempt from their effect; many fled their home countries, taking their radical experiments with them. Much modernist German art was destroyed by the Nazis and in the bombings of World War II.

Paula Becker (1876–1907) joined the Worpswede art colony, outside of Bremen, where she met her husband-to-be, Otto Modersohn. On the first of four visits to Paris in 1900, she discovered Gauguin and Cézanne, Egyptian mummy portraits, and Gothic sculpture, and in works like *Seated Naked Girl with Flowers* (1907), she synthesized these influences, including a "weathered" texture taken from sculpture. Hers is a haunting modernism that employs simplified forms and features, harmonious colors, and decorative elements, sometimes symbolically, to convey a spiritual essence. Toward the end of her life Modersohn-Becker painted a number of nudes, including self-portraits, that are as extraordinary for their vitality now as they were then, and indeed, her letters and journals chronicle a vibrant life devoted to friends, family, and art. Modersohn-Becker gave birth to a daughter in early November 1907 and died of an embolism a few weeks later.

Käthe Kollwitz's (1867–1945) work was controversial for its political content, not its hyperbolically naturalistic style—for fifty years, in paintings, sculpture, and graphic work, Kollwitz protested the inhumanity of poverty, injustice, and war. The unflinching images in her etchings strike a universal chord. *Woman with Dead Child* (1903), a scene of feral anguish, eerily foreshadows the loss of her son, Peter, in the First World War, and of her grandson in the Second. Images of mothers sheltering their children in *The Mothers* (1921) and in her sculpted version, *Tower of Mothers* (1937–38), are equally powerful in their intimate, yet universal themes. Married to a physician who served the poor, and the mother of two sons, Kollwitz worked unremittingly, gaining international fame in her native Germany, and in Russia and the United States. Because she had been declared a "national treasure," and even though her work, along with that of Emy Roeder, Jacoba van Heemskerck, and others was included in the 1937 Nazi exhibition of "degenerate art," Kollwitz believed she could remain safely in Germany during World War II. But the outspoken Kollwitzes both lost their positions under the Nazi regime; Käthe was forced to give up teaching and her work was removed from exhibitions. Kollwitz's most representative body of work may be the series of self-portraits she began as a student and continued until ten years before her death—they map the aging of a woman with honesty, insight, and skill.

At the experimental Phalanx school, Gabriele Münter (1877–1962) took classes from Wassily Kandinsky, a Russian émigré at the center of Munich's circle of progressive artists. Münter and Kandinsky became lovers and lived as a couple, but never married. Their vacation house in Murnau, in the Bavarian Alps, was ideal for painting and became a gathering place for Alexei Jawlensky, Franz Marc, Marianne Werefkin, and the other highly expressionistic Blaue Reiter (Blue Rider) artists. Münter's and Kandinsky's interest in the Fauves and in local folk art, particularly Bavarian glass painting, led them to use heightened colors and to flatten and simplify forms, but Münter did not follow Kandinsky into abstraction. Instead, in landscapes, still lifes, and painted "snapshots," Münter took pleasure in arranging and juxtaposing objects and colors. In her *Portrait of Marianne Werefkin* (1909), Münter's dissonant colors illustrate the revolutionary ideas about "harmonious disharmonies"

that Kandinsky introduced in his groundbreaking treatise, *Concerning the Spiritual in Art* (1912). When World War I broke out, Münter waited in Stockholm while Kandinsky returned to Russia, but the relationship ended and he married another woman in Russia. Much later, after World War II, Münter and her new partner, art historian Johannes Eichner, worked to rehabilitate the reputation of the denounced Blaue Reiter and their work.

Another Russian émigré, Marianne Werefkin (1860–1938), vacationed at Murnau with her longtime partner, Alexei Jawlensky. From 1895 until the onset of World War I, their home in Munich was another gathering place for the Blaue Reiter, with Werefkin a central figure. Influenced by Jawlensky's earlier association with the French Symbolists known as the Nabis, she adopted two of that group's radical hypotheses: that before it represents a horse or any subject, a picture is "a flat surface covered with colors arranged in a certain order," and that "art is a means of communicating between souls." Werefkin's unsentimental *Washerwomen* (1909) reflects her ongoing commitment to social themes and, with its large flat, outlined areas, the principles of the Nabis. For a time Werefkin all but gave up her own work to promote Jawlensky, but she and Münter painted together at Murnau and exhibited with the men of the New Art Union (Neue Kustlervereinigung, or NKV), Der Blaue Reiter, and the groundbreaking gallery in Berlin, Der Sturm.

In 1911, Milly Steger (1881–1948) was the object of furious controversy, when four of her larger-than-life-size sandstone figures, commissioned for the Municipal Auditorium at Hagen, were labeled "obscene" and threatened with removal. Karl Osthaus, her modernist champion, called upon influential friends in Germany's art world to save the monumental nudes, which are still in place. Steger's later figures, often based on dance, would become less static, and more gestural. When Steger and Emy Roeder (1890–1971) had simultaneous exhibitions in 1922 in Berlin, critics compared Steger's "powerful" stone nudes with Roeder's "sensitive" carved figures.

Roeder thrived on the atmosphere of pre-World War I Berlin, but her admiration for folk art inspired her to move toward greater simplification and abstraction. Her angular Madonnas and family groups are infused with spirituality: a small *Crèche Relief* (1920), completed after she learned wood-carving at Oberammergau, exemplifies their strong expressive quality. Back in Berlin in 1920, Roeder married a fellow-sculptor, Herbert Garbe, but they separated in 1936, when she left for Italy on a travel award. After her sculpture was shown in the 1937 Nazi exhibition of "degenerate art" and her studio was bombed, she remained in Italy until 1949. When she returned home, she continued working and became a much-honored teacher.

Lotte Laserstein's (1898–1993) paintings were not denounced, but the part-Jewish artist moved to Sweden in 1937, after her family was harassed and she found it difficult to work in Berlin. Combining portraiture, figure studies, still life, and landscape, *The Roof Garden, Potsdam* (1928) is a masterpiece of Laserstein's detailed, straightforward naturalist style. The clothing and hairstyles of the figures date the picture to a specific moment in time, as does the look of Potsdam before it was bombed. The picture's remarkable stillness is enhanced by Laserstein's characteristically muted palette.

Jacoba van Heemskerck (1876–1923) was working toward abstraction through Cubism in Holland before she came in contact with Der Blaue Reiter in Berlin. She adopted their expressive form and color, but went even further by abandoning subject matter—even titles. In compositions like *Composition* (n.d.), the color is highly charged with emotion, as the line is with force and tension. Barely hinting at trees in a landscape, its fluid forms, suffused with color, enclose and embrace one another around a yellow core of inner light. Van Heemskerck also produced striking woodcuts, mostly semigeometric landscapes, and stained glass. She participated in avant-garde exhibitions at Der Sturm and elsewhere. Although acclaimed during her lifetime in Germany—her work was later denounced—van Heemskerck was little known in her native Holland.

Sigrid Hjertén-Grünewald (1885–1948) and Vera Nilsson (1888–1978) looked to French, rather than German Expressionism. Former students of Matisse, Hjertén and her husband, Isaac Grünewald, introduced a bold, decorative style into Sweden. Major forces in their country's Modernism, they also held joint exhibitions at Der Sturm. A 1914 self-portrait comments on Hjertén-Grünewald's multiple roles: she sits in her studio, brush in hand, surrounded by her modernist work; she is a stylishly dressed "new woman," a wife, and the mother of a son whose energy and toys occupy her professional space. The conflicting demands of her life may have contributed to the artist's occasional deep depressions and to long periods when she did not paint.

Nilsson exhibited with Hjertén-Grünewald and her husband briefly in Paris. At home, she lived in Öland, a small island off Sweden's southeast coast; her many landscapes of this region portray its bleak perspective as a brutal wasteland. An unmarried mother, Nilsson frequently painted her daughter in unsentimental portraits that explore connections by means of color and compositional relationships.

p. 174:
Gabriele Münter. *Portrait of Marianne von Werefkin*. 1909. Oil on canvas. 31 ⅞ x 21 ⅝ in. (81 x 55 cm). Städtische Galerie im Lenbachhaus, Munich. Photograph: Giraudon/Art Resource, N.Y.

Above:
Emy Roeder. *Krippenrelief (Crèche Relief)*. 1920. Wood. 13 ¾ x 11 ⅞ in. (35 x 30 cm). The Robert Gore Rifkind Foundation, Beverly Hills, California.

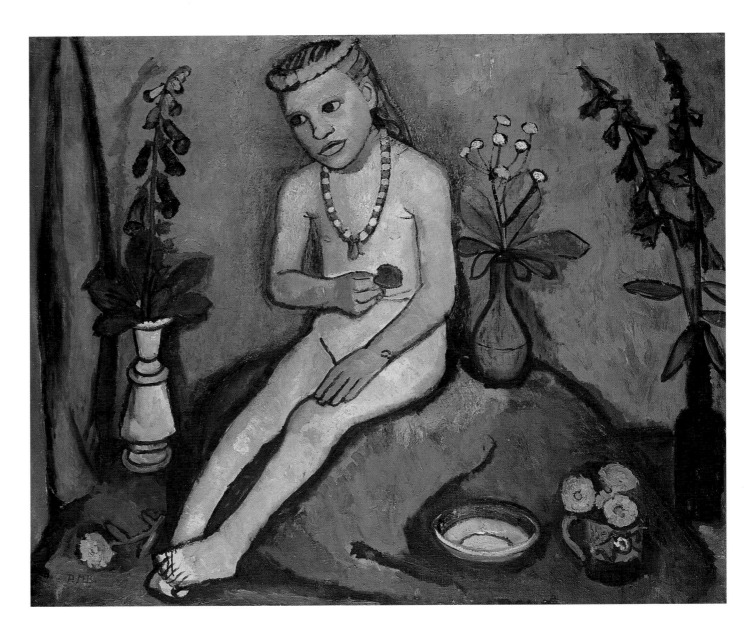

Above:
Paula Modersohn-Becker. *Seated Naked Girl with Flowers.* Oil on canvas. 1907. 35 x 43 in. (89 x 109 cm). Von der Heydt Museum, Wuppertal, Germany. Photograph: Erich Lessing/Art Resource, N.Y.

Opposite:
Paula Modersohn-Becker. *Self-Portrait on Green Background with Blue Irise*s. 1905. Oil on canvas. 16 x 13 ½ in. (40.7 x 34.5 cm). Photograph: Kunsthalle, Bremen.

Paula Modersohn-Becker

From *Paula Modersohn-Becker: The Letters and Journals*

Paris, 9, rue Campagne Première, January 18, 1900

My dear Father,

Many thanks for your two long letters. Don't look at the world and me so darkly. You will feel far better, and so will the two of us poor abused people, if only we could be left with that little bit of rosy hue which does, in fact, exist. In the end, though, it doesn't make that much difference to us.

So you are upset by my recent move? As far as order is concerned, it's a step forward. The old *hotel* furniture and carpets were worn and filthy beyond redemption. Where I am now everything is clean. Fairly empty, but pleasant. As to expense, both places are about the same.

It's almost like spring here now. I am sitting at an open window. Outside a friendly sun is shining. I am happy that we are being spared your cold weather, because the fireplaces here tend to tease much more than they actually warm us.

A few words about the Académie. Today I had my critique from Courtois. He hits the nail on the head, short and to the point. He has an eye for what I want and doesn't want to push me in another direction. I learned much from him today and am very happy. I have registered for a morning course in life drawing. At the beginning of each week Girardot and Collin come and criticize the accuracy of our work. Toward the end of the week, Courtois comes and criticizes primarily the more picturesque aspects of what we have done, our tonal values, etc. This double-teacher method here has proved to be successful; the Académie Julian also has this arrangement. And it's very agreeable to me, too.

In the afternoon there is a course in *croqui*s also from the nude in which for two hours we draw models in four different poses. This is very instructive for understanding movement. Each of us pays a fee for this course every afternoon. That way we are not bound to it, and every so often can take a trip to the Louvre instead. The Old Masters there also do their part in helping me along.

I am taking different courses than Clara Westhoff is. In fact, my style of living is totally different from hers. Enough for today. Your two letters did depress me a little. They made you sound so dissatisfied with me. I, too, can see no end to the whole thing. I must calmly follow my path, and when I get to where I can accomplish something, things will be better. None of you, to be sure, seems to have much faith in me. But I do.

Your Paula

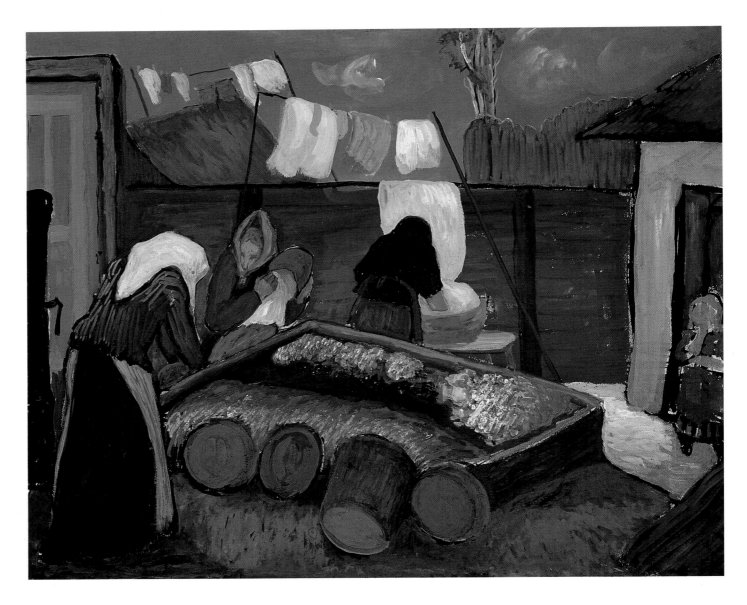

Marianne Werefkin. *Washerwoman*.
1909. Tempera on paper. 19 ⅞ x
25 ¼ in. (50.5 x 64 cm). Städtische
Galerie im Lenbachhaus, Munich.

Jacoba van Heemskerck.
Composition. n.d. Oil on canvas.
27 ½ x 49 ¼ in. (70 x 125 cm).
Collection Gemeentemuseum,
Den Haag, The
Netherlands/Beeldrecht
Amstelveen. Photograph: Rob
Kollaard.

Above:
Käthe Kollwitz. *Turm der Mutter*
(*Tower of Mothers*). Bronze. 12 x 12 x
12 in. (30.4 x 30.4 x 30.4 cm). The
Robert Gore Rifkind Foundation,
Beverly Hills, California.

Opposite:
Käthe Kollwitz, 1927.
Photograph: Corbis/E.O. Hoppé.

Käthe Kollwitz

From Käthe Kollwitz, *In Retrospect* (1941)

From my childhood on my father had expressly wished me to be trained for a career as an artist, and he was sure that there would be no great obstacles to my becoming one. . . .

In my seventeenth year I became engaged to Karl Kollwitz, who was then studying medicine. My father, who saw his plans for me endangered by this engagement, decided to send me away once more, this time to Munich instead of Berlin. That was in 1889.

In Munich I lived in Georgenstrasse, near the Academy, and attended the girls' art school. Once more I had good luck in my teacher, ludwig Herterich. He did not put so great a stress upon my drawing and took me into his painting class. The life I plunged into in Muchich was exciting and made me very happy. Among the girls who were studying there were some who were very gifted. . . .

I so liked the free life in Munich that I began to wonder whether I had not made a mistake in binding myself by so early an engagement. The free life of the artist allured me. . . .

My father no longer watched my work with the serene confidence that I was making progress. He had expected a much faster completion of my studies, and then exhibitions and success. Moreover, as I have mentioned, he was very skeptical about my intention to follow two careers, that of artist and wife. My fiancé had been put in charge of the tailors' *Krankenkasse*, and with this prospect for earning a livelihood we decided to take the leap. Shortly before our marriage my father said to me, "You have made your choiuce now. You will scarcely be able to do both things. So be wholly what you have chosen to be."

In the spring of 1891 we moved into the home in North Berlin where we were to live for fifty years. My husband devoted most of his time to his clinic and was soon burdened with a great deal of work. In 1892 I had my first child, Hans, and in 1896 my second, Peter. The quiet, hardworking life we led was unquestionably very good for my further development. My husband did everything possible so that I would have time to work. My occasional efforts to exhibit failed. But in connection with one of these exhibitions, a show of the rejected applicants was arranged, and I took part in this. . . .

A great event took place during this time: the Freie Buehne's première of Hauptmann's *The Weavers*. . . .

That performance was a milestone in my work. I dropped the series on Germinal and set to work on *The Weavers*. At the time I had so little technique that my first attempts were failures. For this reason the first three plates of the series were lithographed, and only the last three successfully etched: the *March of the Weavers, Storming the Owner's House*, and *The End*. My work on this series was slow and painful. But it gradually came, and I wanted to dedicate the series to my father. I intended to preface it with Heine's poem, "The Weavers." But meanwhile my father fell critically ill, and he did not live to see the success I had when this work was exhibited. On the other hand, I had the pleasure of laying before him the complete *Weavers* cycle on his seventieth birthday in our peasant cottage at Rauschen. He was overjoyed. I can still remember how he ran through the house calling again and again to Mother to come and see what little Käthe had done. . .

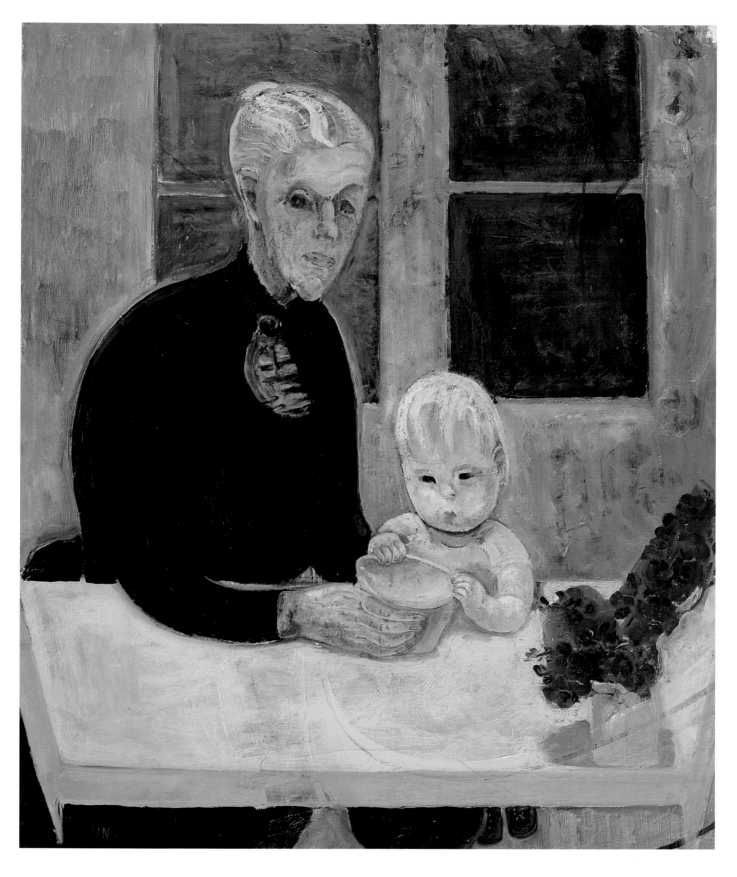

Opposite:
Sigrid Hjerten-Grünewald. *Self Portrait.* 1914. Oil on canvas. 45 ¼ x 35 in. (115 x 89 cm). Malmö Museum, Malmö, Sweden.

Above:
Vera Nilsson. *Mormor och Lillan.* c. 1925. Oil on canvas. 36 ¼ x 28 ¾ in. (92 x 73 cm). Collection Nationalmuseum, Stockholm. © Vera Nilsson/Licensed by VAGA, New York, N.Y. Photograph: Nationalmuseum, Stockholm.

14
Smashing the Past, Designing the Future
From Futurism to Constructivism and Beyond

In principle, and often in practice, women participated as equals in the rapid succession of art movements in pre- and post-Revolutionary Russia. Like their male peers, they were mostly the children of prosperous, well-educated families, and like the men, they made the obligatory pilgrimage to Paris. For centuries, the Russian upper classes had adopted French culture; now—thanks largely to Serge Diaghilev and his Ballets Russes—Russian art and artists were a significant presence in Paris. French modern art, from Impressionism to Cubism, had become part of the Russians' art education. Futurism was an Italian movement launched in a Paris newspaper in 1909 with publication of a manifesto calling for art that reflected the mechanical dynamism and promise of modern life. Because the men excluded them, in 1912 the Italian Futurist women issued a manifesto of their own, asserting their equality in the face of their comrades' explicit contempt for women. The Futurists' ideas were enormously influential, and it was in part to counter this Western influence that Diaghilev helped found the World of Art, a movement to promote the "Russianness" (meaning non-Western aspects) of Russian art. Artists vied for commissions to design their sets and costumes, which were usually quite spectacular.

Zinaida Serebriakova (1884–1967) developed a Russian version of French Impressionism: Serebriakova, who was from a family of artists, filled her portraits and idealistic views of peasant life with light and color. In *Self-Portrait at the Dressing Table* (1909), the artist frames herself in the mirror, which reflects a still life of jars and objects. The composition contains many formal geometric elements—verticals, circles, and angles—and the surface is richly textured, made up of contrasting smooth and thickly applied areas of paint. World War I and the Revolution caused a turning point in Serebriakova's fortune when she lost her husband and suddenly had to support her family. After completing a 1924 commission in Paris, she was unable to return home and spent the rest of her life in unhappy exile.

Benedetta Cappa (1897–1977), who married the founder of Italian Futurism, Filippo Marinetti, also sought to represent the speed and excitement made possible by industrial progress. During the years between the world wars she was joined by Rosa Rosà, Adriana Bisi Fabbri, Alma Fidora, Leandra Angelucci (Cominazzini), and Regina (Prassade Cassolo), all of whom were dedicated both to portraying the energy and power of modern life and to demanding equal rights for women. In Benedetta's *Speeding Train by Night* (1924), rapidly turning wheels generate an electric forward movement that lights up the night. Combining theory and plastic means, the Italian Futurists and the Russian Cubo-Futurists employed often fantastic forms and formulae to depict time, space, light, and movement. The various groups issued statements detailing their artistic and political ideologies, which ranged from Futurists in Fascist Italy to Suprematism in Communist Russia.

Natalia Goncharova (1881–1962) progressed quickly through the "isms" to Rayonism, an innovation shared by her longtime lover, painter Mikhail Larionov—they would marry in 1955. Rayonist abstractions such as *Cats* (1913) were intended to show the actual break-up of intersecting light rays on the surface of an object. Exhibited at home in Russia and in Germany, France, and England, these inventions caught the eye of Diaghilev, who brought Goncharova to Paris in 1914 to design sets and costumes for his production of *Le Coq d'Or;* she would design sets for him until 1938. Her decorative blend of Russian folk art and contemporary abstract constructions were tremendously popular, and Goncharova returned home to great acclaim. A few years after the 1917 Revolution, however, she and Larionov left Russia, joining the army of artists who rejected the policies requiring that their production support national goals. Goncharova returned to Paris, where she spent the rest of her life.

p. 186:
Alexandra Exter. *Abstract Composition*. Oil on canvas. Russian State Museum, St. Petersburg. Photograph: Scala/Art Resource, N.Y.

Left:
Natalia Goncharova. *Set design for "The Firebird" by Igor Stravinsky*. 1914. Pen and ink, watercolor, gouache, and gold. 24 x 24 ½ in. (61 x 62.2 cm). Victoria & Albert Museum, London. Photograph: Victoria & Albert Museum/Art Resource, N.Y.

The Revolutionary establishment encouraged artists to abandon easel painting and instead to put their talent and training to use making functional art or art in line with the Revolution's aims. Like Goncharova, Alexandra Exter (1882–1949) made the transition from painting to set and costume design. In the theater—a vital aspect of Russian culture—experimentation still throve, but by 1924 Exter's abstractions were no longer acceptable. She, too, left for Paris, where she taught in Fernand Léger's academy; she continued to work in the theater, for which she designed complementary sets and costumes, in which dynamic lines and diagonals, overlapping planes, and sectors of color formed a unified whole. Besides being visually theatrical, her costumes were physical, designed for three dimensions: for *Salome* (1917) she employed lightweight, fluid fabrics; other times, costumes might be painted onto the performers or stiffened with wires to produce the effect of mechanical movements.

Olga Rosanova (1886–1918) used the idea of Cubist collage to transform commonplace subjects into art. Believing that art should be a process of creation, not reproduction, she eventually abandoned recognizable subjects for Suprematism, a form of geometric abstraction. Whether simulating collage, as in A *Hairdresser* (1915), or illustrating a book on the devastation of war or the Futurist poetry of her husband, Aleksey Kruchenykh, Rosanova followed the underlying principle of integrating art and everyday life. Rosanova supported the Revolution and was participating in the reorganization of the industrial arts education system when she died suddenly from diphtheria.

Upon returning home from Paris at the start of World War I, the friends Liubov Popova (1889–1924) and Nadiejda Udaltsova (1886–1961) joined Kazimir Malevich—one of the formulators of Suprematism—Vladimir Tatlin, and other artists of the avant-garde. From working in a Cubist style, as in Udaltsova's *At the Piano* (1914), they went on to experiment with overlapping abstract forms, before finally painting in a completely nonobjective manner. They alternated between palettes of deep, rich hues and bright playful colors to render simplified angular shapes. Udaltsova's *Painterly Constructions* (1915 and 1916) and Popova's *Painterly Architectonics* (1917), produce an effect of brilliant, geometric forms moving in space.

After the Revolution, the friends followed divergent paths. Udaltsova was one of few artists to continue easel painting, although by the late 1920s, inspired by Revolutionary ideals, she had renounced abstraction in favor of scenes celebrating peasants and workers. Popova abandoned easel painting in favor of "production art"—before her early death from scarlet fever, she was a prolific and influential designer of textiles, clothing, posters, books, and theater sets.

Varvara Stepanova (1894–1958), another friend and associate of Popova, was more a designer than an easel painter; her vibrant but functional clothing and innovative typography for posters and books were instrumental

in establishing a state-sponsored image of progress. With her husband, the artist Aleksander Rodchenko, and others, she contributed to the formulation of Constructivism, an art of structural design concerned with depicting space and time in two and three dimensions, by stripping a work down to essential geometric forms. Among her last easel paintings is a series of figures in motion that explores this practice; in *Two Figures* she reduced the human form to geometric shapes, connected in such a way as to suggest gestures.

The sculptor Vera Mukhina (1889–1953) first met Popova in 1910, when they were students in Moscow and then Paris, and they remained friends. Mukhina developed her highly expressive, yet stylized sculpture from a variety of influences, including classical Egyptian, Greek, and Roman art, Michelangelo, Cubism, and Futurism. A supporter of the Revolution, she was one of a number of sculptors who carried out official memorial portraits and monuments. Works such as *Flame of the Revolution* (1922) reveal the strong Cubist and Futurist influences that she later rejected in favor of heroic representations of the Socialist Realism mandated by the official ideology. Mukhina's exultant *Worker and Collective Farmworker*, for example, which topped the Soviet Pavilion at the Paris Exposition of 1937, became a universal symbol of the Soviet state.

Katarzyna Kobro (1898–1951) and her husband, Wladyslaw Strzeminski, both sculptors, met as students in Moscow. They lived for a period in Smolensk, where they adopted Malevich's Suprematism. By 1922, however, Kobro and Strzeminski had emigrated to Poland, where she continued her explorations in written as well as plastic terms. Kobro's use of primary colors in works like *Space Composition 4* (1929) emphasizes the spatial connections among overlapping geometric planes. Her rhythmical compositions balance horizontal and vertical elements with connecting curves that are sculptural expressions of complex theories of movement, tension, and division of space. Unfortunately, most of Kobro's work was destroyed in World War II.

Olga Rosanova. *Hairdresser.*
1915. Oil on canvas. 28 x 21 in.
(71 x 53.3 cm). State Tretyakov
Gallery, Moscow. Photograph:
Sovfoto/Eastfoto, N.Y.

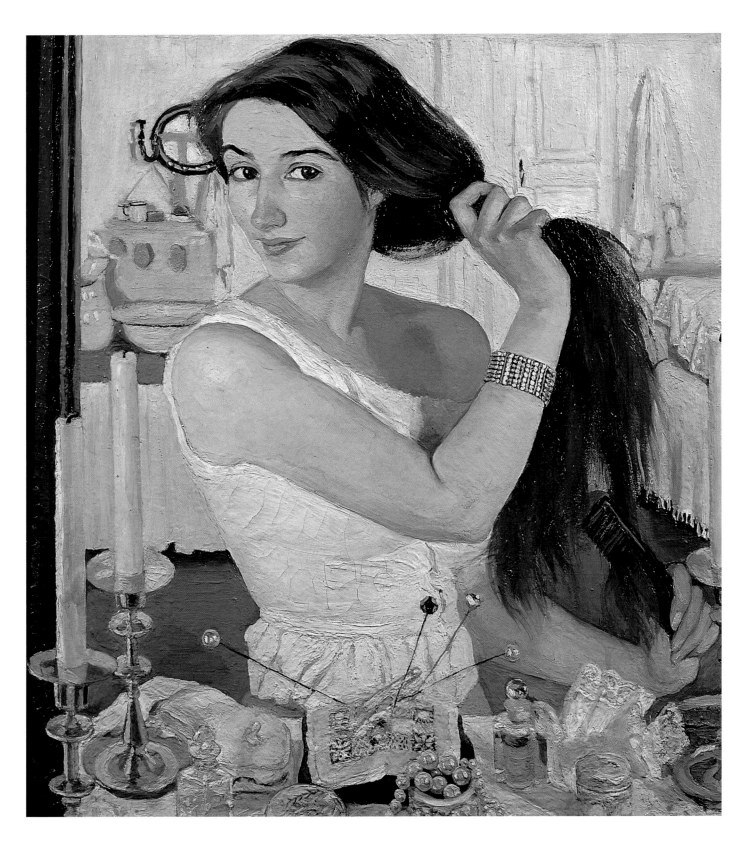

Zinaida Serebriakova. *Self Portrait at the Dressing Table*. 1909. Oil on canvas. 29 ½ x 25 ⁹⁄₁₆ in. (75 x 65 cm). State Tretyakov Gallery, Moscow. Photograph: Scala/Art Resource, N.Y.

Benedetta Cappa Marinetti.
Speeding Train by Night. 1924. Oil on
canvas. 19 ½ x 26 ¾6 in. (49.5 x
66.5 cm). Collection of Luce
Marinetti, Rome. Reproduced by
permission of Farrar, Straus &
Giroux, Inc. on behalf of Luce
Marinetti and the Estate of F.T.
Marinetti. Photograph courtesy
The Galleries at Moore College
of Art, Philadelphia.

Liubov Popova. *Painterly
Architectonic*. 1917. Oil on canvas.
31 ½ x 38 ⅝ in. (80 x 98 cm).
The Museum of Modern Art,
New York. Philip Johnson Fund.
Photograph © 1999 The Museum
of Modern Art, New York.

Nadezhda Udaltsova. *At the Piano.*
1915. Oil on canvas. 42 ⅛ x 35 in.
(107 x 89 cm). Yale University Art
Gallery. Gift of Collection
Society Anonyme. © Estate of
Nadezhda Udaltsova/Licensed
by VAGA, New York, N.Y.

Above:
Katarzyna Kobro. *Space Composition 4.* 1929. Painted steel. 15 ¾ x 25 ³⁄₁₆ x 15 ¾ in. (40 x 64 x 40 cm). Collection Kröller-Müller Museum, Otterlo, The Netherlands.

Opposite:
Vera Mukhina. *Worker and Collective Farmworker.* 1937. Bronze. Height: 64 ³⁄₁₆ in. (163 cm). © Estate of Vera Mukhina/Licensed by VAGA, New York, N.Y. Photograph: Sovfoto/ Eastfoto, N.Y.

15
Complementary Realities
Early Abstraction on Two Continents

Experimentation, innovation, and "progress," with breakthroughs in all directions—such was the process of art practice during the first half of the twentieth century. Consuming the "isms" as rapidly as they appeared and joining with like-minded associates, female artists reinterpreted the new styles in light of their own sensibilities and inclinations. French Fauvism, German Expressionism, and Italian Futurism were major modernist influences during the second decade of the century, but Cubism and its abstract and nonobjective progeny would prove the most adaptable and enduring of modern idioms. It shattered traditional representations to find new expressions of perception by examining multiple views of each object at once, while simultaneously reassembling the same objects.

Art and life were inseparable for Sonia Delaunay-Terk (1885–1979). She and her husband, Robert Delaunay, soon adapted Cubism to an abstract art of pure color. Like Eugéne Delacroix and some of the Impressionists, they were influenced in part by Michel Chevreul's color theory, as well as their own experiments in simultaneous color contrasts. The poet Guillaume Apollinaire dubbed their work "Orphic," after the mythological musician Orpheus, because its style was so lyrical. Robert was the first French painter to abandon subject matter completely, but Sonia quickly followed. Delaunay-Terk designed book covers, quilts, and toys for their son, Charles (born 1911), scroll-like illustrations, legendary clothing and fabrics, and much more. Until the Russian Revolution in 1917, the Ukrainian-born Delaunay-Terk received support from her wealthy adoptive family in Saint Petersburg. In Spain for several years during World War I and later in Paris, Robert continued to focus on painting and theory, while Sonia pursued the more lucrative decorative arts, including set designs for Diaghilev's Ballets Russes and a thriving fashion business. When the Depression came and she was forced to close her business, she returned to painting, finding mural and other commissions to support her family. From her early, luminous experiments in simultaneity such as *Bal Bullier* (1913) to the richly hued geometric abstractions of the late 1960s, like *Triptych* (1963), her paintings were informed by the rhythms and movements of life.

The independent-minded Swiss artist Alice Bailly (1872–1938) arrived in Paris in 1904 to study, and by 1908 her pictures were hanging in the same room of the Salon d'Automne as those of the Fauves. Two years later she was combining her heightened color palette with the fragmented structures of Cubism, before moving on to Futurist-inspired studies of speed and motion. Back in Switzerland during World War I, Bailly experimented with collage, creating a series of "paintings" in which she substituted bright wool strands for brushstrokes. In *Woman with a White Glove* (1922), Bailly freely combined the geometry of "classic" Cubism with a layering of harmonious painted forms.

Helen Saunders (1885–1963) was an enthusiastic exponent of English Vorticism, a brief but heady movement centered around the artist Wyndham Lewis and his publication *Blast* (1914–15). The periodical's avant-garde contents were designed to "blast" the Britons into the dynamic modern age, but unlike the Futurists, who tended to consider war an expression of modern mechanical power, and thus desirable, the Vorticists adopted aggressive stances against war and dehumanization. Their works often shared a restless quality, like Saunders's *Vorticist Composition with Figure in Blue and Yellow* (c. 1915), filled with piercing, angular shapes. Mixing Futurist agitation, robotlike figures, and shattered Cubist forms in her paintings, Saunders joined Lewis and others in often bombastic dissent.

From 1916 to 1920, the Swiss-born Sophie Taüber (1889–1942) and her future husband, Jean Arp, were central to Zurich's iconoclastic Dada movement. They eventually took another path, to geometric abstraction,

collaborating in both their art and their life—they were married in 1922. Taüber-Arp performed at the Cabaret Voltaire—Dada "headquarters"—and was a respected teacher and textile designer at Zurich's applied arts school. Her versatility is evident in her elegant abstract tapestries and in the wooden "portrait" heads she made of Arp (1917–18), in which she rearranged and painted his real and imagined features on hat forms, droll symbols of a more practical use for one's head. *Rectangular squares suggesting a group of people* (1920) prefigures the horizontal/vertical combinations and geometric variations that would continue to fill Taüber-Arp's canvases and environments. She easily translated her ideas into tapestries, paintings, even room designs, but what remained consistent from youth to maturity was Taüber-Arp's modernist elimination of ornament in favor of clean, uncluttered forms.

A twentieth-century equivalent of Vigée-Lebrun's eighteenth-century celebration of the rich and famous might be the portraits painted by Tamara de Lempicka (1898–1980). After the Russian Revolution, the Polish-born socialite and her playboy first husband emigrated to Paris, where, to support herself and their daughter—her husband refused to work—she painted wealthy Europeans and Americans. Her highly stylized portraits and erotic nudes, which would later be described as Art Déco, were at once Cubist-inspired and traditional, fashionable and decadent. The artist's only child is the subject of *Kizette in Pink* (1927); with its steely colors and eerie sensuality, any maternal quality the painting might display is very unconventional. De Lempicka frequently used a diagonal composition that seems to squeeze the subject into the picture plane; other signature features include firm flesh, stylish hair and clothing, and vivid color accents. During the 1930s, a de Lempicka portrait was considered the height of style in New York and Hollywood.

Substance, not style, was the concern of a California native, Marguerite Thompson Zorach (1887–1966). When she was a student in Paris, she and William Zorach fell in love with each other and with the Fauves. Disappointed with both developments, Margaret's chaperon aunt promptly removed her from the scene. Despite the aunt, the couple married in New York, were prominent in the city's small but active modernist community, and participated in the 1913 Armory Show, where her Fauvist work received disapproving reviews. Although Margaret had been introduced to Cubism in Paris, where she met Picasso during a visit to her aunt's friend, Gertrude Stein, it was not until the summer of 1916 that she incorporated broken planes and abstract elements into paintings such as *Provincetown: Sunset, Moonrise*. After their children were born, Margaret found in needlework a satisfying alternative to painting—easier to pick up and leave. Thrilled with the possibilities offered by brightly colored threads, she created lighthearted yet sophisticated tapestries on linen that were inspired by family activities, vacations, and imaginary landscapes. Although William gained recognition for his sculpture and taught, it was Margaret's tapestry commissions that provided their primary means of support.

Before Elsie Driggs (1898–1992) withdrew from the New York art scene, following her 1935 marriage to painter Lee Gatch, she was instrumental in redefining American scene painting. One of the first exponents of the Precisionist style, Driggs captured the power and dynamism of the expanding industrial landscape in works like *Queensborough Bridge* (1927), which romanticized steel and smokestacks. Her clean-edged vision was very considered, grounded as much in Piero della Francesca's simplified expressions of volume as in modernist geometric simplifications. She returned to New York after Gatch's death in 1968, but her late work was derivative, lacking the clarity of her early vision.

By the time Wisconsin-born Georgia O'Keeffe (1887–1986) was twenty, she was at the heart of New York's avant-garde circles. As a student, teacher, and struggling young artist, however, she created for herself a highly personal abstract language. When a friend showed some of her drawings to Alfred Stieglitz, the photographer, whose 291 Gallery in New York was a modernist mecca, "discovered" O'Keeffe. Unbeknownst to her, Stieglitz exhibited her work, and there is little doubt that his mentorship was instrumental in her subsequent fame. Wherever she lived, O'Keeffe internalized and personalized her environment, in cityscapes, landscapes, and flower studies that are immediately recognizable as hers. Her New York view *Radiator Building, Night, New York* (1927) features night-lit skyscrapers subtly defined by patterned lights, while works like *Purple Petunias* (1925), with its oversized flora and abstractions force viewers to see familiar forms anew. In New Mexico, where O'Keeffe lived for the last half of her life (Stieglitz, whom she married in 1924, died in 1946), the artist found a landscape and lifestyle that suited her temperament. Much has been made of the phallic and vaginal symbolism in her early paintings—an interpretation the artist always denied—but a sense of the organic, of the cycle of regeneration, emanates from the hills, adobes, bones, and sand and sky that she painted with the precision and sensuality that distinguished her earliest work.

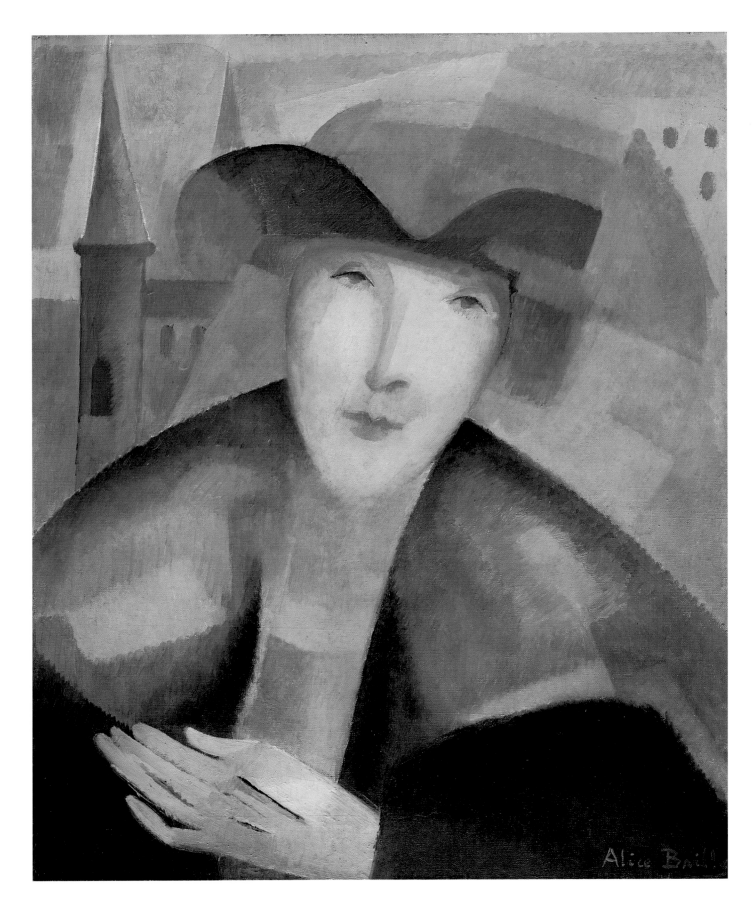

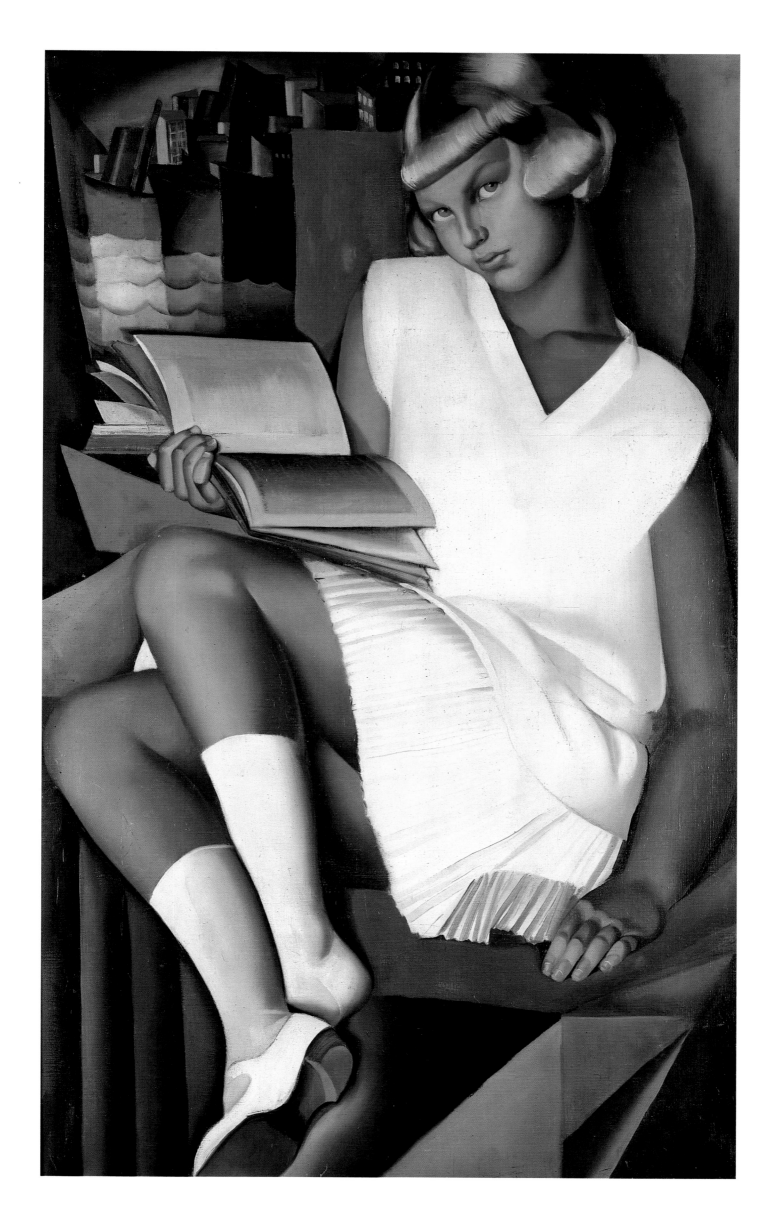

Opposite:
Helen Saunders. *Vorticist Composition with Figure in Blue and Yellow.* c. 1915. Watercolor. 10 ⅞ x 6 ¾ in. (27.6 x 17.1 cm). Tate Gallery, London. Photograph: Tate Gallery/Art Resource, N.Y.

Above:
Sophie Taüber-Arp. *Rectangular Squares Suggesting a Group of People.* 1920. Distemper. Private collection, Paris. Photograph: Giraudon/Art Resource, N.Y.

Georgia O'Keeffe. *Purple Petunias*.
1925. Oil on canvas. 15 ⅞ x 13 in.
(40.3 x 33 cm). Collection of the
Newark Museum. Bequest of
Miss Cora Louise Hartshorn,
1958. (Inv. 58.167) The Newark
Museum, Newark, New Jersey.
Photograph: The Newark
Museum/Art Resource, N.Y.

Above:
Marguerite Zorach. *Provincetown, Sunset and Moonrise*. 1916. Oil on canvas. 20 x 24 in. (50.8 x 60.9 cm). Sheldon Memorial Art Gallery, University of Nebraska, Lincoln. Nebraska Art Association, Nelle Cochrane Woods Memorial Collection (1968.N-229).

p. 206:
Georgia O'Keeffe. *Radiator Building, Night, New York*. 1927. Oil on canvas. 48 x 30 in. (121.9 x 76.2 cm). Collection of Fisk University, Nashville, Tennessee.

p. 207:
Georgia O'Keeffe, c. 1945. Photograph: Corbis.

Georgia O'Keeffe

From Exhibition Catalogue, "An American Place," 1939

A flower is relatively small. Everyone has many associations with a flower—the idea of flowers. You put out your hand to touch the flower—lean forward to smell it—maybe touch it with your lips almost without thinking—or give it to someone to please them Still—in a way—nobody sees a flower—really—it is so small—we haven't time—and to see takes time, like to have a friend takes time. If I could paint the flower exactly as I see it no one would see what I see because I would paint it small like the flower is small.

So I said to myself—I'll paint what I see—what the flower is to me but I'll paint it big and they will be surprised into taking time to look at it—I will make even busy New Yorkers take time to see what I see of flowers.

Well—I made you take time to look at what I saw and when you took time to really notice my flower you hung all your own associations with flowers on my flower and you write about my flower as if I think and see what you think and see of the flower—and I don't.

Then when I paint a red hill, because a red hill has no particular association for you like the flower has, you say it is too bad that I don't always paint flowers. A flower touches almost everyone's heart. A red hill doesn't touch everyone's heart as it touches mine and I suppose there is no reason why it should. The red hill is a piece of the badlands where even the grass is gone. Badlands toll away outside my door—hill after hill—red hills of apparently the same sort of earth that you mix with oil to make paint. All the earth colors of the painter's palette are out there in the many miles of badlands. The light Naples yellow through the ochres—orange and red and purple earth—even the soft earth greens. You have no associations with those hills—our waste land—I think our most beautiful country. You must not have seen it, so you want me always to paint flowers. . . .

I have picked flowers where I found them—have picked up sea shells and rocks and pieces of wood where there were sea shells and rocks and pieces of wood that I liked. . . . When I found the beautiful white bones on the desert I picked them up and took them home too. . . . I have used these things to say what is to me the wideness and wonder of the world as I live in it. . . .

I was the sort of child that ate around the raisin on the cookie and ate around the hole in the doughnut saving either the raisin or the hole for the last and best.

So probably—not having changed much—when I started painting the pelvis bones I was most interested in the holes in the bones—what I saw through them—particularly the blue from holding them up in the sun against the sky as one is apt to do when one seems to have more sky than earth in one's world. . . . They were most wonderful against the Blue—that Blue that will always be there as it is now after all man's destruction is finished.

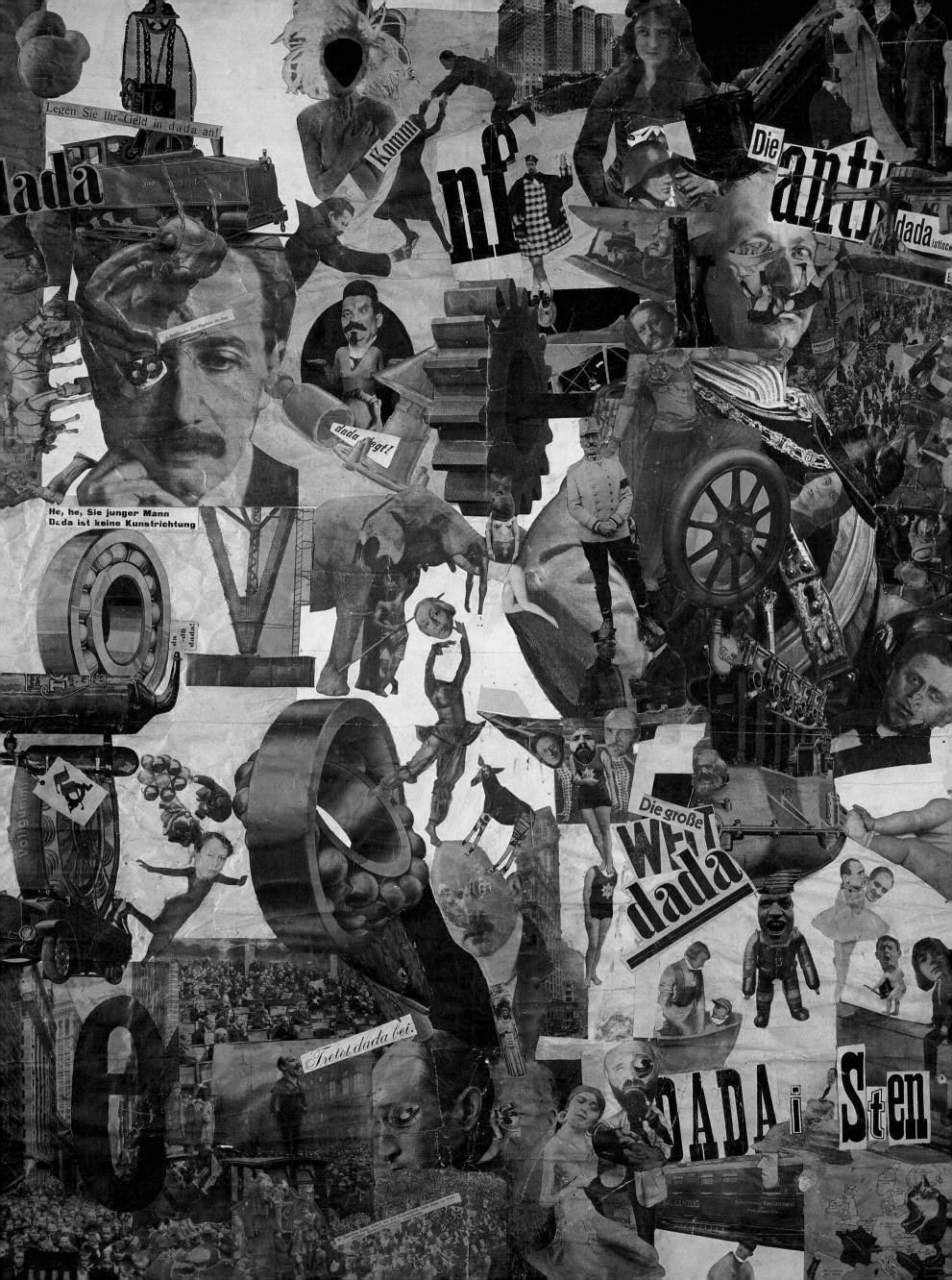

16
Dada and Surrealism
Reports from the Unconscious

Out of lives disrupted by war in the first half of the century came art forms and perspectives independent of terrestrial topographies. Artists on the cutting edge worked from the inside out, selecting from nature only what expressed their personal visions. Unlike Cubism and Expressionism, Dada and Surrealism had more to do with mental— especially subconcious—processes and a philosophy of the irrational than with a specific style or technique.

In the case of Dada—a movement whose name was reportedly composed of random nonsense syllables— artists and writers uprooted by World War I dispersed the movement to cities throughout Europe and to New York. In a counter-Futurist kind of way, their nihilistic manifestoes and other writings protested war, industrialization, and other dehumanizing offenses of modern life. Dada's multimedia creations were chaotic, absurd, and humorous, and they took the forms of performances, "readymades" or found objects, self-destroying machines, and mystifying abstractions.

In politically charged Berlin, Hannah Höch (1879–1978) reordered reality in radical photomontages, a medium that she and her companion, Raoul Hausmann, are credited with inventing. Höch mined a rich range of print sources to find the ingredients for her provocative fusions of photographic images—one of her first such pieces, *Cut with the Kitchen Knife* (1919–20), illustrates the process of the new art form. To make the work, whose title refers menacingly to women's traditional realm, she cut out text and photo fragments, using a collage technique to fashion fantastic compositions that comment wryly upon the experience of life in Weimar Berlin in the wake of World War I. She combined areas of paint with photographic images of hardware, buildings, disconnected heads and bodies, and figures in motion in and about images of modern life, including the modern machinery of war. Cut-out "dada" texts weave backward and forward among the images. Comic touches such as circus performers mark her style. Höch remained in Germany through the Nazi era and World War II, at the cost of largely refraining from political statements.

The German-born Elsa von Freytag-Loringhoven (1874–1927) had been a chorus girl, artist, poet, and muse before emigrating to the United States in 1910. Abandoned in New York in 1913 by Baron Leopold von Freytag-Loringhoven after their brief marriage, she gravitated to Greenwich Village. She supported herself as an artist's model, and, seen around the streets in the nude or draped with fruit and cookware, became a highly visible "character" even in that bohemian community of artists and intellectuals. Because theatricality was so essential an aspect of Dada, her poses for Man Ray, Marcel Duchamp, and Francis Picabia render the resulting works in effect collaborations. Her "junk art" 1918 Dada portrait of the photographer Berenice Abbott, who called von Freytag-Loringhoven a friend and a great influence, is made from a brush, stones, metal objects, cloth, paint, and various detritus. Her 1920 portrait of Duchamp was an elegant but short-lived "bouquet" with feathers and metal gears in a champagne glass. Like much of today's conceptual art, it survives only in a photograph.

In some respects, Surrealism was an outgrowth of Dada, as Salvador Dalí, Duchamp, and others renounced protest and absurdity in favor of the dislocated, symbolic imagery of the subconscious. Gathered around the founding father, the writer and critic André Breton—a great admirer of Frida Kahlo—the Surrealists embraced certain theories of Sigmund Freud and psychoanalysis. Responding to the power of dreams, letting themselves go to the predictable results of "automatism," spontaneous drawing and writing, the Surrealists became a major force in art beginning in the 1920s.

Initially, women were important to the Surrealists not as artists but as muses and lovers. As sexual creatures who inspired creativity they were loved; as real women and mothers who would squelch men's freedom they

p. 208:

Hannah Höch. *Cut with the Kitchen Knife.* 1919. Collage of papers. 44 ⅞ x 35 ½ in. (114 x 90.1 cm). Stiftung Preussischer Kulturbesitz, Berlin. Photograph: Erich Lessing/Art Resource, N.Y.

Right:

Eileen Agar. *Angel of Anarchy.* 1936–40. Canvas, plaster, and other materials. 20 ½ x 12 ½ x 13 ¼ in. (52 x 31.7 x 33.6 cm). Tate Gallery, London. Photograph: Tate Gallery/Art Resource, N.Y.

were feared. Paintings by Max Ernst, Duchamp, and Dalí are rife with controlling violence and brutality against women. Nevertheless, attracted by the Surrealists' democracy-of-the-mind mentality, their wholehearted commitment to avant-garde art, the fun, and, for some, the sexually charged, creative atmosphere surrounding them, women were drawn into their circle. Most were a generation younger than their mates, and were adored as long as they remained the *femme-enfant*, the Surrealist ideal of the child-woman.

Visionary and symbolic, the women's imagery frequently incorporated dreamscapes and architectural interiors in which women were strong, dominant figures controlling their environments. Water and egg imagery, symbols of rebirth and regeneration, appear frequently. Many of the women developed strong friendships: Leonor Fini, Leonora Carrington, and Meret Oppenheim in Paris, and later, in Mexico, Carrington and Remedios Varo. Like their male cohorts, some of the female Surrealists also published short stories, poetry, and memoirs, and espoused sexual liberation — the Marquis de Sade was a Surrealist hero. Fini and Tanning also transmit some of this sexual charge in their work.

Leonor Fini (1908–1996) lived what she believed. Born in Buenos Aires and raised in Trieste, she was acquainted with Carlo Carrà and the Futurists before she moved to Paris in the 1930s. True to her independence, she refused to marry and resisted joining the Surrealists because of their disparaging attitude toward women, although she counted group members among her friends and exhibited with them. Fini's early works often feature beautiful women presiding over events. They are commanding figures, whether shown bare-breasted and seductive, as in *Composition with Figures on a Terrace* (1939), or armored, as in *Young Girl in Armour* (n.d.). Fini portrays herself in the former as lion-maned and powerful. Males, when present, play a secondary role, even that of victim. These imagined scenes, like Fini's detailed still lifes of decaying plants, are beautifully rendered in precise detail.

The Czech-born Marie Cermínová (1902–1980), known as Toyen, did poetic abstractions before she and her husband, the painter Jindrich Styrsky, discovered Surrealism in Prague. At first influenced by Styrsky's obsession with The Marquis de Sade (the couple illustrated his stories), Toyen's work maintained their erotic edge. In *Relâche* (1943) — the title has several meanings, including "respite" and "relax" — the pose is impossible, the setting ominous, the pale virginal skin and props (sack and riding crop) frighteningly real and highly evocative of what might be coming. Briefly, after World War II, Toyen turned her attention to political statements in works like *Before Spring* (1945), a landscape with rows of stone grave mounds, evocative of what had come.

During the war years, when Ernst, Breton, André Masson, Yves Tanguy, and other Surrealists emigrated to New York City, Kay Sage (1898–1963) arranged for exhibitions of their work and helped them establish new lives. From a prominent upstate New York family, Sage had lived in Europe on and off with her erratic mother, and for ten years was married to an Italian prince. She became involved with the Surrealists shortly after arriving in Paris in 1937, and later, in New York, she married Tanguy. Her command of painting belies her sparse formal training, and though she had begun by recording the Italian countryside, her work quickly became abstract, stark, sweeping dreamscapes. Curving forms fill *My Room Has Two Doors* (1939), a work that shows the influence of the Italian Surrealist Giorgio De Chirico: a large egg rests above a stairway to nowhere, against a rising wall, near a shadowy archway. In *Danger, Construction Ahead* (1940) there is no possibility of a human presence in either of the spiky formations joined across a chilly prospect by a slender bridge. Sage also wrote poetry in English, French, and Italian. Despondent after Tanguy's death in 1955 and a partial loss of vision, she failed an attempt at suicide, but succeeded the second time, eight years later.

Among the most memorable Surrealist objects are Eileen Agar's *Angel of Anarchy* and Meret Oppenheim's *Fur-Lined Teacup* (both 1936). Agar (1899/1904–1991) was painting abstractions in Paris in the late 1920s when she was introduced to Surrealism. Back home in England, she began exploring automatic methods and unusual juxtapositions in her paintings and experimenting with collage. She was one of a group of British artists who actively protested war and promoted art; *Angel of Anarchy*, a sculptural response to the Spanish Civil War, is a plaster cast of her husband's head mysteriously shrouded in sensuous silks, and adorned with feathers, beads, and shells. Agar continued co-opting found elements into fantasy objects and paintings.

Meret Oppenheim (1913–1985), daughter of a German-Swiss Jungian psychologist, in many ways resembled Meretlein, the free-spirited character in a German novel for whom she was named. Arriving in Paris in 1932, she

quickly found Breton, Duchamp, Ernst, and Man Ray. Although she continued drawing, painting, designing, and assembling clever and fanciful objects for the next fifty years, it is one piece, *Fur-Lined Teacup* (1936), that is synonymous with her name and, for many, with Surrealism. Oppenheim had decorated a bracelet with fur, and Picasso jokingly commented that fur could cover anything. Her response was another joke: a fur-covered cup, saucer, and spoon, *Le Déjeuner en fourrure*, its official name. Breton included the piece in the landmark *Fantastic Art, Dada, and Surrealism* exhibition in 1936 at New York's Museum of Modern Art—which purchased it on the spot. Oppenheim was just twenty-two years old.

The Parisian Jacqueline Lamba (1910–1993) was attracted to Breton's writings, which addressed art and politics, her two principal interests, and to Breton: the two married during the turbulent decade (of 1934–1943), during which they fled the war, first to Mexico and, finally, New York. Lamba practiced automatism, giving expression to her unconscious in dreamscapes that have often been compared with those of Masson and the Chilean painter Matta. The invented flower forms that make up *In Spite of Everything, Spring* (1942) seem to materialize through an internal prism.

Leonora Carrington (b. 1917) left England in 1937 to live in Paris with Max Ernst. During their three years together, through intensive self-exploration, she developed a personal mythology and pictorial vocabulary. In both stories and paintings, female characters—often including the artist—encountered a bestiary of real and imagined creatures. A white horse, in particular, variously represents mythic, transformative, sexual, and, when a rocking horse, nurturing and magical powers. Ernst, a German, was arrested, then failed to return to her after his release; Carrington was devastated by their separation, and she, too, eventually sought refuge in Mexico, where later, marriage and the birth of her children were energizing forces.

In Mexico, Carrington's close friend and fellow spiritual traveler was Remedios Varo (1913–1963). Simultaneously and independently, they both evolved a mature Surrealist idiom in which the practice of alchemy synthesized woman's domestic identity and spiritual longings. Varo and her husband, the Surrealist poet Benjamin Peret, had left Spain after the Civil War, settling first in Paris, then, after 1942, in Mexico. As a teenager, Varo had escaped rigid convent school life through a brief marriage, but she never totally abandoned the church: she joined aspects of Catholic mysticism with alchemy and hermetic occult traditions in her quest for creative and spiritual fulfillment. Her intense, arcane compositions frequently feature fantastic creatures and machines—an interest acquired from her father, a hydraulic engineer—that are powered by natural forces such as light, water, or sound. One of these vessels carries the sophisticated traveler in Varo's *Exploration of the Sources of the Orinoco River* (1959), to a fountain springing in a gleaming goblet, a holy chalice of sorts.

Determined to meet Ernst and the other Surrealists after seeing their 1936 exhibition in New York, Dorothea Tanning (b. 1912) arrived in Paris in 1939, just as the war was breaking out. Having been inspired more by the extravagant illustrations of Aubrey Beardsley than by the art education she received at home in Galesburg, Illinois, and in Chicago, she had seen in the Surrealists' visions something akin to her own. When Tanning finally met Ernst, back in New York, where her work was being shown at the Art of the Century gallery, owned by his wife, Peggy Guggenheim, they fell in love. After living for a number of years in Sedona, Arizona, they returned to France, where Tanning lived and worked until after Ernst's death in 1976. Many of Tanning's early paintings contain strong images of female sexual transformation. In *Birthday* (1942), the bare-breasted artist celebrates the beginning of an uncertain maturity (with Ernst), while in *Jeux d'Enfants (Children's Games)* (1942), the wall comes to life, sucking in two of the disheveled young girls, one by the hair, while a third has succumbed to its power. Likewise, in *Eine Kleine Nachtmusik* (1946) and *Palaestra* (1949), strangely suspended prepubescent girls inhabit enigmatic corridors defined by open and closed doors. In contrast with their allusive, oneiric subject matter, Tanning's dream images, filled with mystery and foreboding, are exquisitely detailed and finished.

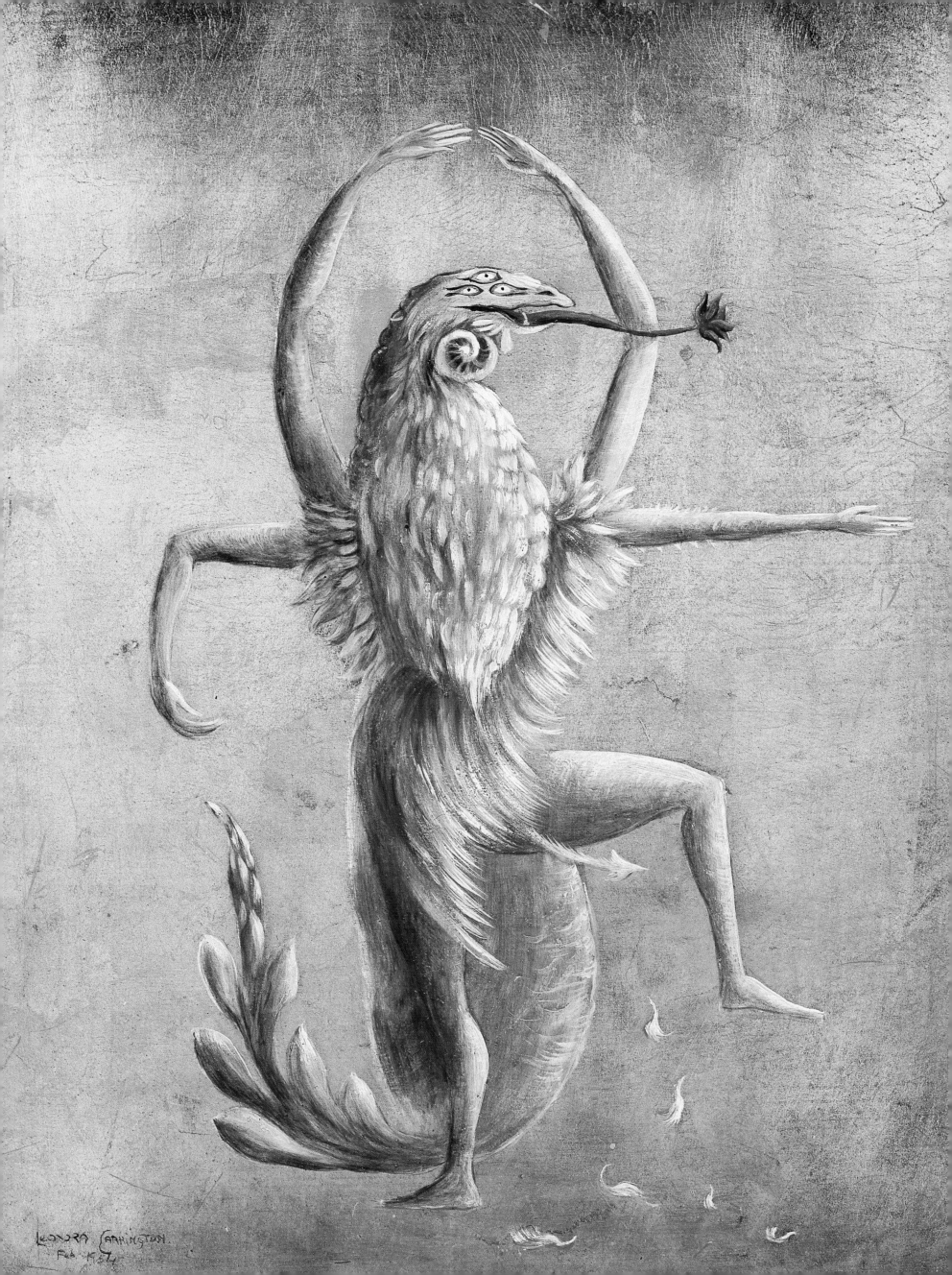

Leonora Carrington

**From Leonora Carrington, *Leonora Carrington: A Retrospective*
(New York: Center for Inter-American Relations, 1976**

Commentary, 1975

The Cabbage is a rose; the Blue Rose, The Alchemical Rose, the Blue Deer (Peyote), and the eating of the God is ancient knowledge, but only recently known to "civilized occidental" Humans who have experienced many phenomena, and have recently written many books that give accounts of the changing worlds which these people have seen when they ate these plants. Although the properties of the cabbage are somewhat different, it also screams when dragged out of the earth and plunged into boiling water or grease—forgive us, cabbage.

Writing and painting are alike in that both arts—music as well—come out of fingers and into some receptive artifact. The result, of course, is read, heard or seen through the receptive organs of those who receive the art and are supposed to "Be" what all these different persons perceive differently. Therefore it seems that any introduction to art is fairly senseless since anybody can think or experience according to who he is. Very likely the introduction will not be read anyhow.

Once a dog barked at a mask I made; that was the most honourable comment I ever received.

The Furies, who have a sanctuary buried many fathoms under education and brain washing, have told Females they will return, return from under the fear, shame, and finally, through the crack in the prison door, Fury. I do not know of any religion that does not declare women to be feeble-minded, unclean, generally inferior creatures to males, although most Humans assume that we are the cream of all species. Women, alas; but, thank God, Homo Sapiens. . . !

Most of us, I hope, are now aware that a woman should not have to demand Rights. The Rights were there from the beginning; they must be Taken Back Again, including the Mysteries which were ours and which were violated, stolen or destroyed, leaving us with the thankless hope of pleasing a male animal, probably of one's own species. . . .

There are so many questions and so much Dogmaturd to clear aside before anything makes sense, and we are on the point of destroying the earth before we know anything at all. Perhaps a great virtue, curiosity can only be satisfied if the millennia of accumulated false data are turned upside down. Which means turning oneself inside out and to begin by despising no thing, ignoring no thing . . . and make some interior space

for digestive purposes. Our machine-mentation still reacts to colossal absurdities with violence, pleasure, pain . . . automatically. Such as: I am, I am, I am. [Anything from an archbishop to a disregarded boot.] But is this so? Am I? Indigestion is imminent; there is too much of it. The Red Queen told Alice that we should walk backwards slowly in order to arrive there faster and faster.

The Sacred Deer is still worshipped in the desert here in Mexico.

The cabbage is still the alchemical Rose for any being able to see or taste.

Footprints are face to face with the firmament.

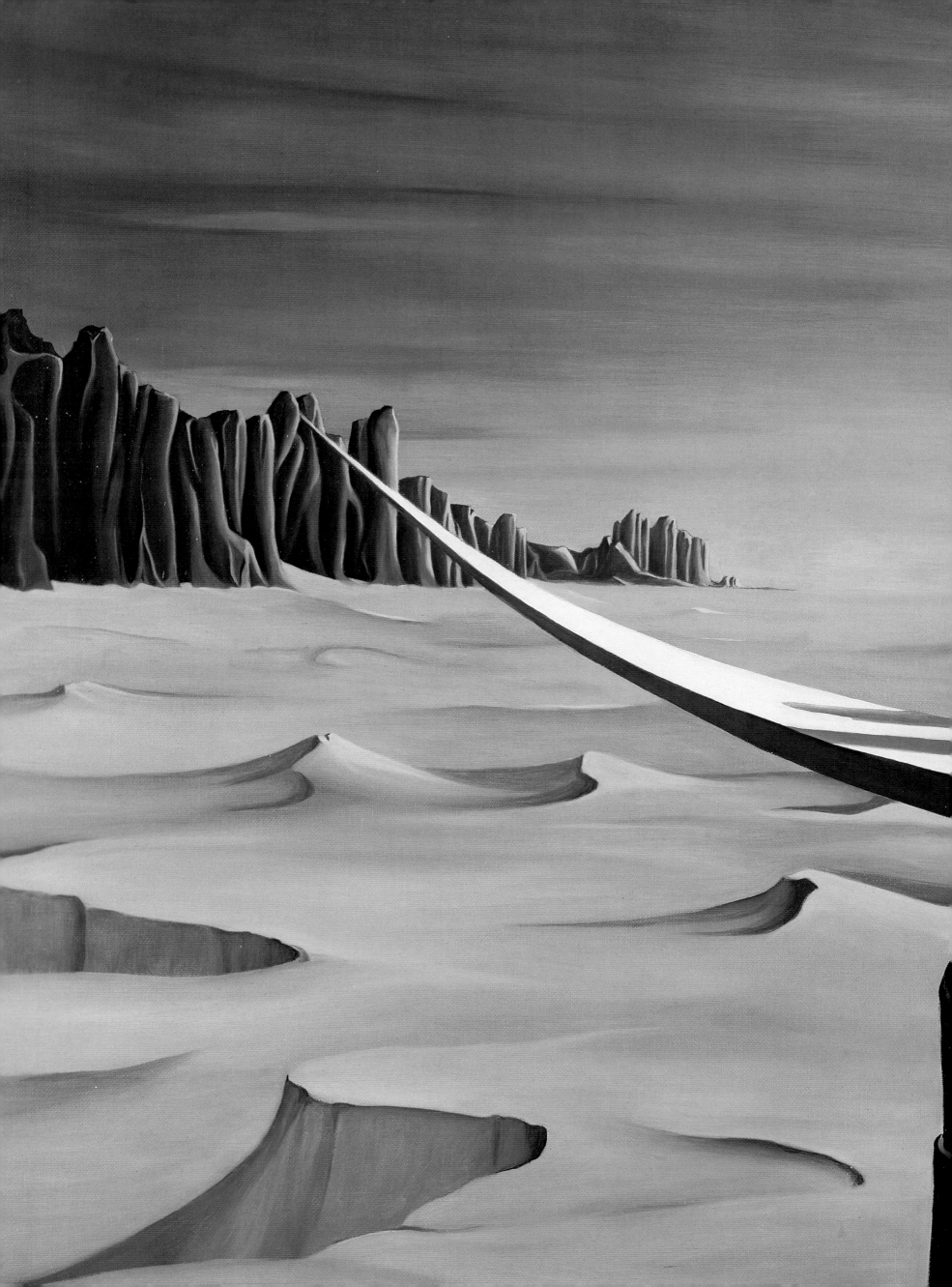

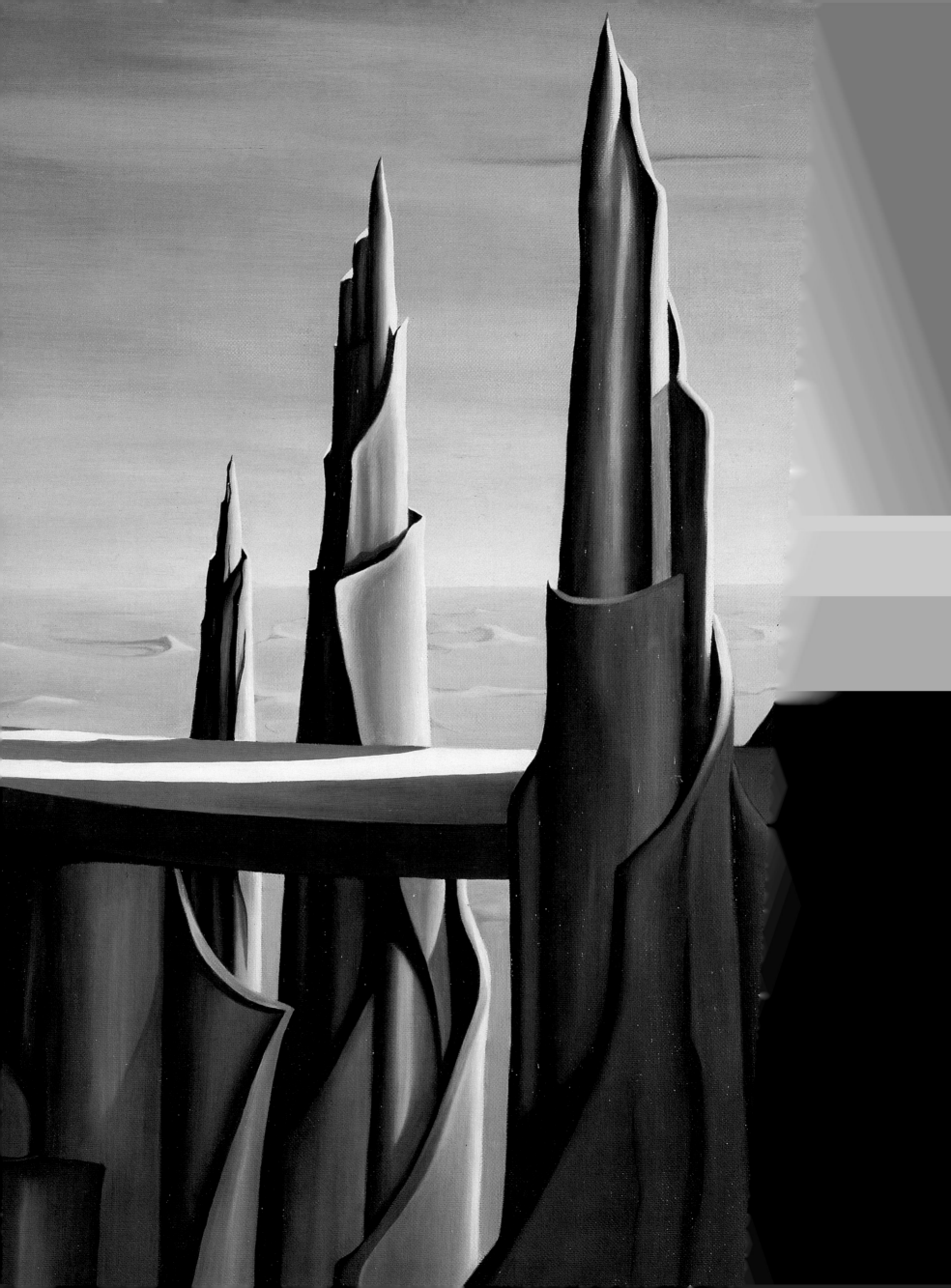

p. 214:
Leonora Carrington. *Figuras Miticas: Bailarin I.* 1954. Oil on canvas. 12 x 9 in. (30.4 x 22.8 cm). Private collection. Photograph: Christie's Images Ltd., 1999.

p. 215:
Leonora Carrington, c. 1987. Photograph courtesy Brewster Arts Ltd/Daphne Wagner.

p. 216-17:
Kay Sage. *Danger, Construction Ahead.* 1940. Oil on canvas. 44 x 62 in. (111.8 x 157.5 cm). Yale University Art Gallery. Gift of Mr. and Mrs. Hugh Chisholm, Jr.

Above:
Jacqueline Lamba. *In Spite of Everything, Spring.* 1942. Oil on canvas. 43 ⅝ x 60 ¾ in. (110.9 x 154.3 cm). Private collection. Photograph courtesy Salomon Grimberg.

Meret Oppenheim. *Objet
(Le Déjeuner en fourrure* or *Fur-Lined
Teacup)*. 1936. Fur-covered cup,
saucer and spoon; cup, 4 ⅜ in.
(10.9 cm) diameter; saucer, 9 ⅜ in.
(23.7 cm) diameter; spoon, 8 in.
(20.2 cm) long; overall height,
2 ⅞ in. (7.3 cm). The Museum
of Modern Art, New York.
Purchase. Photograph © 1999
The Museum of Modern Art,
New York.

Leonora Carrington. *Figuras Fantasticas a Caballo*. n.d. Oil on canvas. 12 x 28 in. (30.4 x 71.1 cm). Photograph: Christie's Images Ltd., 1999.

Above:
Remedios Varo. *Exploration of the
Sources of the Orinoco River.* 1959.
Oil on canvas. 17 ⁵⁄₁₆ x 15 ½ in.
(44 x 39.5 cm). Private collection.

Opposite:
Dorothea Tanning. *Jeux d'Enfants
(Children's Games).* 1942. Oil on
canvas. 11 x 7 in. (27.9 x 17.7 cm).
Private collection. Photograph
courtesy Salomon Grimberg.

17
Making Gestures
Abstract Expressionism

During the late 1930s and early 1940s, as war and the Holocaust decimated European art centers, many artists emigrated to the United States, especially New York City, which was quickly taking shape as the world's cultural capital. Concomitantly, creative young Americans, who during more peaceful times would have felt the need to study in and otherwise experience Europe's artistic milieus, also flocked to New York. From this highly charged melting pot emerged Abstract Expressionism, the first art movement in which American-based artists were the Old Masters. Rooted in Braque's and Picasso's Cubist deconstructions, Matisse's and the Fauves' color, and the Surrealists' search for archetypal symbols, it concealed a profound experience of nature and a high level of sophistication behind the macho image of chief practitioners like Jackson Pollock and Willem de Kooning. A few women in the so-called "second generation" of Abstract Expressionists were acknowledged a decade later, but Lee Krasner, a "founding mother," remained best known for too long as Mrs. Jackson Pollock.

The artists of what became the New York School gravitated to the bohemian atmosphere of Greenwich Village. The men frequented the Cedar Bar and met at The Club they had established on 10th Street to talk art and socialize; among the invited women were Perle Fine, Elaine de Kooning, and, later, Helen Frankenthaler and Joan Mitchell. Almost all were members of the American Abstract Artists (AAA), an organization formed in 1936 to provide an exhibition venue for artists more involved with European Modernism, and especially abstractions, than with American Scene Realism.

In many ways Lee Krasner's (1908–1985) story exemplifies the situation of many female artists. Committed to painting, she earned early attention as an innovator until marriage and promotion of her husband's career took priority over her own work. She never stopped painting and her husband took her work seriously, but as Mrs. Jackson Pollock, her public role became that of the Artist's Wife and, after his death in 1956, caretaker of a famous man's estate. Thanks in large part to the women's movement, Krasner finally gained critical acceptance.

The Brooklyn-born Krasner studied at conservative Cooper Union and the National Academy of Design until she discovered European Modernism in 1929 at the newly opened Museum of Modern Art in New York. During the Depression, she worked for various branches of the Federal Art Project and in the late 1930s became a student of Hans Hofmann. Absorbing his seminal lessons on simultaneous color, form, and "push-pull" tension, Krasner also investigated Cubism and its derivations in the paintings of Cézanne, Matisse, and Piet Mondrian. She evolved a new manifestation of abstraction. She knew the critic Clement Greenberg and others who would popularize Abstract Expressionism, and met Pollock in 1942, when both participated in an exhibition of contemporary French and American paintings. She immediately comprehended Pollock's breakthrough to painterly abstraction, his domination of the canvas with gesture as subject, but it took Krasner several years to find her own voice—the first such paintings are her Little Image series. She was a working artist for some forty years, her broad intelligence and innate lyricism informing hundreds of drawings, paintings, and collages, often organized into various series and cycles. *Listen* (1957), with its large, sweeping anthropomorphic and organic forms filling the canvas, is an example of Krasner's relatively light, Matisse-like palette, even the year after Pollock's death.

Perle Fine (1908–1988) came to New York from Boston and enrolled at the Art Students League. She, too, became a student of Hofmann and abandoned figuration in favor of nonobjective form. She was influenced by Kandinsky as well as by Picasso, and Abstract Expressionism liberated her to go beyond Cubism, to synthesize and balance geometry with sensual, organic forms. An AAA member, Fine proposed Pollock for membership

in the early 1940s, seeing in him an ally in her struggle to transcend strict geometric abstraction. She was one of the first women to join The Club. Her continuous explorations developed several nonrepresentational styles, many entailing dramatic contrasts of light and dark, as in *Charcoal Red* (1960).

One could say that Ethel Schwabacher (1903–1984) worked out personal concerns and ghosts through her painting. She grew up in New York City, and began studying art at age fifteen; she was a sculptor before turning to painting and psychotherapy simultaneously in 1927. Arshile Gorky, an Armenian immigrant whose fusion of geometric and biomorphic forms, dream imagery, and expressionist gestures drawn from the subconscious was in synch with Schwabacher's own preoccupations, became her teacher and mentor. Her husband, Wolf, encouraged her painting; the Schwabachers were generous patrons toward the as yet undiscovered Gorky and other needy artists; and it was Schwabacher who in 1957 published the first major study of Gorky. After Wolf's death in 1951, Schwabacher raised their two children, battling depression and, though exhibiting regularly, what she felt was an unwelcoming art world. Like the French Symbolist Odilon Redon, Schwabacher often portrayed dark emotions through lyrical, luminous imagery. Works like *Red Bird* (1955) were drawn from Schwabacher's dreams and her deep experience of nature, while others, like *Antigone I* (1958) celebrated women and fertility or explored the far reaches of the unconscious through mythology.

From the time she opened her gallery in 1946, Betty Parsons (1900–1982) promoted and exhibited young artists whose work was ignored by the established galleries. Born into New York wealth and privilege, Parsons, like others of her generation, spent several years in Paris studying painting and sculpture. Her early landscapes were transformed by Abstract Expressionism, and landscape remained the basis of her work, in particular, in sketches from her travels, sometimes worked out in paintings such as *Biloxi* (1957), or later, in painted wooden sculptures. During her gallery's first decade, she exhibited in dozens of solo and group shows—elsewhere.

Elaine de Kooning, another New York native, was better known as a voice for the Abstract Expressionists than as one of them. Early abstractions like *Untitled, Number 15* (1948), painted when she and her husband, Willem, were at Black Mountain College—where they studied with Josef Albers—remained rolled up in her

studio until after her death. Elaine de Kooning's insight was evident in her portrait work and art criticism, and in the pieces written for *Art News* that gave readers a firsthand introduction to artists, their studios, and the new ideas and techniques. Perhaps to escape her husband's shadow, beginning in the 1950s de Kooning traveled frequently as a visiting artist and lecturer. Large late works, inspired by visits to Altamira and Lascaux, invoke the power of the prehistoric cave paintings there. Suffused with washed and dripped color, they attest to her continuing authority over the canvas.

Grace Hartigan (b. 1922) crossed the river from Newark, New Jersey, to become a New York painter. In 1948, attracted by their work, she sought out Pollock, Krasner, de Kooning, and Franz Kline, whose influences are visible in her early work—"discovered" in the early 1950s, Hartigan was uncomfortable with such early success, and for several years she copied reproductions of Rubens, Velasquez, Goya, learning art history by painting it. Not quite at home with pure abstraction, Hartigan quoted transformed fragments from these Old Masters and from city life, nature, and popular culture, with slashes and swabs of color, in works like *Grand Street Brides* (1954) and *Billboard* (1957). Since 1960, she has lived and worked in Baltimore.

Joan Mitchell (1926–1992) was also tapped early for success when her work was chosen by members of The Club for exhibition in the 1951 Ninth Street Show. Educated at Smith College, at the Art Institute of Chicago (in her hometown), and on a study fellowship in France, Mitchell arrived in New York in the early 1950s. Drawing on Cézanne and Cubism, de Kooning, Gorky, and Kline, her early works were abstract references to nature; for Mitchell, who inherited from her mother a poet's sensibility, an abstraction of a landscape often came out of an emotional response. Painting became the physical act of conveying present or recollected feelings: large and small gestures of the brush may clash colors, admit light, or evoke subtle harmonies.

The youngest artist in the 1951 Ninth Street Show was Helen Frankenthaler (b. 1928). That same year, the Bennington graduate, daughter of a New York Supreme Court Justice, had her ideas about painting transformed by Pollock's method of working on the floor and his paintings. However, whereas Pollock dripped paint onto large primed canvases, building thick layers, Frankenthaler poured thinned paint onto unprimed canvas, allowing the pigments to penetrate the surface and controlling the forms with brushes, sponges, cloths, even her hand. Frankenthaler's immense (seven by almost ten feet) *Mountains and Sea* (1952) was recognized as a landmark work in Color Field painting for the freshness and liberating possibilities of the deeply imbued stain. Space, it seemed, had instantly become lighter with her departure from the traditional loaded-brush approach to painting. Frankenthaler's main subject was landscape; in later works, such as *Untitled (July 75)* (1975), she eliminated added lines and splotches in favor of simplified forms and large expanses of color washes that suggest the complex spatial relationships in nature.

Instead of simplifying nature's colors and forms, Nell Blaine (1922–1996) multiplied them. The rebellious Virginia native, who came to New York in 1942 to study with Hans Hofmann, found herself happily at home in Greenwich Village. At age twenty-two she became the youngest member of AAA, and through the 1940s was an energetic teacher and organizer of group and cooperative exhibitions. Married to a jazz musician, Blaine found a strong connection between the improvisations of abstract art and jazz. In the 1950s, however, after a visit to France, Blaine saw new possibilities in applying her rhythmic brushstrokes to landscape and still life. In 1959, on a painting trip in Greece, she was stricken with polio, but many of her friends in the New York art community came to her aid, making it possible for the partially paralyzed Blaine to resume painting. Using color like musical notes and phrases, she shared her joyous nature in radiant still lifes like *Table with Flowers and Yellow Bird* (1981).

Jane Wilson, and Jane Freilicher (both b. 1924) were university-educated before entering the heady world of Greenwich Village and the New York School. The Iowa-born Wilson supported herself initially as a fashion model by day—to the chagrin of her more bohemian artist colleagues—and painted abstractions at night. Wilson's first, broadly brushed works such as *American Landscape* (1959) recalled Great Plains and mountain landscapes she had seen during her early travels. With broad swaths of muted hues she recast remembered skies, fields, and hills. Later, applying her loose, gestural brushstrokes to traditional still life subjects, as in *Some of Willa's Things* (1971), Wilson created richly textured compositions of patterned fabrics, fruits, and flowers.

Freilicher, who, like Blaine, her teacher, became disenchanted with pure abstraction which she considered exposing one's subconscious. Freilicher preferred to paint the unseen vital substances in still lifes, landscapes, and cityscapes, and her evocative paintings owe as much to Pierre Bonnard as to her Abstract Expressionist roots.

Like Blaine, Wilson, and Freilicher, many second-generation Abstract Expressionists explored the movement's unconscious, gestural roots only briefly. Whether finding their imagery in nature, the figure, or still-life objects, these artists infused these traditional genres with some of the new vitality.

p. 224:
Joan Mitchell. *Petit Matin.* 1982.
Oil on canvas. 25 ½ x 21 in.
(64.7 x 53.3 cm). Private
collection. © Estate of Joan
Mitchell. Photograph: Christie's
Images Ltd., 1999.

p. 226:
Nell Blaine. *Table with Flowers and
Yellow Bird.* 1981. Oil on canvas.
28 x 32 in. (71.1 x 81.2 cm). Private
collection. Courtesy Tibor de
Nagy Gallery, New York.

Opposite, top:
Perle Fine. *Charcoal Red.* 1960.
Oil on canvas. 52 x 90 in. (132 x
228.6 cm). Courtesy Vered
Gallery, East Hampton.

Opposite, bottom:
Jane Wilson. *Some of Willa's Things.*
1971. Oil on canvas. 60 x 80 ³⁄₁₆ in.
(152.4 x 203.7 cm). (1972.3)
Courtesy of the Pennsylvania
Academy of the Fine Arts,
Philadelphia. Gift of the
American Academy of Arts
and Letters (The Childe
Hassam Fund).

Above:
Lee Krasner. *Listen.* 1957. Oil on
cotton duck. 63 ¼ x 58 ½ in.
(160.6 x 148.5 cm). Private
collection. Courtesy Robert
Miller Gallery, New York.

p. 230-231:
Elaine de Kooning. *Untitled, Number 15*. 1948. Enamel on paper mounted on canvas. 32 x 44 in. (81.3 x 111.8 cm). The Metropolitan Museum of Art. Purchase, Iris Cantor Gift, 1992. (1992.22) Photograph © 1992 The Metropolitan Museum of Art, New York

Above:
Ethel Schwabacher. *Antigone I*. 1958. Oil on canvas. 69 ½ x 84 in. (176.5 x 213.3 cm). Wadsworth Atheneum, Hartford. The LeWitt Collection.

Grace Hartigan. *Billboard*. 1957.
Oil on canvas. 78 ½ x 87 in.
(199.3 x 221 cm). The Minneapolis
Institute of Arts. The Julia B.
Bigelow Fund.

Helen Frankenthaler. *Untitled
(July 75)*. 1975. Acrylic on paper.
22 x 30 in. (55.8 x 76.2 cm). Private
collection. © 1999 Helen
Frankenthaler. Photograph:
Christie's Images Ltd., 1999.

Jane Freilicher. *Bluish Horizon.*
1984. Oil on canvas. 80 x 70 in.
(203.2 x 177.8 cm). Private
collection. Photograph:
Christie's Images.

18
Essence Matters
Abstraction and Nonobjective Painting

In the period between the two world wars, a number of European artists, searching for a way to make universal order and harmony manifest, turned to geometric abstraction. Russian artists evolved Constructivism, Weimar Germans developed the Bauhaus, and the Dutch created *de Stijl* (literally, "the style"). All these schools rejected traditional representation in favor of what the de Stijl painter Piet Mondrian called Neo-Plasticism, that is, an art that strove to eliminate the personal element, to achieve a "pure reality" and universality reduced to essential lines and colors. For some, the work represented the visual counterpart of more spiritual subject matter.

This was certainly true of the very private, idiosyncratic Maria-Elena Vieira da Silva (1908–1992), the Portuguese-born painter who waited out World War II in Brazil, then made her home in Paris, becoming one of Europe's best-known painters after the war. Da Silva's complex arrangements, often based on architectural and other urban subjects, extended a continuum that led from Cézanne through Cubism toward formal abstraction. Whether by suspending forms or constructing large, ambiguous panoramas or aerial views, Vieira da Silva created puzzling spaces in paintings such as *The Corridor* (1950), where grids and walls colliding at some distant point on a highly textured surface provide a sense of space more personal than probable.

Many avant-garde European artists fleeing the war headed for New York. Among the new arrivals in 1940 was Mondrian, who had lived in Paris for many years. He was welcomed by the Russian-born Ilya Bolotowski and the Bauhaus-trained Josef Albers, among others, into the AAA (American Abstract Artists).

The Federal Art Project supported many young artists in the United States during the Depression; better remembered for American Scene paintings than works in the modernist vein, the federal projects still fostered mutual support and learning. Those committed to Modernism found each other, especially in New York.

I. (Irene) Rice Pereira (1907–1971) and Loren MacIver (1909–1998) exhibited together several times in the 1950s, including in 1953 at the Whitney Museum. While light played a major role for each, Pereira's complex explorations of planes receding into space, such as *Undulating Arrangement* (1947), contrasted sharply with MacIver's jewel-like atmospheric evocations like *Violet Hour* (1943). By the time of the Whitney show, these artists, acclaimed in the previous decades, were being eclipsed by Abstract Expressionism.

Irene Rice's family moved from near Boston to Brooklyn, New York, when she was ten. After her father's early death, she supported the family as a typist, but evening classes in fashion design, literature, and art led her to the Art Students League. In 1929, the first of her three marriages was to a commercial artist, Humberto Pereira, and the couple settled in Greenwich Village. Pereira saw European Modernism firsthand during a brief study trip to Paris in 1931, but it was in North Africa that her encounter with the awesome Sahara desert brought her notions of space and light together—Pereira's published philosophical writings underline the deeply spiritual essence of her painting. A teacher and painter with the federal projects, Pereira, an early member of AAA, was looking for a way to express light and deep space in two dimensions, at times using unique media such as parchment or, as in *Undulating Arrangement*, etched glass. The artist believed that by layering geometric forms she could evoke space and light in a cosmic sense, and find plastic equivalents for the kinds of revolutionary discoveries then being made in science and mathematics.

Loren MacIver's formal training in painting ended at age ten. Married at twenty to the poet Lloyd Frankenberg, MacIver initially took an ostensibly naïve approach to art: she reduced objects to simple geometric forms, using color to imbue an everyday detail with mystery. Native New Yorkers MacIver and Frankenberg lived in Greenwich Village but spent time in Cape Cod, Key West, and, after the war, in Europe.

Everywhere, MacIver painted her immediate surroundings but found her richest vein of inspiration in cities. Finding poetic beauty in an ash can, a puddle, or a tree, or, later, in formal studies of light and atmospheric effects, MacIver was open to every way of seeing, and, like a camera, explored every kind of shot: close-up, X ray, panoramic, or aerial, as in *Paris* (1949). Using an increasingly bright palette, MacIver brought forth the underlying mystery and lyricism of ordinary subjects.

Alice Trumbull Mason (1904–1971), born in Connecticut, was the descendant of artists, including the eighteenth-century painter John Trumbull and her mother, Anne Train Trumbull. (Her daughter Emily is also a painter.) Mason, determined not to give up art to raise her family, as her mother had done, began her art training at age seventeen in Rome, during a stay there with her wealthy family. In New York, she left the conservative National Academy of Design in 1927 to study with Gorky, who opened her eyes to Cubism and modern art generally. Influenced by the designs in Greek and Byzantine art, she painted her first geometric abstractions in 1929, preceding her teacher in this. Although Mason stopped painting briefly after the birth of each of her two children, by the mid-1930s she had joined with other painters in creating an art whose subject was its formal elements. In 1936, she, with Esphyr Slobodkina, was one of the founding members of AAA. Biomorphic forms in early works like *Free White Spacing* (1939) briefly gave way to austere, Mondrian-like compositions, like *Small Forms Serving Against Large* (1949) and, later, to architectural arrangements that appear simple but are, like the poetry she wrote and published, refined and profound.

Esphyr Slobodkina (b. 1908) arrived in New York in 1928. In her native Siberia, her experience of viewing art was mostly restricted to religious icons, with the occasional opportunity to see an exhibition of Russian modernism. In New York, she met artists such as Alice Mason, George L. K. Morris, and Bolotowski (to whom she was married briefly during the 1930s), all of whom, like herself, were interested in geometric abstraction. Working simultaneously as an artist and a successful children's book illustrator—her 1940 *Caps for Sale* is a classic—Slobodkina continued to refine the hard-edge abstract style she had developed in the 1930s. In works such as *Composition in an Oval* (c. 1953), she orchestrated new forms and color harmonies.

Charmion von Wiegand (1899–1983) was born in Chicago, but the family traveled widely and she was educated in New York and Berlin. During the 1930s, when she was a news correspondent in Russia, she began painting, inspired by European modernist works in Russian collections. Back in New York, a writing assignment in 1941 on Mondrian would prove to be a turning point in her art and in her life. The two formed a close relationship during his last three years: she was instrumental in translating and setting down his ideas and theories, while he encouraged her painting and her association with AAA. Their shared interest in Theosophy, a religious philosophy derived from Asian mysticism, deeply affected the content of her paintings. Works like *Individual Worlds* (1947) must be read symbolically, with archetypal geometric shapes and primary colors enabling the achievement of various stages of consciousness and spiritual connectedness.

Abstract Expressionism exploded onto the scene, revolutionizing the art world, and, by the 1950s, all but eclipsing Neo-Plasticism. Nevertheless, it did not meet the need of certain artists for a systematic vision encompassing personal perceptions, expressions, and spirituality. Alma Thomas (1891–1978) did not find her personally significant style until she was in her sixties. The first art graduate of Howard University in 1924, for the next thirty-five years she taught art in Washington, D.C., and was instrumental in creating a gallery for modern art in that city. Through the years she painted and studied with Lois Mailou Jones and other artists in the area, evolving her trademark abstract style suffused with effervescent color. The work of the Washington Color Field painters that she saw in the early 1960s suggested a new direction in her art—for a 1966 retrospective, Thomas determined to look ahead instead of back, to make something totally different. The resulting paintings, with their masterful, loaded brushstrokes, were inspired by patterns of gardens and leaves; these mosaic-like compositions of luminous color express Thomas's communion with nature, music, or, as in *Antares* (1972), cosmic phenomena. In many such late canvases, a single color resonates through the rough brushstrokes and surface textures to create a glowing presence.

Agnes Martin's (b. 1912) quiet paintings, often compared with those of Mark Rothko for their mystical quality, were a far cry from the more blaring forms of Abstract Expressionism. Martin was born in Saskatchewan but came to the United States for school; in the early 1940s, she pursued her interest in art, preparing to teach. Betty Parsons encouraged her in the early 1950s, but Martin left New York to paint in Taos, New Mexico. Back in New York in 1957, living in a neighborhood of artists, and looking at the paintings of Rothko, Barnett Newman, and others, Martin found in their geometric abstractions the spiritual art practice she had been seeking. Eventually reducing forms to lines and points, then to parallel pencil lines that

shimmered with palest color, as in *Falling Blue* (1961), Martin created light-filled surfaces. In her writings, Martin has described her desire for an art that is devoid of human pride, an expression of purity through humility.

It was its effect on the eye, not on the soul, that made Op Art wildly popular in the 1960s. The British artist Bridget Riley's (b. 1931) tense early compositions were hard to look at—and even harder to look away from. The artist, formally trained and citing influences as diverse as Piero della Francesca, Jean-Auguste-Dominique Ingres, Umberto Boccioni, and Georges Seurat, has said that she is concerned with "principles of repose and disturbance." Swelling or wavy lines, or circles, squares, or triangular units shift and split, causing an almost hallucinatory experience. Riley initially worked in black and white, but later added color; her paintings continue to evolve with a combination of a great deal of planning and discovery, as the artist plays forces against one another to bring forth the desired yet serendipitous perception, energy, intensity, structure, and movement.

An art establishment enthralled with Minimalism had declared painting dead by the time Elizabeth Murray (b. 1940) arrived in New York in 1967. After playing with Minimalist lines and grids, the Illinois native, who had studied painting at the Art Institute of Chicago and Mills College in California, eventually returned to old-fashioned abstraction. With thickly applied paint, she added texture to richly nuanced color-shapes. By 1980, the shapes were gone or, rather, had entered the canvas, becoming pieced, sometimes geometric forms, their white clefts outlining denotive shapes. With works like *Just in Time* (1981), a cartoon-like eight-foot coffee cup, or the topsy-turvy *Arm-Ear* (1993), Murray found an audience ready for sumptuously painted abstractions with a discernible subject. With a lively sense of humor and imagination, Murray brought new life to commonplace subjects and new dimensions to the painted canvas.

p. 236:
Alma Woodsey Thomas.
Antares. 1972. Acrylic on canvas.
65 ¾ x 56 ½ in. (167 x 143.5 cm).
National Museum of American
Art, Smithsonian Institution,
Washington, D.C. Photograph:
National Museum of American
Art, Smithsonian Institution,
Washington, D.C./
Art Resource, N.Y.

p. 239:
Maria-Elena Vieira da Silva.
The Corridor. 1950. Oil on canvas.
25 ½ x 35 ⅞ in. (64.8 x 91.1 cm).
Tate Gallery, London.
Photograph: Tate Gallery/Art
Resource, N.Y.

Above:
Irene Rice Pereira. *What is
Substance?* n.d. Oil on canvas.
40 ¼ x 46 in. (102.2 x 116.8 cm).
Collection of Norton Gallery of
Art, West Palm Beach, Florida.

Above:
Alice Trumbull Mason. *Small Forms Serving Against Large.* 1949. Oil on canvas. 26 ¼ x 36 ¼ in. (66.6 x 92 cm). © Estate of Alice Trumbull Mason/Licensed by VAGA, New York, N.Y. Photograph courtesy Joan T. Washburn Gallery, New York.

Overleaf:
Loren MacIver. *Paris.* 1949. Oil on canvas. 42 x 62 in. (106.6 x 157.4 cm). The Metropolitan Museum of Art. George A. Hearn Fund, 1949. (49.161) Photograph © 1986 The Metropolitan Museum of Art, New York. Courtesy Tibor de Nagy Gallery, New York.

Above:
Esphyr Slobodkina. *Composition in Oval.* c. 1953. Oil on gesso board. 32 ½ x 61 ½ in. (82.5 x 156.2 cm). Grey Art Gallery and Study Center, New York University Art Collection. Gift of Mr. and Mrs. Irving Walsey. (1962.19)

Right:
Charmion von Wiegand. *Individual Worlds.* 1947. Oil on canvas. 30 x 25 in. (76.2 x 63.5 cm). © Estate of Charmion von Wiegand. Courtesy Michael Rosenfeld Gallery, New York City.

Agnes Martin. *Falling Blue.* 1963.
Oil and pencil on canvas.
71 ⅞ x 72 in. (182.5 x 182.8 cm).
San Francisco Museum of
Modern Art. Gift of Mr. and
Mrs. Moses Lasky.

Elizabeth Murray. *Arm-Ear*. 1993.
Oil on canvas mounted on
bentwood. 74 x 71 x 12 in. (187.9 x
180.3 x 30.4 cm). Collection of the
Newark Museum. (Inv.94.85) The
Newark Museum, Newark, New
Jersey. Photograph: The Newark
Museum/Art Resource, N.Y.

Bridget Riley. *Nataraja*. 1993.
Oil on canvas. 65 x 89 ⅝ in.
(165.1 x 227.7 cm). Tate Gallery,
London. Photograph: Tate
Gallery/Art Resource, N.Y.

19
An Art of One's Own
Latin American Painters and Sculptors

Latin America comprises many countries and cultures—both indigenous and imported. The artists, women and men alike, received their art training in academies at home in Mexico City, Havana, Rio de Janeiro, and São Paulo, as well as abroad, often in Paris or New York. Most assimilated the preeminent modernist movements of their time in addition to their own popular culture, and in every case, the multiplicity of influences has enriched their work. One of the most celebrated examples, of course, is Frida Kahlo, whose deeply personal paintings display a singular synthesis of Mexican and European cultural components.

The Cuban painter Amelia Peláez (1896–1968), like other aspiring artists of the early decades of the twentieth century, began her education at home, at Havana's Art Academy. In New York in 1924 she attended the Art Students League, and in 1927 she moved to Paris, remaining in Europe until 1934. Peláez, still considered one of Cuba's foremost painters, was one of a number who brought Modernism to Latin America: her highly decorative work stems from Cubism as well as from Constructivism, which she absorbed in Paris from her friend the Russian artist Alexandra Exter. Peláez's bold compositions build upon a strong structural base, gaining energy from their union of intricate outlines and solid forms. The rich colors that imbue these natural and geometric forms sometimes echo the sun-drenched hues of her lush tropical garden. In *Marpacifico* (*Hibiscus*) (1943), which is typical of her prolific output, her lyrical line evokes both the still-life flower subject and its setting—the intricate iron grillwork of her Havana home.

Also celebrated in her lifetime was the Mexican painter María Izquierdo (1902–1955). Trained first in traditional academic art, she was later singled out by Diego Rivera for her independent eye and spirit. Izquierdo, who had entered an arranged marriage at fourteen and had three children, was divorced by the time she met Rufino Tamayo, like Rivera, a leading Mexican muralist and political artist. While they were together, in the early 1930s, each influenced the other; well educated in the history of art, Izquierdo borrowed liberally from every century, but colored her style heavily with the folk art influences being promoted by Rivera, Tamayo, and others. Many of her still lifes resemble indigenous altarpieces, combining religious and everyday objects, while horses are frequent subjects, especially in her bright and lively circus scenes. A late work, *The Indifferent Girl* (1947), in her distinctive style, combines a folk-art solidity with surrealistic otherworldliness. Despite several paralyzing strokes after 1948, Izquierdo continued to paint, holding the brush in her disabled right hand and guiding it with her left. Her late works include a memorial painting for her friend Frida Kahlo.

A Parisian poet, Alice Rahon (1904–1987) was one of the Surrealists who emigrated to Mexico to escape World War II, along with Leonora Carrington and Remedios Varo. With her husband, the Austrian painter Wolfgang Paalen, Rahon was part of the Surrealist group in Paris. In 1939, the couple arrived in Mexico, where Rahon took up painting. Kahlo and other friends helped Rahon assimilate Mexican culture, and Rahon often referred to the landscapes and legends of her adopted country in her poems and paintings. In brilliant, saturated colors, sometimes textured with sand, she interpreted the indigenous art forms of places where she had traveled—not only Mexico but the Pacific Northwest and India—mixing folklore, literary allusions, psychology, and notions of transformation specific to the Surrealists. Works like *La Gente del Tecolote* (*People of the Owl*) (1961) were highly allegorical both in color—blue embodied the spirit and intellect—and in her use of symbols such as the owl, which, here representing the world of darkness, looms among other large blue birds like a ghost in a glowing grove.

Tomie Ohtake (b. 1913) traveled from Japan to Brazil in 1936 to visit a brother. She remained, (thereby escaping the war at home with China), and married into São Paulo's large Japanese community, which included a number of artists. After her two children were grown, she took up painting, quickly developing an abstract style notable for its simplicity. Ohtake's geometric and other shapes are juxtaposed or overlapping, while harmonious tones and modulating textures give the work an almost tactile sensuousness. In the ancient tradition of Japanese painting, much feeling is conveyed with a single brushstroke, as in an untitled work of 1968. In the late 1980s, Ohtake made a successful transition to sculpture. This artist, whose paintings represented Brazil in the 1972 Venice Biennale, represented her country again in 1993, this time with a large sculpture.

The sculptors Lygia Clark (1920–1988) and Lygia Pape (b. c. 1930) were at the forefront of Brazil's modernist movements, including the Grupo Frente (the Front) and the Grupo Concreto (the Concretists). In 1959, both artists also became involved with the Neo-Concretists, whose goal was to mix media so as to appeal to many senses. Clark, who had studied painting in Paris with Léger, among others, took up sculpture, creating organic forms that actively involve the viewer. Works in her Bicho (Strange Insect) series, for example, are hinged metal forms made to be manipulated and moved. Clark's experimental works required increasing degrees of human participation; they deftly combined movement and pliable materials, creating performance-like "Experiences." For a few years in the early 1970s, Clark taught in Paris at the Sorbonne, then returned to Rio de Janeiro where, for her remaining years, concentrated on her practice of psychotherapy.

Pape's "Ballet" of 1958 also wedded sculpture and movement: dancers encased in cylinders and boxes moved in geometric progressions in this first of many interactive performances she designed. Pape's interest in philosophy and aesthetics spawned a few highly esoteric, more durable works, such as her multimedia *Book of Creation* (1959), and the *Book of Time* (1960), a symbolic calendar based on ancient sources. In the form of 365 "pieces" or "pages" or "units," time becomes a variation on cubic "embryos." Other cubic works included "egg" boxes, from which people might break out to experience a sensation of rebirth.

The life of Joy Laville (b. 1923) has been one of journeys: from her birthplace in England, to Canada, and, in 1956, newly divorced, to Mexico, where she first studied art. Laville was encouraged and promoted by her second husband, the Mexican writer Jorge Ibargüengoitia, whose tragic death in a 1983 airplane crash eventually inspired a compelling series of dream paintings in which airplanes tumble in desolate landscapes. She has retained her highly personalized style, which features miniature figures and large monochromatic blocks of

colors in a pastel palette, although pale pinks and blues have given way, in works such as *Girl in Red Room* (1993), to less tranquil reds and violets. In this spare interior a dwarfed, faceless female figure is weighed down by the heaviness of her continuing anguish.

In 1964, the painter and printmaker Liliana Porter (b. 1941) journeyed from her native Argentina to New York to visit the World's Fair. Impressed by the art climate and the easy availability of materials, she stayed, although she maintained strong ties with Argentina. Her experience with dual "homes" and dual realities contributed to her appreciation of the multiple conditions of time and space that shape the writings of her countryman Jorge Luis Borges, one of the influences in her life. Much of Porter's work has to do with voyages, including a series of mixed media images based on Lewis Carroll's fantastic adventures of Alice in *Through the Looking Glass*. In *Fragments of the Journey* (1983), points along a triangular course within the canvas are marked with an open book—perhaps Carroll's—a box open to chance, and the timeless geometric forms that underlie artistic creation.

After completing a university fine arts degree in her native Colombia, Fanny Sanín (b. 1938) went on to study in the United States, England, and Mexico, eventually, like Porter, settling in New York. The hard-edge geometric abstractions she has painted since the 1970s are distinctive for their intricate symmetry and unusual palette: Sanín's arrangements create their own space with contrasting colors of subtly or starkly varying tones. Although her color and spatial harmonies have evolved from intricately woven bars and rectangles to incorporate triangles and diagonal elements, her work remains strongly architectural.

Jac Leirner (b. 1961) has achieved fairly rapid success in an increasingly international art world: her Minimalist sculptural compilations of non-art objects have found acclaim far beyond her home in São Paulo. In her multimedia arrangements she assembles the detritus of a global consumer society, collecting and classifying everyday articles—including discarded items such as cigarette wrappers and old airline tickets—for our reconsideration. Large installations such as *Directions* (1992) at the Hirshhorn Museum in Washington, D.C., offer "road signs," both real and invented, compatible and conflicting, legible and illegible.

With the instant availability of new art images and theories and with frequent travel, it becomes difficult to define a regional, or even national, style. Many of the artists discussed here, whether born into Latin cultures or elsewhere, living at home or abroad, have made themselves comfortable in two cultures, with their art gaining sustenance from each.

p. 248:
María Izquierdo. *The Indifferent Girl.*
1947. Oil on canvas. 33 ¾ x 26 in.
(85.7 x 66 cm). Collection Galería
de Arte Mexicana. © Estate of
Maria Izquierdo/SOMAAP,
Mexico City/Licensed by VAGA,
New York, N.Y.

p. 250:
Liliana Porter. *Fragments of the
Journey.* 1983. Acrylic, silkscreen,
assemblage on canvas. 62 x 84 in.
(157.4 x 213.3 cm). Private
collection.

p. 251:
Fanny Sanín. *Acrylic No. 6.* 1979.
Acrylic on canvas. 50 x 61 ¹³⁄₁₆ in.
(127 x 157 cm). Collection of the
Art Museum of the Americas,
Organization of American States.
Gift of the artist.

Above:
Joy Laville. *Girl in a Red Room.* 1993.
Acrylic on canvas. 47 x 39 in.
(119.3 x 99 cm). Private collection.
Photograph courtesy Salomon
Grimberg.

Amélia Peláez. *Marpacifico (The Hibiscus)*. 1943. Oil on canvas. 45 ½ x 35 in. (115.5 x 88.9 cm). Collection of the Art Museum of the Americas, Organization of American States. Gift of IBM.

Alice Rahon. *La Gente del Tecolote
(People of the Owl)*. 1961. Oil on
canvas. Private collection.
Photograph courtesy Salomon
Grimberg.

Tomie Ohtake. *Untitled*. 1968. Oil on canvas. 54 ½ x 44 ½ in. (138.4 x 113.0 cm). Collection of the Art Museum of the Americas, Organization of American States.

20
Figuring It Out
Twentieth-Century Representation

Beginning with the cave paintings in Altamira and Lescaux, artists have depicted themselves, their family and friends, their leaders, their deities, and their surroundings. With the advent of photography in the mid-nineteenth century, and the hegemony of abstract art in the twentieth, critics and historians have predicted the end of figurative and object-oriented art—in the face of that art's continued appeal to painters and the public. Figure painting, still life, and landscape have survived, transformed by artists who have appropriated from the past to find new ways to chronicle contemporary life. Some artists have chosen expressive means, loading their brushes with paint and distorting images to communicate meaning, as Theresa Bernstein does. Others, like Hung Liu, base their paintings on photographs, some of which they take themselves, most of which are culled from old books or photographic archives.

Like many young artists of her generation, Theresa Bernstein (b. 1890) first experienced modernist art firsthand at the groundbreaking 1913 Armory Show in New York and on several trips to Europe. Bernstein, whose life has spanned more than a century, was married for more than sixty years to the painter William Meyerowitz, whose art she promoted more than her own. She developed a realist style characterized by expressive brushwork, and, like the Ashcan painters, who also had roots in her hometown of Philadelphia, Bernstein painted urban scenes, particularly of working-class life in New York City, where she still lives. Her palette varied from the Ashcan school's dark, earthy tones to rosier hues, in her light-filled Coney Island and Cape Ann, Massachusetts, beach scenes. Early experiences of having her canvases rejected when her sex was revealed provoked a lifelong commitment to women's issues—in many early paintings, including *In the Elevated* (1916), Bernstein depicted the daily activities and interactions of working-class women.

Brought up on Philadelphia's affluent Main Line, Alice Neel's (1900–1984) rebelliousness is reflected in her gallery of portraits. The sitters included her neighbors in New York's Greenwich Village and Spanish Harlem, her two sons and eventually their families, and dozens of the artists and celebrities that she befriended throughout her event-filled but troubled life, which included two husbands, the loss of two daughters, and many lovers. She couched old themes like motherhood in no-nonsense, realistic portrayals; the delicate gestures of her subjects' hands are as eloquent as their piercing eyes and expressive faces. In *Nancy and the Twins* (1971), Neel's alert granddaughters remain within reach of their relaxed but watchful mother. Neel continued to apply her style of Social Realism, developed in the 1920s and 1930s, to capture the character and substance of each subject, as in her haunting portrait of the aging painters Raphael and Moses Soyer (1973). Among her most notorious works are unromanticized nudes of males, couples, pregnant women, even herself at eighty, brush in hand.

In marked contrast to the paintings of the bohemian Neel, Isabel Bishop's (1902–1988) are dignified and refined. Her work combines Old Master techniques and practices with contemporary subject matter: the faces and figures of hobos and working women recall the portraits and compositions of Rembrandt, Frans Hals, and Peter Paul Rubens. Street scenes capture the tenor of life in New York, especially around her Union Square studio. Bishop's well-known *Virgil and Dante in Union Square* (1932), a mural-like expanse of souls in movement, at once elevates and reflects upon the daily lives of ordinary working people. Born in Cincinnati, raised in Detroit, and sponsored by a wealthy cousin during her early years in New York, Bishop never stopped painting. Following her marriage to a physician, their move to the suburbs, and the birth of their son, she commuted each day to her studio. Bishop, like Neel, also painted the nude figure, but, where Neel's confront the viewer, Bishop's many female nudes, like those of Degas, are absorbed in the gestures of daily routines.

p. 256:
Paula Rego. *Joseph's Dream*. 1990.
Acrylic on paper on canvas. 72 x
48 in. (183 x 122 cm). Courtesy
Marlborough Gallery, London.

Right:
Augusta Savage. *Gamin*. c. 1930.
Painted plaster. 9 ¼ x 5 ½ in.
(23.5 x 13.9 cm). Private collection,
New York, N.Y. Courtesy
Michael Rosenfeld Gallery,
New York City.

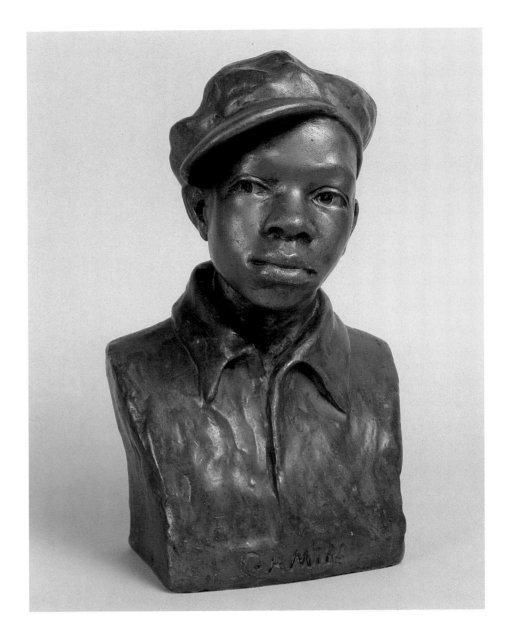

The African American artist Lois Mailou Jones's (1905–1998) 1932 painting *The Ascent of Ethiopia* was inspired by Meta Warrick Fuller's sculpture on a similar theme, and Fuller's stories about studying with Rodin also fueled Jones's ambition to travel. In Paris just before World War II—on a sabbatical from Howard University, where she educated several generations of black artists—Jones, who was painting Post-Impressionist street scenes and Cézannesque landscapes, discovered African masks. Her 1938 painting, *Les Fetiches*, also reveals the artist's movement from a largely volumetric European style to the flat, angular, geometric forms of African art. In the 1940s, friends who were well-known figures in the Harlem Renaissance encouraged Jones to look at African art. Visits to Haiti, her husband's homeland, and, later, trips to Africa intensified this influence. *Peasant Girl, Haiti* (1954) and *Vendeuses de Tissus (Cloth Vendors)*, (1961), a joyous, friezelike panel, are two examples of Jones's interest in the lives of working women. These pictures also reveal the artist's shift from a largely volumetric European style to the flat, angular geometric forms of African art.

The work of the Scottish painters Anne Redpath (1895–1965) and Joan Eardley (1921–1963) revealed various strains of Modernism. Although born a generation apart, both attained acclaim in the 1950s and were among the first women elected to membership in the Royal Scottish Academy. (Eardley was already dying of cancer when she received this recognition.)

Anne Redpath, schooled in Edinburgh, painted little during a long period in southern France, while her three children were young. Back in Scotland, needing to earn money after her architect husband lost his job, she resumed painting. Her subjects, close to home, were mostly city scenes, landscapes, and interiors. The years during which she did not paint seem to have intensified Redpath's appreciation for the possibilities inherent in everyday subject matter; her paintings reflect intimations of similar subjects by Matisse, van Gogh, Gauguin, and Bonnard. Figures appear infrequently in her work, but when they do, they are treated more as forms to be explored than as character studies, as in a painting of her daughter-in-law, *Eileen in a White Chair* (1953).

Just as Alice Neel painted her poor neighbors, so did Joan Eardley find her subjects, especially children, in

the tenements of Glasgow. *Jeannie* is an instance of Eardley's unsentimental manner. During the last fifteen years of her life, Eardley divided her time between Glasgow and a fishing village on the northeast coast of Scotland, the latter inspiring paintings devoid of human presence. In an expressionist style that approached abstraction, Eardley worked out of doors, painting land and seascapes in various atmospheric conditions, even painting through storms to capture the power of wind and rain.

The paintings of Paraskeva Clark (1898–1986), a naturalized Canadian, also have an element of social commentary. The Russian-born Clark studied art in Saint Petersburg before emigrating to Paris, where she married a Canadian. For a time, she expressed her social conscience in topical paintings like *Petroushka* (1937), a social-political commentary in the guise of a modern-day Punch-and-Judy show, in which the actions of crooked politicians and ruthless police officers are met with cheers instead of outrage. Caricatural figures appear against a new-style cityscape of impersonal high-rises that fan out as far as the eye can see. Clark later found the vast and varied Canadian landscape a powerful subject for her modernist contemplation.

The photo realist still-lifes of another Canadian, Mary Pratt (b. 1935), wife of an artist and mother of four, have been viewed either simply as domestic subjects or as social commentary on violence in society. Viewers coming to her work for the first time are often unprepared for the jarring bite of Pratt's depictions of an eviscerated salmon, cups of currant jelly, or a roast beef. Likewise, her female nudes contribute to an ongoing issue of debate among feminists: the exploitation of female nudity and specifically, voyeurism. Exploring the tradition of the classical female nude as muse, in *Venus from a Northern Pond* (1987) a pale and monumental figure emerges from the dark river into glistening sunlight. Pratt concluded that she would look elsewhere for the source of her creativity, to fire and light and her disturbing still-life subjects, inanimate but crackling with life.

Even when Paula Rego's (b. 1935) figures are animals, the subject is human interactions. The Portuguese-born artist has lived in London since attending the Slade School of Art, where she met her husband, the artist Victor Willing, who died in 1988. In The Vivian Girls, Red Monkey Series, and other series in the early 1980s, Rego portrayed animated females—at times adolescent, cartoonish, or cruel—fighting cunningly against animal-like adversaries in fanciful settings and situations. In a series called Heroic Handmaidens, massive female figures stoically abide subservient roles, and tasks, such as polishing the boots of their male relatives. Several paintings that Rego made when her husband was dying portray women caring for him, as if they could bring him back to life. Invited by the National Gallery in London to create new works based on paintings in the collection, Rego used the opportunity to reinterpret women's roles. In *Joseph's Dream* (1990), based on a seventeenth-century work by Philippe de Champaigne, it is the artist herself, a robust, solid triangle, who provides the central force as she paints a soundly sleeping Joseph.

Where artists of earlier generations had renounced traditional art training in favor of Modernism, and especially abstraction, Audrey Flack (b. 1931) found herself in the opposite predicament: drawn to realism and in search of training in anatomy and perspective. Using a photorealist approach, Flack directed her attention in the 1960s to current events and social themes, including the assassination of a president and Civil Rights marches. Flack turned feminist concerns in the 1970s into striking images based on works of earlier female artists: her emotional saints and madonnas were inspired by the Spanish Baroque sculptures of Luisa Roldan, her Vanitas paintings by the still lifes of Dutch artist Maria van Oosterwyck. Exaggerating color and scale, Flack attacks contemporary subjects and concerns—in *World War II Vanitas* (1976–77), she eloquently combined a photo of prisoners at Buchenwald with symbols both traditional (butterfly, candle, clock, rose) and more specific (Star of David, text and music fragments). More recently, Flack has switched to sculpture, creating monumental figures of women from history and mythology for public sites.

The Chinese-born Hung Liu (b. 1948) has lived and worked in California since 1984. The immigrant experience, her reflections on East and West, art and history, and the blending of cultures, including those of old and new China, have given rise to the powerful imagery of Liu's paintings and mixed-media works. In her compelling *Goddess of Love, Goddess of Liberty* (1989), a sexual scene is much less shocking than the rare and forbidden view of a naked bound foot. Working from old photographs, many taken from albums of "available" courtesans, Liu uses Western modes of painterly representation to create portraitlike depictions of Chinese women in traditional roles, conveying their dignity as well as the indignities and pain of thousands of years of subjugation.

As much a mirror of time, place, and society as the painted image, three-dimensional portrayals of the figure reflected the edges and facets of twentieth-century life. Whether using traditional or contemporary

forms, women sculptors, too, made the personal universal, examining the human form in search of the human spirit. In bronze, wood, or clay, and as the century progressed, sometimes the detritus of modern life, they sought to bring pathos, humor, energy, and strength to the subject, underscoring its connectedness—or its dislocation—with nature and humankind.

Augusta Savage (1892–1962), born in rural northern Florida, and Elizabeth Catlett (b. 1915), from Washington, D.C., overcame blatant racism to obtain excellent art educations. Savage, for most of her life, also faced financial restrictions that inhibited her production—many of her pieces were created in inexpensive plaster and never cast. It was 1929 before she received a fellowship with funds that enabled her to travel and study in Paris, where her sensitive, insightful, realist busts and larger pieces won praise in the Salon. In New York at the height of the Depression, Savage received numerous commissions. But perhaps her greatest contribution to the Harlem Renaissance of the 1920s and 1940s was her art school, which later, with federal WPA funding became the Harlem Art Center, where younger artists found an inspiring teacher and mentor. Savage's stirring *Lift Every Voice and Sing*, a children's choir in the form of a harp, stood at the entrance of the American art exhibition at the 1939 New York World's Fair. Like many of her pieces, it was never cast in bronze, for lack of funds; considered one of the fair's "temporary structures," it was bulldozed when the fair closed. Only a few smaller works, like *Gamin* (c. 1930), can be found today.

Like Savage, Elizabeth Catlett was a dedicated art educator. As a teacher in segregated schools in North Carolina, Catlett aroused controversy when she introduced her students to life drawing and crossed color lines to take them to museums where they were made unwelcome. Married briefly to the painter Charles White, she continued teaching and frequented the circles of black intellectuals in 1940s Harlem. In the late 1940s, Catlett moved permanently to Mexico, remarried, and raised three sons. Her early archetypal females, even small figures like *Tired* (1946), have a monumental quality; her elegant later sculptures in wood, marble, and bronze became more abstract but her subject matter has remained strong females, inspired by Mexican as well as African figures.

The life cycles of insects that fascinated Germaine Richier (1904–1959) as a child may have inspired her later fantastic creatures. Dissatisfied with the art training available in Montpellier, near her home, in 1925 Richier entered the Paris studio of Antoine Bourdelle, a protégé of Rodin. There, along with fellow student Alberto Giacometti, Richier learned to treat character as well as form, and in the 1930s her Rodinesque figures were singled out for prizes and exhibitions. She and her husband, the Swiss sculptor Otto Bänninger, spent the war years in exile in his homeland; after the war, responding to the violence and decay of World War II, Richier introduced the acid-pitted, torn surfaces that became her hallmark. At first applied to human forms, like *Hurricane* (1948–49), a gruesome nude female, Richier later used the rough, shredded skins to shape spidery extremities in half-human, insectlike creatures like *The Devil with Claws* (1952), at once delicate and grotesque.

The larger-than-life presence of Richier's pieces, their rough surfaces, and her direct working methods—building upon an armature—influenced the British sculptor Dame Elizabeth Frink (1930–1993). Frink imbued her more classical and mostly male figures with an inner vitality: the balanced physicality of her running and leaping men of the 1970s and 1980s is made sensuous by an expression of their mental as well as physical energy, and by their textured surfaces. In the less active *Seated Man* (1986), the same energy is contained in a restive stillness. Frink did not use pedestals, preferring the figures, sometimes single, sometimes in groups, to be at eye level and spaced apart in such a way as to encourage viewers to walk among them. Like Richier's, Frink's life was cut short by cancer.

When World War II broke out in Europe, many families sought safer ground in the United States. The American mother of Mary Frank (b. 1933, England) came "home" to New York, leaving her husband behind. Niki de Saint Phalle's (b. 1930) French family had business ties in New York and relocated there. Life in Europe had provided essential experiences in Frank's and Saint Phalle's development as artists, even though they were busy young wives with children. Both artists were teenage brides: Frank married the Swiss photographer Robert Frank, and Saint Phalle, the musician Harry Matthews.

Travel provided folk art influences for Marisol (Escobar) (b. 1930), whose Venezuelan parents were in Paris when she was born and lived the war years between North and South America. Unable to leave Europe, the family of Magdalena Abakanowicz (b. 1930) remained in Poland, where the war devastated their life of comfortable gentility.

Outside her home in upstate New York are some of the female figures Mary Frank has constructed from slabs of rolled clay; delicate incising and leaf imprints on reclining forms like *Woman with Outstretched Arms* (1975) emphasize their mythic connection with the earth. Conceived as wholes, Frank's assembled figures reveal a full

range of women's spiritual, emotional, and physical experience. Frank expressed a series of personal tragedies, including the loss of her adult daughter in 1975 and her son's grave health problems, in figures whose sharp, hollowed-out lines describe acute pain and anguish. Just as powerful are the artist's drawings and monoprints made of finished sculptures, and those of flowers strong with nature's generative force. In works suffused with penetrating allusions to poetry, mythology, and music, Frank's suspended swimmers, graceful dancers, and horse riders (*Horse and Rider*, 1982) energize the space they inhabit.

A peripatetic member of an international arts-and-letters community, Niki de Saint Phalle gleaned ideas at every stop. When she was a young wife and mother, she acted and painted, but when she discovered the fantastic structures of the Catalan architect Antonio Gaudí in Barcelona in 1955, it set her course: to create a sculpture park. Through the wilder-than-Dada New Realists in Paris she met Jean Tinguely, whom she later married. Their numerous collaborations include an eighty-three-foot "cathedral" in the form of a reclining pregnant nude in Stockholm (1966) and the whimsical Beaubourg Fountain (1980), near Paris's Pompidou Center. In the mid-1960s Saint Phalle created some of her best-known works, a series of fat, dancing Nanas (French slang for "women") covered head to toe with colorful hearts and flowers. In Tuscany, Saint Phalle's Tarot Garden is taking shape with sculptures and buildings representing figures from those oracular cards.

Marisol was one of a growing number of art students in the 1950s for whom New York had supplanted Paris as their mecca. Needing a break after three years in the Abstract Expressionist Hans Hofmann's painting classes, Marisol began fashioning humorous figures in clay. By the late 1950s her droll figures had made her famous. Combining drawing, painting, modeling, casting, carving, woodworking, and everyday objects, Marisol created sophisticated folk sculpture that mocked society's rituals, leaders, and institutions. *The Family* (1963) pokes fun at the nuclear family, with its well-behaved but vicious-looking children, a mother at the center and in charge, and a father who practically melts into the wallpaper. In *The Cocktail Party* (1965), fifteen figures stand trancelike, some gowned in real clothing, frozen in ritualized social gestures, while a multiheaded waiter serves drinks in real glasses. All the women in *The Cocktail Party* have Marisol's face, but she has also interjected movie stars, world leaders, religious figures, even artists into her symbolic, outrageous assemblages. Unnerved by the public demands of success, this very private artist escaped for a time to Europe; since then, Marisol has maintained both her privacy and prolific output.

There is nothing satirical about Magdalena Abakanowicz's precise, moving, and hand-shaped figure groups. She trained and began her career as an artist under difficult conditions in postwar Poland, but it was after she was invited to major international exhibitions in the 1960s that Abakanowicz gained critical acclaim for her

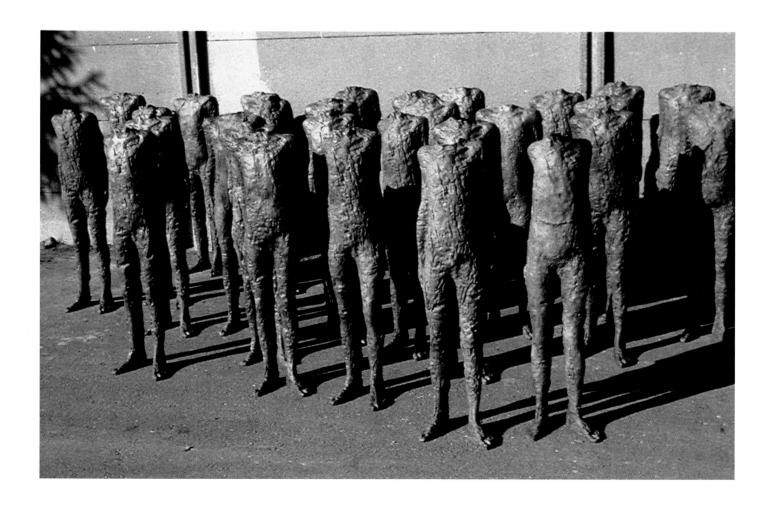

immense "garments," abstract dyed "Abakans," and room-size installations made from woven natural fibers and rope, perhaps a hyperbolic reference to women's traditional medium of weaving and fabrics. What evolved for Abakanowicz as she sought ways to come to terms with history and civilization was a series of encounters with the human figure, installations at various locations of large groups of fragmented forms—faceless *Heads* (1973–1975), limbless *Backs* (1982), and headless *Ragazzi* ("Children," 1992–1993). Of handsewn burlap or bronze replications of the woven fabric, they are alike, but, because they are hand-crafted, each is different, and the effect of so many is stunning. Although her recent works are of wood, bronze, and stone, Abakanowicz is at heart a fiber artist.

Clothing and fiber were also the starting point for the Philadelphia-born Judith Shea (b. 1948). Inspired by sculpture of the past—Asian, Greek, Egyptian, and Neoclassical, the designer-turned-artist appropriates these formal styles to comment on contemporary life and art: her monumental figures seem very much at home in outdoor placements with conceptual and environmental pieces. At first Shea presented empty bronze casts of clothing, either freestanding or hanging, as minimalist compositions, and her figures still seem formed by their clothing instead of the more usual opposite. (Her "empty dress" forms became a leitmotif for many feminist sculptors.) Without face or hands, Shea's figures, like *Public Goddess* (1992), communicate meaning through form, gesture, surface texture, color, and materials. Animated and shaped by a force from within, Shea's large outdoor sculpture forces a dialogue about the female form and its relationship to the natural environment.

An even more subtle dialogue is contained in Deborah Butterfield's (b. 1949) first life-size plaster horses. Conceived as antiwar statements, her unusual figures are monumental procreators instead of mighty battle horses. Since then, by eliminating the plaster and exposing the armature and the mud, brush, steel, or found materials of their creation, Butterfield has increasingly focused on the animated lines and essential "anatomy" of her gentle beasts. The artist has called her horse images "metaphorical substitutes" for herself, a way of communicating her deep connection and identification with these animals. Butterfield's thorough exploration of the horse, in works like *Rory* (1992), extends to capturing its eloquent features, rather than its speed or ability to fight, work, race, or perform.

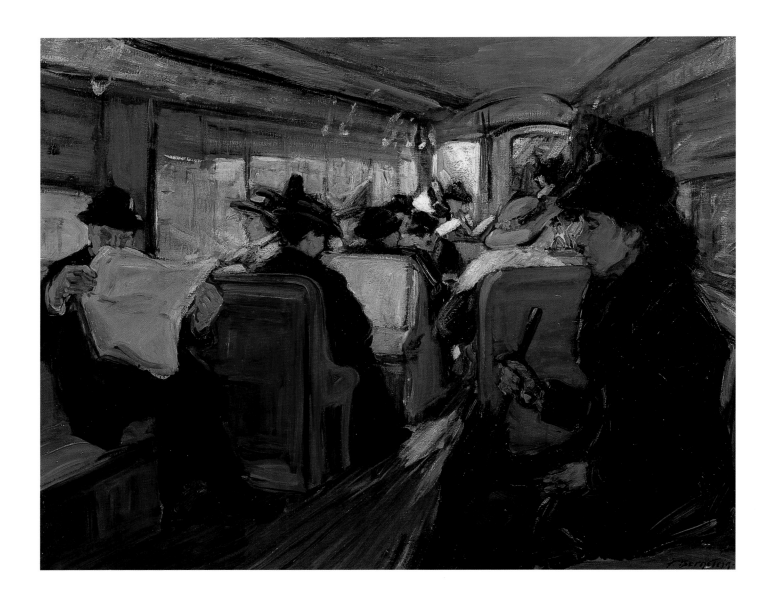

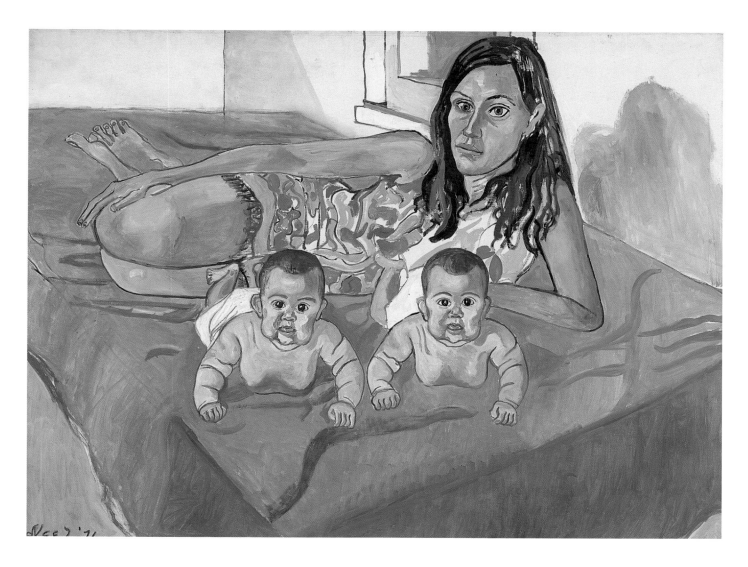

p. 261:
Magdalena Abakanowicz. *Puellae.*
1992. Bronze, 30 figures. 39 ¾ x
43 ¼ in. (101 x 110 cm). ©
Magdalena Abaknowicz.
Courtesy Marlborough Gallery,
New York.

Opposite:
Theresa Bernstein. *In the Elevated.*
1916. Oil on canvas. 30 x 40 in.
(76.2 x 101.6 cm). Courtesy Janet
Marqusee Fine Arts, New York.

Above:
Alice Neel. *Nancy and the Twins.*
1971. Oil on canvas. 44 x 60 in.
(111.7 x 152.4 cm). © The Estate of
Alice Neel. Courtesy Robert
Miller Gallery, New York.

Overleaf:
Isabel Bishop. *Virgil and Dante in
Union Square.* 1932. Oil on canvas.
27 x 52 ⅜ in. (68.6 x 133 cm).
Delaware Art Museum. Gift of
the Friends of the Arts. Courtesy
DC Moore Gallery, New York.

p. 266:
Lois Mailou Jones. *Les Fetiches.*
1938. Oil on canvas. 25 ½ x
21 ¼ in. (64.7 x 54 cm). National
Museum of American Art,
Smithsonian Institution,
Washington, D.C. Museum
purchase made possible by
Mrs. N.H. Green, Dr. R. Harlan,
and Francis Musgrave.
Photograph: National Museum
of American Art, Smithsonian
Institution, Washington,
D.C./Art Resource, N.Y.

p. 267:
Joan Eardley. *Jeannie.* Gouache,
pen, and chalk. 14 x 10 in. (35.5 x
25.4 cm). Photograph: Bourne
Fine Art, Edinburgh, Scotland.

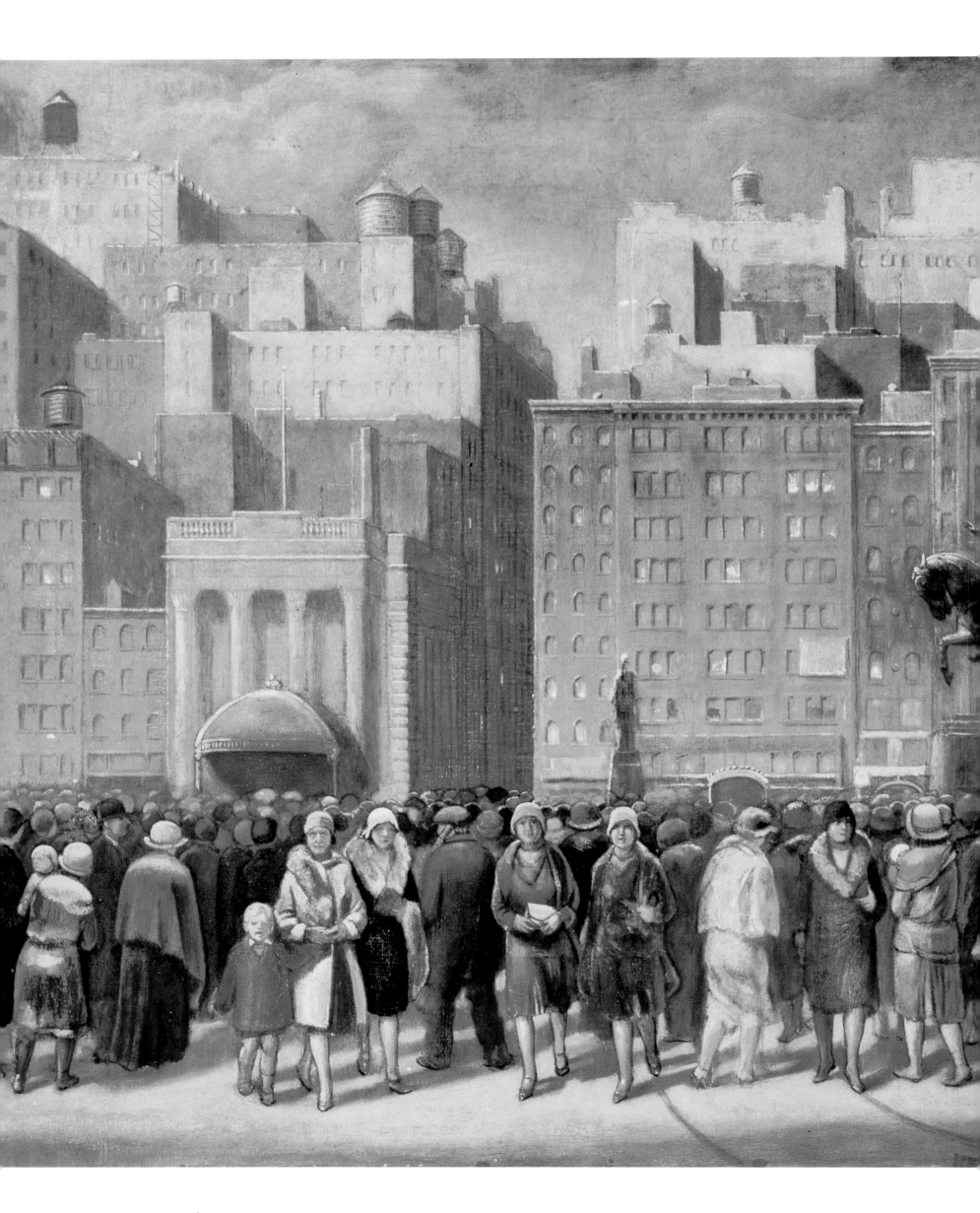

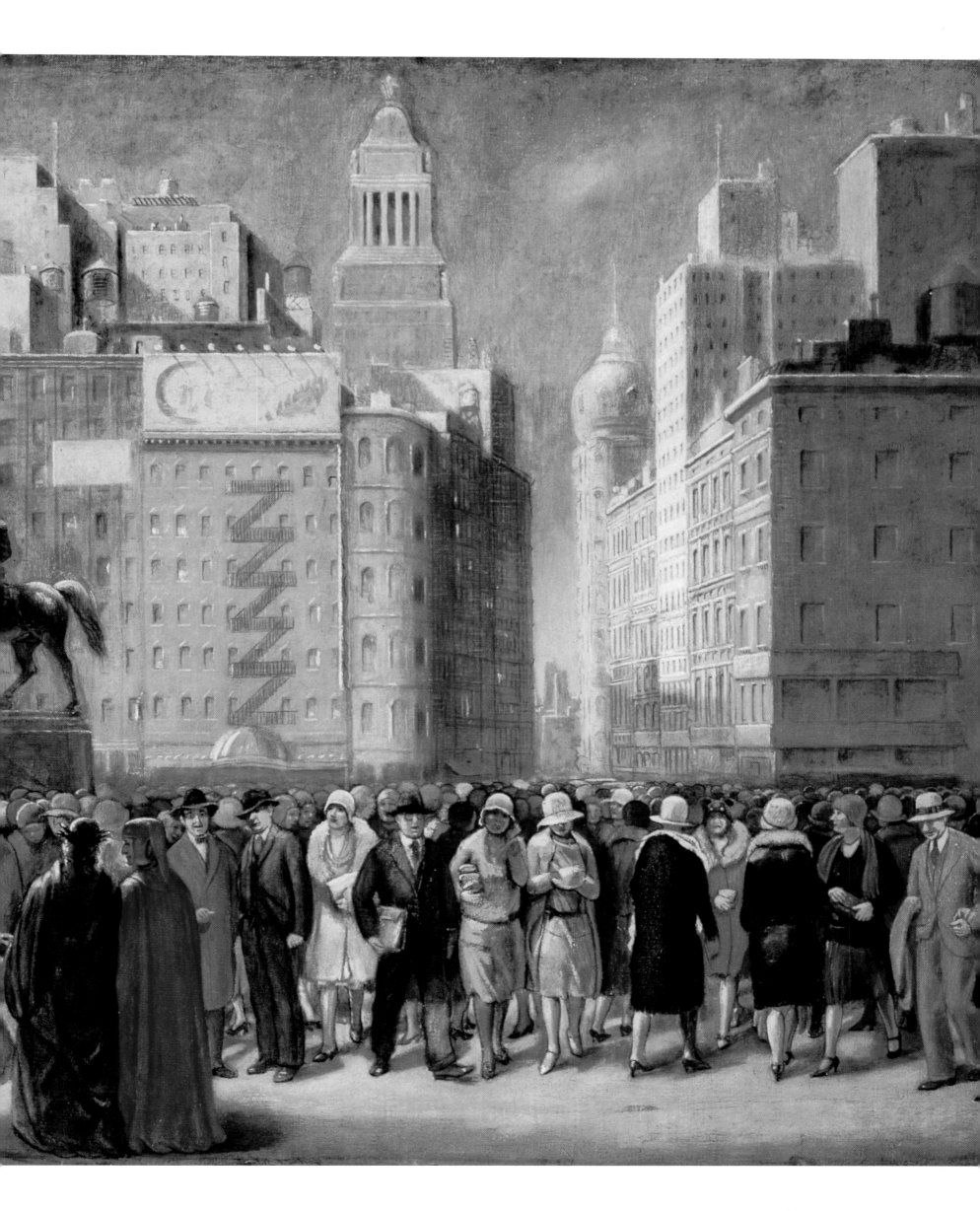

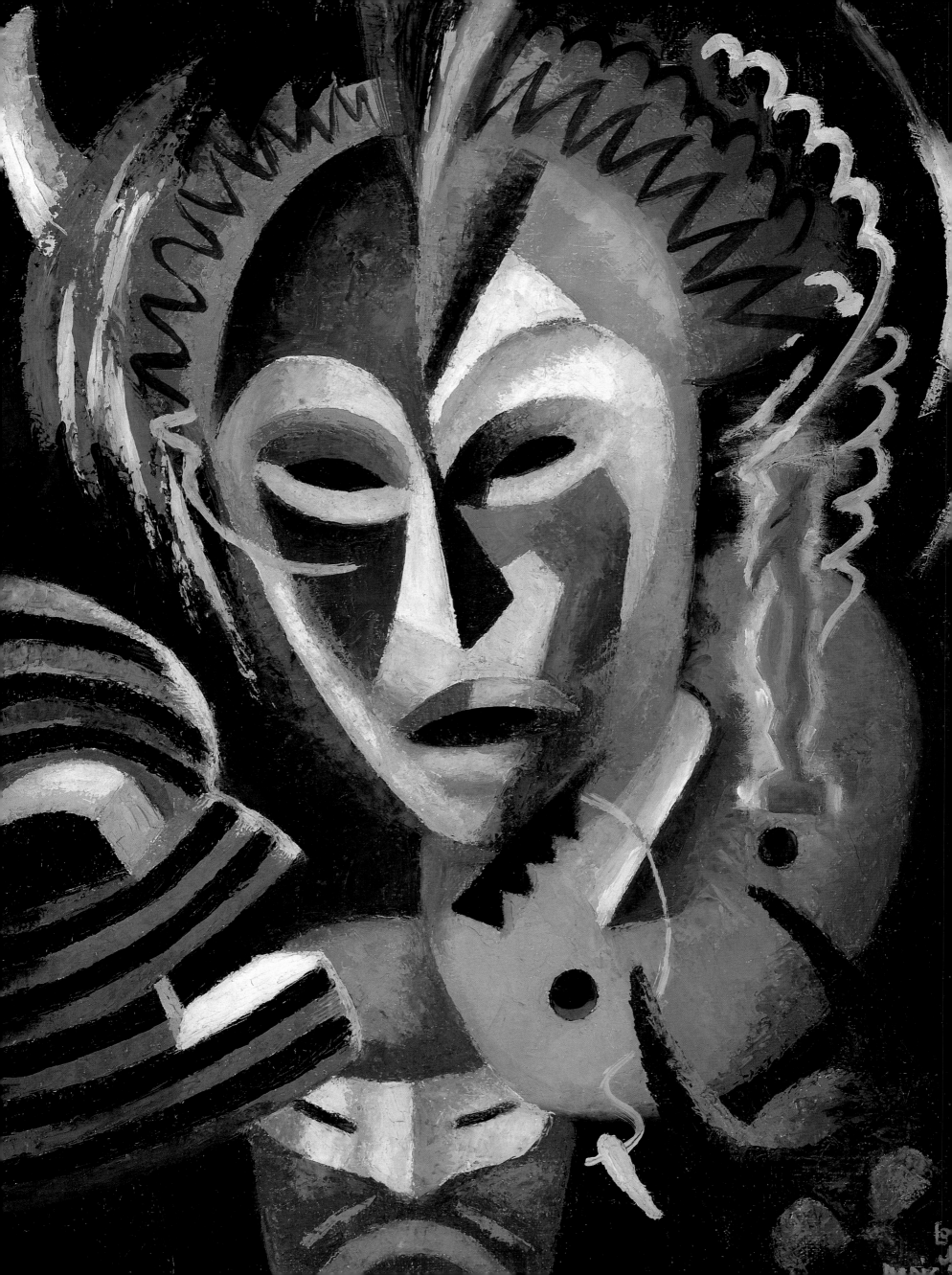

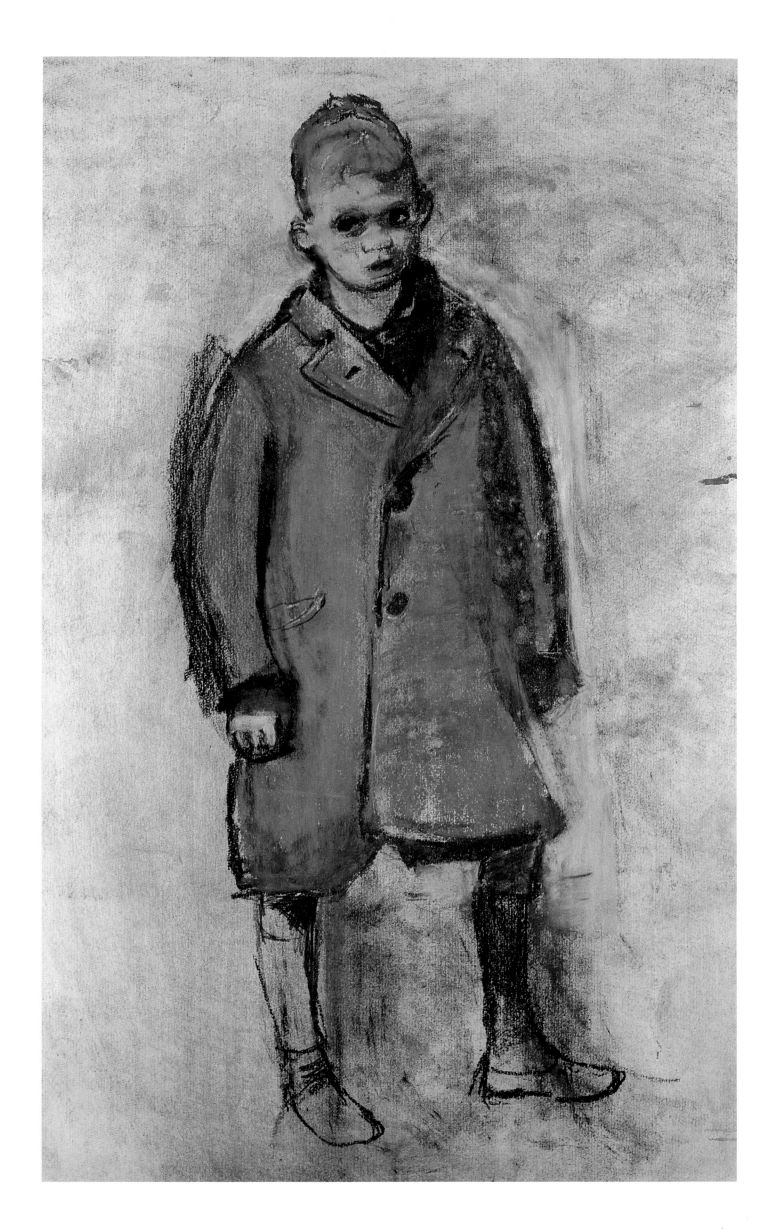

Opposite:
Paraskeva Clark. *Petroushka.* 1937.
Oil on canvas. 48 ¹³⁄₁₆ x 32 ¼ in.
(122.4 x 81.9 cm). National
Gallery of Canada, Ottawa.
Purchased, 1976.

Above:
Mary Pratt. *Venus from a Northern
Pond.* 1987. Oil on masonite.
25 ½ x 32 in. (64.8 x 81.3 cm).
Photograph: Beaverbrook Art
Gallery, Frederickton, New
Brunswick, Canada

Above:
Audrey Flack. *World War II (Vanitas)*, incorporating a portion of the Margaret Bourke-White photograph *Buchenwald, April 1945*, © Time, Inc. 1976–77. Oil over acrylic on canvas. 96 x 96 in. (243.8 x 243.8 cm). Private collection.

Opposite, above:
Marisol. *The Cocktail Party.* 1965–66. Painted wood, cloth, plastic, shoes, jewelry, mirror, television set, etc. Collection of Mrs. Beatrice Cummings Mayer, Chicago, on loan to The Minneapolis Institute of Arts. © Marisol Escobar/Licensed by VAGA, New York, N.Y.

Opposite, below:
Hung Liu. *Goddess of Love, Goddess of Liberty.* 1989. Oil on canvas, wooden bowls, broom, chalkboard. 92 x 72 x 24 in. (233.6 x 182.8 x 60.9 cm). Collection the Dallas Museum of Art. © Hung Liu. Courtesy Steinbaum Krauss Gallery, New York City.

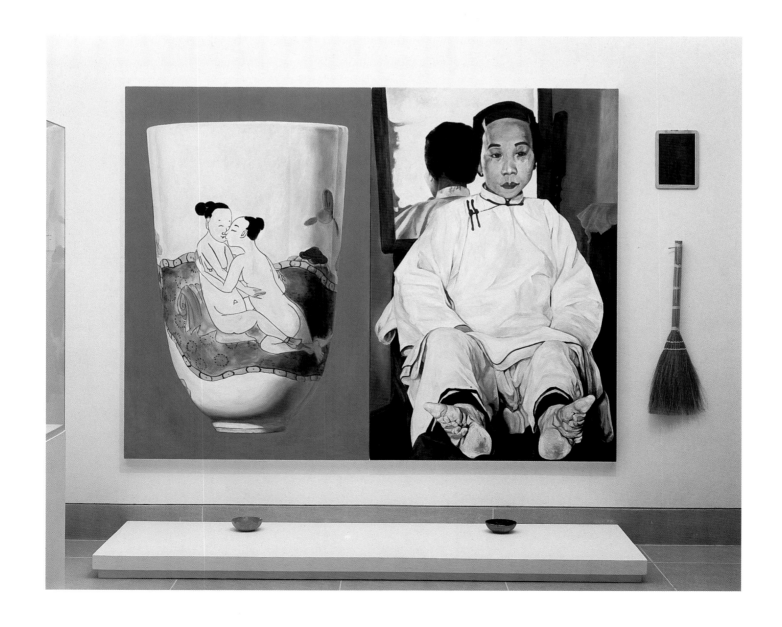

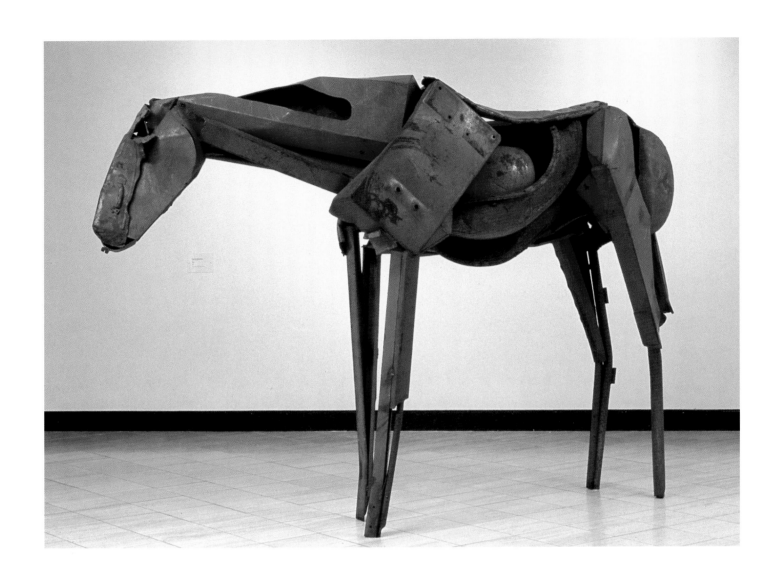

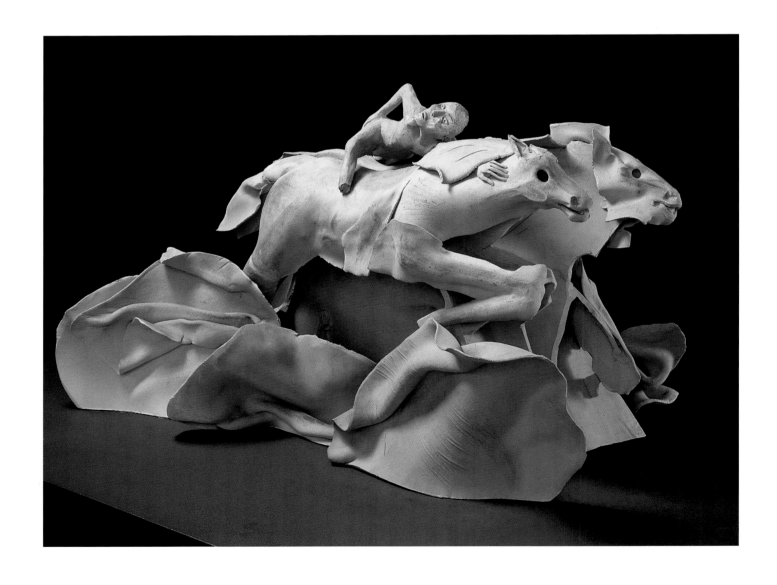

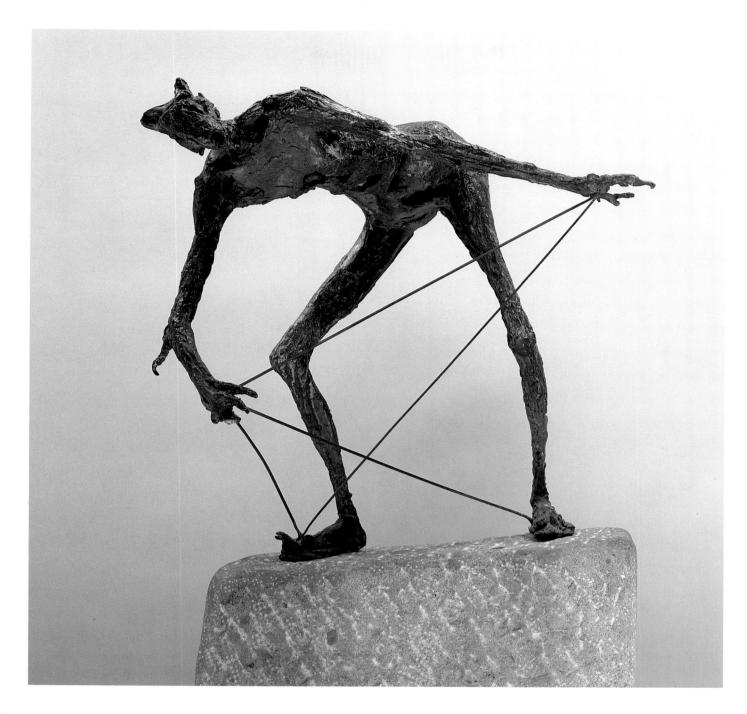

Opposite, above:
Deborah Butterfield. *Rory.* 1992.
Steel. Collection of the Harn
Museum of Art, University of
Florida, Gainesville. (1998.4)
Museum purchase, gift of the
James G. and Caroline Julier
Richardson Fund and S.F.I.

Opposite, below:
Mary Frank. *Horse and Rider.* 1982.
Ceramic. 23 ½ x 48 x 28 in. (59.6 x
121.9 x 71.1 cm). Everson Museum
of Art, Syracuse, New York.
Photograph © Courtney Frisse.

Above:
Germaine Richier. *Devil with
Claws (Le Griffu).* 1952. Bronze.
34 ½ x 37 ¼ in. (87.5 x 94.5 cm).
The Museum of Modern Art,
New York. Wildenstein
Foundation Fund. Photograph
© 1999 The Museum of Modern
Art, New York.

Niki de Saint Phalle. *Nana.*
c. 1965. Mixed media. 50 x 36 x
31 in. (127 x 91.4 x 78.7 cm).
Albright-Knox Art Gallery,
Buffalo, New York. Gift of
Seymour H. Knox, 1978.

Judith Shea. *Public Goddess.* 1992.
Cast bronze, burnished foil,
wrought iron, and paint.
Laumeier Sculpture Park, St.
Louis, Missouri. Photograph:
Ray Marklin.

21

And Justice for All

Taking on the Culture Coast to Coast

Just as their foremothers had done in the previous century, many of the newly politicized women of the mid-1960s came to the realization of their own political, social, and economic oppression through their struggles on behalf of others. Since most of what was said about women had historically been said by men, feminists started from scratch with "consciousness-raising" groups that generalized from shared experiences, locating the political within the personal, and personalizing the political. This personal analysis would outlive the consciousness-raising groups, becoming a mainstay of artistic practice.

The 1960s were a decade of fanciful exuberance, as much as of desperate and sometimes fatal protest. Political demonstrations were often theatrical; performances often had political content. The media of art were proliferating well beyond the traditional canvas and marble, crossing traditional boundaries of art, artisanship, manifesto, and, often, "good taste." It was natural that female artists would enter this stimulating, real-world arena, sometimes with the confrontational language of other political movements. The New York group Women Artists in Revolution, for example, founded in 1969, prepared a manifesto of demands. But some female (and some male) artists also reappraised conventional "feminine" materials, such as fabric, and traditional expressions, such as quilts. And it turned out that contrary to what their adversaries maintained, feminists, and women generally, had a sense of humor . . .

Other female artists looked for strength, succor, and role models to a new past—"herstory"—the ancient earth goddesses and female artists that feminist historians and art historians were rediscovering and reevaluating. By and large, the "second wave" feminist movement that began in the 1960s was a collective one that would continue to overlap the civil rights struggles, the antiwar movement, environmentalism, and other affirmations of a passion for justice and a solidarity that, at times, transcended species . . .

By 1972, women's cooperative exhibition venues had opened on both coasts, among them Womanspace Gallery in Los Angeles and the long-lived A.I.R. (Artists in Residence) Gallery in New York. These and the many others that sprang up all across the nation played in turn an important role in the burgeoning feminist movement, at the same time exposing the "white European" bias that many feminists have worked toward redressing.

The most enduring icon of 1970s feminism may be *The Dinner Party* (1974–79), a collective project conceived and midwived by Judy Chicago (b. 1939). In 1970, Chicago—her birth name is Cohen; she took the name of her native city—co-founded the feminist art program at the California Institute of the Arts. The process of recovering the lives of accomplished women in history provided Chicago with the initial impetus for *The Dinner Party*. The complex, resonant project features a triangular table set for thirty-nine, with individual dinner plates molded and painted with different flowerlike vulval images, and resting upon ornate embroideries of the honorees' names. Enlisting hundreds to assist, here and in subsequent woman-identified works like *The Birth Project*, Chicago challenges several traditionally highly valued aspects of art—beginning with the preeminence of the individual artist—and the standards that could relegate so many remarkable women to obscurity.

Art was always personal for Louise Bourgeois (b. 1911), who, born and educated in France, came to New York in 1938 with her new husband, the art historian Robert Goldwater. Certain indelible childhood traumas, feelings of alienation in her new environment, and the demands of balancing her roles as a wife, mother, and artist emerged in Bourgeois's drawings and sculptures. In her "crude" *Femme Maison* drawings (1945–47) of women whose heads are houses and in subsequent nurturing breast and penetrating phallic forms and

p. 276:
Miriam Schapiro. *The Passion of Raggedy Ann*. 1997. Acrylic and fabric on paper. 30 x 22 in. (76.2 x 55.8 cm). © Miriam Schapiro. Courtesy Steinbaum Krauss Gallery, New York.

Right:
Louise Bourgeois. *Femme Maison*. 1983. Marble. 25 x 19 ½ x 23 in. (63.5 x 49.5 x 58.5 cm). Courtesy Cheim & Read, New York. Photograph: Allan Finkelman. © Louise Bourgeois/Licensed by VAGA, New York, N.Y.

disturbing, sometimes ominously humorous installations, she has expressed struggles among forces in the universe and her own past-in-the-present. A participant in group shows from the late 1940s, and a world-acclaimed artist today, Bourgeois's work has never fit neatly into any category.

Art-world feminists of the early 1970s, however, reappraised Bourgeois's "eccentric" but highly refined sculpture, recognizing in her creations themes of female-male confrontation and expressions of anger and protest, for example, in the latex *Fillette* (1968), at once a penis and a female image. The artist, in turn, was re-enlivened, producing smaller pieces and large installations that are simultaneously sexually explicit, metaphorical, and personally revealing artifacts exorcising her childhood demons. The house for Bourgeois continues to represent a source of life and a container of emotionally mixed memories: her *Femme Maison* sculptures of the early 1980s include suggestive organic forms bending under the weight of a tiny house. Equally at home with old and new media, Bourgeois has taken sculpture installations into video and other new technologies.

Canadian-born and raised in New York, where she still resides, Miriam Schapiro (b. 1923) was heading toward success as an Abstract Expressionist painter after her first solo exhibition in New York in 1958. A decade later, after moving with her husband, the artist Paul Brach, to southern California, Schapiro's feminist consciousness had been raised, and she co-founded, with Judy Chicago, the Cal Arts' feminist art program. Since then, in her own work, Schapiro has invoked images by successful mainstream artists such as Mary Cassatt, but she has also appropriated aspects of decoration, crafts, and popular culture associated with women, subversively transforming them, as in *The Passion of Raggedy Ann* (1997). Using a collage technique she called "femmage," Schapiro incorporated pieces of quilts, lace, appliqué, embroidery, and other needle-arts into her painted compositions. In a number of monumental works based on the Japanese kimono, the artist achieved a universal statement by overlaying opulent and sensuous textures, patterns, and colors on simple geometric elements. Not only did such works bring together decoration and abstraction, East and West, Old World and New, but they incontrovertibly redefined the woman-made object as high art, casting a fresh light on women's history in the process. Schapiro has been influential in defining feminist art and instrumental in organizing feminist exhibitions and other cooperative projects for young artists.

Decades before taking up feminist issues in the 1970s, May Stevens (b. 1924) followed her conscience into political causes. She was active in the civil rights struggles, and her art memorialized both the racist church-burnings and the heroic Freedom Riders. With Schapiro and others, Stevens founded *Heresies* in 1977, a publication of feminist theory and art. Illustrating the feminist adage that "The personal is political," Stevens used her art to examine forces that have shaped women's possibilities at different times, in different places, and in different social settings. In the late 1970s she embarked on a series of images, Ordinary/Extraordinary, comparing the lives of two women: the German political martyr Rosa Luxemburg and Stevens's own working-class mother, Alice Stevens. *Green Field* (1988–89), showing the small and rather bewildering figure of Alice in a sea of grass, is part of that series. Unlike Luxemburg, whose associations and intellectual powers supported her activism, Alice Stevens's small personal revolts led her only to greater hopelessness and, at times, to a mental institution.

In response to the military-industrial complex's rise to power in the 1960s, fueled by the Cold War, Lee Bontecou (b. 1931) made machine art, with empty holes instead of warheads. These dark gaping cavities were key to the New York-born Bontecou's aggressive industrial-strength assemblages, while the mosaic quality of her surfaces has been compared to both aircraft construction and stained glass. Over welded frames, Bontecou's "skins," made of second-hand canvas from conveyor belts, tents, and hoses, with added bits of industrial debris, retain their original stains and markings but are transformed into powerful, menacing forms. In an untitled work of 1962, a gaping "mouth" visibly punctuates the main aperture. Are the deep, mysterious openings, sometimes small, often large, for looking out of or looking into? It is never clear.

Nancy Spero's (b. 1926) outrage over the Vietnam War turned to a lasting, constructive anger at the victimization of women. Spero, from Cleveland, studied and lived in Chicago and in Paris. Beginning in 1969, she made large, scroll-like works of protest in which active, and often distorted, female figures inhabit a space filled with hand-printed texts on kinds of injustice, quoted from the Dada-Surrealist French writer Antonin Artaud. Spero continued to focus on the situations of women of every culture and corner of the earth. Mixing collage, drawing, and painting, and using an increasingly bright palette, she represents women's work, rituals, energy, and movements, as well as the oppression that women continue to endure and resist.

Even as a child in Pasadena, California, Betye Saar (b. 1926) enjoyed arranging her collections of small objects and family trinkets. In her mid thirties, inspired by an exhibition of Joseph Cornell's boxes, she abandoned her plans to become a teacher and began making her own assemblages. Saar used images from the tarot and the zodiac in some works, but also combined precious keepsakes from a beloved aunt into nostalgic creations emblematic of the African American experience. Politicized by the murder of Martin Luther King, Jr., and the vigor of the Black Power movement, Saar employed her art practice to call attention to the pervasive manifestations of American racism. In *The Liberation of Aunt Jemima* (1972), against a background of pancake-mix boxes, a cookie-jar Aunt Jemima packs a rifle instead of a syrup jug, while a black fist is raised against the black "mammy" holding her white charge. Since the 1980s, Saar has been making large-scale public sculptures, emphasizing their relationship of art to people and neighborhoods.

In the late 1960s, the Harlem-born Faith Ringgold (b. 1930) became an activist, incorporating themes from the civil-rights struggle into her paintings and confronting racism and sexism in the art world. By the mid-1970s she was making more accessible art that adapted concepts from African art, such as painting on cloth. Ringgold employed skills learned from her mother to execute sewn works including stuffed figures with African mask faces like *Mrs. Jones and Family* (1973). These and her story quilts depicting family and black history can be packed in a trunk, and more easily transported than large paintings. This has allowed Ringgold to show her work widely, often in conjunction with personal appearances.

Barbara Chase Riboud (b. 1936; also sometimes D'Ashnash-Tosi) has characterized the African-American experience in novels and poetry, as well as sculpture. The Philadelphia native won her first art prize at eight years old; her long experience as an artist in several media and her extensive travels with her French photojournalist husband no doubt contributed to the sophistication and emotional intensity of her symbolic sculptural works. Thoroughly schooled in traditional and modern European practices, Chase Riboud has also been influenced by her firsthand encounters with Egyptian, Asian, African, and Oceanic art. *Tantra* (1993) is, like much of her work, about contrasts: of materials (bronze and silk) and of influences (European and non-European). Ancient architectural forms imbue many of Chase Riboud's pieces, including *Harrar* or *Monument to the 11 Million Victims of the Middle Passage* (1993), a model for a memorial shrine. The imposing gate is also the source of the endless chain, a ghastly reminder of the slaves' brutal burden.

Emma Amos's (b. 1938) more contemporary figures fall into an uncertain future. Negotiating life as an African American woman artist, Amos weighs and balances issues of race, gender, and virtuosity over and above daily concerns. Whether floating in a dreamy night sky or suspended over a broken cityscape, her figures express estrangement and fear in a difficult, sometimes cruel world. The Atlanta-born Amos exhibited in the 1960s with Spiral, an otherwise all-male group of African American painters that included Romare Bearden and Hale Woodruff. In works like *Tightrope* (1995), she incorporates various textiles, including patterned African fabrics, as a way to bring her personal history and heritage to bear. This urbane artist, who matured during the overlapping civil rights and feminist movements, continues to locate her far-reaching social consciousness in her work.

Lynda Benglis (b. 1941) also left Louisiana—her southern home—after college, and headed to New York: there, active in the feminist movement of the early 1970s, she poked fun at macho imagery with a photo ad in which she posed naked with sunglasses and a dildo. Benglis liked the clarity of minimalist art, but countered its industrial edges with a deliberately in-your-face femininity: rounded forms, bright colors, and sparkly materials. Her constructed knots, signature pieces from the 1970s, evolved into flowing, highly finished works like *Chubasco* (1991). Sensuous and jewel-like, it flaunts its ornate fabrication as well as its refined texture and lustrous surface.

Alison Saar (b. 1956) lets the spiritual side dominate her sculptural constructions. Even in staunchly feminist expressions such as *Clean House* (1993), her modern-day golden "goddess" is connected, but not chained to both earth and hearth by living branches. Saar's assemblage techniques are rooted in the folk arts of many cultures: the middle daughter of Betye Saar, Alison's objects and ideas come from European, African, Native American, and Chicano sources—all of which figure in her ancestry or travels. There is a mystical side to both Saars' work, but unlike her mother, whose materials are often fragile, cherished items, the younger Saar's less delicate pieces comprise crude wood and tin components or shards of glass and ceramic.

Ana Mendieta's (1948–1985) transplantation from Cuba to Iowa at the age of twelve was a painful experience. Art, especially painting helped sustain her until her shift to experimental multimedia in the early 1970s, at the University of Iowa, which was crucial in her exploration of her identity. Some of Mendieta's earliest works were shocking performances that called attention to sexual and physical violence against women. Her own body, however, remained her chief agent of expression, whether she identified it with rituals of the Afro-Cuban practice of Santería or with the earth itself. Like other Conceptual works, some of Mendieta's art

Barbara Chase-Riboud. *Africa Rising*. 1994. Bronze. 18 ½ x 9 x 5 in. (47 x 22.8 x 12.7 cm). Courtesy Stella Jones Gallery, New Orleans.

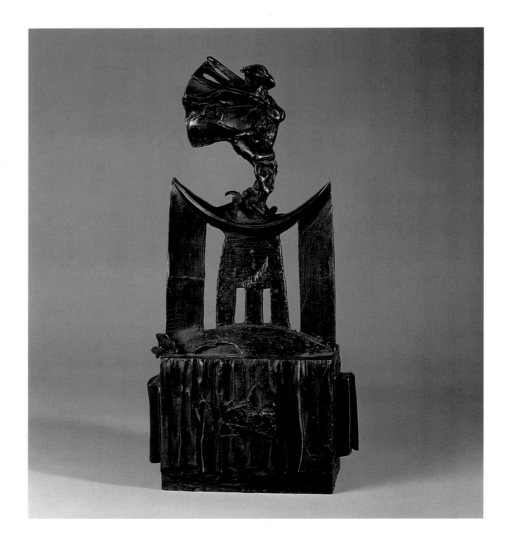

Ana Mendieta. *Arbol de la Vida 294 (Tree of Life)*. 1977. Color photograph of earth-body work with tree and mud executed at Old Man's Creek, Iowa City, Iowa. 20 x 13 ¼ in. (50.8 x 33.6 cm). Collection of Ignacio C. Mendieta. Courtesy of the Estate of Ana Mendieta and Galerie Lelong, New York.

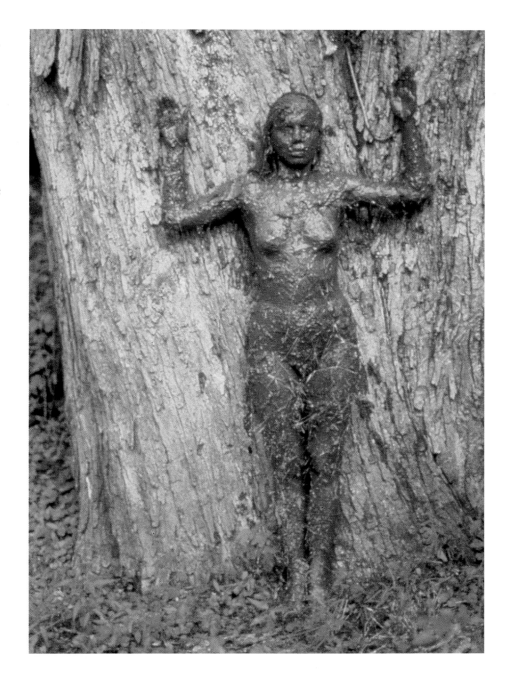

was ephemeral, recorded in photographs, such as those of her *Silhueta (Silhouette)* series, which show Mendieta relating to specific locations by imprinting her body in the soil, sometimes decorating the resulting silhouette to invoke a goddess or other local connection. In *Arbol de la vida 294 (Tree of Life)* (1977), the mud-covered artist materializes against a tree, her feet planted among its roots, her arms spread toward its branches.

Kiki Smith's (b. 1956) reflections on female physicality can even take the form of jars of bodily fluids. The German-born American artist is the daughter of the sculptor Tony Smith. Whether intact and contorted or damaged parts, her figures, characters drawn from mythology and the bible, embody the messiness of universal realities faced by women, from menstruation and childbirth to social oppression. Smith's *Mary Magdalene* (1994), for example, is bound by a dehumanizing chain—though cleansed in spirit and forgiven by Jesus himself, the repentant prostitute—and, by extension, her descendants—continues to be treated like a base, but apparently dangerous creature who must be kept under strict control.

Jenny Holzer's (b. 1950) medium is far more accessible and straightforward. For two decades she has taken her public art literally to the street, blaring her morally authoritative "truisms" in neon and emblazoning them on T-shirts and phone booths, park benches and parking meters. On an electronic signboard in New York's Times Square, Holzer answered neighboring advertisements for cameras, cars, and cigarettes with PROTECT ME FROM WHAT I WANT (1985), while on a flashing sign in Las Vegas the following year she declared, LACK OF CHARISMA CAN BE FATAL. COMMIT RANDOM ACTS OF KINDNESS has been absorbed into the culture. Still, Holzer's most impressive creations are complex architectural environments like *Selected Writings* (1989) at the spiraling Solomon R. Guggenheim Museum, or the haunting *Laments* at the Dia Foundation, also in New York, where message columns emit light into a cryptlike space, and sarcophagi carry notes on AIDS, war, damage to the environment, and light.

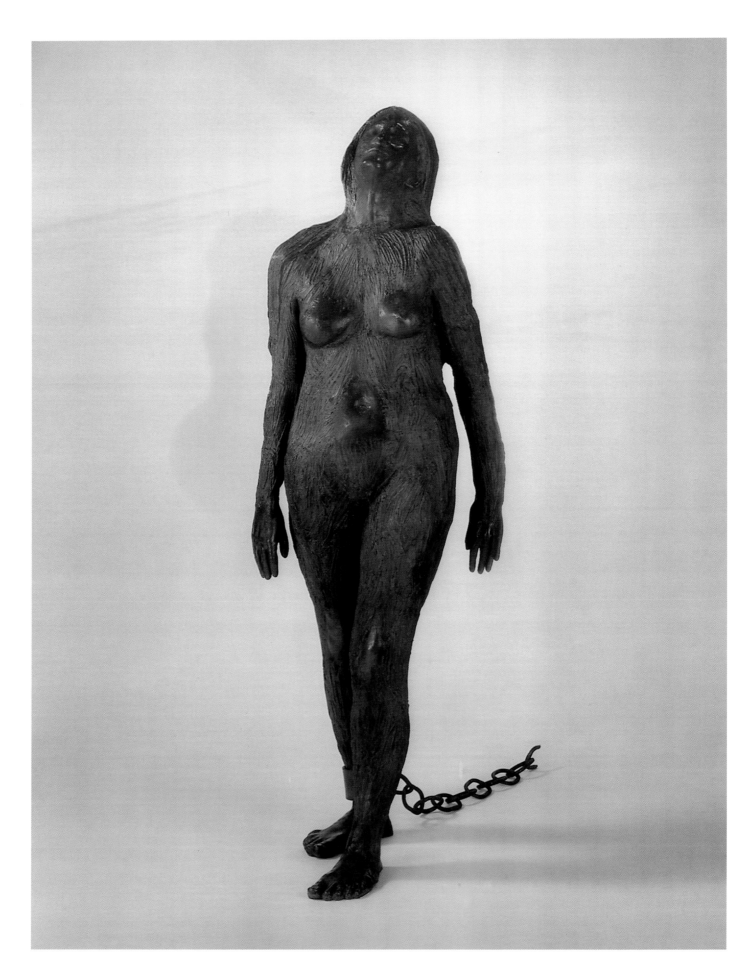

Kiki Smith. *Mary Magdalene*. 1994.
Cast phosphorous bronze and
forged steel. 60 x 20 ½ x 21 ½ in.
(152.4 x 52.1 x 54.6 cm). Courtesy
PaceWildenstein. Photograph:
Herbert Lotz.

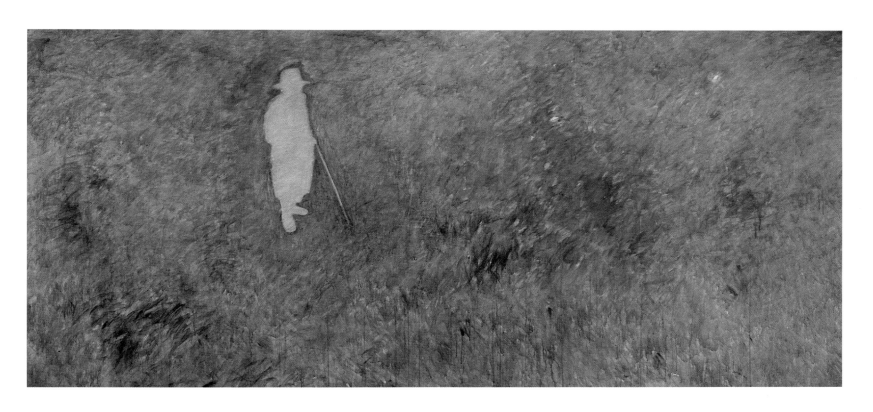

Above:

May Stevens. *The Green Field*. 1989. Acrylic on canvas. 84 x 144 in. (213.3 x 365.7 cm). Courtesy Mary Ryan Gallery, New York.

Below:

Nancy Spero. *Liberty / Athlete*. 1995. Handprinting and printed collage on paper. 24 ½ x 19 ½ in. (62.2 x 49.5 cm). Courtesy Jack Tilton Gallery, New York.

Above:
Judy Chicago. *Earth Birth* from the *Birth Project*. 1983. Quilting over air-brushed fabric. 63 x 135 in. (160 x 342.9 cm). © Judy Chicago. Photograph: © Donald Woodman/Through the Flower Archives.

p. 286:
Betye Saar. *The Liberation of Aunt Jemima.* 1972. Mixed media. 11 ¾ x 8 x 2 ¾ in. (29.2 x 20.3 x 6.9 cm). University of California, Berkeley Art Museum; purchased with the aid of funds from the National Endowment for the Arts (selected by The Committee for the Acquisition of Afro-American Art).

p. 287:
Faith Ringgold. *Mrs. Jones and Family.* 1973. Mixed media. 60 x 12 x 16 in. (152.4 x 30.4 x 40.6 cm). © 1973 Faith Ringgold. Photograph: Karen Bell.

Opposite:
Emma Amos. *Tightrope.* 1994. Acrylic on linen, African fabric. 82 x 58 in. (208.2 x 147.3 cm). © 1994 Emma Amos.

Above:
Lee Bontecou. *Untitled.* 1962. Welded metal and canvas assemblage. 20 ½ x 60 x 8 ½ in. (52 x 152.4 x 21.5 cm). Courtesy Michael Rosenfeld Gallery, New York City. Photograph: Christie's Images Ltd., 1999.

Below:
Jenny Holzer. *Untitled (Selections from Truisms, Inflammatory Essays, The Living Series, The Survival Series, Under a Rock, Laments and Child Text.* 1989. Extended helical tricolor L.E.D. electronic-display signboard. 16 ½ in. x 162 ft. x 6 in. (41.9 cm x 49 m x 15.2 cm). Subject to change with installation. Solomon R. Guggenheim Museum, New York. Partial gift of the artist,

1989. Courtesy Cheim & Reid, New York. Photograph: David Heald/© The Solomon R. Guggenheim Foundation, New York. (FN 89.3626)

22

On and Off the Wall

Reinventing the Mainstream

Working in and out of the mainstream, often in nontraditional materials, women found ways to assert their presence. More than fifteen years after Women Artists in Revolution had taken aim at the dearth of women's art in museums and galleries in 1969, not much had changed. With female representation still running at around 10 percent in 1985, the Guerrilla Girls, an exuberant, anonymous group of self-styled avengers in gorilla masks, took to the streets of New York to publicize sexism and racism in the art world.

Their goals were traditional—to protest the perpetuation of an exclusive and narrow culture by its guardians—but their tactics and language were new. Where the feminists of the 1960s and early 1970s had often personalized their statements in order to validate them by attaching faces to principles, the Guerrilla Girls' facelessness (although rumors abounded about their identities, they were well-kept secrets in sympathetic art circles) focused their protest on their well-researched facts.

An expression of a new sense of confidence and of a new generational style was their reappropriation of the word "girls"—rather than the hard-won "women" of the previous decade—at the same time that they demanded recognition for women and other outsiders as serious artists.

More and more, artists were working in an explosion of mediums and materials that often leave viewers puzzled, shocked, and skeptical that what they are seeing is art at all. While some art continues to be explicitly political, much remains resonantly personal, locating universal considerations in indirection and metaphor, and requiring viewers, to an unprecedented degree, to plumb their own emotions, imaginations, associations, and histories to make sense of the often bewildering enigmas before them.

Surprising perhaps, but never bewildering, are Dorothy Gillespie's (b. 1920) animated waves and curls of color. Painted cutout shapes and swirls made three-dimensional animate a seemingly endless variety of spatial configurations. Gillespie experimented with "environments" in the 1960s, and brought her paintings off the wall in the 1970s with room-size installations of painted paper in intricate cutouts and giant spirals. These evolved into permanent cascades and explosions made in aluminum and steel, luminous in bright, primary colors and more subtle palettes. A strong proponent of public art, the Virginia-born but New York-based Gillespie's site-specific works for airports, hotels, and college campuses are energized by the human, as well as architectural, interactions of their settings.

On arriving in the United States in the 1950s, the Greek-born, Paris-educated Chryssa (born Vardea Mavromichaeli, 1933) was struck by the vivid culture of American advertising. Chryssa was especially fascinated by the blaze of colored lights in New York's Times Square, a sight she found both vulgar and poetic. In vivid plaster and Plexiglas compositions of the late 1950s, she brought forth rhythmic, abstract elements, repeating letters of the alphabet. Chryssa learned signmaking techniques and began incorporating neon tubing into complex projects. In *Five Variations on the Ampersand* (1966), Chryssa boxed each multilayered form in Plexiglas and programmed the pulsating lights as if choreographing a ballet or conducting a piece of music.

Eva Hesse's (1936–1970) family emigrated to New York from Nazi Germany in 1939. Ironically, almost thirty years later, it was in Germany, when Hesse was living briefly in Düsseldorf with her husband, the American sculptor Tom Doyle, that she developed the minimalist-inspired sculptural process of grouping and repetition that engaged her during her few remaining years. In the former textile factory the couple was using as a studio, Hesse explored the linear and plastic properties of rope and string. Some of her most dramatic works, such as *Accession II* (1969), are ordinary machined boxes made extraordinary with these materials

transmuted into "fur" linings. These constructions are minimalist in their basic geometric forms, but the persistence, even obsession, with which Hesse hand-knotted miles of cut plastic tubing to produce the lining effect remove her work from the industrial to the personal. Hesse often worked out her compositions by juxtaposing squares—a legacy, perhaps, of her painting teacher at Yale, Josef Albers—and circles. Her art is disturbing, giving rise to the agitation that comes with their ostensibly meaningless repetitions and ultimate absurdity. Hesse died of a brain tumor at age thirty-four.

Jackie Winsor (b. 1941) interpreted minimalism with rope and wood, calling on the experience of her childhood in a Newfoundland fishing village. As in Hesse's art, the pieces' apparent simplicity belies the intense manual labor invested in them. Beyond the elementary shapes and rudimentary materials are the thousands of nails hammered in *Nail Piece* (1970) and the elegantly wrapped wire in *#2 Copper* (1976). In *Exploded Piece* (1980–83), Winsor exploded one of her boxes then patched it back together. From her early rope columns and circles, to her later wooden boxes and brick domes, Winsor compresses energy into simple forms, giving them an air of mystery.

Helen Hardin (1943–1984), a Native American artist, crossed cultures to encompass both traditional and contemporary expressions in her painting. Hardin, the daughter of the painter Pablita Velarde, grew up largely off the reservation because of her Pueblo mother's marriage to a non-Indian and this complicated Hardin's sense of her own identity. While her imagery reflects Native American design traditions, including interpretations of kachina dolls—she never made actual copies of these sacred objects—Hardin's sophisticated investigations of personal issues encompassed European Modernism as well, especially in their compositions. In *Bears in Rainbow* (1978), the animal figures overlap intricate patterned structures. Stylized feathers, facial features, and ancestral symbols appear as sharp diagonals that cut across and through the circle that is both the face and a universal symbol of a whole. Hardin's many struggles, as a daughter, wife, and mother, and as someone with one foot in each world, ended when her life was cut short by cancer.

Determined to find new forms within traditional figurative sculpture, Nancy Graves (1940–1995) chose camels as the matter of her art. Organic and ancient, here was a subject that had not been explored in Europe, and in 1969, her life-size, realistic beasts became the art world's cover girls. In later works Graves—introduced to art and natural history by her father, a professional at the Berkshire (Massachusetts) Museum—used internal structures and fossils to define real and imaginary creatures, exhibiting groups of upright camel and other "bones" as if the animal were in motion. After rediscovering ancient methods of casting delicate objects in bronze, Graves began experimenting: she stacked, combined, and balanced objects into gravity-defying birds and conceptual pieces, made even more fanciful by their brilliant, painterly coloring. Combining timeless leaf

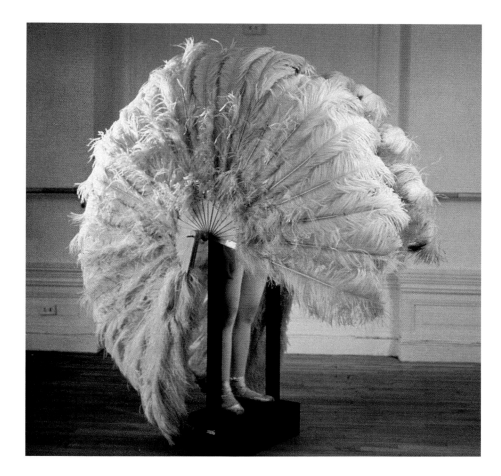

Rebecca Horn. *Feathered Prison Fan.*
1978. Metal, motor, wood, and
white peacock feathers. 43 ⁵⁄₁₆ x
32 ¹¹⁄₁₆ x 12 ⅝ in. (110 x 83 x 32 cm).
Courtesy Marian Goodman
Gallery, New York,

and palm forms with toy wheels and other found objects in works like *Zaga* (1983), Graves's inventive archaeology creates its own identity.

Using her success in the mainstream, the Native American painter Jaune Quick-to-See-Smith (b. 1940) focuses attention on numerous causes, from injustices and environmental concerns to saving historic sites to promoting Native American art and artists. Her own work is based in the Southwestern landscape she loves, with shifting perspectives that refer as much to ancient local petroglyphs as to the European Modernism she assimilated in her university art education. The vitality of Smith's brush and her incorporation of ancient symbols express her experience of landscapes as living, almost sentient entities. Figures, especially horses, take on monumental proportions, appearing larger than the rockscapes they inhabit. Smith's pervasive spirituality conveys her strong connections with her own past and the collective past of her Flathead and Shoshone ancestors.

Howardena Pindell (b. 1943) makes her own connections with history and culture by setting herself in the center of an elaborate universe that mirrors her experience of it. Her world travels began in the 1970s, when she worked as a curator at New York's Museum of Modern Art, but she also experienced a personal journey of recovery from a debilitating 1979 automobile accident that damaged her memory; both converged in a transformation in her art. With elements from her early abstract and color-field paintings, she began to create works that fuse the political and spiritual. She takes issue with the racism she experiences as an African American, for example, in a series of large multimedia studies that center on her self-portrait as a metaphor for change and development. In *Autobiography* (1988), Pindell's own figure takes the same form as the slave ship in the dark passage to her left. Personal symbols, including portrait heads and multiple eyes overlap universal symbols of the long journey from slavery.

Susan Rothenberg's (b. 1945) paintings manifest her dedication to an inward journey through the practice of her art. Having come of age at the moment of high feminism and antiwar protests, her initial appropriation of the horse to symbolize herself had more to do with the abstract possibilities than any universal symbolism. Docile and placed on a grid, as in *IXI* (1976–77)—most of her work is untitled—and like her later human figures tumbling into space, Rothenberg's early horses stand for her dual identity as a dancer and as an artist capturing anxiety in motion. A transplant from New York (she was born upstate, in Buffalo), to New Mexico in the 1990s, where she lives with her husband, the artist Bruce Naumann, Rothenberg has returned to the horse as a theme, this time from a closer vantage point.

Sue Coe (b. 1950) looks at the outrages of modern life and takes a less poetic approach. The British-born artist, who has lived and worked in New York since the early 1970s, graphically depicts the dark side of

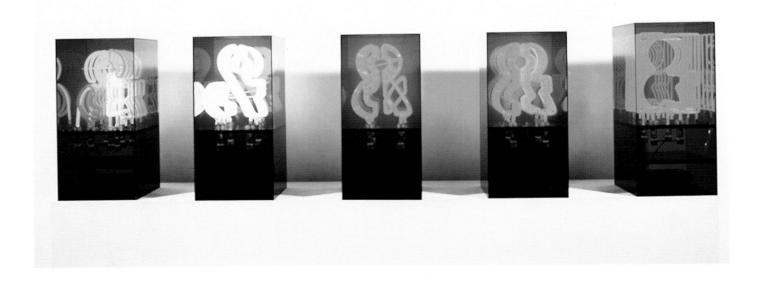

current events. In the 1980s she began an examination of the ugly realities behind much of modern business and industry, focusing particularly on meat production and the mistreatment of animals. On visits to farms and research facilities, as well to feedlots, slaughterhouses, and meat-packing plants, she found no limits placed on the cruelty and malice of living creatures toward one another. The darkly expressionistic *Poultry Plant Fire* (1991) portrays the hideous implements used in the animals' torture and death, and tells the story of a 1991 North Carolina plant fire in which twenty-five workers died, trapped because the fire doors were kept locked to prevent theft. Here, the connection between human brutality to animals and to other humans in the name of profit is made inescapably clear.

The German sculptor Rebecca Horn (b. 1944) linked the human and animal worlds and expanded the senses through her body extensions, which she introduced in live performances and films in the 1970s and 1980s. As elegant as they were surreal and erotic, the enormous feathered wings and wraps (*Feathered Prison Fan*, 1978), unicorn horns, and finger extensions hid, revealed, enclosed, restrained, or stretched the human forms, while enlarging their spatial presence. Horn incorporated movement and sound, and this led her in several directions, including the creation of mechanical beasts and the production of feature-length films starring her masked and transformed characters.

Jana Sterbak (b. 1955) and Rosemarie Trockel (b. 1952) also created coverings for the human body. Unlike Horn's suave extensions, the Czech-born Canadian Sterbak's unusual clothing forms from the 1980s appear to border on the absurd. They are earnest, however, in import: women, in particular, are rigidly confined and controlled and must find the means to shed their various restraints. *Remote Control* (1992), reveals an evening gown whose movements are operated by remote access—an extremely unpleasant experience for the wearer.

Rosemarie Trockel's unusual unisex knitwear, from her two-headed *Schizo-Pullover* (1988) to the machine-woven knits patterned with swastikas, Playboy bunnies, and other logos for *Balaclava* (1986), speaks to a number of feminist and cultural issues. The German-born Trockel also creates sophisticated mixed-media sculptures, whose scholarly references often feature one or more exotic, fetishistic objects, either found or fabricated. Irony, too, infuses Trockel's pieces, as in the untitled work in which a traditional female bust is threatened by two irons, both unplugged.

Katharina Fritsch (b. 1956), who has written about Trockel, enlarges and multiples familiar images, making them frightening. Since her statement about conformity and dullness—thirty-two identical men staring blankly—in *Company at Table* (1988), the work of this German artist has become even darker. An encounter with Fritsch's *Rat King* (1993), a circle of sixteen ten-foot black polyester rats, their tails knotted together, is terrifying. Worse is the threatening effect of *Baby with Poodles* (1995), with 224 perfectly groomed giant black dogs encircling a tiny infant on a gold star.

Embracing Minimalism, Conceptualism, and Neo-Dada, some believing art is not a commodity to be sold but an environment to be experienced, these women, with their comments on contemporary life, stand at the forefront of contemporary art.

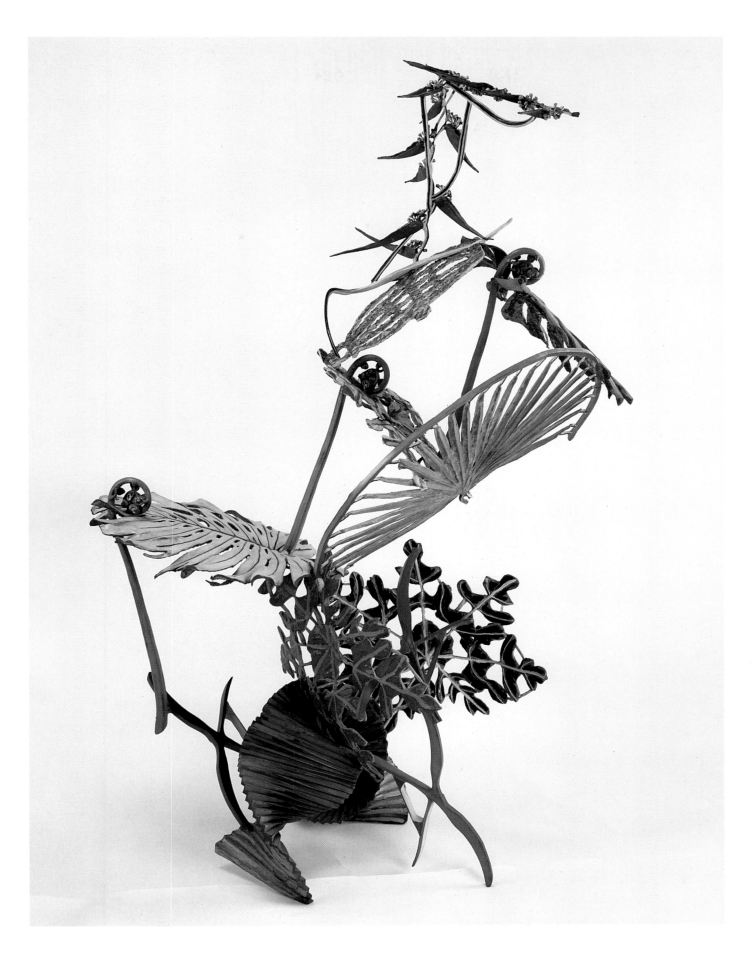

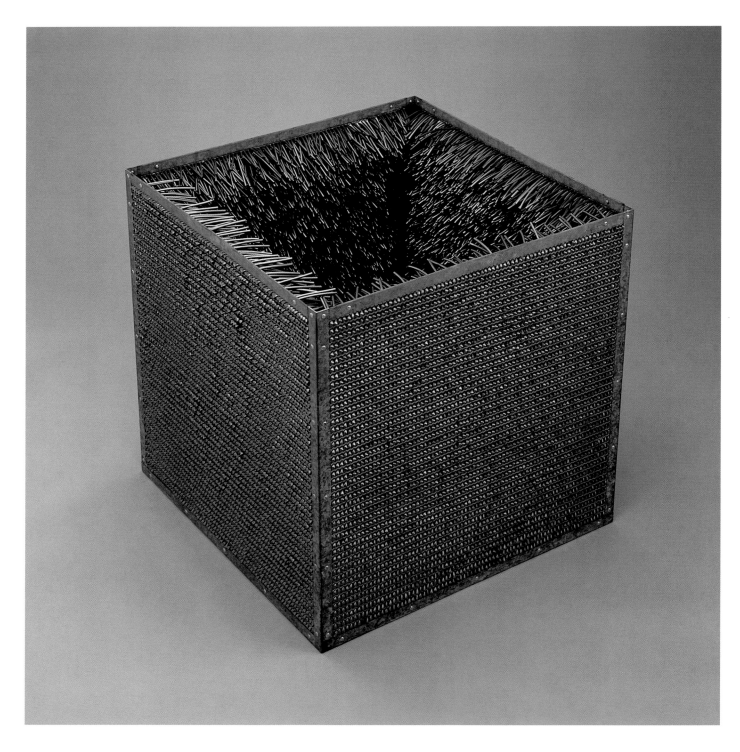

Above:
Eva Hesse. *Accession II.* 1967. Galvanized steel and plastic tubing. 30 ¾ x 30 ¾ x 30 ¾ in. (78.1 x 78.1 x 78.1 cm). Founders Society Purchase, Friends of Modern Art Fund, and Miscellaneous Gifts Fund. © The Estate of Eva Hesse, courtesy Robert Miller Gallery, New York City. Photograph © 1999 The Detroit Institute of Arts.

Opposite:
Eva Hesse. © The Estate of Eva Hesse. Courtesy Robert Miller Gallery, New York City.

Eva Hesse

Copy of letter to Sol Le Witt [Minimalist sculptor and friend]

April 1965

It is to you I want to talk to about what is on my mind. It is because I respect and trust you and also in this case you are one who understands somewhat me personally and my art existent or non-existent. Also, we strike some diametrically opposed balance reacting emotionally so differently yet somewhere understanding. . . . I want to explain (try to) what I am going through in my work or non-work.

I trust myself not enough to come through with any one idea; or maybe a singular good idea does not exist, and if there would be one among the many I don't think I could recognize it. So I fluctuate between working at the confusion or non-working at the confusion. When not actually at work I nevertheless struggle with the ideas. . . . At this time I can no longer see what I have done nor distill the meaning. I want to too much and try too much—the joke is on me, constant frustration and failure. . . .

What drives us to work. It seems to me some kind of recognition which maybe we can't give ourselves. Mine seems to be disproportionate like I respect myself too little so too much must come from the outside. . . .

One should be content with the process as well as the result. I'm not! I find nothing I do gives me the feeling that this is right—go at it—do it—explore and ye shall find and I am I see and so it should or shall be. I am constantly at ends with the idea, myself and or what I am about.

I mean to tell you of what sits in front of me. Work I have done, drawings. Seems like hundreds although much less in numbers. There have been a few stages. First, kind of like what was in past free, crazy forms—well done and so on. . . .

2nd stage contained forms somewhat harder often in boxes and forms become machine like, real like, and as if to tell a story in that they are contained.—Paintings follow similarly.

3rd stage—drawings—clean, clear—but crazy like machine forms larger and bolder articulately described so it is weird they become real nonsense.

So I sit now after two days of working on a dumb thing which is 3 dimensions supposed to be continuity with last drawing. All borders on pop at least to the European eye. That is anything not pure or abstract expressionist is pop-like. The 3rd one now actually looks like breast and penis—but that's o.k. . . .

How do you believe in something deeply? How is it one can pinpoint beliefs into a singular purpose? Or then to accept if this is impossible a feat how to just grin and bear it. Grin and bear it. Why it seems to me others do more than bear it they actually can grin. How grand to state a cause or to be ambivalent and ride the waves and feel no serious pain. Or those who do act and are fooled by their own actions and never the wiser shall be. Anything is better than the inactive or no ending suffering of not knowing and trying to know, to decide on a purpose or way of life—a constant approach to even some impossible end—even an imagined end. . . .

Helen Hardin. *Bears in Rainbow.*
1978. Acrylic on board. 12 x 18 in.
(30.4 x 45.7 cm). © 1978 Helen
Hardin. Photograph © 1999
Cradoc Bagshaw.

Above:
Jaune Quick-to-See Smith. *Herd.* 1998. Acrylic, oil, mixed media collage on canvas. 60 x 150 in. (152.4 x 381 cm), triptych. Courtesy Steinbaum Krauss Gallery, New York. Photograph: Jeff Sturges.

Below:
Susan Rothenberg. *Untitled.* 1976. 26 ⅛ x 36 in. (66.3 x 91.4 cm). Acrylic, gesso, and graphite on paper. Photograph: Christie's Images Ltd., 1999.

Sep 3, 1991 North Carolina, Imperial Food Products Poultry Plant
25 workers, mostly women, were killed when fire broke out. The exit doors
were locked at the boss. Feared chickens might be stolen. Witnesses
heard screams as people tried to force the doors open. Workers bodies
were piled up against the doorways. There were 56 injuries.
The non union wage was $11,000 a year

FIRE DOOR

Opposite:
Howardena Pindell. *Autobiography:*
Water / Ancestors / Middle
Passage / Family Ghosts. 1988. Oil on
canvas. Wadsworth Atheneum,
Hartford. The Ella Gallup
Sumner and Mary Catlin Sumner
Collection Fund.

Above:
Sue Coe. *Poultry Plant Fire.* 1991.
Pastel, gouache, and pencil. 48 ¾
x 40 in. (123.8 x 101.6 cm). © 1991
Sue Coe. Courtesy Galerie St.
Etienne, New York.

Above:
Katharina Fritsch. *Baby with Poodles.* 1995. Plaster, chromium-plated brass, color. 15 ¾ x 208 in. (40 x 528.3 cm). Courtesy Matthew Marks Gallery, New York.

Below:
Rosemarie Trockel. *Untitled.* 1988. Machine knitted wool. 78 ¾ x 126 in. (200 x 320 cm). Courtesy Barbara Gladstone Gallery.

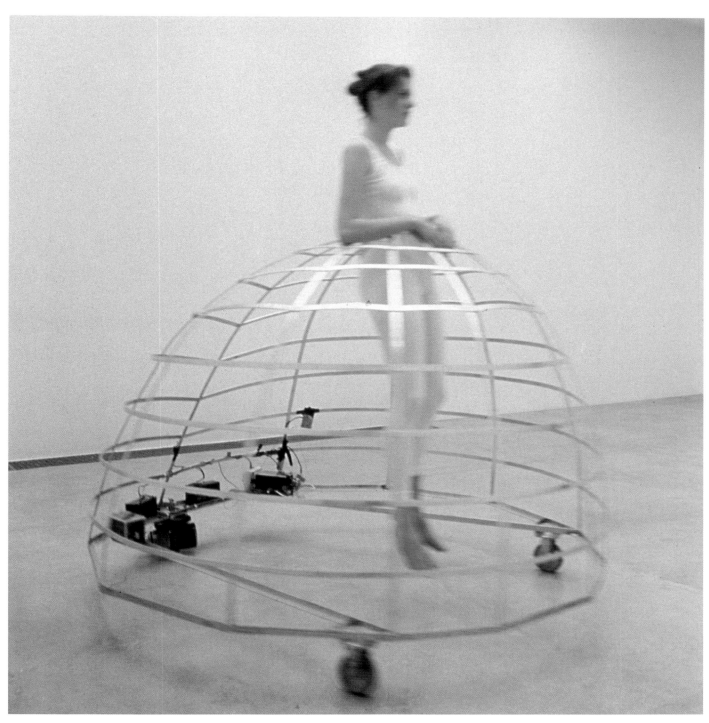

Jana Sterbak. *Remote Control I.* 1989.
Aluminum, canvas, motor in
wheel, casters, servo amplifiers,
battery. 56 x 72 ¹³⁄₁₆ x 79 ½ in. (142
x 185 x 202 cm). Collection Musée
départemental d'art
contemporain, Rochechouart,
France. Photograph: Galerie
Chantal Crousel, Paris.

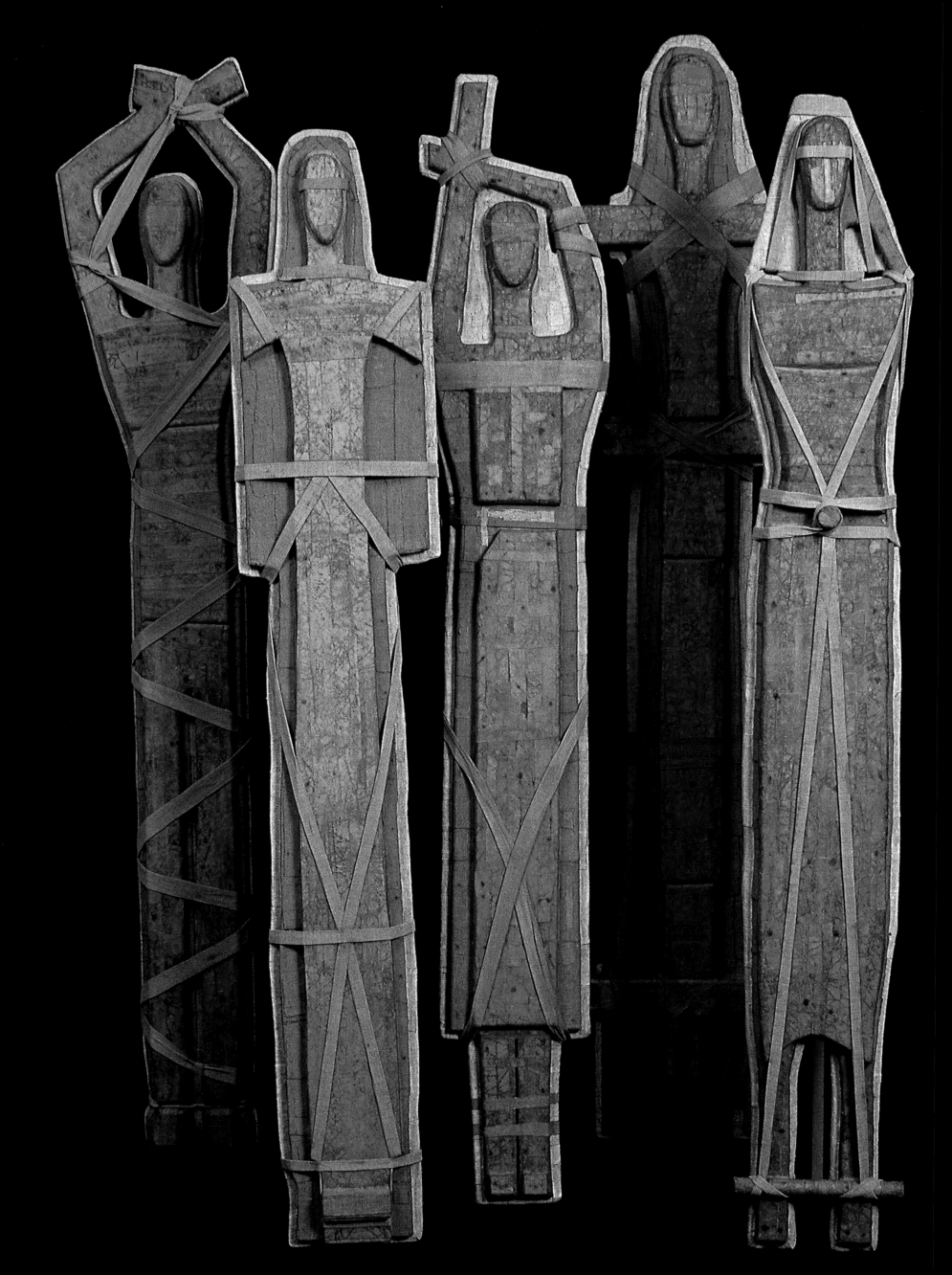

23
Moving Heaven and Earth
Sculpture Abstractions and Environments

Abstraction, with its tension between a seemingly open-ended invitation to stylistic and thematic freedom, and its corresponding rigor, provides an effective means for sculptors to address the relationship of art to audience: Small or large, abstractions in three dimensions take art directly into the viewers' physical space. Bringing together traditional and unconventional media to explore connections and changing ideas of history, nature, science, and space, large-scale abstract sculpture seduces the viewer into the process.

Two major figures in abstract sculpture, Barbara Hepworth (1903–1975) and Louise Nevelson (1900–1988), emerged on opposite sides of the Atlantic. Unusual for women of their generation, both, after an initial struggle for recognition, now are considered major contributors to the history of Modernism. Hepworth, an engineer's daughter, studied sculpture at Leeds School of Art, the Royal College of Art in London, and the British School of Rome. Particularly after giving birth to triplets in 1934, Hepworth's work became more abstract, including multiples and Mother and Child pieces that focused on qualities specific to forms in space—their size, textures, and relationships. Her carved biomorphic forms in stone and wood are often compared with those of her fellow-student Henry Moore. With her second husband, Ben Nicholson, she was part of a Constructivist collective,with Naum Gabo, Mondrian, and other artists who had escaped Europe during World War II. The group's explorations, combined with her love of the rocky Cornish landscape, led her first to small landscape forms and then to large forms set into the landscape; she would also create forms that suggested the human figure, as well as dimensions of the human spirit. In the 1950s, after representing Britain in the Venice Biennial, she received a number of commissions for large public sculpture—it was at this time that she added metal, especially bronze, to her repertoire of materials. The large-scale work for which Hepworth is best known is her tribute to Dag Hammarskjöld, the monumental *Single Form* (1964) at the United Nations in New York, a rough-hewn monolith featuring an eye-like opening common in both figure and landscape. Inspired by the late Secretary General's efforts to bring order to a divided world, Hepworth expressed the power and unifying purpose of the man and the institution in a single form.

Anxious to escape Rockland, Maine, where her family had settled in 1905 after emigrating to the United States from Kiev, Louise Nevelson, born Leah Berliawski, married a wealthy businessman in 1922 who offered her the chance to move to New York. There, Nevelson took courses in dance, theater, and art, delighted at last to be in a cultural center. Discouraged by her husband from any interest stronger than "dabbling," she eventually left him and her son to study painting at the Art Students League and to travel. During the Depression, Nevelson taught, joined the ranks of WPA (Works Progress Administration) artists, and assisted Diego Rivera on his mural project for Rockefeller Center before switching to sculpture. By the mid-1950s, the Abstract Expressionists had opened the way for audacity, and the always audacious Nevelson stepped in. Her fascination with Dada led her to use piles of wood and debris she had collected from building and demolition sites to create her first "walls;" free-standing and composed of stacked boxes filled with scraps of wood, metal, and cast-off furniture parts, they are worlds within themselves. Whether geometric, flat, or ornamental, they are formal structures, made mysterious by their arrangement, their disparate parts unified by monochrome coats of paint, black at first, later white or gold, each color creating a different mood. With fanciful titles such as *Tropical Garden II* (1959), *Sky Cathedral* (1958), *Royal Tide* (1961), and *Dawn's Wedding Feast* (1959), they could be viewed as metaphorical landscapes or architecture, although their resemblance to stage sets recalls Nevelson's penchant for drama. They are also rooted in the ancient monuments and sacred sites that had impressed her during her travels.

Dorothy Dehner (1901–1994), born in Cleveland, Ohio, lost both parents when she was in her teens. Growing up in California, she was more interested in theater than art before traveling to Europe, where, at the Paris Exposition of 1925, she responded to Modernist art, especially the work of Picasso and Matisse. She enrolled in sculpture classes at the Art Students League in New York, but disillusioned with her teachers, she turned to painting. During her marriage to the sculptor David Smith, from 1927 to 1952, she continued making drawings and paintings rooted in Abstract Expressionism, but, like many female artists before and since, concentrated on promoting her husband's career rather than her own. Her extensive travels with her husband, including stays in St. Thomas, Greece, and Russia, and their mutual interests nevertheless provided her a grounding that took root when, finally, in the 1950s, she returned to sculpture—and to college, where she earned a teaching degree. (During this time she met Nevelson, who became a lifelong friend.) Firmly committed to abstract imagery, Dehner used the ancient lost-wax process, which she taught herself, to create elegant, dynamic bronzes. Totem-like early pieces such as *All American Girl* (1955) or *Two Saints* (1959), built up with forms and fragments to suggest the figure, belie their small size, foretelling more sizeable, monumental figures like *Egyptian King* (1972). Dehner continued producing large vertical landscapes and architectonic environments in aluminum and corten steel, even in her eighties and nineties, when she was almost blind.

Far from the New York art world, Clyde Connell (1901–1998) found her calling as an artist after she and her husband retired. Largely self-taught, but well acquainted with Modernism, she was in her sixties when she began creating totemic sculptures using cedar, cypress, Spanish moss, stone, and iron, materials she found in the vicinity of her Louisiana bayou home. Connell's architectonic constructions, reminiscent of gates and platforms with ladders are symbolic structures intended to initiate a discourse on historical injustices—her references are the totems and houses of Africa's Dogon people, as well extant slave quarters closer to home.

Insinuating ancestral mysteries into the outdoor sites she imprints, Beverly Pepper (b. 1924) uses industrial design techniques to create timeless markers. Pepper, who makes her home in Italy, studied advertising design at Pratt Art Institute in her native Brooklyn, but quickly abandoned a promising career in that industry to take up painting, studying at New York's Art Students League and in Paris. She traveled extensively throughout Europe, the Middle East, and Asia, and when she began her transition to sculpture, she drew on influences as wide-ranging as Japanese Haniwa funerary monuments and the fantastic architectural ruins of Angkor Wat. In 1961 she was living in Italy when she was invited to contribute a welded work to an exhibition of American artists; having no experience with the technique, Pepper signed on as an apprentice at a foundry, where she learned to fabricate on a large scale. She has since created large site works in seemingly endless variety, forming intricate geometric volumes into fountains, totems, and large, harmonious earthworks such as the 1974 *Amphisculpture.* One of her "urban altars," *Genesis Altar* (1985–86) is at once architectural and figurative, combining ritual and industrial design, and intimating mythic aspects of the male and female forms.

When Athena Tacha (b. 1936) moved to Oberlin, Ohio, in the 1960s, she missed the European tradition of open, inviting public spaces, and, indeed, many of her outdoor works carry echoes of the terraced hillsides and ancient amphitheaters of her native Greece. An art historian and museum curator as well as a sculptor, Tacha brings to her vision of a "cosmocentric" sculpture a sense of how human and aesthetic values can relate to the larger universe. From Alaska to Florida, her ideas have taken shape in plazas, fountains, and memorials created for specific urban environments; many of her public commissions feature flowing banks of unequal steps designed to stimulate a consciousness of the relationship between the body and the site. These irregularities both lend her work their rhythmic quality and confound expectations of conformity in art. In works like *Blair Fountain,* the centerpiece of a park in Tulsa, Oklahoma, Tacha applied a system of classical order and logic to harnessing the fluidity and chaos of the natural world. Close to her heart are designs for a series of built and unbuilt memorials to commemorate the Holocaust, the destruction of Nagasaki and Hiroshima, and other contemporary abominations.

Nancy Holt (b. 1938) is inspired by ancient examples of earthworks and architecture, and like the structures she admires, many of her works relate to the cycles of heavenly bodies. She collaborated with her husband, Robert Smithson, a pioneering figure in "land" art, and completed his *Amarillo Ramp* with friends after his death in 1973. Holt's tunnels, mounds, and rings are powerfully integrated into their natural settings across the United States: works like *Sun Tunnels* (1973–76) in Lucin, Utah, and *Stone Enclosure: Rock Rings* (1977–78) become naked-eye observatories from which to view the surrounding landscape and celestial events. The arched openings of *Rock Rings,* on the campus of Western Washington University in Bellingham, Washington—where Pepper, Alice Aycock, and Magdalena Abakanowicz, also have works—are aligned with the North Star, its porthole apertures with the compass points. Inside, viewers experience the calmness of a light-filled enclosure,

whose openings then divide and shape the surrounding panorama of trees, fields, and sky. The Massachusetts-born Holt, who studied science before turning to art, extends her ecological interests to nature's hidden—and less poetic—processes in ongoing works such as *Sky Mound* (begun in 1988), a park design for a New Jersey landfill, in which methane gas, a byproduct of decomposition, is collected as an alternative energy source.

Although Mary Miss (b. 1944) was born in New York, her father's military career caused the family to travel throughout the United States, Asia, and Europe, and from an early age she was impressed by the architecture and ruins she saw. Like Holt, Miss wants her structures to be experienced from within and without; and to that end, she introduces posts, arches, screens, and other built elements to contrive unusual views, viewpoints, and allusions. Rows of posts radiating out from a central sunken pinwheel form in the 1981 *Field Rotation* extend like spokes into the surrounding field. In this way, their sites are integral to the works, which Miss maintains must "inhabit" rather than "dominate" their setting. A student of the mechanics of perception, Miss at times challenges established ideas regarding size, shape, distance, and built conventions with her layered, multilevel structures that may contain often bewildering, ambiguous tunnels, rooms, and stairways. Human-scaled designs for city spaces, such as her South Cove project for New York's Battery Park (1985–87), link land and water with a dramatic curving walkway.

More so than Holt or Miss, Alice Aycock's (b. 1946) constructions elicit emotional responses. In works of the early 1970s, like *Maze* and *Low Building*, erected on her family's land in central Pennsylvania, she explored her childhood fears of cramped spaces. Although viewers must enter Aycock's works to understand them, the ensuing discomfort is meant to lead them toward a higher awareness. Mechanical devices derived from myth, religion, antiquated science, and autobiography pretend to channel forces of the human imagination—their poetic titles, such as *The Machine that Makes the World* or *How to Catch and Manufacture Ghosts* (both 1979), refer to Aycock's sources and the forces she conjures out of them. Text plays an increasingly important role in Aycock's complex, symbolic structures.

Ursula (Karollszyn) von Rydingsvard (b. 1942), born in Germany to Polish parents, emigrated to Connecticut in 1950. Her evocative outdoor pieces, which are at once primitive and sophisticated, reinvent simple forms as reverential objects. Originally trained as a painter, von Rydingsvard takes an unorthodox approach to sculpture, layering cedar boards, carving, and using a grinder to elicit sensuous shapes from the wood, and applying graphite to create a surface look of stone. There is an odd ambiguity about objects made unrecognizable by their size, such as *Three Bowls* (1990), so large that one can only imagine the entirety of their elemental forms.

The British sculptor Rachel Whiteread (b. 1963) gives shape to spaces by turning them inside out, casting them in solid white—closets, the spaces around tables and chairs, even rooms. Her controversial 1993 *House* was an entire house cast in resin: room upon room of the last of a row of Victorian terrace houses in London's East End, slated for destruction, were presented in impenetrable block forms, with their original apertures and architectural ornamentation strangely bulging or inverted in reverse. (*House* itself was destroyed the following year.) Here, as in her smaller resin-cast cabinets, shelves, and tables, Whiteread's monochrome medium gives these overlooked spaces a look of classical repose. A 1997 commission resulted in a "water tower" on top of a New York building; except for the reflections as daylight turns to dusk, the work of art is visually indistinguishable from its functional neighbors.

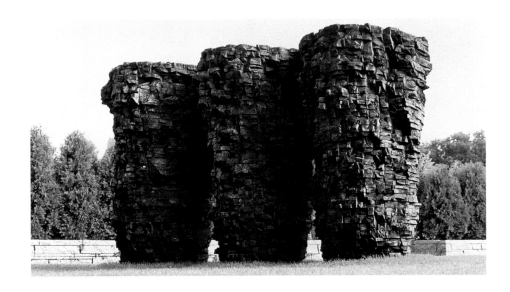

p. 306:
Clyde Connell. *Bound Women*. 1987.
Mixed media: wood, paper, and
cloth. Photograph: Neil Johnson.

p. 309:
Ursula von Rydingsvard.
Three Bowls. 1990. Cedar and
graphite. 9 ½ x 16 x 8 ft. (2.9.5 x
4.8 x 2.4 m). Collection of the
Nelson-Atkins Museum, Kansas
City, Missouri. Courtesy of
the artist and Galerie Lelong,
New York.

Above:
Barbara Hepworth. *Three Forms*.
1935. Marble. 7 ⅛ x 21 x 13 ½ in.
(20 x 53.3 x 34.3 cm). Tate Gallery,
London. Photograph: Tate
Gallery/ Art Resource, N.Y.

Louise Nevelson. *Tropical Garden II*. 1959. Painted wood relief sculpture. 110 ½ x 131 ½ x 12 ¼ in. (280.6 x 334 x 31.1 cm). Centre National d'Art Contemporain, Paris. Photograph: Giraudon/Art Resource, N.Y.

Athena Tacha. *Blair Fountain.*
1982. Concrete and rocks. 36 x 60
x 80 ft. (10.9 x 18.2 x 24.3 m).
Riverfront Park, Tulsa,
Oklahoma. Photograph ©
Athena Tacha.

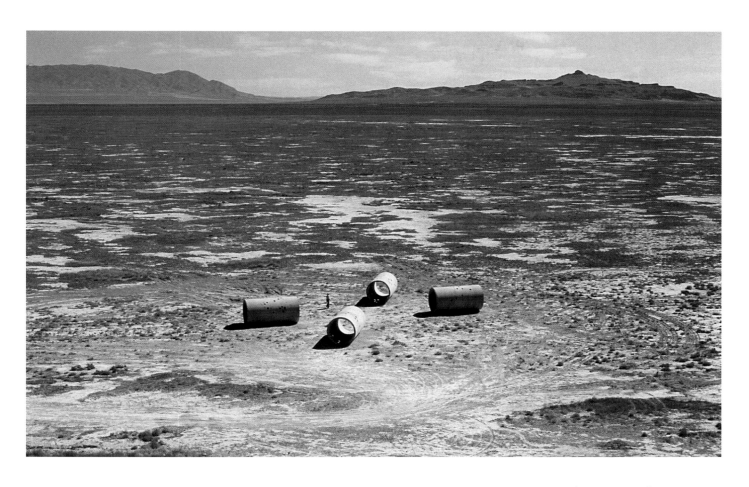

Nancy Holt. *Sun Tunnels.* 1973–76. Concrete, aligned with sunrise and sunset on solstices. Tunnels, 18 ft. (5.5 m) long. Total length, 86 ft (26.2 m). Great Basin Desert, NW Utah. Photograph courtesy Nancy Holt.

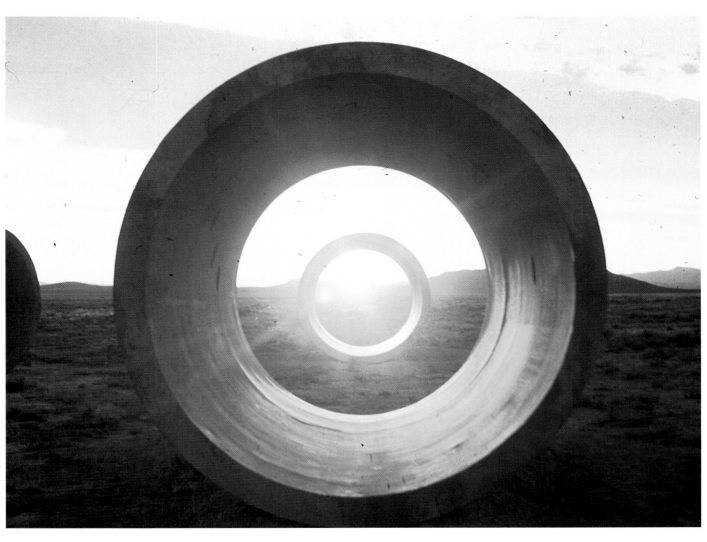

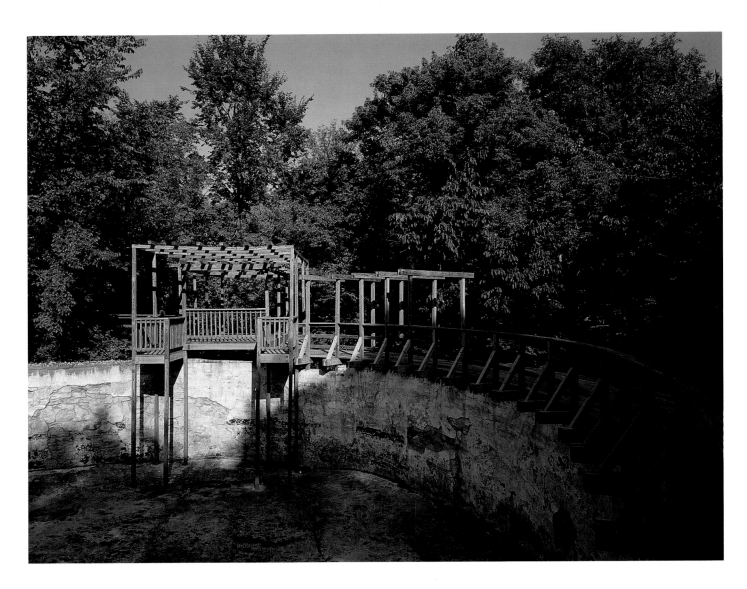

Mary Miss. *Pool Complex: Orchard Valley.* 1985. Concrete, stone, galvanized ferrous metal. Laumeier Sculpture Park, St. Louis, Missouri. Photograph: Robert Pettus.

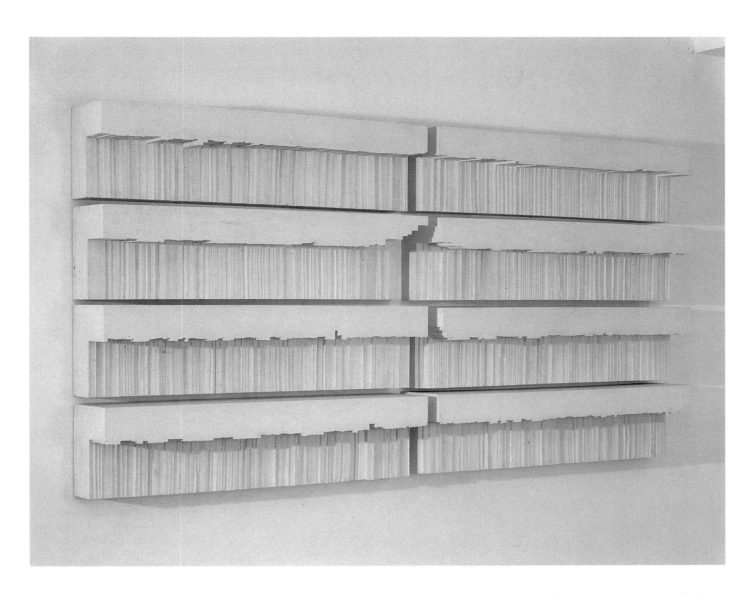

Rachel Whiteread. *Untitled (Eight Shelves)*. 1995–6. Plaster. 11 x 46 ½ x 8 ½ in. (27.9 x 118.1 x 21.6 cm). Courtesy Luhring Augustine, New York.

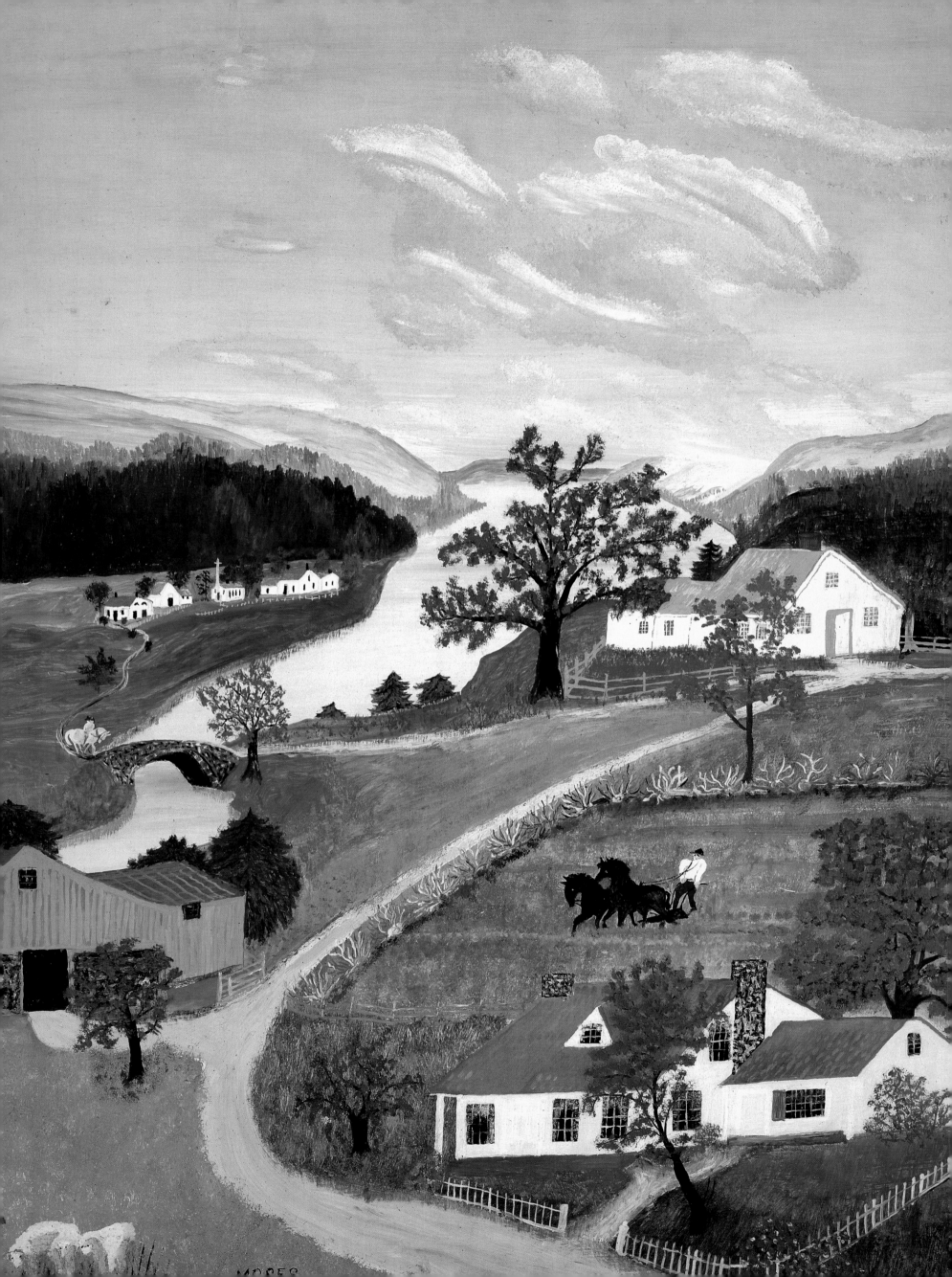

24
Just Folks
Traditional Art and Artists

With the exaltation of the individual, beginning with the Renaissance, "art," once merely a synonym for "skill," came to be defined as a combination of talent—even genius, in the classical, Socratic sense—and training. Since women, also by definition, could possess neither of these qualities, women could not be artists of genius. The societies that espoused these rules permitted, even encouraged the exceptions that ostensibly proved the rules: thus, female artists.

An apocryphal anecdote relates that Louis Armstrong was once asked in an interview whether his music was "folk music." Satchmo replied, perhaps stressing the vernacular to make a point, "Its *all* 'folk music.' Ain't no hosses doin' it." Just so, "folk art" is everyday art, sometimes applied to functional objects, sometimes taking on traditional artists' mediums. The traditional role of women as homemakers—and home embellishers—provided and continues to offer daily opportunities to make art, art that is often dismissed as naïve and simplistic, or else viewed by a status- and consumption-driven aesthetic as an expression of poverty, and so less desirable than store-bought, name-brand things.

Like music, the visual arts down through time have often referred to folk art for various reasons and diverse ends. In the questioning 1960s, domestic concerns surfaced in the work of Andy Warhol, and traditional women's mediums became prominent in Robert Rauschenberg's assemblages. With the so-called "second wave" of feminism, in the 1960s and after, some trained artists publicly recognized the work of women, while others made the conscious decision to feature the folk art made by women and so long derogated or ignored.

Like most girls in rural upstate New York in the years during and after the Civil War, Anna Mary Robertson Moses (1860–1961) received little formal education. She learned to paint from her father, the less practical of her parents, but as a hired girl, then as a farmer's wife and a mother, she had little time for frivolous pastimes. Still, her embroidered and yarn pictures were prized by her family, who, after she was widowed in 1927, encouraged her to try the faster medium of paint. Grandma Moses was discovered in her seventies by a collector who saw her pictures in a storefront window. During the last two decades of her life, Moses was celebrated worldwide, best known for her scenes of rural life. In countless landscapes, often broad vistas recalled from her long-ago past, she displayed an instinctive sense of color and composition. Interior scenes, such as *Christmas at Home* (1946), were rare for Moses. Her loving portrayal documents the various activities of her family members—here several generations—including her children (five of ten survived), their children and grandchildren. Colorful details suggest a lively atmosphere where old-fashioned and modern life co-exist, and grown-ups and children (and family pets) share in the holiday games and preparations.

Less sophisticated are the paintings of the Louisiana artist Clementine Hunter (1887–1988). Born on a plantation, the granddaughter of a freed slave, Hunter was a teenager when the family moved to what became known as Melrose Plantation, near Natchitoches, where she worked in the fields and later in the laundry and kitchen. Cammie Henry, the owner, turned Melrose into a retreat for artists and writers; Hunter was nearly fifty when she asked to keep some discarded paint tubes and began to "mark" pictures. Her first stunning efforts received great encouragement from the residents, several of whom collected and promoted her work. She sold her pictures, painted at first on cardboard, plywood, even brown paper bags, for a few dollars, managing to support her grown children and their families, until in her last decade she became something of a celebrity. Colorful and bright, Hunter's simple scenes capture the work and amusements of rural black life—from picking and carting cotton to dances and nightlife—as well as flowers, birds, and religious subjects,

frequently replete with "flocks" of heavenly angels. Like similar, highly animated subjects, *Saturday Night* (c. 1968), derives its lyrical quality from its straightforward, simplified, colorful presentation.

In the mid-1900s, the Canadian government sponsored rural cooperatives intended to promote local arts and create jobs, and it was through one of these that, in the 1950s and 1960s, after her husband's death, Pitseolak Ashoona (c. 1900) discovered that she could earn more for her "lines on paper" than for embroidering clothing for sale. Her felt-pen drawings depict "the old ways" of the Inuit of the Arctic Archipelago, before the encroachment of modern society. A hunter's wife from Cape Dorset, Baffin Island, Pitseolak and her family moved frequently, perpetuating age-old nomadic customs such as making their homes and clothing from animal skins. In *Migration Towards Our Summer Camp* (1984), Pitseolak depicts such a migration, with family members dressed in their animal-skin parkas, the older ones with heavy packs, the younger helping to lead the pack dogs. The background suggests the snowy trail the family is following. The atmosphere is one of joy in their journey.

Outsiders also played a role in Pablita Velarde's (b. 1918) life. Born in New Mexico's Santa Clara Pueblo, Velarde and her sisters—who were given Spanish names as well as Pueblo names—were sent first to missionary schools and then to the United States Indian School in Santa Fe after their mother's early death. Her grounding in Christianity conflicted with the Pueblo way, creating a lifelong tension for the artist, which was exacerbated by Velarde's determination to paint—to Native Americans, this is a man's occupation—and her marriage to an Anglo. It was the 1930s. Art instruction at the school emphasized what the Anglo teachers considered "tribal." An early inspiration was Tonita Peña, considered the first Indian woman easel painter, whom Velarde met at the Indian School; both women were hired by the Works Progress Administration (WPA) in the 1940s to create murals and paintings describing Pueblo life and legends. Velarde's crisp, picturesque paintings are often layered with information about ceremonies, ancient patterns and motifs, habitat, and clothing, with a profusion of revealing details. In *Old Father: The Story Teller* (c. 1960), the title work for a book of paintings and stories, Velarde evokes the traditional ritual of keeping history and legend alive by looking to the night sky to see ancestors act out their habitual migrations. Unlike the modernist abstract work of her daughter, Helen Hardin, Velarde's paintings remain representational.

Spanish settlers brought *santero* art, the carving of saints, or *santos*, to the American Southwest in the eighteenth century; it is being revived in this century by artists like the New Mexican Marie Romero Cash (b. 1942). Cash uses aspen wood and tin to produce figures and groupings in the old style, employing the techniques she learned in conserving old works to recreate authentic colors and designs. A typical *nicho* (niche) is her *Holy Family* (1987), with its highly stylized faces and figures. Here, Cash has used watercolors to paint the flowing, organic designs in reds and blues akin to those of century-old examples; she substituted decorative pressed tin, usually employed for crowns and accessories only, for a carved wooden foundation.

Uemura Shoen (1875–1949) was one of the very few professional female painters in Japan. Her father died before she was born, but her mother, a tea shop proprietor, recognized her daughter's talent and encouraged her to seek art training. Shoen became famous as a painter of *bijin-ga* or, paintings of beautiful women, often characters from literature and drama or else refined women engaged in routine activities. She studied with a series of teachers, at first practicing their styles, as dictated by custom, and eventually developing her own. Purposely rejecting any hint of the European influences that were seeping into Japanese painting, she retained her purist's approach, aspiring to represent beauty and morality. Shoen achieved success when she was quite young: so well accepted was her work, which garnered prizes in prestigious exhibitions, that she survived the scandal of bearing an illegitimate child in 1902, when she was still in her twenties. Her son's father was her first painting teacher, whom she had known since she was twelve, and once again her mother stepped in, helping to raise the child so that Shoen could teach and paint. A work of 1934, *Oyako (Mother and Child)*, shows her daughter-in-law and first grandchild; done shortly after her mother's death, the painting depicts a figure in the hair and clothing styles of an earlier era. Shoen's traditional painting style, with clean lines and contrasting areas of pattern and solid color, exhibits the very qualities of earlier Japanese prints that had influenced Mary Cassatt and the French Impressionists.

The Polish painter Zofia Lubanska Stryjenska (1891–1974) received academic art training in Krakow and later in Munich, where she posed as a boy because female students were not accepted. Later, sometimes leaving her husband, the architect and sculptor Karol Stryjenska, with their three children, she pursued commissions and other opportunities to work. After World War I, the couple found friends among artists who, though familiar with various modernist art practices, promoted folk life and traditional "peasant"

subject matter as expressions of Polish nationalism. Stryjenska worked both on a large scale, executing murals and wall decorations, and on numerous series of smaller paintings and graphics, images of regional costumes and dances, Polish Christmas carols, even a pantheon of invented Slavic gods, that continued to be published and remained well known even after their maker had been forgotten. Her popular style is apparent in *Meeting with the Son* (1917-18), one of several paintings from her Pascha cycle, based on the Passion of Christ. The Christ figure, a blond Slavic type; his mother; and the others are dressed in Polish peasant costumes, some with fantastic headdresses, and are set in a landscape of imaginative trees and plants, created in the tradition of folk art designs.

Although born and educated in England, Edna Swithenbank Manley (b. 1900) was one of the artists who defined modern Jamaican art. She went to Jamaica in 1922 with her husband, Norman Manley, who later became a prime minister, as did their son, Michael. Adapting to a culture in which women were treated as second-class citizens, Edna supported her husband's career in law and then politics, while he in turn encouraged her sculpture. Manley turned her academic and modernist art training and modeling skills to creating a distinctively Jamaican expression; her powerful figural subjects were acclaimed in Europe long before they gained popular acceptance at home. Works like *Negro Aroused* and *The Prophet* (both 1935) bespeak the pain and suffering, dignity, hope, and grace she observed in the people around her. In the 1940s Manley and other Jamaican artists established an art school as part of a program to generate enthusiasm for the visual arts. As her husband worked for political change, Manley was sowing seeds for its artistic growth.

The conventions of race, gender, tribe, and class continue to throw up barriers for black women artists in South Africa, even at the close of the twentieth century. Mmakgabo Mmapula Helen Sebidi (b. 1943) addresses some of these concerns in her paintings. A child when her mother left to find work in Johannesburg, Sebidi remained in rural Pretoria with her grandmother, from whom she learned traditional painting practices, including making colors and patterns. Later, when she rejoined her mother, she worked as a domestic for several years before studying painting, first in the studio of the black artist John Koenakeefe Mohl, and later at the Johannesburg Art Foundation. In her early paintings she romanticized rural women—baskets on their heads, babies on their backs—stylized, as gracefully engaged in women's work. Sebidi's later subjects are more complex responses to the more demanding roles contemporary black women play. These figure-filled compositions evoke African proverbs, for example, *The child's mother holds the sharp side of the knife* (1988–89), is an adage that describes an African woman taking charge of situations in her life.

In rural regions of South Africa and West Africa women continue a tradition of painting decorations on their mud homes using hands, spoons, and feathers to apply paints in earth colors made from indigenous pigments—with additions such as "washing blue." As young women leave their villages to work in the cities or adopt "Western" habits and non-native religious beliefs, artistic methods such as these are in danger of disappearing. The designs, which are often specific to a place, may be handed down from mother to daughter within families and communities and are similar to those used in textiles, baskets, and pottery. Generally speaking, the murals are applied to newly plastered walls, inside as well as out, as part of the periodic restoration of the mud houses and compounds, and, like quiltmaking in the United States, the painting is frequently a sociable activity. One example of the many various styles and patterns is the work of Soninke women, in the West African nation of Mauritania.

Artwork by women in traditional cultures, and in traditional currents within industrialized cultures, continues to be unattributed. Sometimes this is because women's art, like women's work, is undervalued; sometimes, because the community perceives the expression as emerging from the group or the tradition, rather than from any given individual; and sometimes for both reasons. Nevertheless, the bitter and sorrowful adage "Anonymous was a woman" is far less true than it once was. Made visible by the women's movement, women worldwide are bolder, taking their place at the forefront of all contemporary art practices—and time-hallowed ones, too—including painting, sculpture, performance art, video, installation, and those yet gestating, awaiting their birth in the century to come.

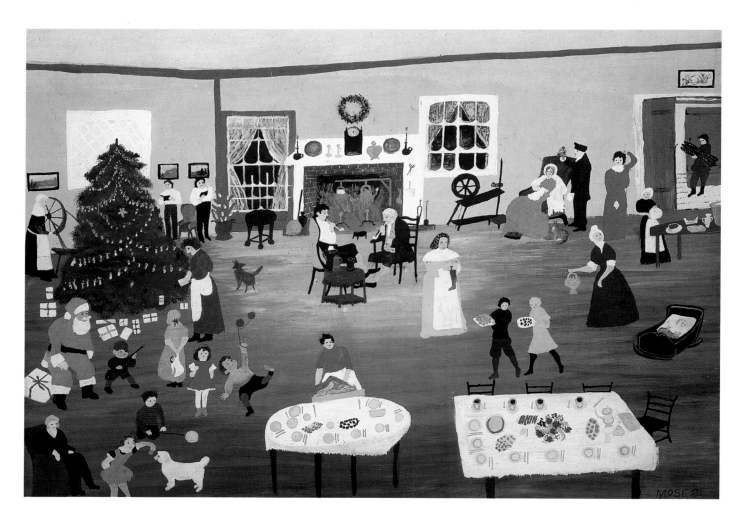

p. 316:
Anna Mary Robertson
("Grandma") Moses. *The Spring in Evening*. 1947. Oil on pressed wood. 27 x 21 in. (68.5 x 53.3 cm). © 1973 Grandma Moses Properties Co., New York.

Above:
Anna Mary Robertson
("Grandma") Moses. *Christmas at Home*. 1946. Oil on canvas. 18 x 23 in. (45.7 x 58.4 cm). © 1973 Grandma Moses Properties Co., New York.

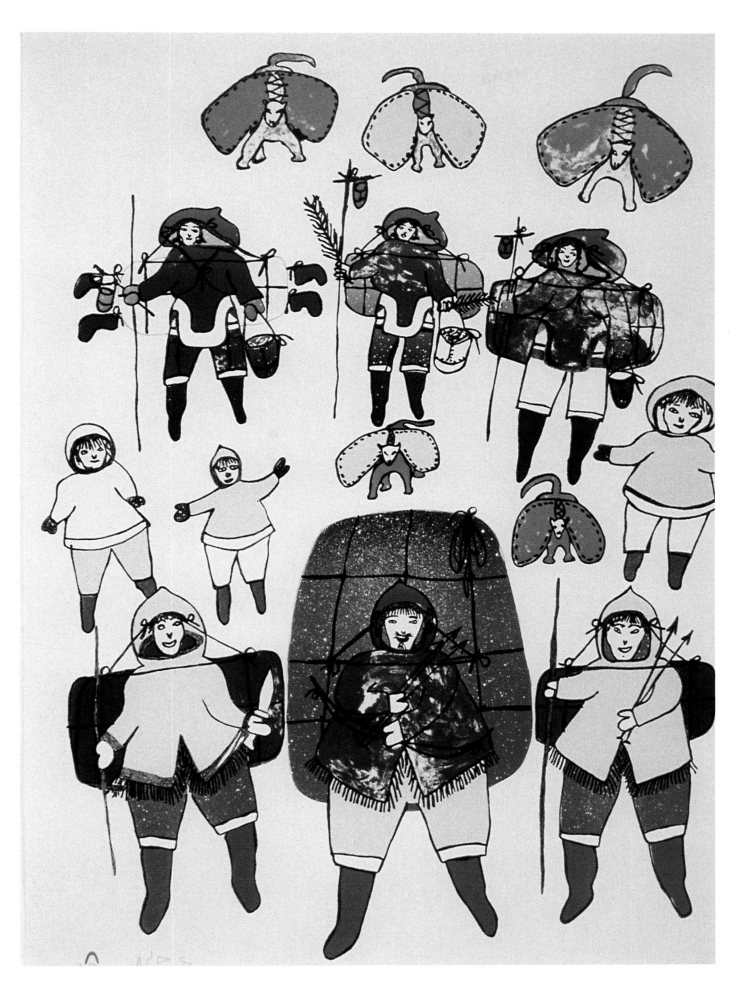

Pitseolak Ashoona. *Migration Towards Our Summer Camp.* 1984. Lithograph. Reproduced with the permission of the West Baffin Eskimo Co-operative Ltd., Cape Dorset, Nunavet, NWT. Photograph: Indian and Northern Affairs Canada.

Overleaf:
Clementine Hunter. *Saturday Night.* c. 1968. Acrylic on board. 24 x 16 in. (60.9 x 40.6 cm). Collection of the Museum of American Folk Art, New York. Gift of Mary Bass Newlin. (1989.9.1)

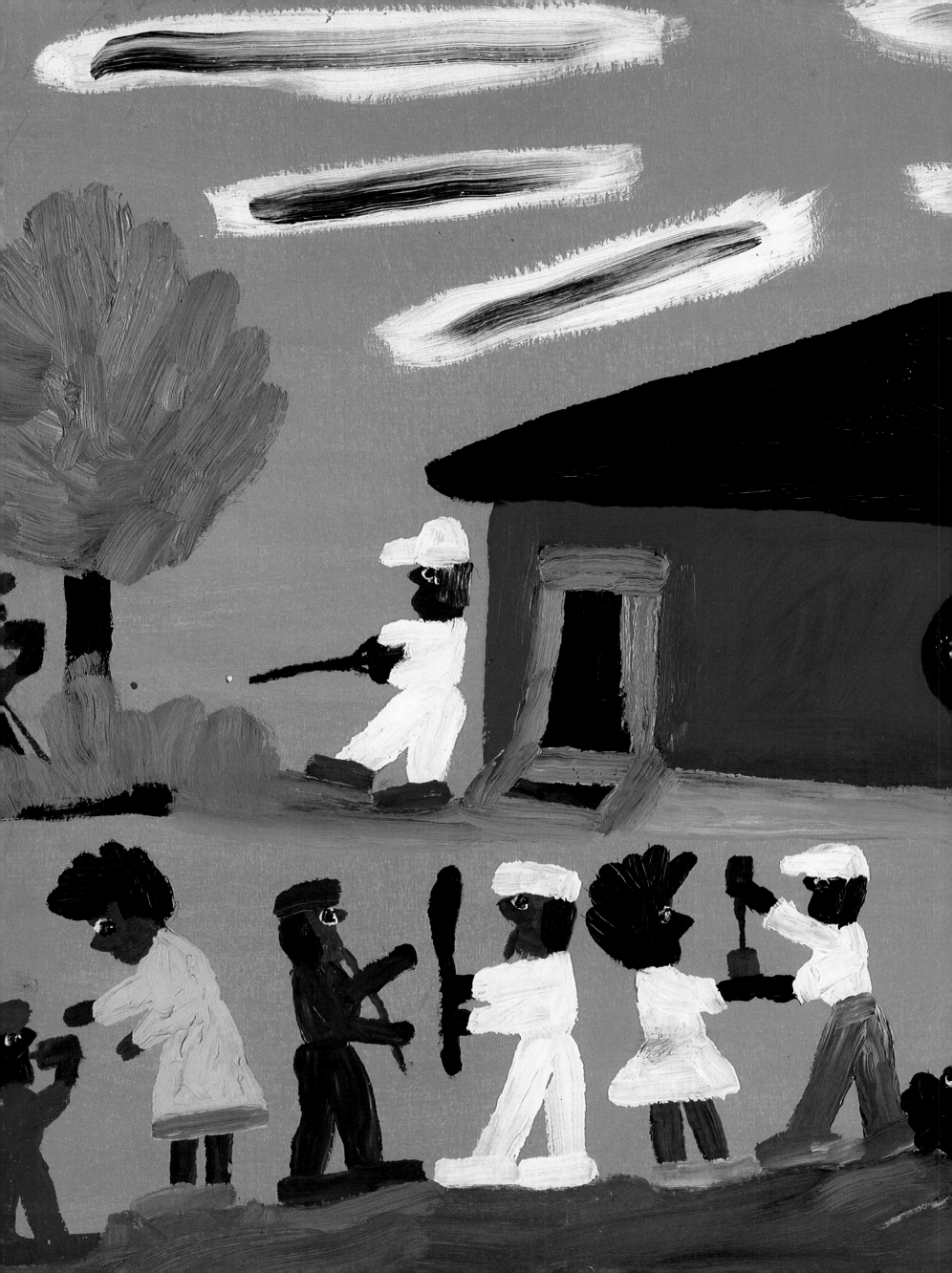

Above:
Pablita Velarde. *Koshares of Taos.*
1947. Watercolor. 13 ¼ x 22 ½ in.
(33.6 x 57.1 cm). The Philbrook
Museum of Art, Tulsa,
Oklahoma. Museum purchase.
(1947.37)

Right:
Marie Romero Cash. *La Santa
Familia en Nicho de Lamina (The Holy
Family).* 1987. Cottonwood, cloth,
gesso and tin. 41 x 39 ½ x 15 in.
(104.1 x 100.3 x 38.1 cm).
Collection of the Albuquerque
Museum. Gift of the artist.
Photograph: Damien Andrus.

Left:
Uemura Shoen. *Oyako (Mother and Child)*. 1934. Color on silk. 67 x 46 in. (170 x 117 cm). National Museum of Modern Art, Tokyo. Courtesy Japan Artist Asociation.

Below:
Zofia Stryjenska. *Meeting with the Son*, from *Pascha* cycle. 1917. Pap stick on cardboard, watercolor, gouache. 27 ³⁄₁₆ x 39 in. (66 x 99.3 cm). National Museum, Warsaw. Photograph: Teresa Zóltowska-Huszcza.

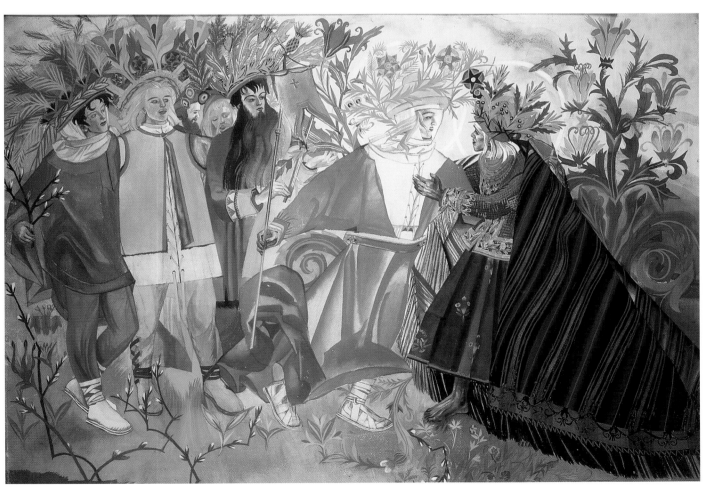

Index

Page numbers in *italics* refer to illustrations.